STORIES BEHIND THE IMAGES

Lessons from a Life in Adventure Photography

COREY RICH

MOUNTAINEERS
BOOKS

MOUNTAINEERS BOOKS is dedicated to the exploration, preservation, and enjoyment of outdoor and wilderness areas.

1001 SW Klickitat Way, Suite 201, Seattle, WA 98134
800-553-4453, www.mountaineersbooks.org

Printed in China
Distributed in the United Kingdom by Cordee, www.cordee.co.uk
23 22 21 20 2 3 4 5 6

Copyeditor: Elizabeth Johnson
Design and layout: Jen Grable
All photographs by the author unless otherwise noted.
Cover photograph: *Tommy Caldwell and Kevin Jorgeson on El Capitan, Yosemite National Park, California*

Library of Congress Cataloging-in-Publication Data
Names: Rich, Corey, author.
Title: Stories behind the images : lessons from a life in adventure photography / Corey Rich.
Description: Seattle, WA : Mountaineers Books, [2019]
Identifiers: LCCN 2018057668 | ISBN 9781680512649 (trade paper)
Subjects: LCSH: Outdoor photography. | Travel photography. | Rich, Corey—Travel.
Classification: LCC TR659.5 .R445 2019 | DDC 778.7/1—dc23
LC record available at https://lccn.loc.gov/2018057668

Mountaineers Books titles may be purchased for corporate, educational, or other promotional sales, and our authors are available for a wide range of events. For information on special discounts or booking an author, contact our customer service at 800-553-4453 or mbooks@mountaineersbooks.org.

Printed on FSC®-certified materials

ISBN (paperback): 978-1-68051-264-9

An independent nonprofit publisher since 1960

To my mom and dad, Ruth and Dave.
And to my wife and daughter, Marina and Leila.

CONTENTS

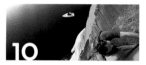

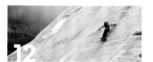

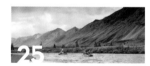
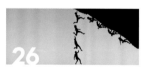
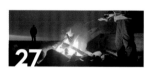

PREFACE

WHEN I WAS THIRTEEN YEARS old, I won a pull-up contest. I did thirty-five and shattered the school record. It ended up being one of the more pivotal moments of my life.

I had grown up doing gymnastics. Being pretty short (and only kind of smart), I knew better than to try out for the football team or the basketball team. Maybe being a gymnast lacked the "cool" factor of being a star quarterback, but it gave me body awareness, a high strength-to-weight ratio, and mental discipline. It also taught me how to suffer. At an elite level, gymnastics is hard, and it hurts badly, every day. But it all paid off when I won that pull-up contest and got to prove my athleticism in front of my peers.

It wasn't classmate recognition that made this moment memorable, however. It was what happened next.

A teacher, Bob Porter, took notice of my thirty-five pull-ups and invited me to go rock climbing with him.

"Not bad, kid. You ever climb rocks?" he asked.

The following Saturday, at 5 a.m., my father dropped my older brother, Scott, and me off at the parking lot of the Quartz Hill High School in Antelope Valley, California. Bob and math teacher George Egbert were already

there waiting. Bob's truck bed was packed with all kinds of shiny carabiners and coiled-up ropes.

"You be safe, guys," my dad said. "Scott, don't let Corey do anything stupid."

We loaded up into our teacher's truck. As soon as we pulled out of the lot, Bob ripped open a box of forty powdered donuts and placed them on the center console. "Help yourselves, fellas!" he said.

Moments later, he had a large coffee from 7-Eleven in one hand, a can of Budweiser in the other, and he was steering with his knees. Given that I don't know the statute of limitations for this sort of behavior, let's be safe and say that the can of beer was closed, OK?

Sugar, caffeine, alcohol, and danger—and no parents in sight. I knew instantly this was the life for me.

We spent the day climbing at Dome Rock, just down the road from the more famous Needles. I fell in love with climbing immediately. It was a physical, mental, and emotional experience—challenging in every meaningful way. And it was all taking place in a beautiful, wild setting unlike any I'd seen before. Most important, I was having an experience that would become a story that I could call my own.

I picked up my first camera the very next week. I simply wanted to take pictures of my weekend climbing trips with my teachers. What I quickly realized is that having a camera—just like having a pair of climbing shoes—is also a good excuse to go out there and have amazing experiences. Experiences that make for great stories and, in turn, a fulfilling and happy life.

Climbing would become a lifelong passion. Over the years, I've realized that what I love just as much as moving over rock is partaking in climbing's rich culture of telling stories. Turns out, legendary stuff happens when you pursue rock climbing long enough. Being able to spin these yarns and share these stories has always been one of the things I've loved most.

My teachers Bob and George were climbing mentors—but they were also storytellers who mentored me in the art of entertaining and bullshitting. This was particularly the case with Bob, who never let facts get in the way of

ONE OF MY FIRST GYMNASTICS COMPETITIONS, AROUND 10 YEARS OLD
(PHOTO BY DAVID RICH)

a good story. (George, being a math guy, mostly stuck to the facts.)

To me, climbing and photography will forever be two passions intertwined. They are merely the weird, quirky, and sometimes adventurous vehicles that have allowed me to do what I really love most: explore the world and come home with good stories.

It's with this sentiment in mind that I wrote *Stories Behind the Images*, which, in fact, is not just a story about one image I've taken, but many stories about many images. This is not a portfolio of my best pictures—though many of them are pictures I'm proud to have created. It's a collection of images that have great stories or lessons attached to them.

Note that this book doesn't need to be read straight through; in fact, it may read better if it isn't. The stories aren't necessarily chronological, and most of the essays are self-contained. Feel free to jump around and pick and choose essays as you see fit. My hope is that this book is a casual, fun read that you can return to anytime inspiration strikes.

Another note: As you will see, my career as a still photographer eventually transitioned into shooting and directing motion pictures. Some of the more recent essays in this book may reference videos, which I'd encourage you to seek out and watch online. Most of the films can be found on my website, http://coreyrich .com, or you can always try Googling the film name and my name, and that should pull it up.

The other by-product of my shift in career focus from still photographer to director is that many of the images in this book are now more than twenty years old. To me, it truly feels as if no time has passed whatsoever. Aside from reminding me that I am, indeed, getting older, the experience of writing this book and reflecting back on all of these moments throughout my career has made me certain that time goes fast when you're doing what you love. If anything, this book has been a healthy reminder that I chose the right career. And I can only say it has energized me for the next twenty years.

One of the real motivations for creating this book is to pass along to my daughter a personal road map of how I

MY DAD'S CAMERA CAME IN HANDY WHEN I WAS SHOOTING PHOTOS FOR THE HIGH-SCHOOL YEARBOOK AND NEWSPAPER, BUT I DESTROYED THE SHUTTER FROM SHOOTING SO MUCH FILM. MY DAD CLAIMS THAT I STILL OWE HIM A CAMERA. (PHOTO BY WYNN RUJI)

turned my passion into a career. I hope she finds something she loves to do and isn't afraid to pursue it with her whole heart.

Stories Behind the Images is a culmination of a passion that was first instilled in me when I was thirteen years old, climbed my first real rock climbs, and picked up my first camera. What it has become is a testament to the power of adventure and creativity—and the fact that owning a camera is a pretty damn great excuse to go out there, explore the world, and start collecting stories of your own.

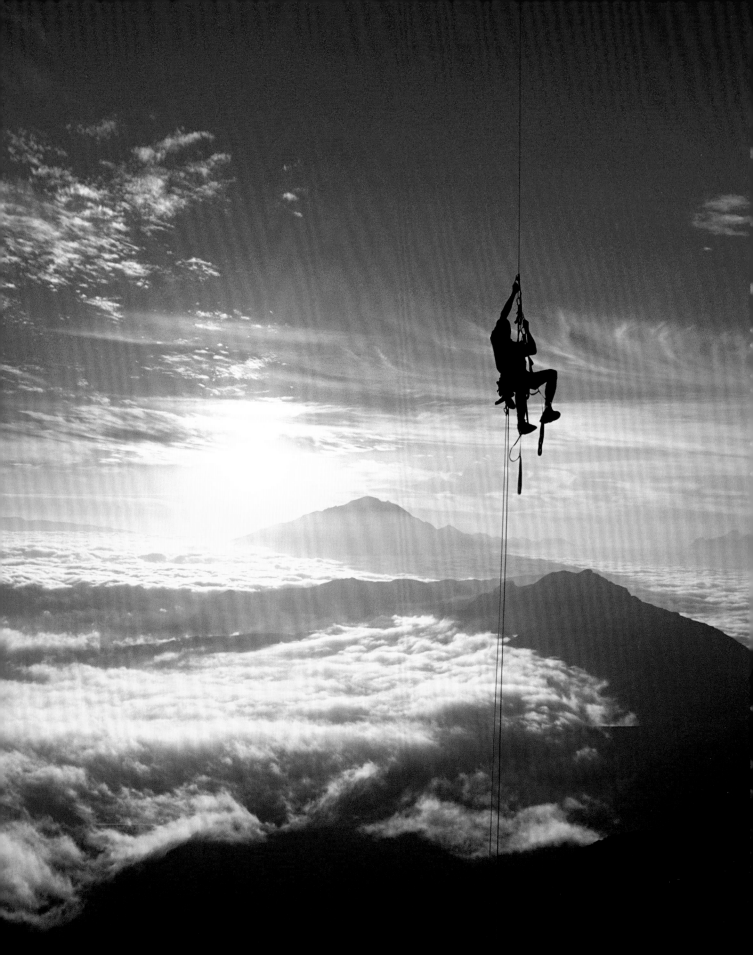

1

DOING WHAT YOU LOVE

THOUGH NOT A LAWYER, MY father served me a contract over Thanksgiving dinner many years ago, stipulating that I'd return to college. I'd recently told him that I'd be taking a semester off from school to travel the West and photograph rock climbing. Understandably, he was concerned that I would never return to my studies. I signed the contract, noting in my head that the language merely said "go back to school," not "finish a college degree."

And while I technically fulfilled my contractual obligations to my father, begrudgingly returning to school after six of the best months of my life, I didn't stay there very long. I'd already seen too much.

Prior to this six-month "drive-about," I purchased a Honda Civic, removed all seats but the driver's, and loaded it up with all my climbing and photography gear, including one hundred rolls of Fuji Velvia film. I hit the road with less than $3,000 to my name, and drove from one climbing area to the next, making pictures along the way.

You meet many fringe characters on an aimless journey like this. I met two legends of the climbing world: Kurt Smith and Jeff Jackson. They invited me to come with them to Mexico, to a climbing area north of Monterrey called El Potrero Chico, a canyon of 2,000-foot limestone big walls. So I went.

At the time, El Potrero was still a nascent climbing area, but it would go on to become one of the most popular winter climbing destinations in the world. From El Potrero, "Jefe," as he is affectionately known, lured me deeper into the Mexican backcountry with spellbinding myths, woven with bullshit. He told me about a

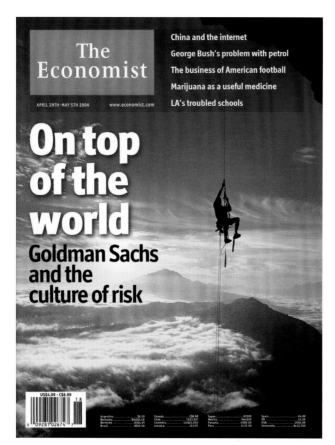

ONE OF THE FIRST SHOOTS OF MY CAREER HAS CONTINUED TO POP UP IN THE MOST UNLIKELY OF PLACES, INCLUDING THE COVER OF *THE ECONOMIST* MORE THAN A DECADE LATER.

for the first ascent. They invited me to join them and shoot photos.

As a climbing photographer, I was still learning the ropes—literally. I was trying to teach myself the most efficient ways to capture the action on a cliff that's taller than your average Manhattan skyscraper, all while suspended from a rope that had me dangling and spinning in space.

We woke at 3 a.m. in order to arrive at the wall for some perfect light. However, our coffee routine got the best of us, and we didn't start climbing till dawn. I was bummed, and figured we had missed the golden opportunity.

By the time I reached the anchor four pitches up, I had written off the potential for making any worthwhile shots. I clipped in to the anchor as Jeff and Kevin ascended the rope ahead of me, and soon found myself dozing in my harness, my head leaning against the cool rock. Then, through a squinted eye, I saw a reflection in my glasses of this dazzling color palette. I opened my eyes and looked around to witness the most incredible fucking sunrise that I'd ever seen. Faint lenticular clouds swirled across a range of pinks and blues, and everything suddenly seemed bright and full of opportunity and new beginnings.

I HIT THE ROAD WITH LESS THAN $3,000 TO MY NAME, AND DROVE FROM ONE CLIMBING AREA TO THE NEXT, MAKING PICTURES ALONG THE WAY.

And there, set against that sky, was Kevin, dangling in space and inching his way up the fixed line. Instantly, I realized: *That* was the photograph! The picture was unfolding in front of me.

I fumbled as quickly as I could to get my camera out of its bag. I started shooting a few frames with a 17–35mm lens. Because I was shooting film, each depression of the shutter button cost me money, the one thing I didn't have much of, so I was conservative.

mystical big wall tucked away in the northern Mexican desert. It was dangerous, too, Jefe said; the wall was guarded by mummies (*las momias de Monterrey*), half-horse, half-human creatures (*naguales*), centipedes, peyote cacti, and bloodthirsty narcos.

"Corey, the wall is called El Gavilan," Jefe said. "It means 'The Hawk,' and it's steep as shit!"

I thought Jefe was crazy. I didn't believe most of what he said, but it sounded like an amazing opportunity and I was willing to go along for the ride.

Establishing a new 900-foot climbing route is a type of manual labor on par with high-rise construction—involving the use of cordless hammer drills to place protection bolts and sledgehammers to remove loose rock.

Jefe and his climbing partner, Kevin Gallagher, had finished the "construction" phase of El Gavilan, and were now working on the even tougher part of doing all the moves continuously in a free-climbing push, gunning

I exposed for the highlights. With Fuji Velvia 50 ISO film, the latitude for exposure was not that great—exposing for the highlights would silhouette Kevin. Because Kevin was swinging around in this ethereal atmosphere, I knew I needed at least $1/250$ of a second shutter speed to prevent blur. I opened the aperture to f/4, knowing that doing so would make the focus difficult. So I manually focused to make darn certain that Kevin was as tack-sharp as possible. I banged off three or four vertical frames and one or two horizontals.

I OPENED MY EYES AND LOOKED AROUND TO WITNESS THE MOST INCREDIBLE SUNRISE THAT I'D EVER SEEN.

It wasn't until months later, when I was back at San Jose State editing the hundred rolls of film from my road trip down to the best images, that I realized how good this picture was. Not just in terms of its technical execution, but in terms of the emotional texture of memory and experience.

I sat in my dorm room, thinking about how I had no plan for how I'd ever make money as a photographer, or how I'd pay for the next trip (let alone the next brick of film), or how I'd turn this passion for photography into a career.

But those anxieties dissipated when I looked at this shot. Holding the slide up to the light, I saw something that I'd gone out and created. Somehow, that seemed like the most important thing. It really was about doing what I loved, following my passion, making pictures and telling stories about the subjects closest to my heart.

It's been interesting to see this image get published in a variety of magazines over the years—and ultimately find its home at the stock photo agency Aurora Photos. But it wasn't till ten years after that road trip that this picture came full circle back to me.

I was walking through an airport, en route to probably the thousandth rock-climbing shoot of my career, when I noticed a magazine stand out of the corner of my eye. Once again, a palette of familiar colors reflected in my glasses. I turned toward the magazine rack, and there was this photo of Kevin, jugging up El Gavilan, on the cover of *The Economist*.

The headline read "On top of the world."

And that's how I felt: affirmed that climbing, this sport that I love, has the power to convey these universal messages and themes of our collective human experience—of challenge, risk, and success. All those things we face every day when finding our paths, or making our careers, or just trying to create something meaningful and lasting in this world.

I thought back to those days when I was roaming the West in my beat-up Civic, and realized that not much had changed. It really is about following your heart and doing what you love. The rest falls into place.

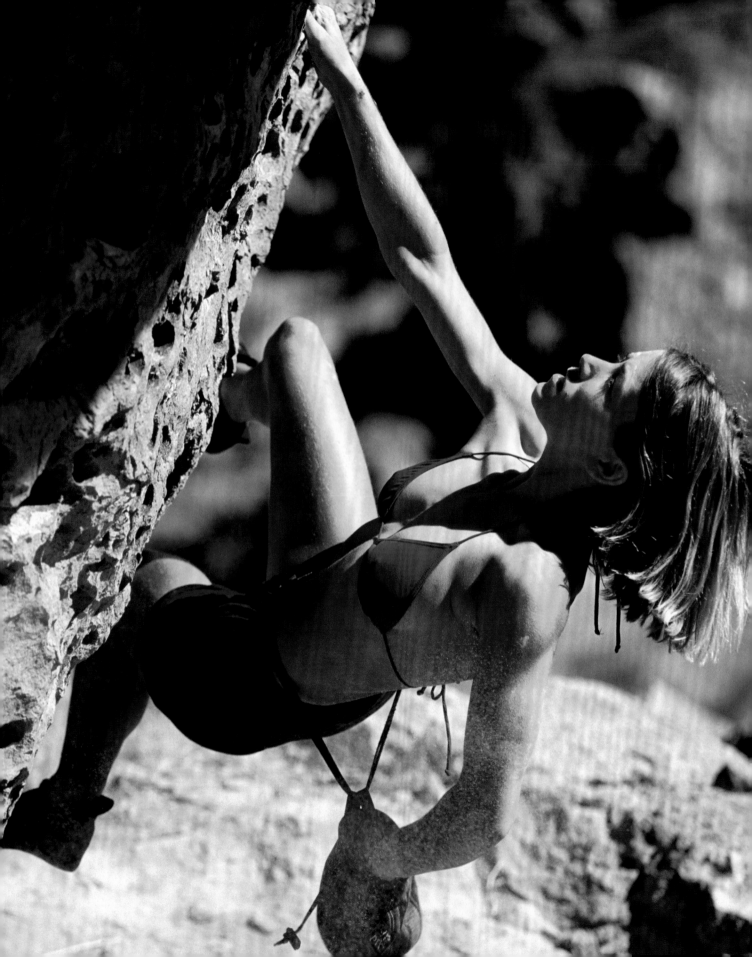

2

COVER GIRL

WHEN I WAS IN COLLEGE, I was much more interested in traveling to the next climbing area than I was in going to class. I wanted to climb, and live the "dirtbag" lifestyle immortalized by writers like John Long and Jeff Jackson. I longed to take climbing pictures like Greg Epperson, who perfected the art of capturing a climber amid a dramatic landscape, and Jim Thornburg, who seems to have the ability to make his photographed climbs look both exciting and gorgeous. And Brian Bailey, who uses light in amazing ways to create photos that look like works of art.

These were the chiefs of the climbing tribe, and they were my inspirations.

Like any twenty-something-year-old, I wanted to find my place in the world, and I had a sense that if I followed my heart to the cliffs and brought my camera, it would somehow all work out.

This was the mid-1990s. The sport of climbing was growing. Crags were getting more crowded, gyms were popping up in major cities, and climbing magazines were in their heyday.

Yet for as much as the sport was maturing, it was still mostly filled with disgruntled single dudes. The guy-to-girl ratio was at least ten to one, or at least it felt that way. It was an era when the sight of a woman carrying a rack of cams and walking through Yosemite's Camp 4 was rare.

Rikki Ishoy looked like she could've been a supermodel if her hands weren't all torn up from being jammed into cracks, and her hair wasn't matted down from sleeping in the dirt.

As it turned out, Rikki was a Danish rock climber on break from law school. She was on an extended tour through the United States to crush rock climbs—and, incidentally, the hopes of just about every guy who laid eyes on her.

I met Rikki through my friend Justin Bastien (see Chapters 3 and 4). She probably found me to be non-threatening, as I was one of those rare climber dudes who actually had a girlfriend. That made me literally the only guy in Yosemite who wasn't tirelessly hitting on her.

Rikki and I became great friends, and we ended up traveling together, to climb and shoot pictures, a lot during that road trip—as well as for many years after. This ended up being a win-win for us both. I got to photograph a tall, Danish supermodel type who had no problem getting up any climb I asked of her. We also never had a problem finding a clueless sucker—I mean, belayer—for Rikki; guys would show up out of nowhere and volunteer for marathon belay sessions, just to hold the other end of Rikki's rope.

Best of all, Rikki got to do all the climbing that her heart desired.

On one of these trips, Rikki and I went to the Happy Boulders near Bishop, California, to go bouldering. As soon as we showed up, a dozen guys carrying pads came creeping out of the rocks, following us around and wanting to know if Rikki needed a spot. It was a hot day. All the guys had their shirts off and were busy flexing their muscles, trying to determine who was the alpha male in the pack through a series of grunts and boasts about bouldering problems they'd climbed.

"You know, it's not fair of the boys to climb without their shirts," Rikki observed, and then proceeded to strip down to her bikini top and climb in that for the rest of the day.

Well played, Rikki.

I snapped this photo of Rikki that afternoon. Being such a hard-core photo dork, I remember thinking it was a decent picture for having been shot in the tough midday light. I was somewhat oblivious to the fact that this was also a picture of a beautiful woman climbing in a bikini.

A few months later, I divided up all my rolls of film and submitted some of my best action shots to Jeff Achey, then the photo editor at *Climbing*.

It was my first-ever submission to a climbing magazine.

A few days later, I got a call from Jeff. His tone was rather inscrutable, even quite gruff.

"Hey, kid, we like one of the images in your submission," he said. "It's pretty good, I guess. We'd like to consider it for the magazine."

He asked me for a caption for the photo of Rikki bouldering in a bikini at the Happy Boulders, and then I didn't hear back from him. About a month later, I opened my dorm mailbox and found the new issue of *Climbing* magazine, with this image of Rikki Ishoy right smack on the cover.

My first cover, I thought. *Cool!*

A lot of people have remarked about how lucky I was to have landed a cover on my first submission. Perhaps there's some truth to that. Maybe the magazine just happened to be hurting for a good cover shot at the time I submitted my photos.

On the other hand, I have to say that luck is maybe only 1 or 2 percent of the equation. I'd spent years pursuing photojournalism, working for newspapers and studying photography in school. And I'd spent the six months prior working my ass off to travel and shoot pictures of rock climbing around the United States—on my own dime, too. I missed out on all the parties and fun that my college comrades were having to shoot a sport and culture that I loved. To me, seeing my shot of Rikki on the cover wasn't mere luck. I had worked hard to create this picture, and this was the result. And for this reason, this image is perhaps one of the most important shots of my career.

The funny part of this story, however, is the response this cover received. Apparently, this was the first time a bikini-clad woman had ever appeared on the cover of a climbing magazine. The editors' mailboxes were flooded with a glut of letters either supporting their decision or, for the most part, outraged by the choice. The complainers were mostly the old dudes who'd climbed back in the 1970s, railing about how the sport was growing and becoming something they no longer recognized.

You have to try to imagine the context of this cover shot. By today's standards, there's nothing even

remotely risqué about this picture. But back then, it was a big deal. Perhaps this cover became a catalyst for some of the negative emotions that had been lying latent in the climbing world at the time: over the sport's growth and transition from fringe to mainstream.

Yet the proof of the photo's impact was in the numbers. This cover actually marked the best-selling issue of *Climbing* magazine—ever. Incredibly, I think it still holds that title to this day. As much as I'd like to believe that my photography skills were the primary reason behind the success, it's obvious to me that the real star was Rikki. I was just a guy who was there with my camera, trying to take a decent picture in some crappy light.

Rikki almost became a professional climber after this cover ran—along with the dozens of photos of her that I subsequently took. She was a good athlete, although perhaps not the best in the world. But she was smart and good-looking. And she was willing to work with me as a model to create the media that was necessary to fill the editorial and advertising pages in the climbing magazines. She was one of those early examples of a climber who, through her presence, helped the sport grow. And she also prefigured what was to come, as today's professional climbers are both climbers and models, using Instagram and social media to tell their stories and inspire their followers.

These days, the industry is able to support dozens of professional climbers and climbing photographers—in part, we have Rikki to thank for setting that precedent.

Opportunity is the single door you walk through that leads to a hundred more. After this image was published, Jeff Achey told me to buy a fax machine, because I was going to be one of the few photographers worthy of receiving the magazine's "Needs List," the list of images *Climbing* magazine was seeking to illustrate each upcoming issue's content. I am almost certain I was the only kid at San Jose State with a fax machine in his dorm room.

When the list came in, I didn't cull through an archive of already-shot images to find something that worked. I saw it as my next month's worth of work, as an opportunity to hit the road, to go out and fill up my portfolio with the best pictures I could take.

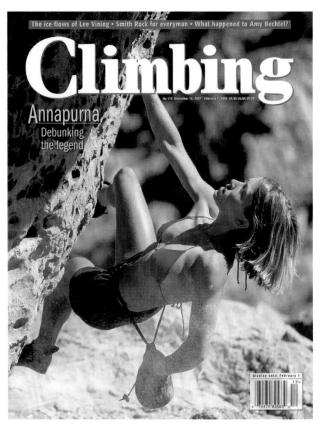

MY FIRST MAGAZINE COVER

And that's exactly what I'd do. I'd load up my Civic, call up Rikki Ishoy, and hit the road. And we'd use the Needs List as an excuse to see the climbing world and live the climbing lifestyle and work to capture every single image that *Climbing* magazine needed that month.

In fact, Duane Raleigh, who became the editor of *Climbing* and is now the publisher of *Rock and Ice*, ended up calling me what seemed like once a week to see if I had captured any more photos of Rikki climbing.

Over the next year, I went from this kid who had never been published in a climbing magazine to a guy who either had the cover shot, a feature, and/or had my images scattered throughout every department—all shot on spec.

This picture of Rikki Ishoy was my first of close to a hundred magazine covers.

And from that, the doors of opportunity continued to open.

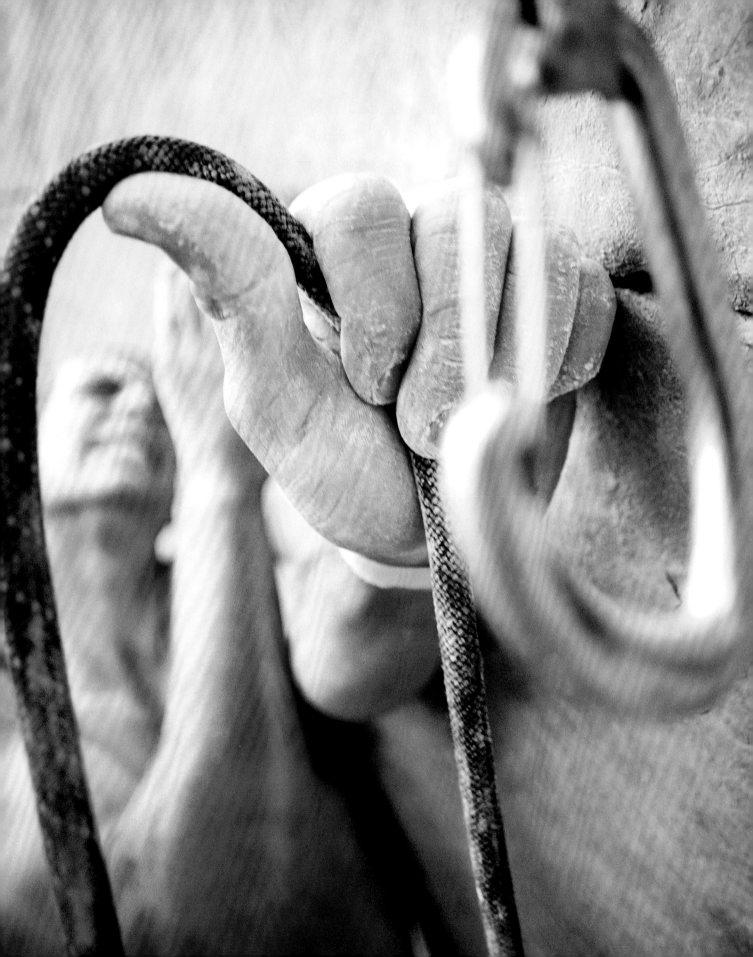

3

DEVIL IN THE DETAILS

I'VE NEVER NEEDED TO CONVINCE my friend Justin Bastien to drop everything and join me on a two-week adventure. Friends like him are some of the best kinds of friends to have.

After I returned to San Jose State from a semester off, a six-month hiatus from academia during which I road-tripped around the western United States to shoot rock climbing, I found myself back in my gloomy dorm room, hearing the call of the open road. I saved up some cash, bought more film, and decided to spend two weeks climbing in Montana and Wyoming.

All I needed was a partner.

I called Justin, whom I had met during my big road trip. "Do you want to go climbing in Montana and—"

"I'm in!" he blurted. "Let's do it!"

"Great!" I said.

Then he added, "The only thing is that I have no money, and my truck is broken, so you'll have to drive." Classic Justin.

I'd upgraded my Honda to a Ford Econoline E-150 van with a futon mattress in the back. We met in Bishop, piled into the van, and chugged north.

My passion for climbing photography was equaled by Justin's passion for climbing. And he was happy to be in my photographs, which made both of our lives easier.

Typically, shooting climbing pictures requires a threesome: a photographer, a climber, and a belayer. Fortunately, Justin had an uncanny gift for meeting people

at climbing areas and convincing them to give him a belay while I shot photos. Usually, these people were stunningly gorgeous single women. If you were a male climber in the 1990s who complained about never meeting any women at the crags, well, here's why: God already sent them all Justin Bastien's way.

Once courted by this unlikely Don Juan, the female belayers would often end up in my photos, too. For instance, I met Rikki Ishoy through Justin—and that's how I ended up with that controversial *Climbing* magazine bikini cover (see Chapter 2).

Anyway . . . Justin and I were optimistic when we arrived at a climbing area called Hellgate Gulch. We looked around, scratching our heads. This was weird. There were no stunningly beautiful single women here waiting to belay Justin. In fact, there were no other climbers at all. It was just Justin and me. I put my camera away, and Justin and I climbed a few pitches under the big Montana sky.

In high school, I'd landed my first photography job at the *Antelope Valley Press*, a daily newspaper serving a circulation of sixty thousand in the Antelope Valley of California, north of Los Angeles. I started out shooting for the real-estate section. I'd get a list of addresses in the morning, then drive around the cities of Palmdale and Lancaster to those specified locations. After

LEFT TO RIGHT: RIKKI ISHOY, ME, AND JUSTIN BASTIEN ON ONE OF OUR MANY MIDNIGHT DEPARTURES TO SHOOT ON THE WALLS OF YOSEMITE, CIRCA 1998

shooting houses all day, I'd head into the darkroom and scramble to meet my deadline that evening.

This was hardly glamorous work, but over time I was allowed to shoot real news assignments. What I learned while shooting there became some of the most important lessons I'd need in my career as a professional photographer.

First, I learned how to be diligent and organized, and to meet a deadline. When I was given an assignment, I quickly learned that there were no excuses: I had to bring back pictures that illustrated the concept of the story, they had to be the right orientation (vertical or horizontal), and they had to be on time.

Second, I learned that all assignments can be broken down into three categories of photographs, each of which needs to be taken in order to tell a successful feature story: the establishing shot, the medium shot, and, last but not least, the detail shot or close-up.

Over time, I learned that this approach works whether you're shooting cutting-edge climbing on the side of El Capitan in Yosemite National Park or the less thrilling world of local news.

While cranking out a bunch of climbs with Justin at that empty Montana crag, I remembered that I was also there to shoot pictures—to build my portfolio and to fund the gas and food kitty to which Justin was not contributing. I treated my time at the cliffs as an assignment. And just like at my local news job, coming home with nothing to show would be unacceptable.

We came up with an idea: What if we duct-taped a quickdraw to the wall and tried to shoot a creative close-up shot? Could we make the mundane act of clipping a rope in to a carabiner interesting and surprising?

So that's what we did. During the heat of the day, on the nearest piece of limestone, we got creative and duct-taped a Black Diamond quickdraw to the wall, and I spent the next half hour working this shot: moving the camera into different positions, altering the focus, changing lenses, changing aperture, directing Justin's body position, and so on.

Justin, in addition to being quite the climber, was also quite the actor. He tried to hang off dime-sized edges, with his feet on the rock a few inches off the ground. The duct-taped quickdraw let Justin pose as if he were

struggling to make a difficult clip with the rope. He was actually trying to do a real rock-climbing move in this mock situation and would often explode backward and land on his back when his grip failed on some tiny ripple.

It was probably better training for Justin than a half hour of actual rock climbing. And, for me, it paid off because I managed to make a couple of interesting pictures.

COULD WE MAKE THE MUNDANE ACT OF CLIPPING A ROPE IN TO A CARABINER INTERESTING AND SURPRISING?

What I didn't quite realize or appreciate at the time was that virtually no good clipping photographs had ever been taken—or at least it seemed that way.

Most climbing photographs were either wide establishing shots, in which you see a small climber amid a large landscape, or classic medium shots, in which the photographer hangs on a rope and shoots down on a climber from an angle of 45 degrees with a wide-angle lens.

Who'd care about clipping? Certainly, no one had cared enough to shoot it. But magazine editors had a different perspective. This photo made its way through all of the climbing magazines. It was printed in magazine photo galleries, and it was used to illustrate how-to articles on sport-climbing and clipping techniques. It was published by Black Diamond in a catalog and used in a giant display at the Outdoor Retailer trade show and its European equivalent. It was turned into a poster, and hung in retail climbing shops around the world. Eventually, this picture landed at the stock agency Aurora Photos, where it's been licensed dozens of times over the years to mainstream brands and magazines.

For being created by a couple of losers goofing off at the base of a cliff in the middle of nowhere, this image has made quite a bit of money.

As a detail shot, it tells a visual story, and it does so in a new, interesting way—at least, it did at the time. But I was concerned about the devil in the details of this image: that we had created a mock climbing scenario.

Coming from a photojournalism background, I knew this was potentially an ethical issue, so I was sure to be up-front with editors in disclosing how the image was created. I was surprised by the fact that they couldn't have cared less. They thought the shot was cool and wanted to publish it. Fine by me!

Perhaps the real takeaway from this story is that I learned to treat every scenario like an assignment. Get the establishing shot and the medium shot, and don't forget about the detail shot. If you push yourself and your creativity, you might come away with a winner.

And if nothing else, bring along a friend like Justin, because at least you will have a good laugh while you try. Years later, Justin went on to become a legit badass photographer and director himself. I'd like to think that he picked up some of his skills during our early trips together.

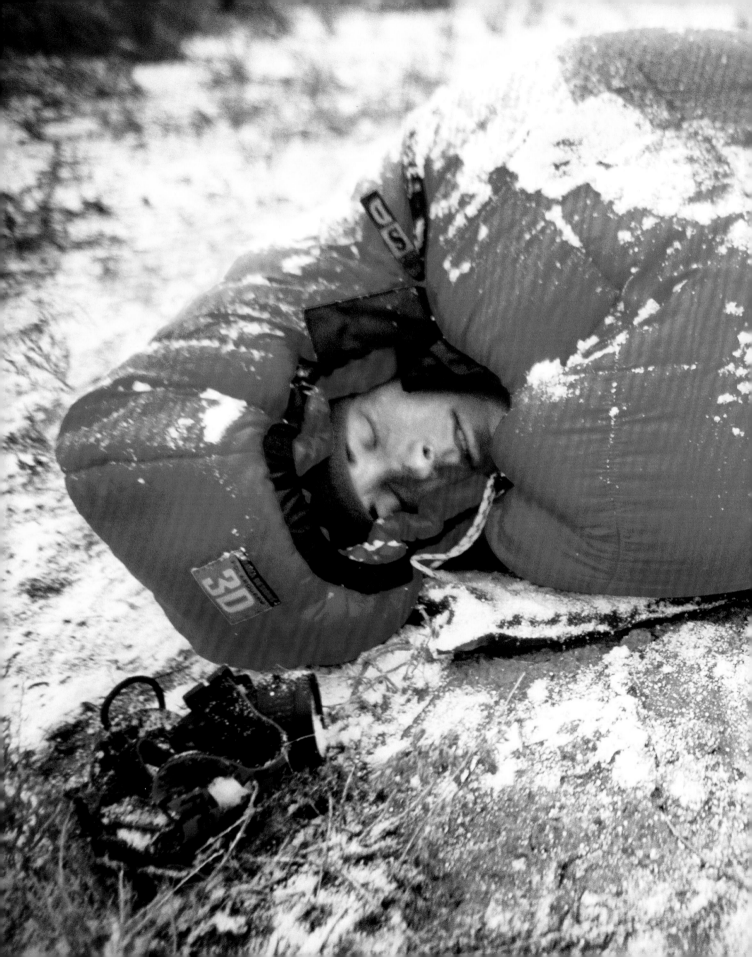

4

PHOTO ROSHAMBO

TIMES ARE CHANGING, MAYBE FASTER than they ever have before. Today, your recently ordered camera gear might be obsolete by the time the UPS driver delivers the package to your door.

Like the world of photography, the climbing world is also advancing by leaps and bounds. Yet there are some things that will never become obsolete. They remain as timeless as El Capitan itself.

One of these things is being a master of the art of roshambo—a.k.a. rock-paper-scissors. Rock-paper-scissors is, believe it or not, one of the most important things for a climber to know. I can't tell you how many fearsome, dangerous leads I've avoided with a well-tossed "rock" or a perfectly played "scissors."

Justin Bastien and I have traveled extensively together, visiting some of the great mountain ranges around the world. Justin was always that guy who was up for leaving for a monthlong trip at a moment's notice. After our road trip to Montana (see Chapter 3), Justin and I decided it was time to climb in the Utah desert. The decision to go to Indian Creek was easy. But it was a twenty-hour drive. Whose car would we take?

I had just driven to Montana, but because Justin was such a broke dirtbag, he tried to get out of his turn to drive.

"Maybe you should drive," he said.

"Let's rock-paper-scissors for it," I offered, knowing full well that Justin had very little chance at beating me.

"OK, fine. Best of three," he said.

With two deft back-to-back "papers," I easily swept Justin. Before he could protest, I had already loaded all my camera and climbing gear into the bed of his pickup, which was outfitted with a hardtop camper shell.

We drove through the night and all the next day, arriving at our destination at dusk. The Utah desert was quite cold in the spring air, and night was falling, painting the red earth shades of blue and violet. There was enough room in the camper shell for only one person to burrow into all the miscellaneous gear and make himself a little nest in which to sleep. The other person would have to sleep in the dirt, which of course neither of us would actually have minded.

Still… being in the truck was going to be a lot warmer. So again, we rock-paper-scissored to see who would be warm and who would not.

As you can see from this photo, Justin once again lost that game, which I took, best out of three, with "paper" and "rock" clinching the victory.

When I woke the next morning, I slipped my head out of the camper shell and saw that a light snow had fallen overnight. The desert looked fantastically beautiful. And there was Justin, sleeping in the dirt with this perfect dusting of snow on top of him. I grabbed my camera, which, like redneck and rifle, I sleep with, keeping it in the "on" position in case I need to quickly fire a few frames.

With catlike stealth, I crawled out of the truck and tiptoed over to Justin. It was near-perfectly quiet, with snowflakes falling through the air, the only sound the occasional wisp of wind. I just had this feeling, this innate sense, that as soon as I depressed my shutter button, and Justin heard that first mechanical *click-clack* of my SLR's mirror, he'd wake up. If he stirred even a bit, the snow on his sleeping bag would be disrupted and this perfect moment would be gone.

Everything we see in this world represents nothing more than a fleeting moment. Never say to yourself, whether as a photographer or otherwise, *I can come back and get this later.* Seize the moment, and make every frame count, because you might get only that one frame before the moment is gone.

I squatted on my haunches in the dirt beside Justin and really took my time composing the image and calculating the exposure in my head. I had a 17–35mm lens, and in this low predawn light, I knew I wanted to be at f/2.8. I was shooting on Fuji Velvia 50, but I pushed it two stops, to 200. I made my best approximation of exposure, massaged the composition until it was perfect, and manually focused my lens, both to make sure that Justin's head was in focus and also to not rouse my sleeping friend with the sounds of the autofocus motor.

I depressed the shutter. *Click-clack.*

ROCK-PAPER-SCISSORS IS, BELIEVE IT OR NOT, ONE OF THE MOST IMPORTANT THINGS FOR A CLIMBER TO KNOW.

Within a split second of my taking this single frame, Justin's eyes opened and his arm shot out of his sleeping bag and punched me in the quadriceps, giving me one of the worst charley horses of my life.

"Leave me alone," he grumbled. "I'm tryin' ta sleep." And he drifted back off.

The moment was gone. The snow had slid off his sleeping bag in the scuffle—which was all in good fun, of course.

I like this photo because it really encapsulates the spirit of being on the road and living outdoors. The beauty of being in a sleeping bag, outside in the dirt, is the implication that you're at some cool location with a full day's adventure awaiting you come dawn. It's a lifestyle I love.

But beyond the cherished memories of my dirt-bag-climber days, spent on the road with my good buddy Justin, I can't help but think about how rare it is for photographers these days to do this kind of mental exposure calculation. Is it a lost art to be bemoaned, or is it potentially something to be celebrated?

Most photographers today often don't understand how camera settings work together—because there are no consequences in getting them wrong. With film,

> SEIZE THE MOMENT, AND
> MAKE EVERY FRAME COUNT,
> BECAUSE YOU MIGHT GET
> ONLY THAT ONE FRAME
> BEFORE THE MOMENT
> IS GONE.

each shot cost money and took a lot of time. But digital cameras allow us to shoot a thousand images with instant feedback and without consequence, enabling the photographer to play with every permutation of ISO, shutter speed, and aperture in a game of something like "photo roshambo." Eventually, a decent-looking shot comes out.

There's a small curmudgeonly part of me that wants to bitch and moan. And yet, I can't and won't be that guy. If anything, digital cameras have unquestionably pushed the overall creativity in photography to atmospheric heights. The bar for excellence has never been higher. And, to be honest, who cares if people don't know the fundamentals, because they don't need to since our cameras take care of all that for us. Come to think of it, had there been mirrorless cameras back then with amazing autoexposure and autofocus, I could've shot hundreds of images without waking Justin—and potentially even have walked (and not limped!) away with something much better than this.

Alas, there's no point in looking back. Still, there are certain values—relics from the "olden days" of photography—that remain a part of my core. Making every frame count and not letting a moment pass are two of them.

Just like rock-paper-scissors is invaluable to climbers, the above are two critical skills photographers ought to know.

TOM BULOW - PASQUALES, MEXICO

20MM LENS / F/2.8 / 1/125 SECOND / SPEEDLIGHT SB 24 / FUJI VELVIA FILM

5

THE IMAGE THAT LAUNCHED MY CAREER

IF YOU WERE TO ASK me to describe, in one word, what drives me, what inspires me as a professional photographer and filmmaker, the simplest answer I can come up with is: *story.*

As a kid, I lived and dreamed every minute within the mesmerizing comic worlds my father spun in his many tales. By age seven, I found myself sitting around with my dad and his scuba-diving pals, engulfed in their masterful stories of weekend adventures spent exploring the deep sea. Those moments left me longing for my own adventures.

Since then, I've had tons of experiences and told thousands of my own stories—usually at the end of a long day's shoot while standing around with a group of friends and colleagues, enjoying that first well-deserved beer. Of all the stories I tell, however, there's one story that people have repeatedly told me is particularly good.

It's the story about the shot that launched my career.

At a basic level, it's just a story about a dirtbag college kid who loved taking pictures and climbing rocks, and then got kind of lucky.

But on another level, it isn't really a story about me. It's a story about following passion and seizing opportunity. It's a story about how a single photograph can change your life.

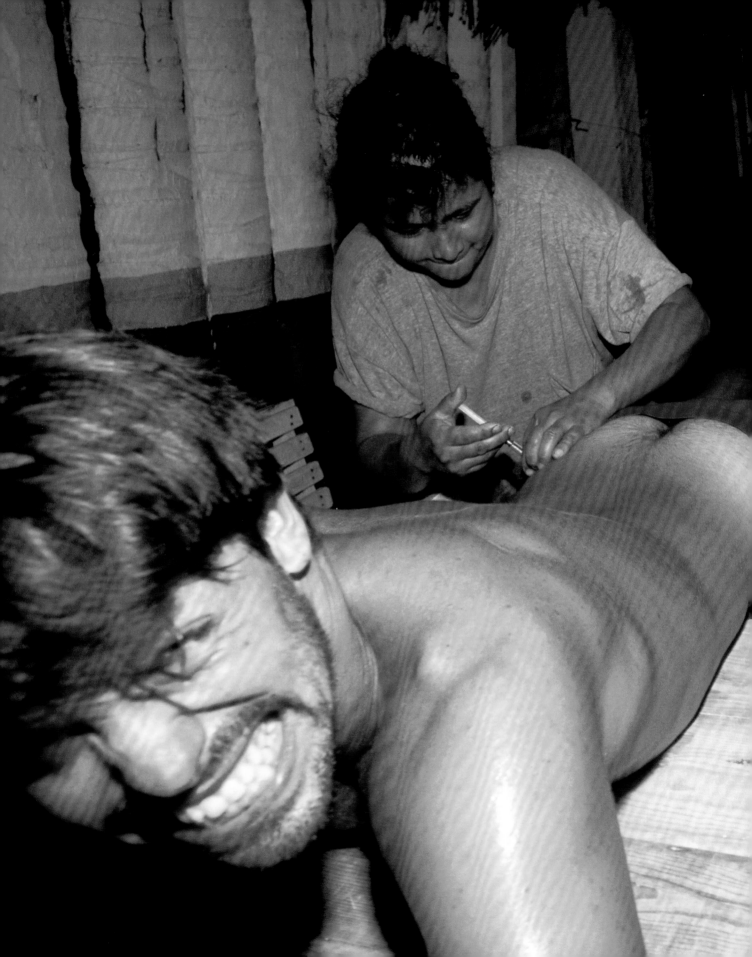

Climbing and photography were the first two passions I could call my own. I discovered them around the same time, at age thirteen. It was then that I realized that climbing offers a really rich way to have experiences, while photography offers a really rich way to share those experiences. Perhaps that's why these ventures will forever feel utterly inseparable to me.

As a freshman and sophomore at San Jose State, I had aspirations of becoming a photojournalist. After completing four semesters of school, I packed my climbing and camera gear into my Honda Civic and set off to document climbing in the American West.

Once back in the dorm, I edited one hundred rolls of Fuji Velvia film down to forty slides of lifestyle/climbing photos, which I sent to the clothing company Patagonia. (I made a separate edit for *Climbing* magazine; see Chapter 2.)

I had just read an article in a photography magazine that included a beginner's guide to making unsolicited submissions to editors, and the tips were aimed at keeping your professionalism high and your hopes low. It recommended using FedEx for tracking purposes, labeling your slides with your name and captions, and then not expecting to hear from the editor for at least six months. By all odds, according to this article, I could expect to receive my slides returned to me years later in a haphazard pile, with a letter recommending that I never quit my day job.

In fact, what happened was that I received a call from Patagonia's photo editor, Jennifer Ridgeway, later that week.

Unfortunately, I received this call decades before I had caller ID. My dorm room phone rang midday, and I picked up, thinking it was one of my college bros.

IN MAZATLÁN, THE FEDERALES HELD US DOWN AT GUNPOINT WHILE THEY SEARCHED OUR CAR FOR DRUGS. WE HAD TO BRIBE THEM WITH $150 AND SOME TRAVELER'S CHECKS, WHICH WE KNEW THEY'D NEVER BE ABLE TO CASH.

"Waaasuuuup!" I bleated into the phone.

"Um, 'scuse me. Is, um, Corey Rich there?"

Instantly recognizing that this might be an important call, I tried to salvage the situation by saying in a different voice, "Oh, yeah, let me see if I can find him for you."

I put the phone down on my lap for five seconds, then picked it back up and said, in the most professional tone, "Hello, this is Corey Rich."

"Hi, Corey. This is Jennifer Ridgeway at Patagonia. We received your slide submission, and, well, who *are* you?"

Jennifer said she'd never received an unsolicited photo submission so strong and visually diverse. She explained that she and her colleague Jane Sievert (who took over Jennifer's position when she retired) wanted to use a few of the photos I'd submitted in the next catalog.

I was ecstatic. A few months later, a big check from Patagonia showed up. But it wasn't the money that was so important. It was the validation that maybe, just maybe, I could actually pull off a career of shooting rock climbing and its lifestyle.

In fact, over time, Patagonia ended up using each and every one of those forty photographs I had submitted, in some capacity or another, whether in its catalog, point-of-purchase displays, ads, or on its website.

Climbing and photography: These were no longer just personal passions. They had become a way to make a living.

That first road trip really changed me. Upon my return home, it became clear to me that my life wasn't meant to be lived or learned in the classroom. There was a whole frontier "out there," waiting to be explored.

And yet . . . I was still a kid. I wasn't quite confident enough in myself to jump down that rabbit hole . . . not yet. I was torn. Should I put nose to book, or foot to gas pedal?

When I returned for my third year at San Jose State, I found myself living in Markham Hall with an eclectic group of guys, one of whom was Tom Bulow, a big-wave surfer from Southern California. We shared a philosophy that when opportunity knocked, school became secondary. Our GPAs really reflected that philosophy, too, though Tom, who's much smarter than me, pulled

it off better. Tom was studying to become a physician's assistant, but riding waves was what really animated his soul. We hit it off because, although climbing and surfing are totally different worlds, they share many of the same core values.

Tom had received a tip that a huge swell was en route to hit mainland Mexico. On a whim, we decided that we should haul ass down there to check it out.

A trip to Mexico is always going to be an adventure, no matter what you're doing. Preparation is key. We loaded up Tom's pickup with camping gear, photography equipment, and six surfboards strapped to the topper. With $800 between us, we divided the money up into eight sums and hid each stash throughout the vehicle.

In Mazatlán, the federales held us down at gunpoint while they searched our car for drugs. We had to bribe them with $150 and some traveler's checks, which we knew they'd never be able to cash.

Then, in one of the biggest (and most ironic) asshole moves of all time, the federales proceeded to dump a bag of their own schwag weed all over the seats of our truck, so that we'd be hassled and probably jailed should we get stopped at a future checkpoint. The corrupt cops howled like jackals as we pulled away and sped down the coast.

We soon landed in the tiny fishing village of Pascuales. Here, we discovered there was little infrastructure to support the visiting gringo tourist. There was just a single cantina, where we ate all three meals, and one hot, mosquito-infested motel, which made Alcatraz look like the Ritz-Carlton.

This was no destination resort. Oh well—it was time to hit the beach.

I'm no surfer, but I still had fun thrashing around in the wake of the much-larger waves across which Tom was masterfully carving and speeding. I shot photos of Tom wearing the latest Patagonia board shorts, which had been shipped to me the day before we'd left.

Though we were sleeping in what amounted to a jail cell and our faces were pockmarked with mosquito bites, the beer was cheap, the food was delicious, and the surfing was all-time. And I was getting to capture the whole adventure with my camera for a paycheck. Life in Pascuales was pretty sweet.

> I HELPED TOM LIMP INTO THE CANTINA AND LAID HIM DOWN ON THE VERY TABLE WHERE WE'D BEEN EATING OUR MEALS. THE WAITRESS PULLED TOM'S BOARD SHORTS DOWN AND ADMINISTERED THE SHOT.

And then . . . the shit hit the fan. Tom got stung by a school of jellyfish and went into anaphylactic shock. Just like that, this laid-back surf trip had morphed into a life-or-death situation.

I ran up the beach for help.

It turned out that the only person in Pascuales who could administer an injection of epinephrine was the waitress who had been serving us breakfast, lunch, and dinner over the past few days. I helped Tom limp into the cantina and laid him down on the very table where we'd been eating our meals. The waitress pulled Tom's board shorts down and administered the shot while I snapped two pictures, using an on-camera flash to light the dark room, of Tom's grimacing, tortured, ever-swelling face.

Tom survived the experience, fortunately. But the surfing part of the trip was over. We packed up the truck to head home.

Just before we left, I waded till I was waist-deep in the ocean and snapped one last picture of this beautiful place with my Nikonos underwater camera. After Tom's harrowing ordeal, I was feeling very serene and full of appreciation for life while standing in that warm, peaceful water.

Then a rogue wave came out of nowhere and knocked me onto my ass. In one final fuck-you from Mexico, the water ripped the glasses off my face and carried them out to sea. All I had left was a pair of prescription sunglasses, which I subsequently wore for the overnight drive to get Tom back to an American hospital as quickly as possible. (Unrelated to the jellyfish sting, he also had developed what he would later learn to be a kidney stone, making the matter much more urgent.)

Life quickly got back to normal. I was back in the classroom, nose to book. Tom, too. Ho hum.

I shipped my film from our ill-fated trip, never expecting anything to come of it. The way it would work back then is that Patagonia would process my film and ship back any slides they didn't want.

A few days later, Jane Sievert called. She asked me why Tom had been photographed lying on a table with his pants down. I told her the story, and, of course, she loved it. A couple of months later, I was blown away when I discovered that Patagonia had decided to run that picture of Tom getting a shot in the ass as a full-page ad in *Outside* magazine.

Technically speaking, this shot is one of the crappiest pictures I've ever taken. Because I used direct on-camera flash, it's blown-out. It's horizontal, which had to be cropped to vertical. The lens I used was too wide. I wasn't thinking about composition. In fact, I barely even remembered taking the shot.

It's a testament to Patagonia and to Jane's unique, creative vision that she was able to sift through hundreds of exposures of surfing in golden light on a solitary Mexican beach, only to choose this harsh, poorly lit horizontal snapshot of a bare-assed man with a swollen face, and turn it into a successful full-page ad in a major magazine.

The photo was certainly gritty and raw and shocking—just what Patagonia was looking for. It lacked the finesse and technique of a more seasoned photographer, but it contained certain elements of that most important form: story.

Wrapped within this crappy shot of Tom lying on a table was a story that transcended details and rose to capture the emotional essence of what it means to be young, on a road trip, and in over your head in the pursuit of adventure.

You might think that landing a national print ad would've been the happy ending to this jinxed Mexican adventure. But compared to what happened next, it turned out to be only the beginning.

Shortly after that ad ran, I transferred from San Jose State to Fresno State, to be closer to Yosemite. But I kept returning to that same, nagging question: Nose to book, or foot to gas pedal?

One day—probably while I was sitting in a classroom—a guy named Brian Terkelsen was enjoying a first-class flight from Europe to the United States. And it just so happened that he was reading the issue of *Outside* magazine containing my photo of Tom Bulow.

It was 1996. The dot-com boom was going off. And Brian had just helped launch a new online venture, Quokka Sports, with lofty ambitions of turning it into the world's premier digital sports-media company. Quokka's websites were cutting-edge in terms of functionality and design. The company would go on to cover everything from climbing on Great Trango Tower, to the America's Cup, to the 2000 Summer Olympics in Sydney.

But this was right when Quokka was starting out, and one of its first big productions involved covering a thirty-day adventure race across Morocco.

I was in my apartment in Fresno, hatching plans for my next road trip, when the phone rang.

"Hello. This is Corey Rich," I said, by now knowing enough to at least answer the phone semiprofessionally. It was Brian's assistant.

"Mr. Terkelsen saw your photograph in *Outside* magazine," she said. "This is exactly the kind of storytelling we want for our company, Quokka.com. We think we might have an assignment for you in the Sahara desert. Would you be able to come down to our office in San Francisco tomorrow to discuss?"

I blew off all my classes and drove there in my Ford Econoline that night. On the drive, I used my first-gen, two-pound brick of a cell phone and called up the one

YOU MIGHT THINK THAT LANDING A NATIONAL PRINT AD WOULD'VE BEEN THE HAPPY ENDING TO THIS JINXED MEXICAN ADVENTURE. BUT COMPARED TO WHAT HAPPENED NEXT, IT TURNED OUT TO BE ONLY THE BEGINNING.

photographer I knew who was big-time: Brad Mangin. Brad was a San Jose State alum all of us looked up to. He was shooting for *Sports Illustrated*. Brad always gave me solid, straight-up advice. I'd show him photos, and he'd tell me what was good and what was shit, never sugarcoating anything. I valued everything he said, like a lost man offered a canteen of cold water in the desert.

At this point, I'd only ever shot on spec. I didn't know what I would say if Quokka were to offer me an assignment. I didn't know how to price myself.

So I asked Brad.

I could hear that Brad's friends were over at his place. In the background, a bunch of dudes sounded like they were playing cards and drinking beers. From his distracted tone, I could tell Brad didn't really want to talk to this green-behind-the-gills college kid just then.

"I dunno. Just tell 'em a thousand bucks," he said. "Listen, Corey, I gotta go, man. Good luck."

Wow! I thought. *If I could make a thousand bucks and go to Morocco . . . I mean, I would pay them a thousand bucks to let me go shoot in the desert!*

My head was still spinning as I parked the van directly outside Quokka's building around midnight, crawled into the back, and tried to go to sleep.

The next morning, I woke up early and "showered" in the street, dumping a gallon of water over my head. I put on my nicest shirt, grabbed my portfolio—which was really just a bunch of pages torn out of climbing magazines and Patagonia catalogs—and walked into Quokka Sports' headquarters.

I was led into an incredible top-floor conference room containing walls of windows that provided a stunning panorama of San Francisco Bay. Herman Miller Aeron chairs surrounded a long table, each filled with a young, slick executive, the new titans of the dot-com boom.

We talked about the job. It was, in fact, for the adventure race in Morocco. They wanted to use state-of-the-art satellite equipment and the latest digital cameras to upload live media of the race to something called "the World Wide Web." It was an ambitious undertaking for the time, with virtually no precedent.

I passed my portfolio around the table, talked about my photography background, and tried not to show how

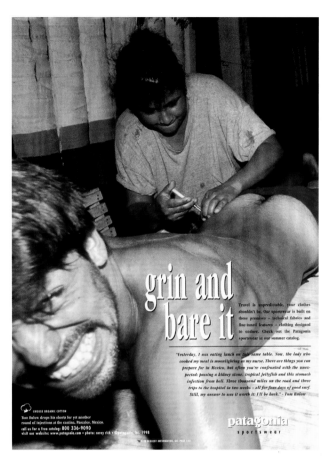

THE AD THAT APPEARED IN AN ISSUE OF *OUTSIDE*

nervous I was. Finally, my photos made it to Brian Terkelsen. He flipped through the portfolio and stopped on my shot of Tom.

"This photo is why you're here," he said. "We loved this photo. And we think you will be the right person for this job. But the big question is, What do you cost?"

At this point, I was so nervous and desperate to lock down the deal that it took everything in my power not to blurt out, "I'll do it for free!" Instead, I took Brad's advice and, with bated breath, said, "I'm a thousand."

The room went dead silent. It felt like we were all standing in a funeral home, only it was my photography career in the casket.

Desperate to clear the tension, I was on the verge of shouting out a quick price adjustment when Brian beat me to the punch.

"Ooh, that's pretty steep," he said. "We were thinking eight hundred."

Now, I'm thinking, *This is freakin' awesome! They're going to pay me eight hundred dollars to go to Morocco!*

But again, I sat there silently, lost in an internal reverie over how incredible it was that these people were really going to send me to Morocco. Also, I didn't want to seem too inexperienced, too gleeful . . . too anything. I didn't want to make a wrong move and blow it.

In spite of myself, that stoic game face worked out in my favor when, once again, Brian beat me to the punch.

"All right, goddamn it, nine hundred dollars a day, but you do realize it's *thirty* days!"

And then it hit me . . .

We weren't talking about $900 total.

He meant $900 times thirty.

Finally, I managed to summon some words.

"That, uh, that works for me. That's great."

Morocco ended up being an amazing trip. Still to this day, it was one of the coolest adventures and coolest assignments I've ever had. By today's standards, producing videos and uploading photos to the internet via satellite is hardly impressive, but back in 1996 it was a big deal. There were about fifteen of us handling the video shooting, producing, writing, still photography, and satellite transmission—and all of these individuals were supertalented in their own specialties.

When I got home, I ended up going back to school . . . for a bit. Just three classes shy of a degree, I dropped out. I was too busy already doing the job I was studying for.

I took the money I'd made from the Morocco trip and bought my first house. The single paycheck in itself, however, wasn't the real gold mine. It was all the jobs that followed. All the doors that subsequently opened. All the word-of-mouth connections and introductions and assignments that ultimately came my way.

There's no college photography course out there that tells students to go to Mexico, get held up at gunpoint, witness your friend's anaphylactic reaction to a jellyfish sting, lose your glasses, and drive home with a bunch of rolls of film containing one of your worst-ever exposures, which will, against all odds, become a national ad that in turn will be seen by an executive who will offer you the biggest, coolest photo gig of your life.

I wonder: Was I just lucky? Is the greater lesson to follow your passion? Do what you love?

Again, I return to that one word: *story*.

When I look at this unlikely picture of Tom, part of me is slightly chagrined to admit that this is the photo that launched my career. Yet there's a bigger part of me that loves that. It's a reminder that photography is not about having the newest, most expensive camera or the fastest lenses. It's about getting inspired to go out every day and live and create and breathe life into your own stories, the way my dad and his friends would do every weekend, and the way I aspire to do each day.

6

BARE IMAGINATION

STANDING BEFORE ME WAS a very beautiful, very naked woman. She had undressed quite suddenly, and I stood there dumbfounded. I was twenty-one years old.

Back then, had you told college-aged me that were I to find myself in a situation like this, I would actually encourage that naked woman to put her clothes back on, I would've called you crazy.

In fact, that's exactly what happened.

Let me back up, to sometime in the winter of 1995.

Through my career, the best assignments always seem to begin with an unexpected phone call. This time, Nate Simmons, co-owner of the Colorado-based PR company Backbone Media, was on the other end of the line. Backbone was still a young agency, but it was already working with some major companies in the outdoor industry.

"Hi, Corey," Nate said. "We've been admiring your work out here in Colorado. Great stuff, man, great stuff. But let me ask you a question: Have you ever done any studio work?"

"Not a lot," I blurted, "but I am totally comfortable shooting in the studio."

Honestly, at this point in my budding photography career, this was a bit of a stretch.

Then Nate asked, "What about nude portraits? Any experience there?"

"Absolutely," I said. "Of course! No problem at all."

Now I was just flat-out lying. I'd never shot a single nude portrait (honest!). But obviously, I was not going to tell the guy who wanted to give me a job this pesky little detail.

My philosophy from day one has been to say yes, then figure out later how to do whatever it is I've agreed to do. This philosophy, however, comes with one important life-or-death stipulation: if you say yes, you cannot fail!

Nate went on to explain that he was handling the advertising account for the textile manufacturer Polartec, and it was interested in a print campaign featuring portraits of four prolific adventure athletes—a kayaker, a skier, a climber, and a mountain biker. The idea was to photograph the athletes in the nude and use their respective outdoor gear to cover their private parts. The tagline of the eventual ad would read: "Imagine a World Without Polartec."

I'D NEVER SHOT A SINGLE NUDE PORTRAIT (HONEST!). BUT OBVIOUSLY, I WAS NOT GOING TO TELL THE GUY WHO WANTED TO GIVE ME A JOB THIS PESKY LITTLE DETAIL.

Several weeks and many phone calls later, I found myself standing in a rented studio space in Denver, Colorado, with my close friend and college roommate Jay Clendenin (who went on to cover presidential campaigns and other big news events for *Time* magazine, and now works as a staff photographer at the *Los Angeles Times*, shooting celebrity portraits, one of the most sought-after jobs in newspaper photography). Jay would be assisting me with the shoot. We had arrived two days early to make sure we knew how to light the studio, and to familiarize ourselves with our rented Hasselblad medium-format film cameras. We needed images of the highest resolution, and the Hasselblad was the rig du jour.

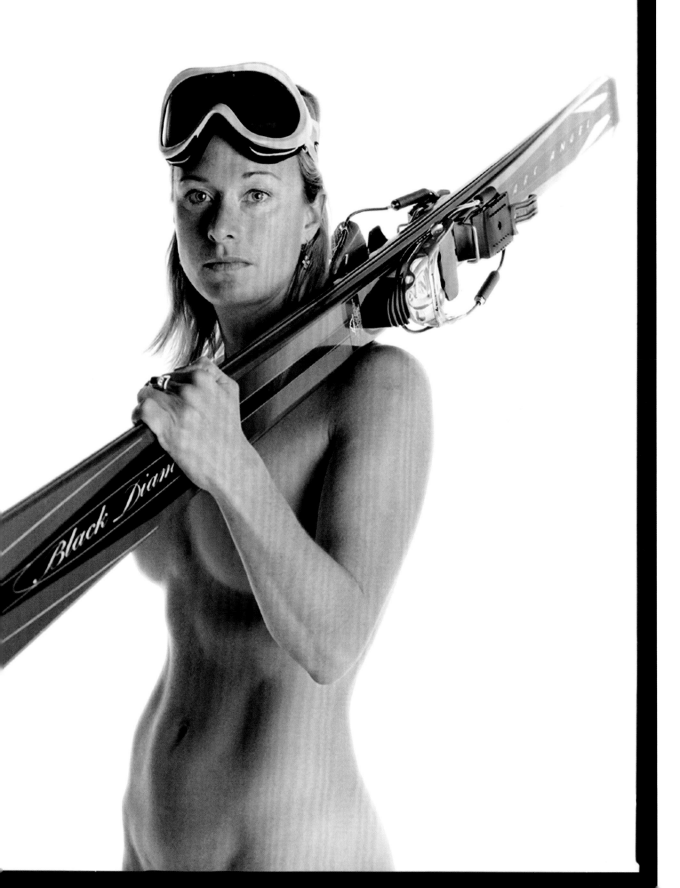

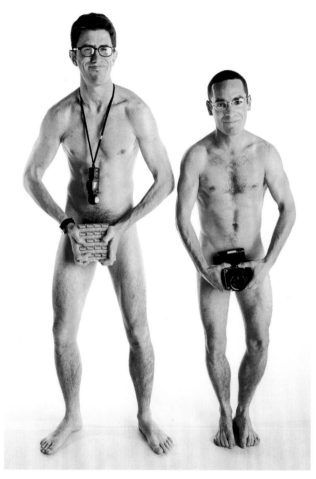

IT WAS ONLY FAIR THAT THIS PHOTO OF JAY CLENDENIN AND ME HAPPENED.

mountaineers in the world. This morning, Kasha was in a bit of a rush. She had a plane to catch to some remote, frozen corner of Asia, where she would be exploring first descents. She walked into the studio with her ski bag draped over one shoulder, an expedition-sized North Face duffel over the other, and a backpack on her back. With a big exhalation, she dumped the cumbersome luggage on the floor.

HOWEVER, THESE IMAGES TOOK ON LIVES OF THEIR OWN IN THE ADVENTURE SPORTS WORLD, WHERE THEY SPREAD LIKE CRAZY.

"I'm a little nervous about all this!" Kasha said without a trace of irony, then proceeded to rip off every article of clothing while still standing in the entryway, in front of us three guys, whom she had never before met.

I swear, it was incredible how quickly her clothing came off! I've never seen anything like it—at least not in a professional situation.

The room fell silent as Nate, Jay, and I searched for the appropriate words. Finally, I turned to Kasha and said, "Uhhh . . . Kasha, we're thirty minutes out from shooting. You're welcome to get dressed again."

We all laughed. It was the perfect icebreaker that we needed to get over our nerves.

From there, the shoot was fantastic, and we made some really creative, interesting pictures. Over the course of the day, I learned that less was more: less equipment covering the athletes resulted in more elegant, graceful images.

But where I saw elegance, others saw a certain raciness. Unfortunately, Polartec ended up not using any

On the day of the shoot, it was bitterly cold and snowing. At dawn, in the flat wintry light, Jay, Nate, and I waded through almost a foot of fresh snow to reach the studio. We wanted to be there early to warm up the space. If the talent was going to be nude, we didn't want them to have goose bumps—a Hasselblad would capture each and every one.

Deep down, I was quite nervous about shooting nudes. How would I tell the talent to undress without appearing awkward or, worse, leering? But I'd gotten myself into this situation. Now, I just needed to not fail.

We started loading film and turning on lights. At about 8 a.m., a taxi dropped off the day's first model: Kasha Rigby, a telemark skier for the North Face.

Growing up as a competitive skier in Vermont, Kasha went on to solidify her name as one of foremost ski

OPEN YOURSELF UP AND GO FOR IT—AS FEARLESSLY AS KASHA.

of the images in print. At the time, the company was run by a third-generation owner, Aaron Feuerstein, who was about seventy. He liked the images, and Polartec used them in its trade-show booth. But the story was that when Mrs. Feuerstein walked into the booth and saw "all the skin," she killed the risqué campaign before it ever saw the printed page.

However, these images took on lives of their own in the adventure sports world, where they spread like crazy. I'm not exaggerating when I say these shots blew up. I can't tell you how many times I've received a request for a print of this image of Kasha, with her signature.

I've always loved this story about the shoot with Kasha, and we remain great friends to this day. Despite— or perhaps precisely because of—her nerves, she was willing to just go for it. I would imagine this fearlessness is one of the reasons Kasha is able to do what she does in the big mountains.

For me, as a photographer faced with unfamiliar projects that I might be nervous about, I've definitely benefited from adopting a little bit of Kasha's naked gusto. When taking on an assignment in which I'm not quite sure how I'll fare, I know it's important to adopt the attitude of saying yes. Open yourself up and go for it—as fearlessly as Kasha.

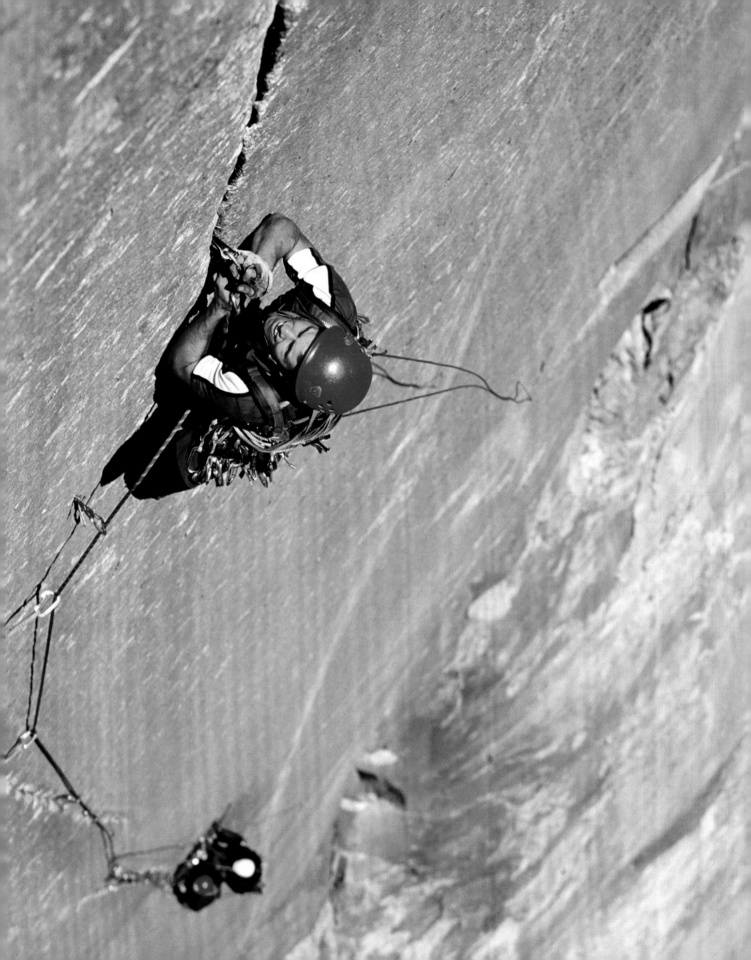

7

EL CAP EASY

I WAS JUST AN IMPRESSIONABLE kid with a spongelike ability to absorb knowledge when I started rock climbing. Not having money, gear, a driver's license, or even the experience needed not to kill myself while climbing were, back then, minor details. I was going to set sail on a vertical ocean of granite.

At thirteen years old, the prospect of climbing a 3,000-foot wall seemed too daunting to even imagine. But I grew older, and each year I climbed a little harder and a little higher on the cliffs surrounding my parents' home in Southern California. By the time I was in college, I was spending every free weekend in Yosemite Valley. I'd peel out of class early on Friday, drive to the valley, lay my sleeping bag in the dirt, and come Saturday morning, feel as though I'd been magically transported into the scene of one of climbing writer John Long's famous stories. There I was, standing in the same place that all the legends of American climbing had once stood. It actually gave me chills.

One day I had an epiphany. I realized I was ready. Ready, that is, to tackle the "Big Stone" itself: El Capitan.

I hatched a plan with a couple of climbers from Missoula, Montana, to tackle El Cap's most famous route: the *Nose*. We did what every new aspiring *Nose* party does: we went out and bought way too much food and water, and packed it all into haul bags that were soon so heavy we could barely pick them up.

Ferrying the haul bags—the "pigs," in climber jargon—to the base of the *Nose* (not a particularly long walk, mind you, and, moreover, one that's dead flat) became

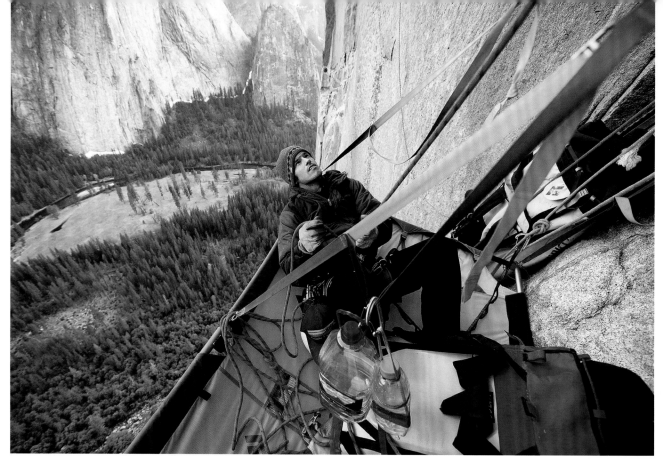

CHRIS MCNAMARA PULLING BELAY DUTY ON ONE OF HIS ESTIMATED EIGHTY-FIVE ASCENTS OF EL CAPITAN

a monumental chore. I'd never had to try so hard, and I hadn't even gotten to the climbing part.

Masking our fear through gung-ho hoots and hollers, we launched off on our big-wall adventure.

We were slow. We suffered. It took us all day just to get up to Sickle Ledge, no more than a smidgen of the way up the 3,000-foot wall.

We rappelled that night, slept on the ground, and returned the next day, climbing a bit higher. Soon, the harsh reality that is big-wall climbing set in. We got the classic spanking that many neophytes receive. Our bags were too heavy, and our systems sucked. We rappelled again—defeated.

I drove back to school that night, convinced that El Cap was, in my own frustrated words, "really fucking hard."

Over time, I continued banging my head against the wall, so to speak. Eventually, I climbed El Cap. And as I was pushing myself as a climber, I was simultaneously pursuing the craft of photography—combining these two passions at every opportunity I could.

I started seeing my work in more and more climbing magazines, and on their covers. Feature story after feature story came my way. I became known as one of the "go-to photographers for climbing" in our little niche world.

When you reach that status of being the go-to guy within your specialty, pretty soon someone from outside that world will tap you. Sitting in my dorm room one afternoon, I got a call from *Sports Illustrated*. They wanted me to shoot a profile of a guy from Berkeley, California, named Chris McNamara.

Sports Illustrated—*how cool is that?* I thought giddily. I tried to remain professional.

"What's the angle?" I asked.

"This kid has climbed El Cap fifty-four times!" the editor exclaimed. "And he's only twenty-one. He estimates he's spent ten percent of the last seven years of his life living on the side of a wall!"

It blew my mind that Chris could drive from Berkeley to Yosemite, arrive at midnight, climb all 3,000 feet of El Cap the next day, and still make it home for dinner.

When I first met Chris, I was struck by his stoicism. He gave me the impression that, were he born thousands of years ago, he might've been the leader of a Greek army or a hero featured in myths and epic poetry. These days, this quality seems to lend itself to systematically and methodically tackling high-risk adventure sports.

Chris is one of the more intelligent people I've met. His father and brother were both Princeton grads, and Chris was also accepted to Princeton. He attended the school for a whole two weeks before realizing that he needed to be closer to Yosemite to be happy. He dropped out, went home, and eventually landed at UC Berkeley.

Through my first assignment with Chris, he and I became fast friends. We were of similar ages and backgrounds and philosophies, and we were both trying to carve out original lives. While I was trying to create a climbing photography business, Chris was pursuing adventure sports alongside business ventures such as SuperTopo, a guidebook publishing company and website, and philanthropic ventures such as the American Safe Climbing Association, a nonprofit Chris started to help with bolt-replacement efforts around the country.

During my time with Chris, I began to see and learn the systems that the best big-wall climbers use to be efficient on El Cap. I was able to draw parallels between the way that Chris perfected his craft and skill for light-and-fast big-wall climbing and how I was pursuing my own craft and skill in photographing these very same walls.

"Damn, dude, if I knew some of this stuff back then, maybe I wouldn't have failed so much!" I said to Chris during the shoot.

"It's all about the systems, Corey," Chris said. "It's easy once you figure it out."

Sports Illustrated may have been interested in Chris because no other twenty-one-year-old had ever spent 10 percent of his life climbing El Capitan, but I soon realized what made Chris truly special. It was and remains his ability to ask the right questions, and to think very clearly about very complex topics—and then make it all just seem so . . . easy.

The reason for his success isn't dumb luck or an unconsidered willingness to court risk. At its heart, his ability to turn everything he touches into gold goes all the way back to the same skills he cultivated as a kid to tackle El Cap. It's that analytical, stoic mind-set—the ability to tackle monumental problems and challenges by making one move, placing one piece, at a time.

Over two decades later, Chris has moved on to other types of climbing, sports, and adventures. He spent a stint as a wingsuit BASE jumper when that sport was still in its infancy. He nearly died on one or two occasions, then walked away once he realized that no jump is worth giving up sixty-plus years of adventure (see Chapter 36).

Photography has brought me all over the world and introduced me to a lot of really interesting people, but what's most incredible is that it has also introduced me to people, like Chris, who have become some of my best friends. Since that original *Sports Illustrated* assignment, our roles have evolved and grown. In addition to SuperTopo, Chris has launched the thriving gear-review websites OutdoorGearLab and TechGearLab. He's also a Tahoe real-estate magnate with multiple houses and commercial properties that he owns and leases. We've even partnered up on two properties, and for me, it'd be hard to imagine tying in to an arrangement like this with someone I don't completely trust or someone who doesn't have Chris's business acumen.

Chris's relationship to adventure has also shifted over the years. It's something he's continually willing to redefine for himself. For a couple years, he changed focus to establishing moderate rock climbs around South Lake Tahoe so that kids and families would have routes to enjoy. Most recently, he's been pioneering another first: creating an all-dirt mountain-bike trail circumnavigating Lake Tahoe. Using maps and GPS and hours of hands-on research, his goal is to establish an official, legal route—something others have said was impossible for years.

Recently, I got to be one of Chris's groomsmen at his wedding. It's been more than twenty years of adventures together—on the rocks, in business, and in life. And, as he says, there are many more years of adventures coming our way.

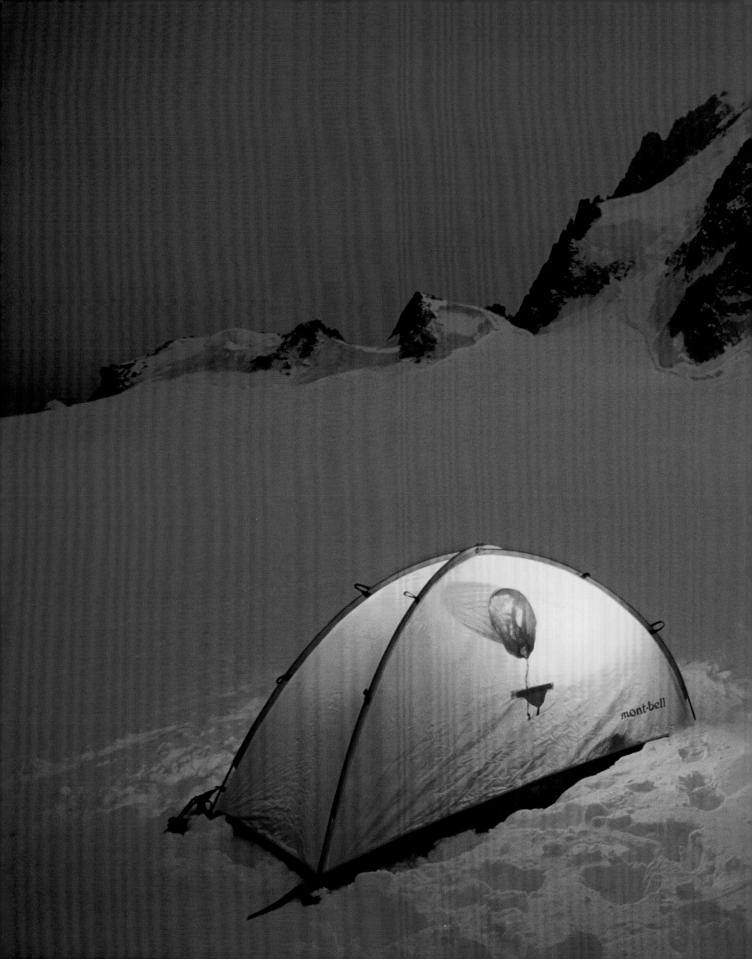

JUSTIN BASTIEN & BRITTANY GRIFFITH - MONT BLANC, CHAMONIX, FRANCE
17–35MM LENS / F/2.8 / 1 SECOND / FUJI VELVIA FILM

8

CHAMONIX DIRTBAGS

I WAS THE QUINTESSENTIAL POOR college student when my first opportunity to travel to Europe arrived. My good friend John Climaco was marrying his fiancée, Laura, in Chamonix, France. I planned to attend John and Laura's wedding, and travel there with our mutual friend Justin Bastien (see Chapters 3 and 4).

As two seasoned dirtbags, Justin and I found little trouble turning the wedding trip into a climbing trip. Obviously, we wouldn't fly all the way to France only to attend a wedding. The fact that John and Laura, both climbers and skiers, had scheduled their matrimony right when conditions were good in Chamonix was extremely considerate of them.

Pretty soon, our friend and fellow climber Brittany Griffith was on board for the climbing leg of the wedding trip. I'm not even sure if she knew John and Laura, but Brittany had a thirst for travel and adventure that made her a perfect companion.

Situated in the shadow of Mont Blanc, western Europe's tallest peak, Chamonix is not only the birthplace of alpinism but also the epicenter of modern alpinism and extreme skiing, and a gateway to some of the most iconic peaks in the Alps. Every climber dreams of one day scaling the granite needles of the Mont Blanc massif above a white blanket of cascading glaciers, just as every skier hopes to carve down into the Vallée Blanche. For Justin, Brittany, and me to have this opportunity was a dream come true.

Unfortunately, Chamonix is also one of the more expensive destinations you can visit. In America, you can almost always find cheap food and a free place to doss in the dirt, but in Europe, people seem to prefer the creature comforts. Dirtbagging

it in America is very different than in Europe, where people tend to stay in the many *gîtes*, hostels, or huts positioned throughout the Alps. (According to a friend who works in the outdoor industry, tent sales are nearly nonexistent in Europe.)

Justin, Brittany, and I had brought a tent, however. And it didn't take advanced dirtbag calculus for us to quickly realize that we'd save a big chunk of change by sleeping in it. We hopped on the *téléphérique* (cable car) to the summit of the 12,605-foot Aiguille du Midi, traversed toward the base of our climbing objectives, and pitched our tent. Completely free lodging with a million-dollar view.

During our first night on the Midi, as the sun set it became quite cold; we three sat shrouded in our sleeping bags, shivering and preparing some hot soup for dinner. We looked out the doorway of the tent to a sky bruising blue in the waning light. I realized there was a fantastic photo opportunity here: the classic shot of a lit tent in a stunning mountain landscape.

Today if I were to shoot this photograph, I'd pull out a Nikon SB-910 strobe or two, and work to create the perfect light ratios between the setting sun and the tent. Having a couple of strobes that I could trigger remotely, using the SU-800 Wireless Speedlight Commander on my D850, would allow me well over thirty minutes' worth of shooting time. Armed with the right equipment and the know-how to balance strobes with the natural light, I'd be able to create hundreds of amazing images in a situation like this.

Back then, however, I don't think I owned even a single strobe. Not to mention the fact that I was shooting film. Each shot, I once calculated, cost me twenty-five cents.

I didn't know any of this, though. I was just a psyched college kid and a climber with a camera. I worked with what little I had. I set my camera up on a tripod and spot-metered off the tent. Justin and Brittany had headlamps that, if pointed directly at the tent's walls, would act as strobes. And I had a handheld light meter—yeah, remember those?—to read the ambient exposure.

There I stood in the cold—light meter in hand, camera on tripod—calculating exposures in my head and waiting for the lighting ratios between the tent and the sky to be perfect.

No American college kid can travel to Europe for the first time without learning at least a few good life lessons, but the one that I really took home from this trip was how to do a lot with a little. Photographers and climbers alike often talk about "fast and light." Being in Chamonix on an extremely tight budget, with only my old climbing gear, a film camera, a few lenses, and a brick of film that I'd saved up for and purchased in advance of our trip, I realized that it's equally important to know how to do things "cheap and light."

JUST AS YOU DON'T NEED A TON OF MONEY TO ENJOY A WEEK OF CLIMBING IN CHAMONIX, YOU ALSO DON'T NEED A TON OF PHOTO GEAR TO MAKE A GREAT IMAGE.

Striving for that ingenuity born of a certain thriftiness is an important philosophy still adhered to by climbers of my generation. Just as you don't need a ton of money to enjoy a week of climbing in Chamonix, you also don't need a ton of photo gear to make a great image.

In other words, it's always better to push yourself to come up with solutions and realize all that you can do with what you have rather than make excuses about what you can't do with what you don't have.

What I found most surprising is how gratifying this approach is. Up on the Midi in our little tent, we had the best view of anyone staying in Chamonix, all for the cost of a cable-car ride. And I wouldn't have traded the company I was with for anything.

Today, when I look at this image, I know I could probably capture a photograph like this with my eyes closed. However, thinking back to my college-aged self standing outside that tent, shivering in the freezing cold, holding a light meter with wooden fingers, and waiting patiently for the light to be just right, I don't see a cliché photograph of a lit tent. I see a kid learning and embracing lessons that will serve him throughout his career.

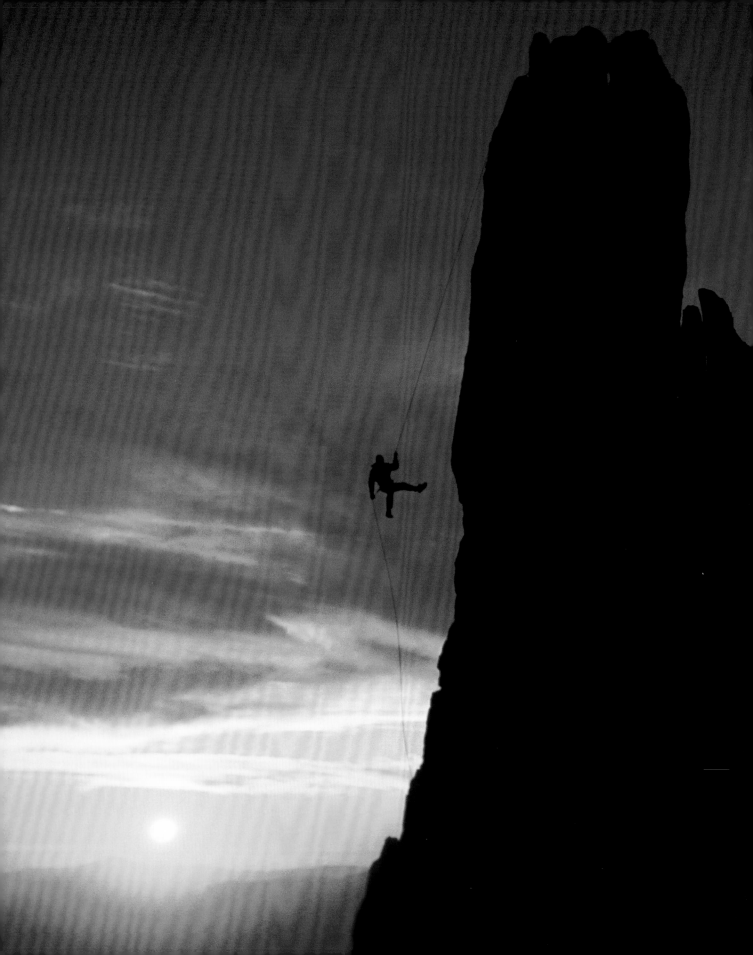

9

THE MOMENT BEFORE IT ALL CHANGES

AS A PHOTOGRAPHER, I'M ACUTELY sensitive to light: how it changes from moment to moment, or even from season to season. What I've discovered over the years is that the most interesting moments—the ones worth photographing—always seem to occur either just before or directly after a decisive culmination, such as before a sunset or sunrise or after a clearing storm. For me, one of those pivotal, dramatic transitions came right in my last year of school.

During my admittedly lackluster college career, I began to notice a phenomenon: The more time I spent outdoors shooting the things I loved, the more images I got published. The more images I got published, the worse my GPA became. The cycle compounded and spiraled on itself. More images published meant more checks coming in, which meant more money for film and gas, which equaled more resources to get outdoors and photograph the things I loved, which meant less time in class.

Eventually, I recognized what the universe was trying to tell me and I dropped out. Really, I was traveling on assignment so much, already doing the job I was allegedly studying to learn how to do, that I no longer had time for school.

Another phenomenon I noticed was, the more photos I got published in magazines, the more frequently I received totally random phone calls from prospective clients who had seen some image of mine in print, looked me up online, and cold-called to hire me for a commercial advertising shoot.

Just after leaving Fresno State, I got one of those phone calls from Nike ACG—the technical outdoor-apparel division of Nike. They wanted striking rock-climbing and hiking images from the High Sierra. I knew Tuolumne Meadows, with its staggering granite formations, would be the perfect location. But winter was just around the corner, and I knew it was risky to plan a late autumn shoot here because the instant a single snowflake touched down, the National Park Service would close the road.

Still, I pictured Tuolumne's iconic, captivating Cathedral Peak and Eichorn Pinnacle, and knew I needed to take the gamble.

Upon leaving school, I'd set up a home office in Sacramento and already had enough work to justify hiring my first full-time studio manager. His name was Todd Snyder, and he had been a substitute teacher at my high school, Quartz Hill. He was one of my first mentors and climbing partners.

I met him because I was walking through the school parking lot and saw an unfamiliar truck with a Five Ten sticker on the tailgate. As there were no climbing gyms back then and we lived in a podunk town in the Mojave Desert, not particularly close to climbing locations, it required extra effort to meet climbing partners. Being an opportunistic young high schooler, I left a note on the truck's windshield that said something to the effect of *If you ever want to climb, give me a call!*

That night, my father got a call from Todd Snyder, whom he knew and who apparently was the owner of that truck with the climbing-brand sticker. My father was surprised to learn that Todd was actually calling to speak to me, and we made plans to climb together.

It's somewhat incredible that many, if not most, of my early climbing partners were teachers from my school. We ended up becoming good friends who stayed in contact and climbed together until after I was done with college.

Throughout his life, Todd has always enjoyed wearing many hats. Before teaching, he was an aerospace engineer—a rocket scientist. Now, this guy who was always looking for the next challenge had decided to take on the challenge of helping me, a twenty-something college dropout, turn my photography passion into a business.

"You're going to need help one of these days when you start getting bigger assignments," Todd had once said to me in the most encouraging way. "And when you do, give me a call."

When that day came, I did indeed call Todd. And he truly helped me take my photography business to the next level. Using the scientific part of his brain, Todd approached my photography business with a keen, analytical eye. He recognized that photography was going to go digital soon, and he developed a way to scan my transparencies and file them in a searchable database. He also helped create a unique file-naming structure, and built an FTP protocol to make submissions to magazines and clients. He even figured out a way to access the database remotely.

Of course, this was about a decade before Adobe Lightroom, as well as all of the other programs that now exist to provide these kinds of services. In the late 1990s, however, nothing like it existed. Todd was an innovator in that sense. But the thing that's always been most impressive to me about Todd is that he isn't just an engineer. He is sensitive to what it means to lead a passionate and fulfilling life. Years later, he sold much of what he owned and moved into a trailer to pursue his own meaningful adventures. It's rare to meet someone so talented, smart, humble, and selfless who prioritizes living life to the fullest.

THE INSTANT A SINGLE SNOWFLAKE TOUCHED DOWN, THE NATIONAL PARK SERVICE WOULD CLOSE THE ROAD.

I think I've always intuitively understood that staging a successful shoot begins with assembling the right team. I knew that Todd, with his enormous climbing and teaching experience, would be invaluable. I also brought on Justin Bailey, a part-time employee, to run logistics and to put to use his incredible skills as a backcountry chef. Finally, I invited my father, Dave Rich, who had recently retired, to help us shuttle cars and gear in and out of Tuolumne.

When the first day of the Nike shoot finally arrived, Dad shuttled me, Todd, Justin, and two athletes into Tuolumne Meadows. Suddenly, we found ourselves situated in this surreal, magical plateau in the High Sierra.

That first day, we shot Eichorn Pinnacle. After I captured the requisite images of the athletes standing in victory on top of the narrow spire, they descended and headed back to camp for dinner. Meanwhile, I hung back and waited for Todd to rappel down and clean the anchor equipment and ropes from the wall. As Todd descended, in a moment just before the sun set, he pushed out from the wall and I took this photograph.

NEVER BE SATISFIED, AND NEVER CALL IT A DAY BEFORE THE DAY IS DONE.

Jim Balog, a photography mentor and great friend of mine, once said that you should never be satisfied with the image you're making. You can interpret those wise words in many ways, but I think he meant that you should never stop pushing yourself. Even if it's been a long day, don't put down the camera and head back to camp for dinner before the sun has set and all the light is absolutely gone.

The ultimate value in Jim's advice, however, is that it forces you to stay out there and be in position to witness those rare, transcendental moments that always seem to occur right before or right after some significant event: the transition from day to night, or fall to winter, or even from a heroic climber on a summit to a regular guy back on the ground.

At the heart of Jim's idea is that you need to push yourself mentally, physically, and creatively to capture those moments. It always seems to involve some degree of discomfort, if not downright suffering. Never be satisfied, and never call it a day before the day is done. I believe that that is what it takes to create a lasting, iconic photograph.

Those two days in Tuolumne were huge. As predicted, the late autumn weather was fickle, throttling toward winter. The nights were freezing and windy. We were way out in the backcountry, among the granite giants of Tuolumne Meadows, with a storm moving in.

As the shoot ended and we hiked out to meet my father, waiting for us at the cars, the first few snowflakes of the season began to fall. We escaped from the park just as the rangers shut the gates behind us, ending the climbing season for the year.

I sped home toward my office in Sacramento, feeling as though a new phase had begun.

10

THE REAL REASON

THE IDEA WAS FOOLPROOF. The ingredients were Lake Powell, a houseboat, and seven days exploring Glen Canyon for new rock climbs with a ragtag crew of hardy climbers whose thirst for hard living and big adventure knew no bounds.

The reality, however, ended up falling short of the idea.

Our core crew included Craig Luebben, Tim Noonan, Todd Snyder, and Dave Madeira—and a few others who joined us by speedboat.

It didn't take long for us to realize that we had botched some crucial details in our planning. The first thing we realized is that we'd come during "hurricane season." Under blue skies, gale-force winds racked the canyon and shook our houseboat with frightening force. Also, fun fact: houseboats travel around 2 miles per hour. So as we tried to chug our broad clunker against a 40-knot headwind, it took an excruciatingly long time to do any kind of real exploring on this 25-mile-wide, 186-mile-long lake. Swimming would have been quicker.

Lake Powell is the second-largest manmade lake in the United States, after Lake Mead. A dam at the edge of Glen Canyon (along with Colorado's snowfall) determines the height of the lake, which in turn determines the height of the climbs jutting out of the water. Our research had us believing Glen Canyon might hold great climbing potential, but in fact, most of the rock we encountered turned out to be poor-quality Wingate sandstone—a.k.a. "choss" in the climbing vernacular. Choss is the kind of garbage rock that in any other, more easily accessed venue you'd turn your nose up at and continue on.

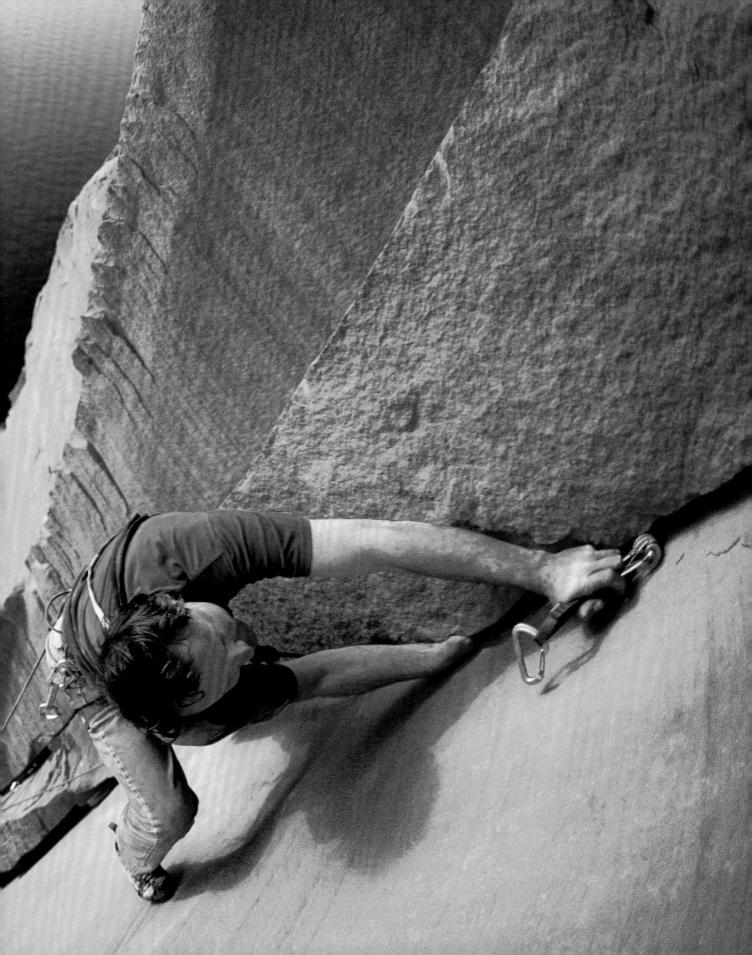

BRINGING A KEG OF BEER ON OUR CLIMBING ADVENTURE SEEMED LIKE A STROKE OF BRILLIANCE—EXCEPT IT TURNED TO TEPID, FLAT SWILL ON THE ROCKING HOUSEBOAT.

If being trapped on a slow-moving houseboat with a bunch of antsy climbers who couldn't climb, either because it was too windy or because the rock was too crumbly, sounds bad, then here's what made the whole thing much, much worse:

Flat beer.

Despite Utah's strict alcohol laws, we had managed to smuggle a keg of full-strength swill onto the houseboat. However, the beer quickly went flat, probably from the houseboat rocking in the wind. That didn't stop us from choking it down anyway. Hell no! I just won't claim it was an enjoyable experience.

We towed a tiny speedboat behind the houseboat. After plodding along the perimeter of Lake Powell to a section of rock that seemed promising, we'd load into the speedboat and zip over to the rock to take a closer look.

The logistics of the trip made it difficult for me to get into a good position to document first ascents as they happened, unfolding with all the realness and authenticity of the climber becoming the first person ever to sink his hands into a stretch of rock. Because I was starting at the base along with the climbers, my ability to find a top-down vantage was often compromised. I instead focused on creative detail shots simply because I was unable to get into a position to capture a memorable wide shot.

Incredibly, one day we came upon a swath of high-quality, aesthetic rock with a stunning crack climb. It was the proverbial diamond in the rough. Craig racked up for the first attempt. He made a bold effort but fell a few times as he pioneered his way up the wall. At about 100 feet, he installed a bolted anchor and lowered down.

With a rope now fixed to these overhead anchors, I was able to jug up and get into the position I'd been hoping for since the start of the trip: shooting top-down at a climber on a striking line, with the grandeur of Lake Powell in the background.

After some rest, Craig reclimbed the crack, squeezing his calloused mitts and torquing his feet into the fissure, smoothly making his way up the wall—this time without falling. The sun was getting low in the sky, and there was our little speedboat bobbing in the water below.

I realized that to really capture the entirety of the stunning situation, I would need to pull out that rare "once-in-a-thousand-shots" lens: the fisheye. I almost never shoot with a fisheye, because of how easy it is

to overdo it. But it felt appropriate here. Capturing the whole panorama, from the light to the lake, the water to the climber, really lent itself to that cool wide-angle distortion you get with the fisheye.

WITHOUT PEOPLE, MOUNTAINS ARE JUST BIG PILES OF SNOW AND SHATTERED ROCK.

Aside from the fact that I was hanging on a rope 100 feet off the ground, this photo was, technically speaking, very straightforward to make. Evening light. Unobstructed skies. Fisheye lens. Kodak Ektachrome ISO 100 film. It was the "perfect sunny 16" exposure: meaning at 100 ISO and $1/125$ of a second shutter speed, your aperture is f/16. (However, because I was shooting action, I was actually at $1/500$, f/8.)

And from there, it was all about capturing frames. The climber was just doing his thing, and I was on the rope next to him, doing my thing.

This photograph was my favorite from the trip, and also the one that went the most places, appearing on various magazine covers and in galleries, and even in a Kodak print ad. It makes Lake Powell look like one of the most appealing climbing destinations you'd ever want to visit. Incredibly, Kodak licensed this image from me, which makes this picture one of the most lucrative frames of my career.

But today, when I look at this photo I have a different emotional reaction. It makes me reflect on the question of why. Why do we do the things we do? It's not just about finding killer new rock climbs or getting amazing portfolio photographs. Once you peel away all those layers, you can find an inherent superficiality to those kinds of things.

Turns out, what matters most is the people you're with.

In retrospect, this was a very important trip for me, because it was the last time I got to spend real quality time with Craig Luebben.

Craig was one of the true crack-climbing masters of his generation, one of the great energies in the sport of climbing. He was pensive and astute; he was a writer, a thinker, and a tinkerer. He invented a type of climbing protection called the Big Bro, designed specifically for wide cracks, and this gear has helped thousands of climbers tackle those fearsome off-widths. He had an absolute passion for exploration and was always looking for that next new route on which to push himself and come away with an amazing experience.

I never saw Craig again after this trip. In 2009, he died in the North Cascades, when a car-sized block of ice calved off and caused him to fall. Again, that question of why returns. Why do we put ourselves in these kinds of situations?

Without people, mountains are just big piles of snow and shattered rock. They have the power to take life away from us, but their real, inherent value is that they have the power to provide us with the experiences that make life worth living.

Looking at this photo of Craig, fully in his element, breathing in this vibrant light and life, reminds me of the real reason we do the things we do.

You could be in the most amazing place with the greatest rock climbing, but if you're surrounded by a bunch of naysayers, you'll have a terrible time. Or you could be in a houseboat with flat beer, battered by hurricane-force winds, and with very little quality climbing at hand, and still have the best time in the world.

I wouldn't trade this trip for anything.

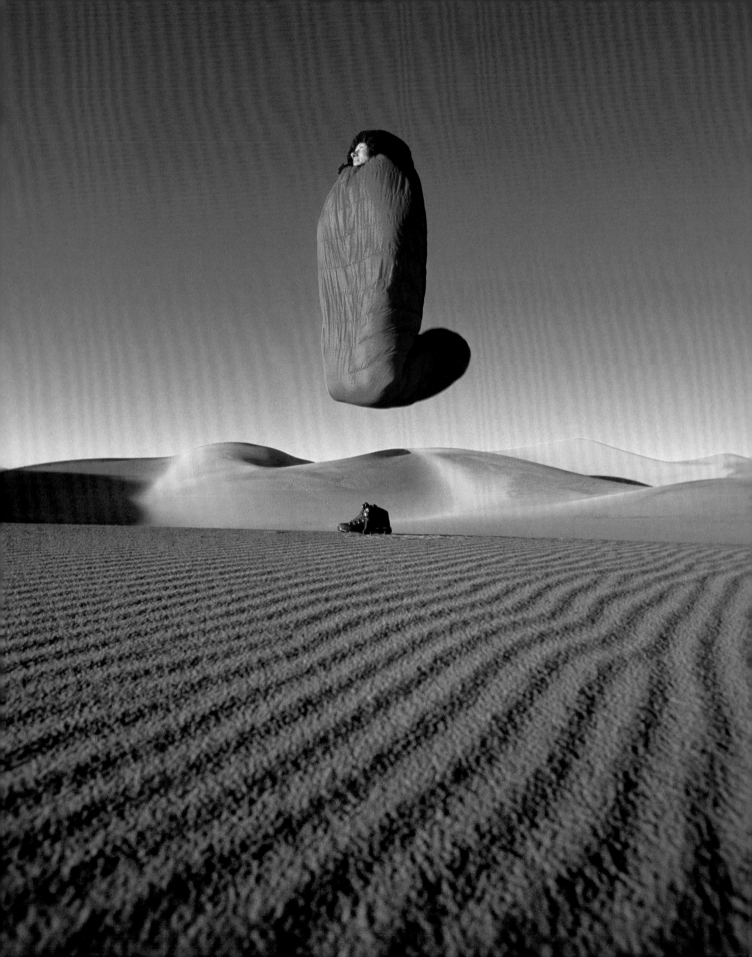

11

CREATIVE SECRETS

ALL GREAT CREATIVE ENDEAVORS HAVE a secret. They almost always begin with a mistake, a failure, or a jump in the wrong direction.

Photography is especially deceptive in this sense, because anytime we see a single photograph, we don't get to see all the other photographs taken first. But those initial pictures, as imperfect as they may be, are often responsible for the final, beautiful creation. This is why I always tell my clients that the longer I have to shoot, the better the pictures will get. The creative process is, typically, not fast. It takes time. You need to sketch your idea. Just as an artist is able to home in on a stronger depiction of his subject with each pass of his pencil, a photographer sketches by taking frame after frame, trying to make each frame better than the last.

This photograph, of Ashley Laux jumping in the air in a sleeping bag, was the result of slow creative process for me. Many years ago, I was in Death Valley on assignment for *Backpacker* magazine to shoot photos for its gear guide. It was a cold and windy day among the sand dunes, and I was getting grit in my eyes. I was shooting a tent-camping scene when I turned my head and saw Ashley bundled up in her sleeping bag, trying to stay warm. I was struck by the contrast of colors and the simplicity of the landscape—the beautiful, untouched patterns in the sand.

"No one move!" I called out. I did not want anyone to accidentally walk through the sand and ruin the patterns with a footprint. I turned all my attention to Ashley and began the slow, methodical process of creating an interesting photograph.

I walked back and forth, looking for the right angle. I considered the lens: Did I want the 50mm or the 17-35mm? Then I began working with Ashley. I shot a lot of

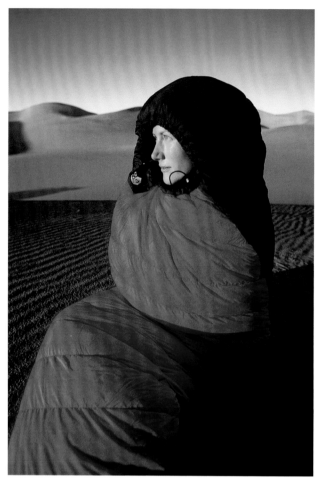

OUTTAKES OF ASHLEY LAUX IN A SLEEPING BAG AND PAULINE HSIEH IN HER HIKING BOOTS, CAPTURED IN THE LEAD-UP TO THE JUMPING SLEEPING BAG PHOTO

photos of her just standing there, bundled in her sleeping bag.

OK, not bad, I thought. *But not good, either.* The horizon lines behind her were colliding with her legs.

So I had her jump. Her figure, against the simple blue sky, suddenly stood out. *Now we were getting somewhere.*

Then I realized I was standing up, and the angle was boring. So, I lay down in the sand. Ashley jumped some more. Now things were getting much better. The new angle really added height and drama to her jump!

Ashley was having fun, which helped immensely.

Ultimately, the little touch that sealed the deal for me—that thing that made me realize that we might have something close to a finished image—was when Ashley jumped and added a slight, playful bend in her legs. At that point, I realized that we had reached the pinnacle of the concept. We'd gone from a snapshot, to an OK picture, to a better one, to a perhaps-even-good picture.

Many folks have asked if I Photoshopped this image, which is always a great compliment to receive when your picture is made entirely in camera.

And while all creative endeavors may begin with a jump in the wrong direction, the point is to not get discouraged, to stay vigilant, and to keep working on it. Photography as a craft means working through the situation—recomposing, repositioning, and retooling all of the elements of what's included in the frame and what isn't. Hopefully, you will end up with something that jumps right off the page or screen.

12

SWIMMING WITH THE CROCS

PHOTOGRAPHY TRANSCENDS CULTURE, LANGUAGE, and borders. A good picture enchants and captivates. It draws us in and speaks to us in a way we can all understand. Perhaps this is why photography, travel, and adventure are such a natural fit.

Some years ago, I had the opportunity to join Stephen Koch and Rob Milne on a climbing/snowboarding expedition for Burton Snowboards to Carstensz Pyramid, officially called Puncak Jaya, a 16,023-foot summit in Indonesia. Stephen was on a quest to become the first person to snowboard down from the Seven Summits—that is, the highest peak on each continent. The list includes Everest (Asia), Kilimanjaro (Africa), Vinson Massif (Antarctica), Elbrus (Europe), Denali (North America), Aconcagua (South America), and Puncak Jaya (Oceania/Australia).

Puncak Jaya is the lowest of the Seven Summits, but what it lacks in altitude it more than makes up for with technical climbing difficulty and a heinous approach, through jungles and across crocodile-infested waters.

Papua, the province of Indonesia where Puncak Jaya is located, has given the world many gifts, but perhaps the most celebrated is the Papua penis gourd, the protruding phallocrypt worn by many males in various ethnic groups throughout the island, including our Dani guide.

Stephen, Rob, and I all live in mountainous environments back home, meaning we're most comfortable in dry air and cool temperatures—not hot, humid swamps.

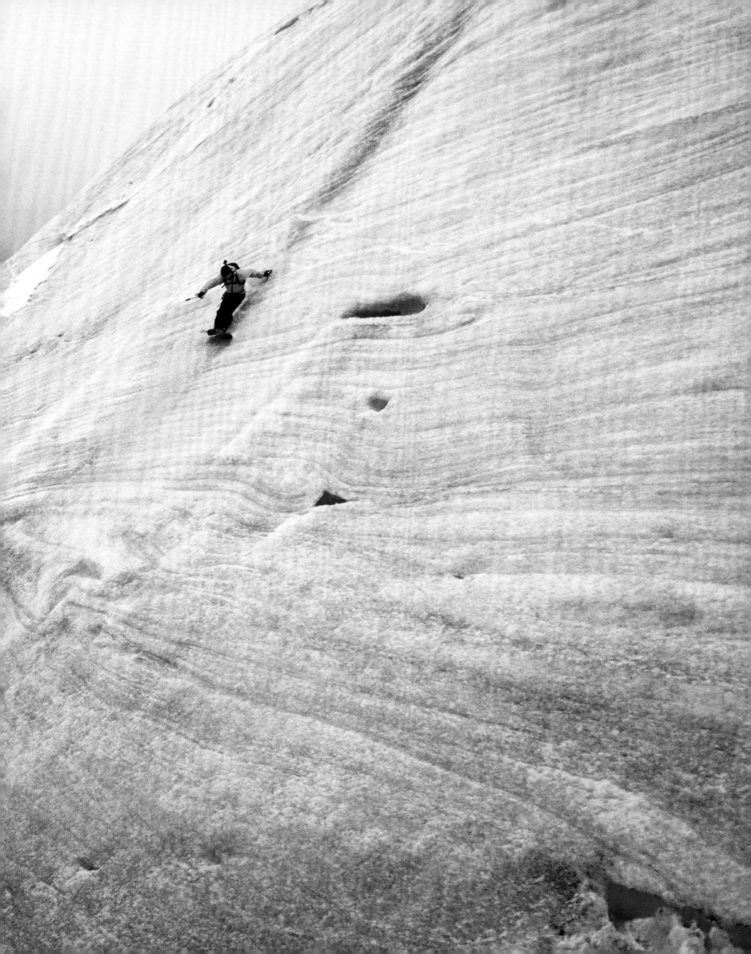

BOOT SELFIE ATOP PUNCAK JAYA: THESE BOOTS WERE STOLEN JUST AFTER THIS ASCENT, AND I SPENT THE REST OF THE TRIP IN FLIP FLOPS.

During the long journey from sea level to our high-alpine base camp, we often traveled by river in a carved-out canoe. Stuck on this handcrafted vessel, we suffered through stretches of the thickest humidity and hottest temperatures I'd ever experienced. Our lightweight, technical Western clothing made us feel like we were trapped in Ziploc bags.

Wearing nothing but a penis gourd for attire was beginning to make much more sense.

At one point, Stephen couldn't take the heat any longer and, in a fit of desperation, threw himself off the canoe into the brown waters of the river. His head emerged, and Rob and I saw an expression of sheer relief wash over Stephen's face as he bobbed in a cool eddy.

It was all the convincing Rob needed, and he, too, threw himself into the muck. Of course, I had to put down my camera and join them. I rolled off the bow into the water, and it felt like I'd extinguished a fire within.

"Wahoo!" Stephen crowed.

"Lovely!" Rob volleyed back in his Scottish brogue.

"Sheer bliss," I sighed.

Floating on my back, with my ears in the water and just my face above the surface, I looked up at our Dani guide, whose face had suddenly taken on an expression of deep concern.

We didn't speak his language, and he didn't speak ours. Thus far, we'd communicated via what might best be described as a primitive game of charades. Now, I recognized that his wide eyes and trembling lips were definitely trying to tell me something. I sat up in the water and put my hands up in the air, as in, "What's wrong?"

The guide thought for a second, then extended his two arms. He began scissoring his arms up and down frantically, all while making his fingers look like teeth. There was only one thing he could be telling us.

> CAPTURING IMAGES THAT SPEAK TO YOU, NO MATTER WHO YOU ARE OR WHERE YOU'RE FROM, IS WHAT DRIVES ME AS A PHOTOGRAPHER.

"Crocodile!" I yelled. "*Croc-o-dile!*"

Adrenaline turned my feet and legs into an outboard motor, and I thrashed back toward the canoe faster than seemed humanly possible. Stephen and Rob were right behind me. Within what felt like a quarter of a second, we were all catching our breaths, dripping river water onto the wood bottom of the canoe.

Sure enough, there was a big brown croc swimming through the water just behind us. Once we were safe in the boat, our guide laughed hysterically.

This image of Stephen Koch on Puncak Jaya isn't one of the best photographs I've ever taken, but it does bring up many emotions and feelings. We ended up reaching the summit, and Stephen made a beautiful snowboard descent. The trip was a success—but reaching summits and attaining goals wasn't what ended up being important. It was all those in-between moments, like narrowly escaping a crocodile attack and laughing for the next hour straight. That's the stuff that really matters.

This was the last trip I took with Rob. Sadly, he died the following year—2005—during a summit push on Everest. When that awful news reached me, I sat processing it all . . . and one of the first things I thought back to was the classic moment when Rob, Stephen, and I were back in the canoe, soaking wet, catching our breaths, and laughing uncontrollably.

The photo that opens this essay reminds me of all the incredible ways we find to communicate with each

ROB MILNE, STEPHEN KOCH, AND A DANI RIVER GUIDE MOMENTS BEFORE MEETING THE CROC

other: across cultures, languages, and borders. For me, photography is that universal language. Capturing images that speak to you, no matter who you are or where you're from, is what drives me as a photographer. Photography enriches the whole experience of travel, adventure, and life, allowing me one more tool to communicate with people and tell stories.

But I'd also say that it helps to know a few universal hand gestures. And if you're going to be traveling by river in Indonesia, I'd strongly urge you to learn the one for *crocodile*.

13

JACK JOHNSON

WHEN I WAS IN COLLEGE, I got an assignment to shoot a magazine cover and story featuring Jack Johnson, Kelly Slater, and Ben Harper. I knew of Ben Harper and liked his music. Jack Johnson was still an up-and-coming artist, and I'm not sure if I had even heard one of his tracks at that point. The only thing I knew about Kelly Slater, beyond the fact that he was a badass surfer, was that he had just broken up with Pamela Anderson.

I had no idea why these people were going to appear together in a magazine. Nevertheless, I was humbled, honored, and psyched for the opportunity to photograph them.

The shoot was for a mag called *Hooked on the Outdoors*. If this had been a shoot for *Vanity Fair*, there would have been a thousand other more-qualified photographers to call first. But this was *Hooked on the Outdoors*, so they called me.

The story was that Jack, Ben, and Kelly were all buddies who played music together, surfed together, and were going to save the world together. Though these details were technically true, the feature was largely ginned up by a PR firm seeking to promote Jack and Ben's new album and tour.

This gig was outside my wheelhouse at the time, to be honest. I was going to have to travel to the Hollywood Bowl, a large outdoor amphitheater, set up a studio in an underground parking garage, and, within just twenty minutes, capture a bunch of portraits of the three subjects—together, alone, and in various couplings.

The night of the shoot, Ben Harper was headlining a concert at the Hollywood Bowl, Jack Johnson was opening for him, and Kelly Slater was going to be in the

audience. This explains the short amount of time I was given.

I didn't consider myself a portrait photographer and had very little experience working in a studio environment with lights. I'd much rather be 2,000 feet up El Capitan, hanging from a 10-millimeter static rope, any day. Still, I was excited about the opportunity to explore new creative terrain and, potentially, to even rise to the occasion. Just so long as I didn't totally botch it, I knew this job would lead to other opportunities. That's what I love about this career.

I've noticed that we photographers are quick to justify splurging on shiny new gear prior to any big assignment. There is a tendency, for better or worse, to spend our paychecks before we've even earned them.

For this shoot, I talked myself into purchasing a high-end SLR film camera. I already owned a very early digital camera but, at the time, digital files weren't large or high-quality enough to hold a two-page spread.

Also, I really wanted a new camera.

I hired Max Becherer, a college buddy and fellow photojournalism student, to be my lighting assistant. On the day of the concert, we caught the first flight to Los Angeles. We rolled into the Hollywood Bowl at 8 a.m. and were struck by the venue's grandeur. In the distance, I could see the iconic Hollywood sign gleaming brilliantly atop Mount Lee in the rosy morning sun. That's when it really dawned on me that this was kind of a big deal, and my excitement grew.

We met the team of PR handlers who had arranged the shoot. They directed Max and me into a dark corner of a parking garage directly beneath the amphitheater.

"You guys can set up here," a PR person said, pointing to a patch of asphalt littered with cigarette butts and dried gum. "The talent will be here at four p.m. sharp. You'll have to be fast, because we only have twenty minutes with them. That time is nonnegotiable."

"That's why we got here so early," I said eagerly. "We want to be sure we're ready, so that we can be superefficient with our time."

"Fantastic!" the PR person said. "After that, you're free to enjoy the concert. Here are some tickets for you guys. I'll be back here at three thirty. See you soon. Good luck."

Max and I went to work setting up our seamless white backdrop and strobes. We were finished with setup by 9:45.

"I guess we just hang out now and wait?" Max asked rhetorically.

"Maybe we should figure out what the fuck we're doing with these strobes," I said, laughing nervously.

"Don't worry," Max said. "This is freshman-level stuff."

Max was as solid as they come. Methodical, smart, and fearless, he was never afraid to charge the battlefield, metaphorically or otherwise, to get a shot. Years later, he became a freelance war photographer whose work ended up everywhere from *Time* magazine to the *New York Times*. This was exactly the kind of person you'd want running your lighting op. I didn't question him for a second.

While waiting, Max and I dreamed up different poses our models could assume during the shoot. We captured test frames using my digital camera. This was a common tactic at the time, and one useful application of the early digital technology. We were surprised by how good the lighting looked.

"This is going to be sick!" Max said.

The stadium was filling with workers who were running around and setting up for the concert, which was slated to begin at 7 p.m.

As 4 p.m. neared, I started getting nervous. A crowd had gathered around our little mock studio in the parking garage, including Mark Anders, a friend and the journalist who was going to write the story for *Hooked on the Outdoors*. There were also agents, PR handlers, and the magazine publisher. I showed the publisher the test frames on the back of my digital camera, and she was blown away.

"Amazing!" she said. She launched into a litany of suggestions, plus questions I had no interest in answering.

"Oh, hey, there's Kelly Slater!" I said, and ducked away from the publisher midsentence.

Conversation with Kelly was nonchalant and easy. Because there's a lot of cultural crossover between climbing and surfing, we instantly hit it off. He struck me as an intelligent, curious guy who wanted to know all about my world. I returned the favor and asked him his thoughts about big-wave competitions and

the ethics behind turning a dangerous sport into a spectacle.

"Thanks for asking about that," he said. "Most people I talk to just want to know how Pamela Anderson is in the sack!"

We laughed, and before I could ask a follow-up—"Well, since you brought it up . . ."—Kelly ran off to find some water.

An outdoorsy-looking guy in a Patagonia hat, who wasn't much taller than me, appeared. We started making small talk. Turned out we knew some of the same folks who worked at Patagonia. I was half engaged in our conversation, because I was running through mental checklists and keeping my eye out for Jack Johnson and Ben Harper.

When Ben Harper, whom I instantly recognized, arrived, I promptly ended the conversation with the guy in the Patagonia hat.

"Hey, man, it was great to talk to you," I said, "but I'm actually doing a photo shoot with Ben Harper and Jack Johnson, and Ben just arrived, so now we're just waiting for Jack to show up and then I need to get to work."

"Oh, I'm sorry. But, um, I'm actually Jack Johnson," the guy in the hat said.

Ouch! There wasn't a big enough shoehorn in all of Hollywood that I could have used to pry my foot out of my mouth. I felt like a complete idiot! Fortunately, Jack was cool. He laughed and told me not to worry about it. It ended up being a great icebreaker, and we all laughed.

Strangely, that fumble didn't throw me off my game. In both athletics and the creative world, top performers talk about entering a flow state. I felt as if I'd entered that state during the shoot. Perhaps it was because, with just twenty minutes to execute, the pressure was on. Or maybe it was because my gaffe had allowed me—and indeed all of us—to loosen up and feel comfortable and free.

I also made the smart decision to show Jack, Kelly, and Ben our test frames, which fired them up. In part, it was because they had probably never seen a digital camera before, but they also got to see firsthand how good the frames were going to look. This motivated them to put in the effort, and they started coming up with their own clever and/or funny ideas for photos as

I DIDN'T CONSIDER MYSELF A PORTRAIT PHOTOGRAPHER AND HAD VERY LITTLE EXPERIENCE WORKING IN A STUDIO ENVIRONMENT WITH LIGHTS. I'D MUCH RATHER BE 2,000 FEET UP EL CAPITAN, HANGING FROM A 10-MILLIMETER STATIC ROPE, ANY DAY.

I snapped the actual images we'd be using with my new film camera.

We were surrounded by around a hundred people, who were watching us work. The strobes were firing, the energy was high, and it all felt somewhat glamorous, though in a very down-to-earth way. I was fully engaged in the moment. I had a clear vision of what I wanted to shoot, and I was able to block out all of the other voices and people. It was just about me and my subjects creating the best imagery possible.

An agent tapped me on the shoulder and said, "Corey, it's been twenty minutes. Are you done?"

And I said, "Yeah, we got it! That's a wrap!" Everyone clapped. We high-fived. Beers emerged. It was a festive moment. The publisher shook my hand and said I had done a brilliant job. I was on top of the world.

That's when I looked over at Max, who was frantically turning the pages of my new camera's manual. His face was tomato red.

I casually made my way over to him. "What's up, Max?" I whispered.

"It's one twenty-fifth of a second," Max said, pointing to the page describing the film camera's sync speed. "It's not one *two hundred fiftieth!*"

He didn't need to say anything more. I knew. We'd fucked the entire shoot.

The digital camera we had used to test our setup had a sync speed of $1/250$. We hadn't thought to check if our film camera's sync speed was different. This was bad.

I had no choice but to play it cool. I smiled, raised my beer, and clinked bottles with the publisher. Inside, I was utterly panicked.

scenario) or at the edges (not ideal, but not catastrophic either).

I didn't enjoy one second of the show, even though there was a big fake smile on my face. I was panicked, silently considering crazier and crazier options. If Max told me that the black stripe was down the center, I decided that I would have no choice but to hire someone to steal my car—with all my camera gear and the film from the entire shoot—light it on fire, and drive it into the river, because there was no way I would be able to own up to the fact that I had screwed up that badly.

As Ben Harper sang songs of peace and love, I sweated.

Finally, my giant first-gen cell phone rang. I picked up, then immediately hung up. This was our signal that I'd call Max back, as this, of course, was before text messaging.

"I'm going to the bathroom," I told the publisher, who was rocking out with a big smile on her face.

In the bathroom, I called Max back. Due to the concert, it was really loud in there.

"What's the verdict?" I shouted.

All I heard was: "...we're...totally...fucked!"

"What?" I yelled into the phone.

"The good news is, we're not totally fucked," Max shouted. *"The black streak is down the right side!"*

"The black streak is down the right side!" I screamed.

People in the bathroom must have been very confused by hearing me yell this, but oh well. At least I didn't need to pay someone to light my car on fire.

In the end, the magazine salvaged a usable cover by compositing two portraits into one image. And thanks to some cropping and Photoshop work, they eked out a full feature using the rest of my photographs, including

LEFT TO RIGHT: KELLY SLATER, JACK JOHNSON, CAMERA SHUTTER SHADOW

My mind ran through the scenarios. When you shoot at the wrong sync speed, that means your shutter curtain will cast a shadow across part of the frame—in other words, there would likely be a big ugly black stripe running down or across part of the frame, depending on how the shutter had opened. The worst-case scenario would be if the big black stripe landed right across my subject's faces.

Max and I devised a plan. I would go to the concert with the publisher and agents and pretend to have a good time while Max would hang back and shoot a test roll of film using the wrong shutter-sync speed. Then he'd find the nearest film lab to rush-process the roll. This way, we would at least know if the black stripe was going to land in the middle of the frame (worst-case

> MAX WAS AS SOLID AS THEY COME. METHODICAL, SMART, AND FEARLESS, HE WAS NEVER AFRAID TO CHARGE THE BATTLEFIELD, METAPHORICALLY OR OTHERWISE, TO GET A SHOT.

this chapter's lead image of Kelly and Jack behind a surfboard and a guitar, respectively, which is my favorite portrait from the shoot.

At some point in the aftermath, I spoke to the photo editor on the phone and just straight-up lied through my teeth when he asked me about the black streaks. I blamed the new camera for everything, even though it had totally been my fault. I even thought that he'd bought it, too. Years later, though, during another random interaction, this editor made a point of calling me out by casually asking, "Hey, you ever figure out that sync-speed issue on your camera?" That floored me. He had known all along.

In Hollywood, the name of the game is "fake it till you make it." I would really hate for that to be the lesson of this essay. Remember: we were in college, spending our weekends actually working in the field we were preparing for. Maybe that gives us some leeway.

I DECIDED THAT I WOULD HAVE NO CHOICE BUT TO HIRE SOMEONE TO STEAL MY CAR—WITH ALL MY CAMERA GEAR AND THE FILM FROM THE ENTIRE SHOOT—LIGHT IT ON FIRE, AND DRIVE IT INTO THE RIVER, BECAUSE THERE WAS NO WAY I WOULD BE ABLE TO OWN UP TO THE FACT THAT I HAD SCREWED UP THAT BADLY.

But I will say this: don't be afraid to go for it, because you will learn a lot more from your mistakes than your successes. It's a lesson I'm constantly reminded of every time I happen to hear Ben Harper or Jack Johnson on the radio.

CHRIS SHARMA - SANTA CRUZ, CALIFORNIA
70–200MM LENS / F/4 / 1/1000 SECOND / FUJI VELVIA FILM

14

CHRIS SHARMA JUMPS AHEAD

I PARKED IN FRONT OF a modest home in Santa Cruz, California, where a teenage Chris Sharma lived. I double-checked to make sure I had the right location and smiled. Of course the world's best rock climber would live at street number 514.

In today's world, where very young, very strong 5.14-crushing youths pour out of climbing gyms across the country with increasing regularity, it's difficult to accurately describe what a prodigy the young Chris Sharma was, not to mention the profound impact he's had on the sport of climbing. He was so much better than everyone else that, virtually overnight, everything changed. He grabbed the sport by its ears and led the way, pushing standards for the next twenty years. Everyone else has since been scrambling to catch up.

On assignment for *ESPN* magazine, I arrived at Chris's home and met the mellow, thoughtful athlete for the first time. We sat on a couch and discussed potential locations for our shoot. We decided on Panther Beach, a crumbling seaside cliff band about 10 miles to the north, where Chris, as a kid, would explore, climb, and play.

"The rock isn't great," he warned me, "but I think it'll make for some good pictures."

We drove up the coast to Sharma's stomping grounds. Just as he'd described, the sandstone was complete choss. It was funny, if almost unbelievable, that Sharma had come from such a humble "home court."

We walked down the beach to this cool cave, where I first saw the photographic potential that Sharma had spoken about. The cave had been eroded away over the years from the crashing waves, creating this perfectly framed "window" looking out to the tremendous Pacific Ocean.

I immediately saw a photo opportunity here—*the* shot would be of Chris in position at the lip of the cave's roof. However, when I looked up, I saw nothing but tiny, slimy, wet holds. You'd need an 8-foot ladder to reach the upside-down, completely horizontal ceiling, some 10 feet above the sand. I shrugged it off, thinking it would be totally, completely impossible for Chris to get into that position at the apex.

Photography is all about having "vision": the ability to see something that might not yet exist, but perhaps could. It means seeing potential in situations where others don't. In that sense, vision is sort of like a photographer's fingerprints; it's what differentiates you creatively from everyone else and makes your work unique. It's listening to that true intuition within and having the courage to follow through.

But having vision doesn't always automatically translate into great photographs. There are logistical hurdles, shortcomings of light, and other external factors that may be out of your control, which sometimes make the vision that's in your head impossible to capture.

This was one of those situations where I had a really inspired vision for a cool photograph, but I also figured there was no way to get the shot I wanted. So I didn't say anything about shooting inside the cave to Chris.

Instead, for an hour or so, I photographed him bouldering around on the beach. I made a couple of interesting pictures, but nothing that I thought would be a double-page spread in *ESPN* magazine.

A little frustrated with what I was getting, I finally said to Chris, "You know, *the* shot would be of you hanging from the lip of the cave . . . but I don't think it's actually possible to hang off those holds."

He looked bewildered. "I dunno . . . maybe," he said.

Chris, being one of the humblest guys on the planet, wandered over to the cave and peered up at the roof, looming above us at the height of a regulation NBA

PHOTOGRAPHY IS ALL ABOUT HAVING "VISION": THE ABILITY TO SEE SOMETHING THAT MIGHT NOT YET EXIST, BUT PERHAPS COULD.

basketball hoop. "I might be able to jump up there and grab those holds," he said modestly.

Bulging from the ceiling were two horrible, greasy protrusions of rock. They were so far overhead I couldn't see how he planned to reach them.

First, Chris positioned himself directly beneath the holds and, from a crouched position, jumped. His arms whiffed a few feet beneath the rock.

I chuckled to myself. *See? I knew it. Physically impossible.*

Then Chris tried a different approach. He ran into the cave from different angles and sprung out of the sand, his arms outstretched toward the holds. He tried this five or ten times, and started getting closer and closer.

Well, maybe he'll touch the holds, I thought. *But there's no way that he'll ever be able to grab them.*

"I think I got it this time," Chris said. He ran, he jumped, and . . .

Shit! He got 'em!

He hung there for a second, but couldn't swing his feet up onto the rock in time. He dropped into the sand, falling directly onto his back.

"Holy shit—that was amazing!" I said. "Are you OK?"

"Yeah, yeah," he said, brushing sand off his body. "OK, I know what I need to do."

Clearly, Chris, like most world-class athletes, was incredibly in tune and familiar with his body—in this case, so much so that he could calculate just how he needed to grab the holds and lever his torso up onto the wall so his feet could create the tension he needed to start climbing.

And you know what? I began to see it, too. I scrambled to set up my camera, framing the composition and exposing for the beautiful turquoise sea and waves

crashing in the background. I knew Chris's body position would be key to getting a great image: that one moment when there would be perfect separation between his silhouetted frame and the Pacific vista behind him. I wanted to capture all four limbs with as much separation between the rock and the sky as possible. Getting that perfect moment would be extremely improbable, so I turned on the motor drive to shoot a continuous burst of images, hoping to nab the split second where the body position, the crashing waves, and the composition would come together like a symphony.

Chris now had the jump start on lockdown. He sprung out of the sand and latched on to the rock. His feet swung wildly, but, like an Olympic gymnast, he levered his body horizontally. He placed his toes on the stone, then he started climbing higher and higher,

until he was right at the lip of the cave. I fired bursts of photographs, totally blown away by what I was seeing, but trying to focus so that I could nail the situation. And I ended up getting a shot that, indeed, was worth a double-page spread in *ESPN* magazine.

More important, Chris taught me a valuable lesson that day. First, I learned that I should never doubt an athlete with a home-court advantage. Second, I was learning to never give up, never be so quick to write off something as impossible, and to always maintain the belief and determination needed to make my vision a reality.

As I continued taking pictures, Chris was fully in his element: climbing a first ascent and doing something no one else in the world could do. Something no one else but him would have ever believed possible.

15

SWIMMING WITH THE FISHEYES

I WAS IN FIJI, ISLAND-HOPPING from Kadavu to Nagigia, which was rumored to have good surf. It was only about a ten-minute flight, and our plane, which was small enough to have an open cockpit, was being operated by two Fijians, both of whom could've had careers as linebackers in the NFL. The pilot was younger, and seemingly in training, from what I gathered. The copilot, meanwhile, was clearly the veteran, supervising the younger pilot's flight.

I was with my writer friend Mark Anders, who had recently joined me on an assignment to cover one of Mark Burnett's first reality TV shows: *Eco-Challenge*, an adventure-race series that was truly unlike anything else on TV at that time. One of these races was taking place in Fiji, and I had been hired to cover it and shoot still advertising photographs for the network hosting the program.

This story isn't about the shoot, however; this story is about what happened next.

Mark, two other surfers, and I were aboard the flight. We all sat on one side of the plane, while our surfboards lay flat across the folded-down seats on the other side. The short flight was beautiful, as we were treated to a view of hundreds of Fijian islands spread across the turquoise waters.

We were coming in for a landing on a dirt runway when all hell broke loose. When we touched down, it felt like the brakes engaged on just one side of the

plane. The plane spun 90 degrees and started skidding sideways. One wing dug into the dirt, ripping apart like an aluminum can!

We finally skidded to a halt, happy to be alive and unhurt. We looked to the pilots to see what had gone wrong. I swear to God, no sooner did the plane come to a rest than the older pilot turned to the younger pilot and slapped him across the face. It was such a hard slap that spittle flew through air, and a little bit got on all of us in the back!

And with that, Mark and I pulled our surfboards out of the wreckage and headed out to find the beach—and a beer.

Tagging a bit of vacation time for climbing or surfing onto your travel-photography or writing assignments—for climbing or surfing, or whatever it is that you're into—is one of those aspects of this business that you don't really need to be taught. It's patently obvious, right? You're going all the way to Fiji on someone else's dime . . . so of course you'll go surfing in Nagigia too!

Kadavu is just across from Nagigia, and between the two islands is the Kadavu Passage, which contains the famous surf breaks King Kong Left and King Kong Right, which got their names, according to the locals, because Kadavu was where the first *King Kong* movie was shot.

Mark is a great surfer, but I was a complete neophyte. Still, I am happy to paddle and thrash around in some waves any day.

Nagigia is one of the most extraordinary places I've ever visited. There can't be more than a dozen bungalows there—in fact, you can see pretty much the entire island in this photo. It's a romantic little island resort, which, now that I think about it, would've been better to visit with my wife than another dude. (No offense, Mark.)

Of course, we found virtually no swell the whole time we were there. The ocean was flatter than a pancake, never living up to its King Kong title.

One morning, the second-to-last full day of the trip, we woke to the promise of actual surf breaking far out on a distant reef. "Real waves!" we said. "Let's go!"

Mark and I joined forces with a couple of honeymooners. We rented a little boat and headed out in search of distant waves to ride.

Of course, I brought my camera bag, which was packed with a camera body, a 17-35mm f/2.8 lens, a 70-200mm f/2.8 lens, and a 300mm f/2.8 lens.

I also own a Nikkor 16mm fisheye. It's one of those lenses that spends most of its life in my bag. At the same time, it's responsible for one of the highest-earning images of my career (see Chapter 10), so I won't claim that the fisheye is without value. If you really push me, I might even admit to secretly loving it.

Anyway, the four of us cruised out toward the King Kong breaks. But when we arrived, once again we found nothing. The water was flatter than a squashed bug. Bummer.

Still, I was enjoying bobbing around with Mark out in this pristine Pacific location, taking pictures and making great conversation with our new friends. The first thing we told them about, of course, was the plane crash that had resulted in easily the hardest face slap we'd ever seen.

IF THERE WAS A PHOTOGRAPHY 101 LESSON THAT I WAS LEARNING, QUITE PAINFULLY, IT WAS THE ALMIGHTY IMPORTANCE OF HAVING INSURANCE.

Then, out of nowhere, King Kong awoke! A wave suddenly struck the boat. And because I was an idiot who had left my camera bag with all of my equipment balancing on the boat's gunwale, I got to watch $15,000 worth of camera gear fall into the clear, salty water, where it bubbled, gurgled, and slowly sank to the bottom.

There's a joke among newspaper and staff photographers that camera gear is disposable. During my internship in the newsroom of the *Modesto Bee*, I had really enjoyed making that joke. Boy, was it funny.

Now, however, I was a freelancer—a freelancer who had just learned the hard, painful realties of what life is like when you're paying for your gear out of pocket.

If there was a Photography 101 lesson that I was learning, quite painfully, it was the almighty importance of having insurance.

Take it from me. Insurance is cheap. And it works. Get it.

I remember telling everyone not to worry, that I actually had insurance. That was a complete lie, though. I don't know why I said it. I guess I was embarrassed and didn't want to bum out these folks on their honeymoon and make them feel bad for me.

Inside, I was cringing. All the money I'd made in the two weeks prior would now have to go toward replacing my equipment.

But there was another lesson I learned on this trip, and that's the importance of redundancy. Back in the bungalow, I had a backup camera body with one lens—the lens that I hate but that I love to use: the fisheye.

The next day, our last in Fiji, Mark and I motored around in a little boat, snorkeling and enjoying our time in the South Pacific. And with my spare camera body and fisheye lens—the only camera gear to my name at that point—I shot this photo.

I even sold the photo to Patagonia. I'm sure the money I made went toward a good cause . . . like purchasing an insurance policy.

On our way back home, we arrived at the airport, which was little more than an open-sided tin-roof hut. Our wrecked plane was in the same place, and I wondered if this Fijian airline had insurance. I wouldn't be surprised if that plane is still there today.

16

PROJECT BANDALOOP

THEY SAY THAT ROCK CLIMBING is like performing a vertical dance. Project Bandaloop has taken that interpretation to its literal extreme.

This dance company (now known as just Bandaloop) combines modern-dance routines with extreme vertical environments. These aerial dances, as they are called, have since the mid-1990s been performed from major city landmarks to the walls of Yosemite.

Back then, I remember some of the more seasoned, jaded rock climbers scoffing at Project Bandaloop. After all, in their eyes, rock climbing was this very hard-core, masculine thing.

But I saw it differently. I was fascinated by the group. The dancers were climbers, like me, but what they were doing was unique and extremely visual. I didn't listen to the old, disgruntled naysayers. I knew it was important to take a broad interest in the world around me, beyond just my own niche.

In college, I spent what little money I had shooting Project Bandaloop. I once flew to Vegas to capture them performing in Red Rock Canyon. I made several trips to Yosemite to work with them on the side of El Cap. I even made a trip to San Francisco when they were performing on one of the city's buildings.

Over time, I established a relationship with these people. I got to know them, and they got to know me. They saw that I could make compelling photographs. They saw that I was safe and knew how to rig my own ropes. And I think they even liked having me around.

Ultimately, all that investment paid off when I got a phone call offering what was my biggest, coolest editorial assignment to date.

I was in my dorm room when the photo editor at the *New York Times Magazine* called. She explained that they were doing a story on Project Bandaloop. Clearly, my friends there had thrown me a bone by tossing my name into the hopper for shooting the story. The photo editor asked if I could shoot their next performance, which would be on an industrial water tower in Salina, Kansas.

This was a huge deal. The *Times Magazine* is a very well-respected publication for both writers and photographers. At the time, I would have paid *them* to give me this assignment!

On the phone, I played it cool while hashing out the details. We went over the logistics of making photojournalistic pictures while hanging on a 10-millimeter rope 100 feet off the ground. She was very concerned about my safety. The whole idea appeared to be utterly death-defying to her.

To climbers, jugging up or rappelling down a free-hanging rope is, quite frankly, no big deal. With a few basic precautions and an elementary understanding of climbing equipment, anyone can get up or down a rope safely.

But this New York City editor didn't know that. And I have to admit I played into her fears, making the whole thing seem a bit riskier than I knew it would be.

For some reason—and I don't know where this came from, to be honest—I blurted, "One more thing. My day rate goes up for each day I am on a rope."

It was a supercocky thing for a college kid to say to the photo editor of the *New York Times Magazine*. But I figured, what the hell, and just went for it anyway.

Sure enough, she didn't even flinch. She instantly doubled the rate.

I KNEW IT WAS IMPORTANT
TO TAKE A BROAD INTEREST
IN THE WORLD AROUND ME,
BEYOND JUST MY OWN NICHE.

I hung up the phone with a smirk.

It took a whole fifteen minutes for me to realize the ramifications of my presumptuous little request. The *Times Magazine* was going to pay me more than what some of its greatest photojournalists were making. I was getting special treatment. Suddenly, I felt an enormous amount of pressure to deliver nothing short of greatness. Yikes.

Within a couple weeks, I was boarding a plane—with an itinerary from California to Denver, then a quick flight to Salina, Kansas. The leg to Salina was scheduled to depart at 10 a.m., but due to thunderstorms hovering over Denver, our flight got delayed to 11 . . . then noon . . . then 2. It wasn't until 5 p.m. that I boarded a sardine-tin-sized prop plane with a dozen other passengers. The plane was so small (and this was so long ago) that there wasn't even a door to the cockpit. Everyone on the flight appeared to know each other, too. Even the pilot and copilot greeted each and every passenger except me by their first name.

Once in the air, the plane bucked with turbulence. I figured that this was normal for a plane of this size and tried to calm my nerves by closing my eyes and reminding myself that this would all be over in thirty minutes.

Then the pilot got on the loudspeaker and said the storms had shifted.

"Keep your seat belts buckled—this is going to get rough!" he said, his voice perhaps a bit too fraught with concern for my liking.

Indeed, it got more turbulent. Pretty soon, shit was flying out of the overhead bins and other passengers were puking into the airsickness bags. I looked ahead and saw the pilots not looking particularly confident as they battled through the storm. Lightning was going off all around us in cataclysmic flashes of brilliant white light accompanied by loud claps of thunder. It felt like we were on the front lines in a war.

There was a moment—or maybe a few—during which you could tell that no one on our flight thought we were going to make it out alive. Not the pilots. Not the pukers. Certainly not me.

Fortunately, we landed safely after one of the longest and most frightening thirty minutes of my life. The one dude out on the dark, wet runway directing the

plane in was actually clapping for us. We all burst out of our seats and started hugging each other. Then the majority of the passengers, the pilots, and I went out for a beer.

By the next day, the storm had passed, the skies were brilliant blue, and I was up on the rope shooting Project Bandaloop.

I hung 100 feet above the concrete on a thin nylon rope, my camera pressed to my eye. I felt overwhelmingly lucky to have this opportunity, not to mention just to be alive.

I chuckled to myself at the irony of the situation: how I'd never expected that getting to Kansas would be the most dangerous part of the whole situation. Perhaps that storm had been karmic retribution for me so nonchalantly demanding a higher day rate.

But soon, I forgot all about the money and got into the zone. The kind of state you find yourself in anytime you do something you enjoy, for no reason other than that it's what you love.

I ended up taking some of the best pictures I'd ever taken to that point. The real affirmation came later when I delivered my rolls of film to the *Times'* editors and they said they were "surprised" by my pictures—the ultimate compliment. It led to more assignments with the *Times Magazine*. And one of the photos from the shoot (not this one) won an esteemed photojournalism Pictures of the Year award.

Climbers say it's not the summit but how you get there that matters. What I took from this whole experience is that climbing is nowhere near as dangerous, risky, or scary as flying into Salina, Kansas, can be.

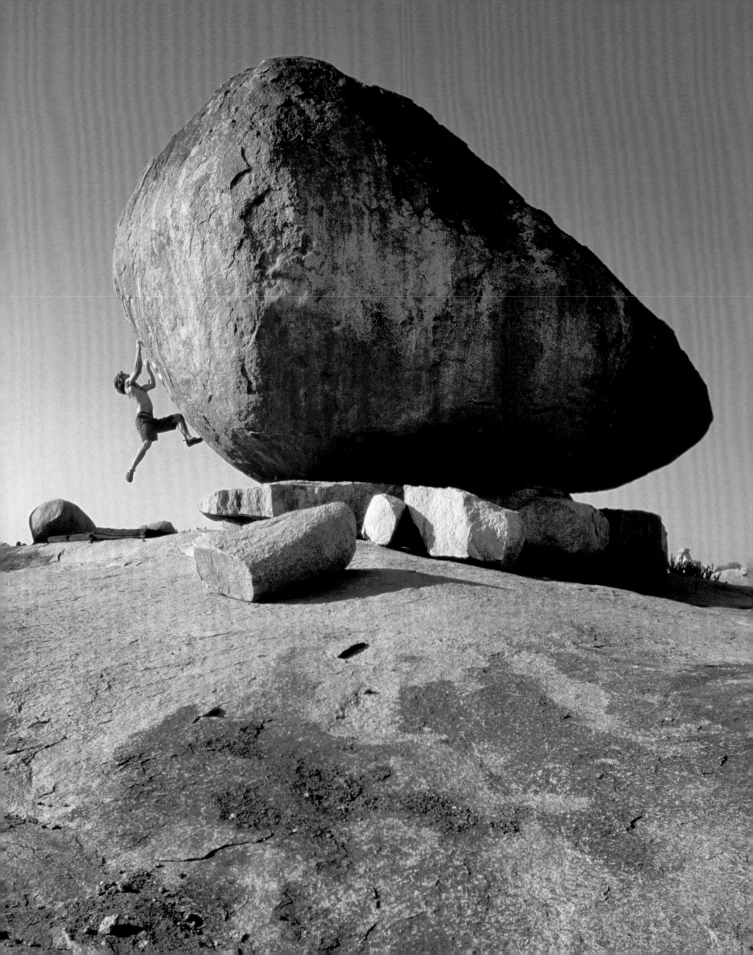

CHRIS SHARMA - HAMPI, INDIA
17–35MM LENS / F/16 / 1/250 SECOND / FUJI VELVIA FILM

17

CHICKEN BUS PILGRIMAGE

MY FIRST TRIP TO INDIA can be summed up by the old saying that the journey is often more memorable than the destination.

In 2002, Josh Lowell, a friend and climbing-film visionary, was planning his next project. Josh's films—shot with the help of his brother Brett for their company, Big Up Productions—started getting popular in the late 1990s, in part because there were virtually no other production companies focusing on bouldering and sport climbing at that time. Josh and Brett pioneered a new genre that would have a massive influence on the sport. Their films were popular in part because Josh often worked with the best climbers in the world—guys like Chris Sharma (featured here and in Chapters 14 and 35).

Josh was interested in doing a feature-length film about a bouldering trip to Hampi, India. The stars of the film would be Chris Sharma, his friend Nate Gold, and Katie Brown, one of the best female rock climbers at the time.

Climbers had recently discovered Hampi, which held endless hillsides of beautiful egg-shaped granite boulders. Josh's idea for the film was to document a few of the best climbers in the world as they explored this emerging climbing area and tried to establish difficult first ascents.

I was delighted—flattered, actually—when Josh invited me to join the adventure and shoot still photographs to help market and promote the film, which came to be titled *Pilgrimage*. Brett's wife, Katie Weems, would also be joining us on the trip.

NATE "BIGGIE" GOLD SCORED THE COVER OF THE *ROCK AND ICE* FEATURE STORY ON OUR HAMPI TRIP.

I decided to maximize my time by arriving at the tail end of the trip, when Chris, Nate, and Katie had figured out all the boulder problems, and when Josh and Brett knew when and where to find the best light. However, I also knew that with a third the number of days in Hampi as everyone else, I'd have to work three times as hard to pull my weight.

I'll admit it. Back then, I was a bit of a neophyte when it came to international travel. You'd only have to take one look at me, trying to carry three giant rollers of luggage and camera equipment through the doors of the Bangalore airport, to see my inexperience. Not only had I packed way too much equipment, but I also had no idea how I was going to get all of it—and myself—to Hampi safely.

This trip took place well before there were such handy tools as smartphones, Google Maps, and Uber rides. In fact, the only directions I had with me were Josh's hand-scribbled notes about which buses to take.

Anthony Bourdain once wrote, "One doesn't take the A train to Mecca." No, indeed, one doesn't.

Right off the bat, I ended up on the wrong bus. It was the local bus, not the express, and it was chock-full of coughing people and squawking chickens. What should have been a six-hour ride ended up being a heinous eighteen-hour tour through every last locality between Bangalore and Hampi.

Over the course of those endless hours, I squirmed around in a tiny seat, crammed between two locals and their flock of chickens.

Finally—finally!—I arrived in Hampi. Covered in dust and smelling like chicken shit, I burst into the bungalow where everyone else was staying. I had never been so happy to see my friends. Their saucer-wide eyes, however, didn't exactly reciprocate my enthusiasm.

"Dude, you look like you need a shower," Josh said.

"You have no idea," I said.

My excitement at having finally arrived in Hampi quickly gave way when I succumbed to India's special brand of gut-wrenching sickness, which everyone else had already experienced. Once I started my own twenty-four-hour bout of being doubled over, puking and shitting my brains out, I felt like part of the team.

A couple of days later, thankfully, I was back on my feet. And the location, the climbing, and the shooting were all incredible.

Chris was fresh off his historic ascent of a sport climb in France called *Realization*—considered the world's first 5.15a—and he was in top form. Katie had just resurfaced on the climbing scene with fresh energy after a hiatus away from the rock and her days as a child prodigy. And then there was Nate—a.k.a. Biggie, a fond nickname in reference to the fact that Nate, at six foot three and all muscle, was a real-life Hulk with dreadlocks.

What I was loving most about this trip, however, was getting to collaborate with the Lowell brothers—two of the most creative and talented people I know. Josh, Brett, and I all worked together to find complementary angles that would create the highest-quality still and motion pictures. Oftentimes, Josh or Brett would find a cool angle that worked best for video, and I'd slide into position and work around them. Or vice versa. It never felt like there was a competition to see who could get

the best shot. We were all psyched to try to achieve the best visuals possible and not get in each other's way.

Watching how Josh and Brett worked, I was also learning a lot about what it means to be a director. In addition to seeing what kind of work went into capturing motion footage, I could also see that a big part of any film crew's success hinges on having talented, energetic people who work together well.

When you are eating, sleeping—and, yes, even puking and shitting—in the same single bungalow alongside the same people, 24/7, and you are all still having a good time and trying your hardest to climb or shoot creative pictures, that's a winning formula.

One problem, however, was that we hadn't really found any boulders that were striking and difficult—the kinds of climbs that could really make the film succeed.

Another problem was that Hampi was hot—shockingly so. This meant that everyone was psyched to climb only in the early morning or at dusk, when the temperatures were slightly cooler. (Cooler rock helps with friction, allowing climbers to hang on to smaller holds without slipping off due to sweaty fingertips.)

Still, even at dawn, the rock was quite warm. The conditions were just not conducive to producing spectacular world-class climbing performances.

But what makes Chris Sharma so special is that once he finds the line that inspires him, he can pull out an amazing performance, even in the most desperate conditions.

Sure enough, we finally found that one really aesthetic, special, and difficult boulder problem. It was a single triangular rock balanced on a smooth slab of rock, the way an egg might sit on a table. Chris, Katie, and Nate all got excited to try this unique boulder,

which seemed impossible to my eyes. The holds were so small and faint that I could barely see them, let alone comprehend suspending my body weight from them.

The three of them attempted to climb the face for a couple of days, but it didn't seem like anyone would actually do it. The problem seemed to be a little too hard, and everyone agreed that the conditions were way too hot.

Then, on one of the last days of the trip, Chris woke up feeling motivated. He flipped the switch and went into beast mode.

"Let's get this thing done," he said. He turned to Brett, Josh, and me and said, "I'm probably going to do this thing now, but I'm not going to be able to do it more than once."

Game on! We scrambled into position.

THE DVD COVER FOR *PILGRIMAGE*

LEFT TO RIGHT: JOSH LOWELL, OUR FRIEND THE SHAMAN, CHRIS SHARMA, NATE GOLD, KATIE BROWN, BRETT LOWELL (FRONT), KATIE WEEMS, AND ME, IN A SHIRT THAT'S ONE SIZE TOO LARGE.

"Corey, you should check this angle out!" Brett called from beneath the boulder. "I think this one is yours, man!"

Brett had found a stunning and dramatic angle that captured how unique the problem really was. The position called for a vertical composition—it wouldn't work for video, but it would be great for still photography.

Once we were all in place, Chris did his thing. Sure enough, he floated right up this beautiful chunk of rock. The picture ended up being used as the DVD cover for *Pilgrimage*, and my other photos from the trip illustrated various magazine articles, which all linked back to the DVD.

It was time for me to leave Hampi and head home. And believe it or not, I made the tough decision not to take another eighteen-hour chicken bus back to Bangalore. Shocking, I know.

WATCHING HOW JOSH AND BRETT WORKED, I WAS ALSO LEARNING A LOT ABOUT WHAT IT MEANS TO BE A DIRECTOR.

Instead, I decided to splurge on a taxi, which would give me a few more hours to shoot photos.

It was late afternoon. My flight was leaving in ten hours. I walked into the town square and found a driver who was probably just getting ready to be done with his shift and head home.

The driver did a triple take when he finally realized that I was asking him to drive me straight to Bangalore—right now.

"Sir, you go to Bangalore right now, sir?" he said, bobbing his head and grinning. "OK, sir. Bangalore, sir. We go, sir!"

For him, this was like hitting the jackpot. He was so happy that before we left Hampi, he brought me to his home and introduced me to his wife and the rest of his family. We all had tea while the driver gathered some personal items for the long trip.

Two hours into the drive, the driver was about to fall asleep. His head kept slumping over heavily before he jerked it back upright. He could barely keep his eyes open. The taxi was swerving in and out of its lane.

I'm going to die right now, I thought.

I started talking to the driver, asking questions to keep him awake. When that didn't work, I started making excuses to pull over—that I had to go to the bathroom or that I was thirsty. Anything.

Finally, I offered to drive. He shrugged me off at first, but he soon realized that we were going to crash if we didn't swap places. I got behind the wheel of a classic Mercedes and figured out how to drive on the "wrong" side of the road.

There I was, cruising in a taxi down an open stretch of highway in India, while the taxi driver's head rested tenderly upon my shoulder as he took a two-hour nap in the passenger seat.

Sometimes, the journey really does make the destination memorable. But really, it's all about surrounding yourself with good friends and creative people, and witnessing impossibilities become realities. It's about putting yourself in situations that you could never have imagined, grabbing the wheel, and taking control of your own destiny.

18

BASIC INSTINCT

HAVING A GREAT SKILL SET, a strong résumé, and even all the right connections can take you pretty far in life. But if you're not fun to be around and people don't like you, they're not going to want to work with you.

I had originally hired Max Morse as my photo assistant because he was such a technically proficient and creative photographer. But his real value, which could never come through on any paper résumé, was his hilarious larger-than-life personality and his ability to connect with just about everyone.

On various photo shoots, these traits came in handy, as Max would entertain the client with his witty banter, leaving me free to focus on making creative pictures without feeling like I had a client breathing down my neck.

A few years ago, I was working on a shoot for a running-apparel company. Our group included me and Max; our running model, Stephanie Voelckers; a hair and makeup artist; a wardrobe stylist; and an art director from an ad agency representing the client.

We'd chosen a scenic stretch of highway near Caples Lake, just outside Lake Tahoe, to stage the shoot. It was a chilly spring day, and snow still cloaked the high peaks.

The agency strictly wanted peak-action running photographs: a striking runner in perfect stride, in an epic location. No portraits. No lifestyle. Just running.

Stephanie was working an office job in San Francisco while moonlighting as a fitness model. All morning, she had been sprinting as fast as possible up and down the road, and she was straight killing it.

Max and the art director were looking over my shoulder at the images on my camera's display screen, discussing the nuances of Stephanie's stride.

And as they were talking, I looked up and noticed Stephanie hunched over and trying to catch her breath between wind sprints.

I knew the agency didn't want any portraits. But when I saw Stephanie in this pose, I knew there was an opportunity for an authentic photograph.

Of course, satisfying the needs of my client is a huge priority. But if I see a cool picture, I'm going to try to make that picture.

I knew that getting an intimate portrait of Stephanie trying to catch her breath wouldn't take long, but that it would require distracting the art director for a moment so I could sneak over and make it happen.

I pulled Max aside and whispered, "Listen, Max, I need you to occupy a few minutes of the AD's time. Can you do that?"

"What should I do?" he asked.

"You'll come up with something," I said.

"OK, I've got just the thing," he said.

Max went over to the car, opened his laptop, and pulled up one of the images from the morning shoot. He called out to the art director: "Hey, would you mind coming over here? We should make sure the shadow detail is OK in these shots. Can your printer handle this sort of exposure latitude?"

Of course, it was all complete BS. The shadow detail was completely fine, and his question about latitude did not even make sense. But it bought me just enough time to stage the shot with Stephanie.

"Could you do two more sprints really quickly?" I asked her. "Then go back to that resting pose, please?"

Stephanie ripped off two more sprints, then returned to the pose I'd seen a moment before. I called over to the stylist to quickly help me hold a reflector and bounce in a catchlight, to do justice to Stephanie's bright blue eyes. Meanwhile, I sat on the pavement with a 24–70mm lens, making pictures.

There are many things, all very subtle, that make this photograph thought-provoking. The critical focus on those striking blue eyes. The authentic bead of sweat dripping down her face. The blue running shirt and the

contrast of her blond hair. The subtle angle of the camera relative to the light.

But one of the reasons I like this photo so much has to do with what happened next.

As we were changing locations, Max pulled me aside and whispered, "Hey, Corey. I think Stephanie has a thing for me."

"Oh?" I said. "Interesting."

"Yeah, man. She's fun. She's cool. She's really hot!"

I failed to see how any of those qualities, as valid as they may have been, could be construed as reasons to believe that Stephanie had "a thing" for Max—outside of his own mind. Instead, I simply patted him on the back and told him, "Yeah, I think you're right."

The day ended, and we all made plans to go out for sushi. Max contrived some oddly convincing reason that

THE SHADOW DETAIL WAS COMPLETELY FINE, AND HIS QUESTION ABOUT LATITUDE DID NOT EVEN MAKE SENSE.

made it necessary for him and Stephanie to ride back to Lake Tahoe together. He piled himself into Stephanie's car, sporting a big, goofy grin.

By the time we arrived at the sushi restaurant, however, Max's expression had changed quite dramatically. In fact, he looked rather crestfallen.

Apparently, Max had learned that Stephanie had a boyfriend. Not just any boyfriend, either. She was dating one of the defensive backs for the San Francisco 49ers.

The night ended, and Stephanie soon headed home to her strong millionaire superstar athlete of a boyfriend. And I found myself chuckling a bit at Max's

expense. But as always, Max had found a great way to look at the situation.

MEANWHILE, I SAT ON THE PAVEMENT WITH A 24-70MM LENS, MAKING PICTURES.

"Whatever. That guy's career is going to be over in a few years anyway, and he'll have to start selling life-insurance policies or something," Max said. "And look at us! We're the ones who spend all day making amazing, creative photos! And every day is different."

Max was right, gosh darn it.

The day ended up being a lesson in following your gut instinct. For me, it meant doing what needed to be done to get a great picture of a runner catching her breath after a hard workout. And of all the pictures I shot that day, this is the only one that made it into my portfolio.

And for Max, it meant being himself, following his heart, and going for it. Even though it didn't work out that one time, the fact is, his is the kind of attitude that ultimately leads to success more often than not.

The moment you stop listening to your instincts is the moment you've given up and abandoned the truest part of who you are, of what makes you an artist and a creative person.

Max, of course, has since gone on to do great things, as I predicted he would. And I learned that, no matter how impressive someone's résumé, I'll never hire a photo assistant who isn't fun to be around. I want to work with people who follow their instincts and their heart.

Even if it occasionally means that their heart gets trampled by a defensive back.

19

WHEN THE GLOVES COME OFF

A FEW YEARS AGO, I was sitting in a marketing meeting at Kirkwood Mountain Resort with a group of executives from Vail Resorts, the parent company, who were looking at this image of Ryan Murray sucking chest-deep powder after one of Kirkwood's biggest storms.

A resort in the Lake Tahoe region, Kirkwood has neither the star power of Squaw Valley (a.k.a. Squallywood) nor the vistas of Heavenly. But what it lacks in stars and scenery, it more than makes up for with bottomless powder.

Kirkwood's president delivered a critique I'd never forget: he said this was an A+ photo except for one bothersome detail—the glove.

"Why is this guy wearing a gardening glove?" the president wanted to know. "We're a high-end ski resort, and the right apparel is what helps us tell that story. You should have the right ski gloves on, not gardening gloves."

The skier side of me happens to love this photo. It shows peak action on an absolutely epic day. I even like the glove, because it's what Ryan, who is a badass skier, actually wore. There's authenticity there.

But the professional-photographer side of me—the guy who was collecting a paycheck from Vail Resorts—took the president's words to heart. I might not have fully agreed with his point, but I would remember the lesson I learned that day.

When you're shooting marketing material, always make sure the talent has the exact right apparel. That means clean pants and bright jackets, no stickers on

helmets, and no gardening gloves. It was a tough but valuable lesson to learn that you can go out on the most epic day of the year and still not be "getting the shot" (GTSing) if your details are off.

There's another interesting story behind the glove in this picture. But before I tell that tale, I want to share a few more tips for GTSing on a chest-deep blower day.

For most commercial, and even editorial, ski photography, the best days of the year for shooting are rare, because so many variables need to align.

First, you need to have a stud or studette skier whom you can call the night before, and who will agree to spend his or her powder day working with you to make pictures. (And, as I just mentioned, they also need the right outfit—I now usually do a wardrobe check the night before to make sure.)

Second, you need a good forecast. The ideal forecast calls for a storm to unload between 12 and 24 inches of snow overnight and then clear out by dawn, leaving blue skies and plenty of light.

Finally, it can't be a wet or warm storm. The snow needs to stay cold enough that it remains light and fluffy for as long as possible.

If these conditions align and you're not on the first chairlift with a few expert skiers who are wearing the right apparel, then you're blowing it. You're not GTSing.

Oftentimes, I'll go a step further and try to make an arrangement with ski patrol to be allowed out on the slopes before the public arrives. That way, I'm not worried about other skiers appearing in my frame or tracking up the fresh-fallen snow. Also, I won't be worried about getting freaking annihilated by the next Bode Miller wannabe barreling down the mountain in a full Olympic tuck.

Most times, though, you won't be able to get a special arrangement like this. Therefore, it's your job to know the mountain well enough to find the secret powder stashes and arrive there before anyone else.

One of the things I love most about adventure photography is how multifaceted it is. It's not just about understanding photography. You have to understand, respect, and be proficient in whatever sport you're shooting—whether that's knowing the ropes on

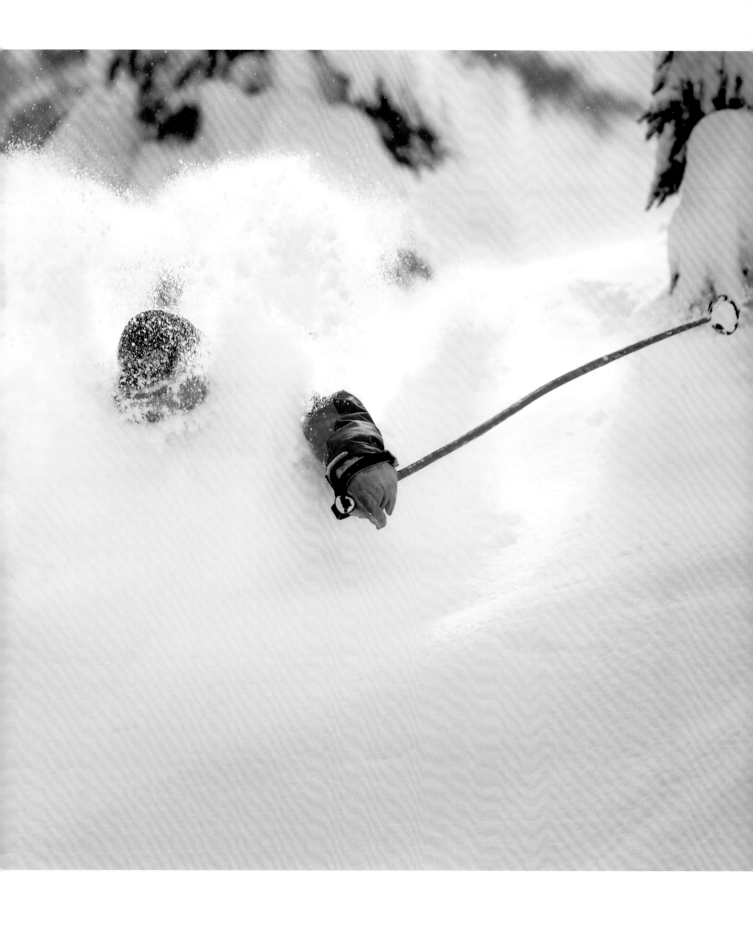

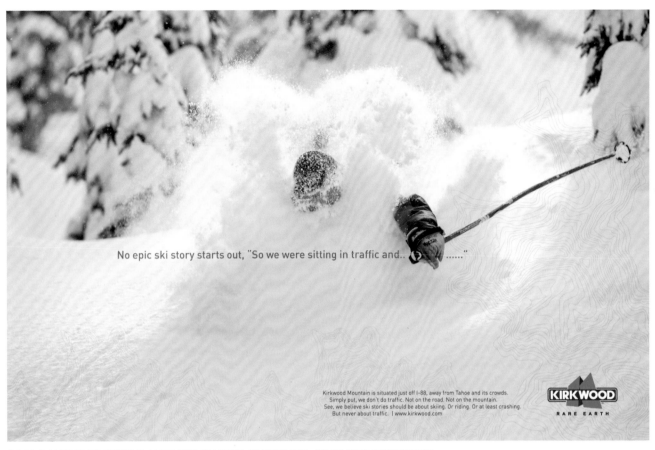

No epic ski story starts out, "So we were sitting in traffic and.................."

Kirkwood Mountain is situated just off I-88, away from Tahoe and its crowds.
Simply put, we don't do traffic. Not on the road. Not on the mountain.
See, we believe ski stories should be about skiing. Or riding. Or at least crashing.
But never about traffic. | www.kirkwood.com

KIRKWOOD
R A R E E A R T H

THE FINAL PRINT AD FOR KIRKWOOD AS IT RAN IN MAGAZINES, ON BILLBOARDS, AND WRAPPED AROUND BUSES

a rock climb or knowing about safe snow travel in the mountains.

Even for commercial photography projects, you're still making a ton of decisions creatively, as well as decisions about safety—all while exerting yourself physically. It's what makes this job so rewarding.

In terms of gear I bring on ski shoots, whether I'm in bounds or in the backcountry, I always take a shovel, a probe, and an avalanche transceiver. I also make sure that the athletes I'm skiing with do the same. If I get buried, I want the people I'm with to be able to find me. Likewise, I know that I'm responsible for locating and digging out my partners if they get caught in a slide.

I also bring walkie-talkies, so that I can communicate with skiers from a distance. Knowing how to communicate in short descriptive phrases is incredibly helpful, too. I describe exactly the kinds of turns I want to see,

as well as details like whether I want them to go skier's right, skier's left, or around that tall pine tree 50 feet above where I'm standing.

I prefer to use a rear-loading backpack for my camera equipment. Once I find a position I'm psyched to shoot from, I'll spend a few minutes tamping down the snow to create a platform on which I can set my pack and open the rear back panel to easily access all my gear.

After I select a camera body and lens, before I do anything else, I always make sure to *close my pack!* Getting snow on your camera gear will cost you precious minutes of trying to clean and dry your equipment.

A related tip is that as the skier makes turns toward me, I'll shoot right up until the very last second, when I'm about to get sprayed by a blast of snow. Then, I'll quickly turn and tuck my camera into my arms to avoid getting the lens wet.

OK, back to the real story about Ryan's infamous gardening glove. A few days after I took this photo, Ryan was back at Kirkwood with another photographer, Greg von Doersten, a fantastic shooter, a veteran skier, and also one of my Aurora Photos colleagues. On this day, Ryan and Greg ducked under the gates to shoot out of bounds.

It was a windy day, and this part of the mountain was wind-loaded with fresh snow.

Ryan was sitting on a rock, gloves off, eating a Clif Bar and waiting for Greg to give him the signal. The wind picked up Ryan's cheap leather glove and sent it sliding down the slope. Ryan snapped into his skis and went to retrieve the glove. However, on his first turn, he triggered an avalanche that ended up burying him.

Fortunately, Greg saw the slide take place and was quick and skilled enough to dig Ryan out and save his life.

It's fascinating to me how this picture, with this gardening glove, means so many things. It's a reminder of how serious commercial photography can be—that even the tiniest details matter.

But then I think about how Ryan almost died chasing that stupid glove, and I'm also reminded about what's really important in life. I'm reminded that mountains are serious places, and adventure photography—as fun as it is—can turn deadly in the blink of an eye. Getting the shot should never come at the expense of anyone's personal safety.

Fortunately, this time, things turned out well.

Ryan survived, but he never found his glove, which was lost under tons of snow. I must say, though, I wasn't sad to see that glove disappear.

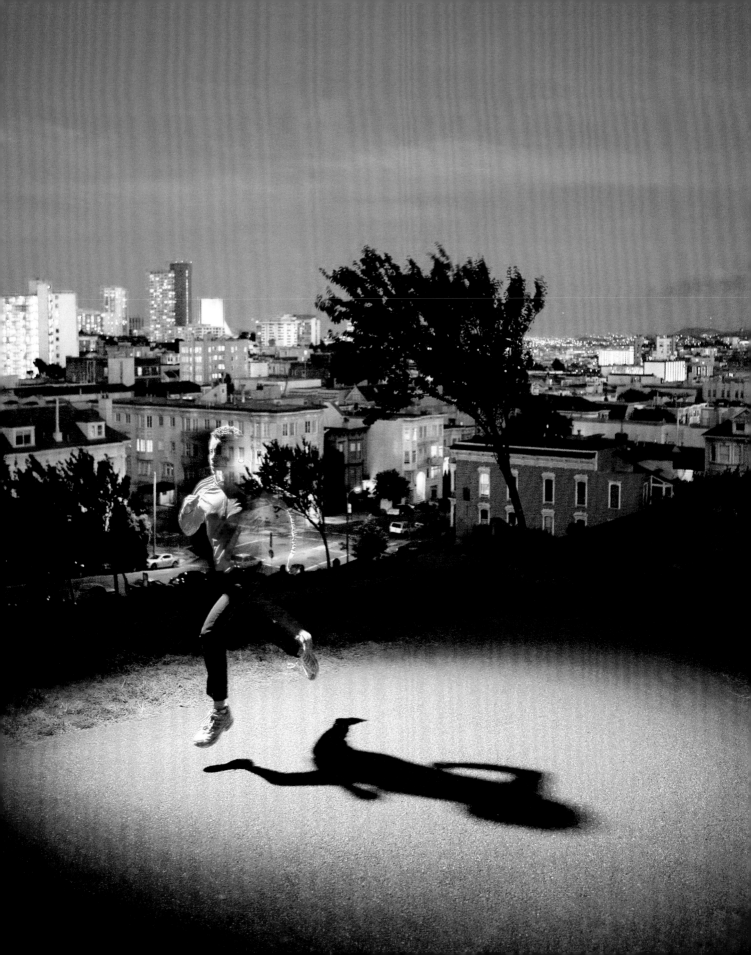

20

SOMETHING OUT OF NOTHING

AS A KID, I ATE breakfast with the smell of sawdust wafting into our kitchen. My father, Dave Rich, was an avid woodworker who carved bowls and built furniture out of whatever log stumps, wood scraps, and lumber he had on hand.

My dad grew up in Brooklyn and earned a master's degree in art from New York University. After graduation, he served in the Marines. Then he went out to Los Angeles, because his brother had moved there to work as a doctor at UCLA's medical center.

One day, my uncle set up a blind date for my father with Ruth Kotlen, one of the nurses at the hospital, who was originally from Pawtucket, Rhode Island.

They quickly fell in love, got married, and subsequently moved to the Mojave desert to fulfill my dad's dream of becoming a rancher. They bought a few acres of land and started raising cows, horses, and sheep.

Within a few years, my parents were also raising me and my brother, Scott—and we grew up in a house on that ranch.

As my dad tells it, "Your mother couldn't resist a New York cowboy." What he saw in my mom, meanwhile, was a person who was caring, kind, selfless, and devoted—you couldn't imagine anyone more perfectly suited to become a nurse.

My dad went on to become an assistant superintendent for the Antelope Valley Union High School District, a job he worked for many years as he and Mom raised me and my brother. But on the weekends, he exercised the artistic part of his brain in his garage woodshop.

I remember being fascinated as I watched him make something out of nothing. The wood began as an ugly block or gnarly tree trunk. Then Dad would throw the chunk of wood on the lathe and carve it into something beautiful and useful.

Some of my work as a professional photographer and filmmaker involves shooting a very specific assignment that has been given to me. Sometimes, the client provides a sketch of the idea, and my job is to go out and create it. Just as often, however, there is no description or sketch. There might only be a vague concept. And the reason I'm being hired in that situation, essentially, is to do what my father would do with wood: create something out of nothing.

It's a skill, if not an art form, that I've found to be pretty useful in this career—sometimes in the most unusual situations.

I was in a park in San Francisco, shooting lifestyle and running photos for Road Runner Sports, one of my long-time clients. The company had an extensive shot list, and my job was to try to acquire all the different shots that day. The schedule was aggressive. We had mapped out twenty to twenty-five scenarios, and planned to get half in the morning and half in the afternoon.

By midafternoon, however, it was starting to feel like we had shot this particular park to death. We'd run out of ideas, but we still had product that we needed to shoot. Further, there was still a bit of daylight left, and when you have marketing and creative directors standing around watching you, there's no excuse for throwing in the towel early, not to mention the fact that it makes you look lazy and uncreative.

As tired as my team and I were, we huddled up and brainstormed. This was an end-of-game Hail Mary kind of situation. The sun was twenty minutes from setting. There were no lights in the park. What were we going to do?

When it comes to assembling the right team for any project, I'm a firm believer that you want people who are more talented, smarter, better-looking, and more charismatic than you.

It's in these do-or-die situations where those attributes pay off.

THE REASON I'M BEING HIRED IN THAT SITUATION, ESSENTIALLY, IS TO DO WHAT MY FATHER WOULD DO WITH WOOD: CREATE SOMETHING OUT OF NOTHING.

My college housemate and longtime friend John Lee was working as my assistant on this day. John (who is now a successful shooter) said: "What if we used a strobe to mimic a streetlamp?"

It was a long shot. I foresaw so many problems to this working out. But it was an idea, and at that moment, it's all we had.

"OK," I said. "You get the strobe and the tallest light stand we have. I'll get some gaff tape and gel. Let's go!"

We hustled around, racing the setting sun. We set up the strobe so that it was pointing down from the top of our 12-foot stand. We started experimenting, having our running model jog back and forth underneath the light.

But the pool of light cast by the strobe didn't look like it came from a streetlamp. So we began shaping it with gaff tape so that it was circular. Then we taped gel over the speedlight to give it the dramatic halogen-orange glow of a streetlamp you might find in a city park in the late evening.

And somehow, from nothing, this photograph began to evolve and take shape—just like my father's woodworking projects. This mock streetlamp situation was beginning to become a damn fine photograph.

By now, the sun had set, and we were shooting during the narrow window when the ambient light in the sky was balanced with the exposure of the city lights just starting to come on in the background. This vantage, atop a hill in the park, wasn't compelling in midday. But at night, you could see the cityscape and its skyline.

I opted for a slow, $1/15$ shutter speed, and used a rear-curtain sync to fire the strobe. In other words, I set the strobe so it didn't fire until the end of the $1/15$ exposure. This froze the runner at the most forward moment and created the blur trailing behind her.

MOM, DAD, SCOTT (FRONT), AND ME CAMPING SOMEWHERE IN THE SIERRA NEVADA (PHOTO FROM RICH FAMILY ARCHIVE)

One thing I've learned about photography is that it's very easy to give up, especially when it's the end of the day and you've been shooting for hours and your brain is fried. But I've also discovered that these moments often lend themselves to surprising bursts of creativity. Even more important, it's about having the right team, because coming up with new ideas when the chips are down is hard, if not impossible, to do by yourself.

There were so many ways we could have used the strobe, but the idea to make it a streetlamp, and the process of making that "streetlamp" look believable, was where this commercial photography shoot became an artistic endeavor.

And that's what it's all about: getting into situations in which you find yourself having to make something out of nothing. That's when you might surprise yourself the most.

As my career went forward and I went from being strictly a still photographer to a filmmaker and a director,

> WHEN IT COMES TO ASSEMBLING THE RIGHT TEAM FOR ANY PROJECT, I'M A FIRM BELIEVER THAT YOU WANT PEOPLE WHO ARE MORE TALENTED, SMARTER, BETTER-LOOKING, AND MORE CHARISMATIC THAN YOU.

these lessons became exponentially more important, especially while working at set locations with even larger teams that had many more moving parts. In these situations, it's also as much about giving as it is receiving—lessons I learned from my mom, who is one of the most selfless, kind creatures I've ever met.

But more on that later ...

21

BECKEY

ONE OF THE MOST COVETED places in the world for a climber's name to end up isn't in the summit registry of some remote desert tower or in the latest *American Alpine Journal*. Rather, it's in the late Fred Beckey's "Rolodex." I use quotation marks because this Rolodex was actually just a bunch of large cardboard scraps that Fred kept in the trunk of his car. The scraps were organized by geographic location, and each one contained a dozen or so hand-scribbled names and phone numbers of vetted climbing partners in those regions.

If you found your name on that list, you could expect to receive an out-of-the-blue call from Fred, probably from a pay phone, as he rolled through town looking for someone to climb with and, secondarily, looking for a couch to crash on.

One day many years ago, my phone rang. A gruff, commanding voice said: "Corey! It's Beckey. I'm coming to Tahoe. And I've got some climbs I want to do. You in?"

Fred Beckey—who always called himself Beckey—was perhaps the most accomplished mountaineer to have ever lived. He wasn't known for climbing the highest or even the hardest mountains—but instead for being the first person to stand atop more mountains, of all difficulties and elevations, than anyone else.

I never met anyone so committed to the culture, craft, and art of climbing and exploration. That passion stretches all the way back to when Fred was a teenager and began exploring the Cascades outside his home in Seattle, Washington.

What Fred seemed to have in excess was an inexhaustible passion for being outside and climbing every single day. He was living proof that there's no such thing as being too old to climb.

For his eighty-fifth birthday, there was a large celebration in Seattle, held at the headquarters of The Mountaineers, a nonprofit devoted to the outdoors. More than two hundred people, including me and my wife, Marina, showed up, dressed in nice pants, shirts, and shoes. Fred showed up with a pair of climbing shoes and a chalk bag, hoping to get some toproping in on the wall at the facility where the party was being held.

Fred may have been a climbing legend, but his unique, quirky personality contributed as much to his storied stature as the mountains he climbed.

When you went out to dinner with Fred, you would talk about one of two things: climbing or girls. He had a reputation for being quite the ladies' man.

But he was also the quintessential dirtbag, having probably spent more nights sleeping outside than inside.

There's a classic story of Fred rolling into Tahoe and making plans to crash at the home of our mutual friend "Tahoe Todd" Offenbacher—the founder of the Tahoe Adventure Film Festival; a pillar of the community; and one of my best friends. Fred would often endure twelve-hour pushes straight from Seattle to California when climbing conditions were good, frequently arriving in the middle of the night. As a rule, he was always very respectful of his hosts' homes.

On this occasion, he reached Todd's house at 2 a.m. Because he didn't want to wake Todd, he just pulled into the driveway, got out of his car, and slept right on the pavement.

The next morning, as neighborhood children were walking to school, they weren't sure what to think of this old man lying fast asleep in Todd's driveway. Later that afternoon, one of the neighborhood kids asked Tara, Todd's wife, "Why do you make your grandpa sleep in the driveway?"

But that was just Fred. After spending so much quality time with him, I realized that the things most people consider conventional were often meaningless to him. He saw the world differently, and it's always pleasant to be around someone like that.

So when Fred called, my answer was always yes.

On this occasion, Fred rolled up to my house—literally. I looked out my front window and saw him parking a brand-new Subaru on a pinecone-covered swath of dirt in my front yard. Why he didn't use the driveway, I do not know. He marched right into the house. No "Hey, Corey. Good to see you!" Again, conventional formalities were meaningless to this guy. Instead, he said the following, which I'll never forget:

"You know, I've been thinking about my slideshows. They need to be funnier! I need to have punch lines! I've been thinking about this, Corey. I've been thinking about it a lot. What do you think if there was a photo of me standing on the side of the road hitchhiking and holding a sign that says something like 'Will Belay for Food.' What do you think, Corey?"

He'd obviously been really thinking about this, probably for the previous twelve hours, when he'd been driving through the night. And the way he described it immediately conjured a very vivid picture in my head. I saw it right away, and it struck me as being quite funny. I pictured Fred standing on the side of the road with his climbing pack, a rope draped across his torso, his helmet on, and a cardboard sign.

I'd called up some friends to let them know that Fred was in town, and by noon, my house was alive with climbers, including Todd Offenbacher, Chris McNamara, Kevin Swift, and Rob Raker, who were drinking beers on the back deck and seizing the opportunity to be around the legend himself.

FRED BECKEY—WHO ALWAYS CALLED HIMSELF BECKEY—WAS PERHAPS THE MOST ACCOMPLISHED MOUNTAINEER TO HAVE EVER LIVED.

Fred, however, wouldn't drop the "Will Belay for Food" photo idea. I had no intention of shooting the photo that day, but Fred was so excited he wouldn't stop talking about it.

Before I knew it, we had all made our way down to Pioneer Trail, a road about a quarter mile from my house. We gave the props to Fred, styling him out with a pack, rope, helmet, and cardboard sign.

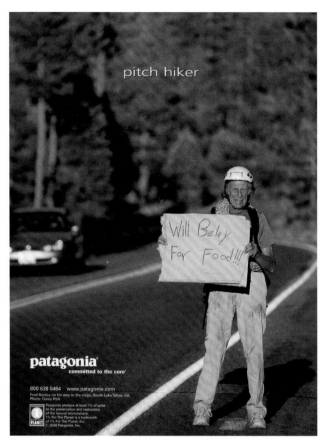

pitch hiker

Will Belay
For Food!!!

patagonia®
committed to the core®

800 638 6464 www.patagonia.com
Fred Beckey on his way to the crags. South Lake Tahoe, CA.
Photo: Corey Rich

Patagonia pledges at least 1% of sales
to the preservation and restoration
of the natural environment.
1% For The Planet is a trademark
of 1% For The Planet, Inc.
© 2004 Patagonia, Inc.

FRED BECKEY'S HILARIOUS IDEA TURNED INTO THIS MEMORABLE PATAGONIA AD.

I started shooting photos, creating the exact picture I'd seen in my head earlier that morning. Meanwhile, Rob, a talented filmmaker, stood behind me shooting video. The whole time, multiple cars kept pulling over to ask if Fred actually needed food or a ride. And Fred absolutely loved it. He explained the whole situation to the drivers by saying, "We're just doing this because it's funny!" Then they'd all zip off, seeming a little confused.

When I took this photo, I didn't really understand at the time just how symbolic it would become. It was published as a Patagonia ad and in numerous other places, and seemed to provoke a positive emotional response in people. Fred set the bar for what it means to be a dedicated climber, and this photo captures what he represented and still represents to the community.

But the real reason this photo works is that it captures who Fred genuinely was. This was his idea from the get-go. He was the creative director in that sense, the architect behind the whole production.

This photo *is* Fred Beckey, through and through.

A couple years later, I got another call from Fred. He'd since gotten a cell phone, which he kept taped to a string that he wore around his neck. As always, he wanted to know if I was around and wanted to climb.

"Hey, you remember that 'Will Belay for Food' photo?" I said. "Did that get the response you were looking for in your slideshows?"

"Yeah, yeah, everyone likes it," he said. "But, Corey, I think I need about five more images like that. I have ideas for them, too!"

At that point, I had to pretend that my cell-phone reception was breaking up, because I wasn't sure if I had that many more shoots in me.

But what's amazing to me was that Fred surely did have fifty more funny ideas that would have made people laugh. And that energy and creative spontaneity somehow seemed to get richer each and every year, right up until his passing, at age ninety-four, in October 2017. What an amazing life he led.

22

MAN VS. BEAR

YEARS AGO, I GOT A call from the Discovery Channel. They asked if I wanted to go to Panama and shoot with Bear Grylls, the star of a television show called *Man vs. Wild*. Going to a Panamanian jungle to do a photo shoot with some guy named Bear sounded cool to me, so I said yes, of course.

As my knowledge about pop culture was nearly nonexistent, I Googled this guy Bear to see what he was all about. Expecting to see photos of a large bearded man, I was instead surprised to discover a rather debonair British guy who might best fit in at a yacht club. I was also interested to see that *Man vs. Wild* was the number one show on the Discovery Channel at the time.

I was not surprised, however, to read the rather typical online banter about the show, calling it staged and claiming that Bear wasn't the real deal.

I left for the shoot having no idea what to expect.

I arrived in Panama City late at night and rendezvoused with the driver who had been hired to take me from the airport to the "hotel," which was actually the barracks of an old US military base situated right on the Panama Canal. It was a jungle-style barracks, with wood walls and a tin roof. My room was spacious and bland, containing nothing but a table, a bed, and a creaky ceiling fan.

I knew that the plan was to leave the next morning and head into the jungle for the shoot. I arrived well after midnight and found a note taped to my bed that read *Wheels up at 5 a.m.!*

I rolled my eyes, crashed onto my cot, and tried to get a few hours of rest.

The alarm went off, and I emerged from my room, bleary-eyed, into a dense, humid fog.

Across the courtyard, a shadowy, well-muscled figure stood under a halogen streetlamp from the 1950s. Was this Bear Grylls?

Hmm. No . . . it's not, I realized as I caught a glimpse of his face. However, this guy did look a lot like Indiana Jones. He had a big floppy hat, jungle fatigues, and a machete lashed to his belt. I walked over toward "Panama Jones" and decided to put my three years of high school Spanish to the test.

"¡Buenos días! . . . Umm . . . *Es un buen día, no? . . . ¿Cómo estás?*"

Panama Jones responded to my elementary Spanish in perfect, flawless English: "I'm good, man. Are you the photographer who just flew in?"

Turned out this guy was our security guard. Not only that, but he used to be on El Presidente Noriega's lead security detail. Well, this was encouraging news. All of this made me feel very, very safe.

Within twenty minutes, the crew arrived. There was Simon Reay, who introduced himself as the director of photography. There was also a director, a story producer, a producer who handled logistics, and a production assistant. There was also a biologist who would follow us around and make sure Bear didn't eat anything poisonous.

Bear arrived shortly thereafter.

As a rule, I don't get starstruck. Maybe it's because all my heroes are climbers who are also friends—and who are all also prototypical down-to-earth dirtbags. Or maybe it's because I don't really give a rip about Hollywood or celebrities. Either way, I decided to treat Bear like I would any other person and just be normal. Just be myself.

I quickly noticed that Bear and his crew were super-close. In fact, Simon was Bear's childhood best friend. The way that they were all joking around with each other showed that they not only liked one another, but also spent an enormous amount of time together.

Except for the director: he was kind of a prick, and no one seemed to like him.

I was the odd man out. The new guy. The freshman pledge, taking his first steps into the lion's den of a fraternity.

As we waited for our cars to arrive to transport us to the jungle, an impromptu pull-up contest took place on a gas or water pipe overhead.

"Let's see how many pull-ups you can do, Mr. Big-Time TV Star!" Simon said, challenging Bear.

"More than you!" Bear fired back.

"Not unless we do multiple takes," the producer said, ribbing Bear, "so you can catch your breath and rest, and then cut all your individual pull-ups together into one seamless clip."

It was on.

Bear went first.

Then Simon.

Then all the producers and the biologist went.

Even Panama Jones put down his machete and gave it a try.

Finally, it was my turn.

OK. I'm not one to brag . . . but in this instance, I just gotta tell it like it is: I completely whipped everybody's asses at pull-ups.

I beat Simon. I beat Panama Jones. I beat the biologist, the director that no one really liked, and all the producers.

And I beat Bear.

With that single impromptu success, I immediately established some street cred with the crew. I was legit. I could hang. Bear and the team welcomed me into their circle.

WITH THAT SINGLE IMPROMPTU
SUCCESS, I IMMEDIATELY
ESTABLISHED SOME STREET
CRED WITH THE CREW. I WAS
LEGIT. I COULD HANG. BEAR
AND THE TEAM WELCOMED ME
INTO THEIR CIRCLE.

The cars came, we hopped in, and my new friends and I headed into the jungle. I felt right at home.

During the ride, I asked Bear questions about his background. And I quickly realized that he isn't the kind of prima donna that you might associate with celebrity. In fact, he struck me as a guy who genuinely loves being outside having adventures. Somehow along the way, he figured out a way to turn this passion into a hit TV show—something that I respect immensely.

That first day was a blast. We were deep in the jungle, filming Bear trying to catch fish by using his shirt as a net. He ate leaves and other disgusting stuff, too—like dead, rotting fish. Sometimes, Simon would ask if Bear could take just one more bite out of the dead fish so he could get another angle. However, I swear that Simon had no intention of filming Bear. He just wanted to watch his buddy suffer through one more gnarly bite.

I laughed. I guess if you're getting paid twenty times what the cameraman is making, maybe you do deserve to eat a rotten fish twice.

Between takes, I would hop in with my camera and go to work shooting storytelling stills. Creating a synergy with the film crew was challenging but necessary. I had to be really quick and use my short windows efficiently. Every now and then, when I saw a shot that I absolutely needed to get, I'd whisper into Simon's ear, "Hey, when you're done, there's a shot here I really need." Then they would stop rolling, and I would do my thing.

Of all the pictures I took that day, the extreme close-up is my favorite, because I realized that when it comes to Bear, we all know only half the story: the one that's bundled up and dramatized for television. Bear might not be the best athlete in the world, but he's pretty darn strong, and, more important, he has a gift

for playing a role on television that conveys a genuine passion for adventure and survival—whether that's braving mosquito onslaughts or eating whatever it is he finds in the jungle.

After Panama, I ended up joining Bear and his crew in several other locations, including Patagonia, Argentina. But it was that first experience in Panama that really opened my eyes on several accounts.

First, I got to see that those internet accusations about Bear not being authentic were false. In fact, on that first night, while the rest of us headed back to our army barracks, Bear spent the night in the jungle, cooking over a fire and staying out in the wilderness.

Second, I learned a lot about video productions. As this trip was prior to the release of the Nikon D90—the first video-enabled DSLR and the camera that changed my life, transitioning me from strictly a still photographer to a director and filmmaker (see Chapter 39)—I saw how small-footprint productions could work. I was learning how a tight group of friends could go into a remote venue and come away with great storytelling content on video. More than anything with Bear, I saw that sometimes you just need to do what you need to do to tell a story, even if that means eating a dead fish twice. That's video production. Call it authentic or dismiss it as staged, what I saw was a group of good friends who were making it happen in a big way.

I learned later that Bear and Simon had filmed their pilot on a crappy handheld camera that recorded to VHS tape. They started from nothing and landed a number one reality show.

We live in a world where anyone who is creative enough, entrepreneurial enough, and talented enough can create a situation in which they get to do what they love and, on top of that, get paid to do it.

Say what you want about Bear Grylls, but don't say that he isn't doing exactly what he loves. Though *Man vs. Wild* ran its course, and Discovery dropped the show in 2012, there's no question in my mind that a guy like Bear will keep reinventing himself and creating new opportunities.

And, Bear, if you're reading this, I hope you're spending your time wisely—by doing pull-ups. I owe you a rematch.

23

SEEING AND SKIING

WHEN I WAS JUST BEGINNING my career, I lived in Sacramento. Opportunities came quickly, my photography career was soon in full swing, and I was traveling all over the place on assignment for various climbing publications.

I had recently gotten out of a relationship, however, and I felt the overarching desire to make a big change in my life. And that's when it hit me: I didn't need to live in Sacramento. In fact—holy cow—I was free to go anywhere I wanted!

I looked at a map. My only real requirements were finding somewhere with a lot of climbing and an airport relatively nearby. I chose Tahoe. I'd been going there almost every weekend to climb on the immaculate Sierra granite. One of my best friends lived there, too. And with only an hour's drive to the Reno airport, I realized that Tahoe was a place I could be happy calling home.

When I was a kid, my parents occasionally took me skiing on Mammoth Mountain. But skiing was never something I was any good at. I was much more interested in climbing, my real outdoor passion. Since I was thirteen, I've always chased dry, sunny rock.

I moved to Tahoe in autumn 2003, during the cool, perfect climbing conditions that fall brings. I was in heaven! But just a couple of short months later, I soon realized that—shit—it snows in Tahoe.

In fact, it snows a lot!

Tahoe, I quickly realized, is much more of a ski town than a climbing town. And if you are an active, outdoorsy person and you live somewhere mountainous where it snows that much, you start skiing almost by default. If you want to stay active

and be outdoors in the winter, there aren't many other options.

After a couple of seasons in Tahoe, however, I really began to love skiing—being active outside all day and then passing the dark, chilly evenings in warm pubs with cold beverages and laughter among friends.

Soon, word got out in our local skiing circles that I was a well-published photographer who was based in Tahoe. Through various connections, I landed a meeting with John Wagnon, the head of marketing for Vail Resorts.

John is a legend in the ski world. His career stretches back decades, and he's held virtually every job there is to have in the sport.

We sat in his office, flipping through my portfolio, and became fast friends. By the end of the meeting, I was offered an opportunity to shoot the ad campaign each year for Heavenly Mountain Resort, the company's flagship resort in the Tahoe basin.

I've always believed that I should say yes to whatever photography job falls in my lap, even if I don't know how to do it, and then figure out how to shoot it later. But for the first time it wasn't a photographic challenge that was giving me pause. It was the skiing.

"You know, I have to tell you this," I said to John. "By no means am I a professional skier."

Being something of a sage, he responded, "This job is not about how well you ski. Of course, you'll figure out how to get yourself into the right locations. We're hiring you because of how you see—not how you ski."

I realized he was right. It was all about getting out there at first light after storms, seeing creative opportunities, and turning those opportunities into compelling photographs—all while working with a small group of talented, fantastic athletes.

In those first few years, everything was fresh and new. I had no problems seeing things in new ways and making great imagery. I was shooting fish in the proverbial barrel.

But eventually, after shooting the same mountain again and again, I found myself having a harder and harder time making original photographs. I'd become much better at skiing, but the "seeing" part of my job felt more difficult than ever.

Five years in, there were no more new locations on Heavenly to photograph. I'd explored every inch of the mountain. It felt like I'd lost that ability to "see" in a new way. I felt stagnant, the way I did back when I was living in Sacramento and knew I needed a big life change.

But moving again wasn't an option, because I was building a life here. I was dating the girl who I knew would one day become my wife. Things were going well.

I realized that sometimes it's easier to run away to a new spot. But will you learn anything new that way? Sometimes, the best way forward is to dig in.

I changed the way I thought about Heavenly. I realized that shooting the ad campaign for the resort each season was not just some rote chore. In fact, it was one of the greatest opportunities I'd ever get as a photographer, a chance to really push my creativity to the next level. What could be more challenging than making something that's essentially static look new, fresh, different, and exciting year after year?

What could be a better skill to cultivate as a photographer?

Energized by this new attitude, I charged into that next season like a big-mountain skier ripping down Heavenly's Killebrew Canyon. I challenged myself to use new lenses, move farther from or closer to the subject, put something in the foreground, try to get a low angle with a long lens.

I even began using a helicopter.

The harder I tried, the more I began to surprise myself. It changed the way I look at creativity.

Travel and adventure inspire a certain kind of creativity that comes easily. But when you're shooting in your own backyard, and you've shot it to death, there's an inconspicuous opportunity to push yourself to see the same old subject matter in thousands of new ways.

24

WHITEWATER DYNASTY

AS A RULE, "WINGING IT" isn't my preferred methodology when it comes to securing a new project, but being able to improvise on the spot during a pitch or a meeting has ended up being a really important skill to have in this career.

I sat at a table in a restaurant in San Francisco across from Sarah Malarkey, an editor at Chronicle Books. Sarah was familiar with my work because she has a passion for climbing, surfing, and the outdoors in general. For months, we had exchanged emails about me one day visiting and showing her my portfolio, but I had been traveling and shooting nonstop. Finally, I had the time to do a face-to-face.

Over a couple of salads, I opened up my portfolio. We started swapping stories from the field, and the meeting felt more like two old buddies getting together than a business discussion.

Sarah asked if I would ever consider doing a book. I said I would when the time was right, but I explained that I was probably not yet ready. She pushed and asked if I had any ideas. I thought I had a couple of decent ones. I wound up and gave my two best pitches.

No response. Crickets.

Sensing that I was about to strike out, I threw out an idea that I had barely begun thinking about. I had no idea how she'd respond to this idea—she might laugh me right out of the restaurant, for all I knew. But at this point, it was all I could think to say.

"What about doing something around the idea of 'playgrounds'?" I said.

"Go on," she said.

Now just improvising, I pitched her on a project in which I would find a dozen or so of the most prolific adventure athletes and get them to take me on tours of their backyard "playgrounds"—the places where they first fell in love with their chosen sport.

As I continued talking, I noted that Sarah was nodding her head, and her expression had changed. "Yeah, yeah. Tell me more," she said enthusiastically.

Encouraged, I kept elaborating, making stuff up on the spot and hoping that Sarah wouldn't see through my pitch as the riff that it actually was.

By the time the check had arrived, Sarah said, "Let's do it. Let's do the book!"

I got back into my old Subaru wagon, and very quickly the sobering reality of now having to shoot an entire book set in.

I made a list of sports stars in the various adventure/outdoor genres, from climbing to kayaking to BASE jumping, and decided to start cold-calling people to see if they would even be interested in agreeing to a project like this.

"I really wish I had thought this through a little more," I muttered to myself.

The first person I called was Eric Jackson, or EJ, as he's commonly known. EJ is probably the most celebrated whitewater kayaker of all time. To my surprise, I barely made it halfway through the description of the project before EJ interrupted me with "Yes! Count us in!"

We talked logistics: dates for the shoot and places for me to stay. EJ said that he lived near Rock Island State Park, Tennessee, and that his house was close to the river but not near anything else. He said I should definitely stay with him.

"Are you sure?" I asked. "I don't mind staying in a hotel and driving up each day. Are you positive you have room for me?"

"Absolutely," EJ said. "Plenty of room!"

I arrived at the Jackson homestead—a double-wide trailer where EJ, his wife, Kristine, and their two children, Emily, thirteen, and Dane, ten, were living while they saved money to build their dream home. EJ came out and greeted me with a bone-crushing handshake and then introduced me to the family. No sooner had we said hello than EJ turned to his kids and said, "You're

DANE JACKSON, ERIC JACKSON, AND EMILY JACKSON, WITH THEIR DOG IN TOW

out of your bedroom for the next week while Corey is here."

The patriarch had spoken. I had the sense that his commanding presence was one of EJ's assets as a kayaker, father, and CEO of Jackson Kayak, one of the biggest kayak manufacturers in the world. He struck me as a guy who always knows what he wants and wastes no time getting it done.

I'd also soon come to discover EJ's "softer" side. Beneath that commanding exterior, he reminded me of a big kid who doesn't hold back when it comes to having fun.

At 6 a.m. the next day, we headed to the river. It quickly became apparent that both Emily and Dane were, like their father, world-class kayakers. After all, these kids had been Eric Jackson's paddle partners from day one. EJ told me that he had Dane paddling before he could even walk, and I believed it.

Emily and Dane were very insistent that I get in a kayak and be on the river with them. They, as well as EJ, wanted to make sure that I experienced everything they love about their sport.

Being around this contagious enthusiasm, I was reminded of myself when I was around the kids' ages. I thought back to when I was thirteen and first discovered rock climbing and photography, and realized that Emily

> AND ISN'T THAT WHAT IT'S ALL ABOUT? SHARING SOMETHING POSITIVE, AND POTENTIALLY LIFE-ALTERING, WITH THE PEOPLE AROUND YOU—AND, IF YOU'RE LUCKY, WITH THE WORLD AT LARGE?

and Dane's eagerness to see me in the kayak came from this very selfless, genuine basic desire to share their passion, to help everyone feel what they are feeling.

And isn't that what it's all about? Sharing something positive, and potentially life-altering, with the people around you—and, if you're lucky, with the world at large? This is precisely one of the things that drives me as an adventurer and a photographer.

I shot all the usual pictures: the Jacksons kayaking together, walking to the river, dropping over waterfalls, loading their gear into their car, hanging out near the fire, etc. But somehow, EJ came up with this idea to shoot a family portrait in which he and Kristine would be driving while the kids would be in their kayaks strapped to the car's roof.

It seemed slightly crazy to me at first, but the entire Jackson clan was completely gung-ho.

"If you guys are comfortable with it, sure, why not?" I said.

This image came together over a number of passes. At first, Eric drove very slowly—10 miles per hour—down the road near his house. But there wasn't enough dust at that speed to give the image the requisite energy. In the second pass, the composition was wrong. For the third pass, I realized I had the wrong lens. Finally, by the fourth pass, Eric felt comfortable enough to drive with both hands off the steering wheel (though we scrapped that idea, thinking it might come off as too reckless and decided to go with just one hand out the window). He knew the line his car would take. And the kids were comfortable atop the roof. Everyone knew what to do with their hands, and we finally landed on this image.

Photography has the power to inspire people, but also to divide people. An image that evokes strong emotions—not a single consensus emotion—presents us with an opportunity to see where we fall on the emotional spectrum—something like a Rorschach test.

ERIC, DANE, AND EMILY SURFING THEIR LOCAL WAVE NEAR THEIR HOME IN ROCK ISLAND, TENNESSEE

MYFAVORITEPLACE

{ great athletes in the great outdoors }

BY **JASON PAUR**

PHOTOGRAPHS BY **COREY RICH**

MY FIRST BOOK LED TO DOZENS OF FRIENDSHIPS WITH SOME OF THE WORLD'S
GREATEST ADVENTURE ATHLETES THAT HAVE CONTINUED TO THIS DAY.

This is probably one of my favorite portfolio pictures, not just because of my affection and admiration for the Jackson family, who have become close friends; it's also because I've enjoyed seeing the mixed reaction people have.

Most people see this shot and have a positive reaction: "That's awesome! These guys are living the dream!"

Then there's the 20 percent minority who see this shot and go to the other side of the spectrum: "That guy's a moron! He's taking a stupid risk with his family, and he's completely out of touch with reality."

Of course, there was nothing truly reckless in the creation of this image. Things were under control, and this picture, taken on a desolate road, is probably a whole lot safer than some of the rapids the Jacksons regularly kayak. They're risk-takers at heart, and they lead lives that aren't in any way conservative or "normal" or safe. This is a family portrait that does justice to who they are and pays respect to their commitment to living originally.

As anyone familiar with the kayaking world knows, Emily and Dane have gone on to become two of the best competitive freestyle kayakers in the world. I can't speak highly enough about the entire family; they're great people with a verve for living life to the fullest.

What I learned is that this kind of spirit doesn't just come out of nowhere. It all begins on a playground.

25

THE RIVER WILD

AS I SAT HELPLESS IN my inflatable kayak, the current carried me swiftly toward an enormous grizzly bear standing in Chilikadrotna River. The regal beast had to weigh at least five hundred pounds and stood 10 feet tall on his hind legs.

"Bear! Bear! Bear!" my friend Dan yelled behind me. "Fucking backpaddle, Corey! Backpaddle, man! Backpaddle!"

Right or left? I didn't know which way. I was frozen by fear and indecision, two attributes that don't get you very far in wild, grizzly-infested habitats in Alaska. The river pushed me faster and faster toward the animal's jaws and claws, which seemed likely to result in the end of me.

As someone who regularly logs 250 days of travel on assignment per calendar year, one of the foremost questions I get asked is which locations are on my must-visit list.

My first reaction, without hesitation, is my home: Lake Tahoe.

Alaska, however, is a close second. It's amazing that Alaska is even part of the United States. It is one of the few remaining places on Earth that allows you the opportunity to go back 150 years in time to experience untamed nature on its most primal level.

I had the opportunity to team up with my buddy, the great magazine writer and book author Dan Duane, for an assignment for *Men's Journal*. The story we were working on was an exposé about a proposed gold and copper mine right at the edge of Lake Clark National Park and Preserve. The site was alleged to hold a half trillion dollars' worth of precious metals, one of the biggest strikes in the

last century. Extracting them, however, would require constructing, on land adjacent to the national park, one of the largest open-pit mines in North America, along with huge dams to hold back 10 square miles of chemical waste. The mine's proximity to a stunning protected wilderness had created an incredibly charged environmental controversy.

Lake Clark is also important because it's one of the largest natural spawning areas for salmon. The lake and its network of rivers don't just provide us humans with our daily dose of proteins and omegas in the form of delicious sockeye, they are also vital to the local ecology.

Our story was two-pronged, in that we would be covering the controversy as well as spending five days floating down the Chilikadrotna River with a few Alaskans, including a biologist who is one of the most prominent fisheries scientists in the state. It was to be a combo environmental/adventure story with a great team, which also included Dan Oberlatz, owner of Alaska Alpine Adventures, a backcountry guide service.

Dan Oberlatz was our gracious host. His love for this region was infectious, and he was here to show us what we all stood to lose should the mine, called Pebble Mine, go forward.

He has a great personal story. He lived in Lake Tahoe, coincidentally, for many years as a ski bum and climber. But he transplanted north after his first taste of Alaska. One season there and he was hooked. He fell in love with the mountains, got married, had kids, and created for himself a business and lifestyle that let him call this supreme wilderness his backyard.

Being such an unpopulated, undeveloped state, Alaska can be tough to travel in. The reality is that with so few roads, Alaskans will often fly little Cessnas from home to work the way we, down in the Lower 48, might commute by car. Whether you're landing on a river, lake, dirt landing strip, or glacier, the Alaskan commute is one to be envied.

Though Dan Duane and I might not consider ourselves city slickers (even though Dan lives in San Francisco), traveling to Alaska from California required adjusting to a new lifestyle. It took days for us just to reach the headwaters of the Chilikadrotna.

By the time we were on the river, I think we were both feeling quite antsy. After all, we are used to our routines

BEAR COUNTRY . . .

Why was it important for us to cover this story by way of boating down the Chilikadrotna River? We could have just as easily chartered a helicopter and viewed the wilderness and the proposed mining site from a safe distance, in the air. It would've been easier—not to mention gotten us back to our routines back home in California more quickly.

The obvious answer, of course, is that you need to be close to nature, immersing yourself in the medium, to experience it fully. It's an old Edward Abbey philosophy: when you're sweating, there's dirt on your face and bee stings on your arms, and your heart is beating like a drum, those are the moments when you actually appreciate the place you're in.

As of this writing, the Pebble Mine is still a hotly debated proposal. But what I learned on this trip is that the guy who goes to a beautiful place like Alaska and immerses himself in that reality (say, by nearly ramming his boat into a grizzly) is going to have a much different appreciation for the place than the guy behind a desk, who might see more value in something concrete that you can put a dollar sign on than in something as abstract as wilderness, something that can only partially be captured on paper and through photos.

My advice? Get as close to these kinds of environments as you can. And bring your camera, too. The images you capture will naturally lead to greater appreciation for and engagement with these rare, wild places, helping us conserve them now and into the future.

DAN OBERLATZ LOADING UP ON A LITTLE BIT OF SECURITY

back home: healthy eating, going to the gym, riding mountain bikes, working out—all on a tight schedule, too.

Once on the river, we paddled like we were trying to achieve a new personal record in a CrossFit class. And it was within those first few overly energetic hours that I found myself about to ram my kayak into a five-hundred-pound grizzly.

"Paddle, for God's sake! Paddle!" Dan screamed behind me.

Finally, I shook off my fear, picked a direction, and backpaddled upriver as hard as I could. There was no way to get around the bear, and I lacked the skills needed to make an evasive maneuver.

Fortunately, the bear had probably never seen humans before and was twice as scared of me as I was of it. The bear darted out of the river and scampered into the tall grass. It was fast, too! Watching an animal of that size move with such speed was horrifying.

From that point on, Dan Duane and I vowed to stay right beside Dan Oberlatz, who kept a loaded .44 Magnum secured on a hip holster for this exact reason.

26

MOTION IN MALLORCA

IT'S NO COINCIDENCE THAT THE popularity of deep-water soloing in Mallorca, Spain, rose alongside the explosion of video technology—and that includes everything from distribution to advances in cameras, computers, and software.

Prior to 2001, few climbers had heard of deep-water soloing, which is climbing ropeless up sea cliffs about 60 feet tall with nothing but the water to absorb your impact when you fall. Even fewer were actually doing it. All that changed, however, with the advent of video and the internet.

In 2001, my friends Brett and Josh Lowell, the climbing-film pioneers, released a short film on the internet called *Psicobloc*. This is Mallorcan climber slang for deep-water soloing, literally translating to "psycho bouldering." Their film featured the European climbers Klem Loskot and Tim Emmett high above a wave-walloping ocean, and instantly sparked many imaginations in the climbing world—including Chris Sharma's.

When Chris, the Santa Cruz–born legend who is considered one of the best rock climbers of all time, visited Mallorca in 2003, it was precisely because he had seen the Lowell brothers' film. And when he tried the sport, he was instantly hooked. In fact, he changed the direction of his life and dedicated the next few years to living in Mallorca, learning Spanish, and playing on the island's sea-cliff faces and grottos. In 2006, he started getting close to completing his hardest deep-water solo yet: *Es Pontas*, a 5.15a that climbs the steep underside of a magnificent sea arch adjacent to the island's coast.

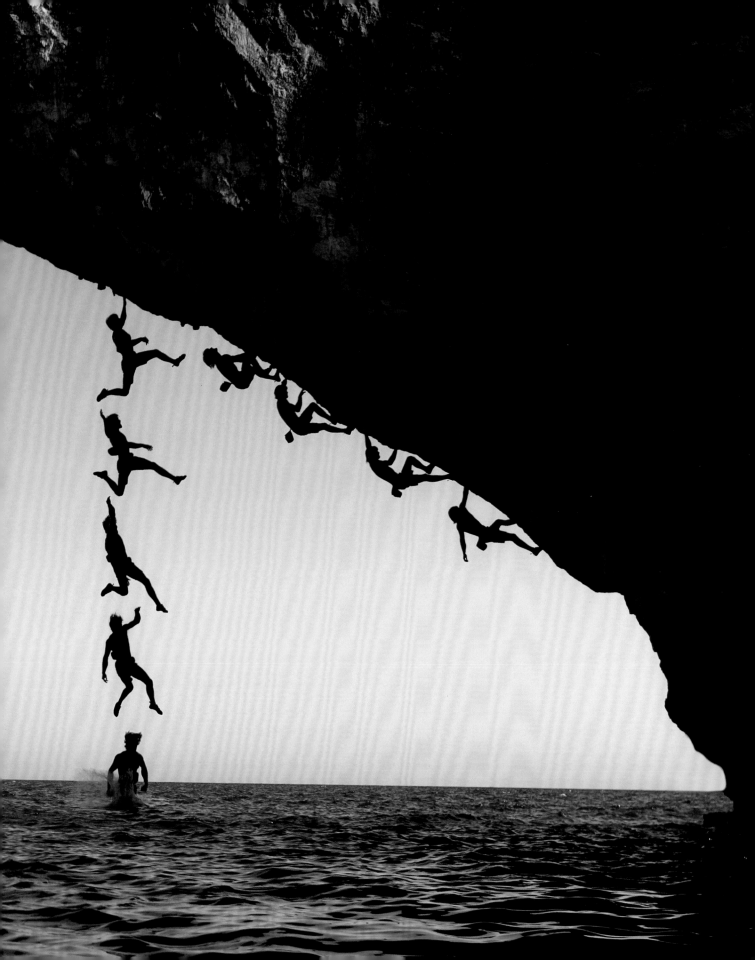

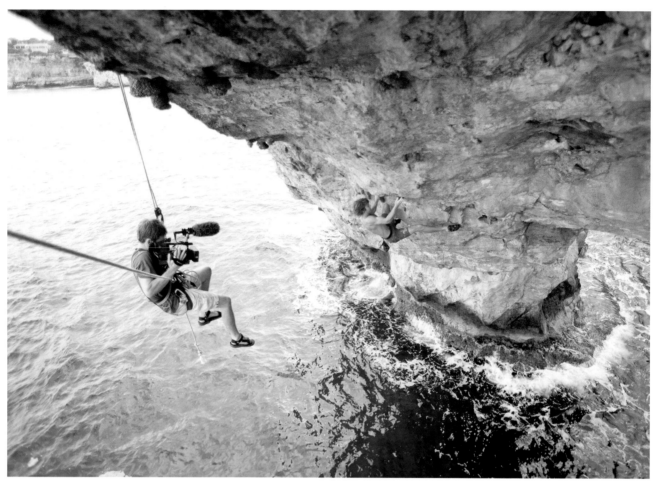

JOSH LOWELL TENSIONING DOWN INTO POSITION TO SHOOT CHRIS SHARMA WORKING ON HIS DEEP-WATER-SOLOING MASTERPIECE *ES PONTAS* (5.15A)

That same year, I traveled to Mallorca to shoot stills of Chris. I joined Brett and Josh, and Pete Mortimer of Sender Films, who were working on a documentary about him, called *King Lines*.

Es Pontas was very much a "king line."

At the time, I didn't really understand the impact the trip would have on my career. And in fact, it wasn't until just recently that I looked at this old composite picture and started reflecting on the progression of my career. I realized what this picture represents, both for me and my career—but also, in a tangential way, for the filmmaking and photography industries.

Brett, Josh, and Pete were shooting with HD cameras, and high-definition video was cutting-edge technology at the time. Today, of course, any camera phone will shoot higher-def video than what Brett, Josh, and Pete had to work with in 2006. Still, what they were logging looked fantastic.

The four of us would often be shooting shoulder to shoulder as Chris put in his burns, trying to stick a huge dynamic jump to a slippery, wet hold 30 feet above the ocean. He tried that move a hundred times, falling again and again into the water.

I was getting great stills. But what Brett, Josh, and Pete were capturing blew me away.

I think part of me wanted, in my own way as a still photographer, to find a way to show the incredible action that was unfolding. So much of the drama and tension of deep-water soloing hinges on whether or not the climber takes that big, scary plunge into the water. The three filmmakers I was with could easily show that reality within a few seconds of footage.

IT WAS AS IF I'D BEEN WRITING POETRY—BUT MAYBE NOW I WANTED TO TRY WRITING A NOVEL.

But how could I tell this story in just a single frame?

This photo was my solution. A lot of people have asked me if this photo was done "in camera." The answer is, emphatically, no. It was not possible to make an image like this in camera at that time.

I set up my camera on a tripod as low to the water as possible (the camera got wet, of course). I shot one master-plate image of the arch itself without Chris in it. Then, when he started climbing, I fired a burst of images.

Over the last ten years a lot has changed, and we creatives are more dependent on postproduction than ever before. When you want to make your files look good, manipulating those files is a mandatory part of the job. Of course, it all begins with your creativity out in the field and capturing that idea in camera—but at the end of the day, you are not finished until you edit your files with professional software.

I edited down my burst sequence of Chris falling to the images I liked best. Then, using Adobe Photoshop, I cut out everything but Chris himself. Then I overlaid these images on top of the master-plate image of the arch. Voilà!

The result is one of my earliest attempts to shoot "motion" through still photography.

This trip was, in some senses, a milestone for me—the place where a seed was planted. While I will always love the ability to show what happens in a thousandth of a second and tell a complete story in a single frame, in Mallorca I first started to understand the power of moving pictures combined with sound and sequencing.

It was as if I'd been writing poetry—but maybe now I wanted to try writing a novel.

Within a few years, I'd completely tip the balance from still photography to motion. The real catalyst for me would be a technological one: the release of the Nikon D90, the first DSLR camera that could record video, in 2008. When I got my hands on that camera, there was no looking back.

These days, Mallorca is bustling with climbers who have been inspired by the last decade of videos to come out of the island, and who then travel from all over the world to experience the freedom and thrill of deep-water soloing. The sport wouldn't be where it is without media. And likewise, I wouldn't be where I am without companies like Adobe, Apple, and Nikon that have empowered me, and many other visual artists, to make that leap from telling stories with still to telling stories with motion.

27

THE LOST COAST

THE DRIFTWOOD BONFIRE CRACKLED and ripped. We stirred our pot of fresh-caught mussels in oil and some wild onions that we'd found in the hills, feeling like we were the only humans on Earth. No one else was here, not for miles and miles. It was just us, humbled yet galvanized by this isolated beach wilderness called the Lost Coast.

Some years ago, I teamed up with the brilliant wordsmith Dan Duane to put together a story about a "secret" surf spot for *National Geographic Adventure* magazine. The Lost Coast, an 80-mile stretch of wilderness in Northern California, is extremely inaccessible. Rugged roads only took us so far before we had to abandon our vehicle and start walking: 10 miles through mountainous terrain abutting a beach and across long stretches of undulating dunes and freshwater streams. I was repeatedly flung like a rag doll into the sand as the wind whipped off the water.

The promise of a landscape containing black beaches, eroded sandstone cliff bands, lush greenery, and inky ocean waters curling frothy and white as they battered the coastline sounded like an amazing opportunity for me to capture some fantastic storytelling imagery of a rare and beautiful place. However, in the editorial world, it takes at least two people to pull off a story.

A photographer needs a writer, and vice versa.

When you hit it off with a writer, you become a team. It's a real relationship. You're constantly on the phone, brainstorming with each other, debating which magazine is right for the pitch. I found that relationship in Dan Duane.

Dan is a passionate climber and surfer, and has an incredible family. His father was both a climber and the attorney for world-renowned nature photographer Galen Rowell; his mother, a publisher. His daughter Kelly is an award-winning filmmaker. His wife, Liz Weil, is also a successful journalist and author.

Dan is a very intelligent writer, who went from writing about climbing and surfing to writing about food and wine. He has been a frequent contributor to *Men's Journal*, *Outside*, *Food & Wine*, and *Bon Appétit*, and he's the author of such classic books as *Caught Inside* and *How to Cook Like a Man*, among others.

What I realized early on was that teaming up with writers who had similar interests, personalities, desire to travel, and high tolerance for the unknown made for the most memorable experiences.

Dan took this story about the Lost Coast as an opportunity to discuss the (overly) protective "locals only" attitude that a few surfers had toward the area's breaks. Surfers, perhaps more than any other group in adventure sports, are extremely territorial about their secret spots.

In his *Nat Geo Adventure* article "Surfing the Perfect Break on California's Lost Coast," Dan wrote: "Before we set out, I made a promise to several good surf buddies—all of them furious that I wanted to write about the secret wilderness surf break that lay somewhere out here, and all of them unwilling to come along—that I wouldn't give away the wave's precise name or location. They didn't buy it; a true surfer, they said, simply never writes about certain breaks."

In my experience, I've found that most people have no problem sharing word-of-mouth information about some "secret" crag or wave with their friends, who then tell their friends and so on.

However, as soon as someone catches wind that a photo or article about their "secret" spot might appear in a magazine, all hell breaks loose.

Some questions must be considered: Are these fears rooted in some actual access issue, or are they just irrational xenophobia? Is the story worth it? And will the potential inspiration outweigh the potential backlash and ire?

SURFING ON THE LOST COAST IS JUST AS WILD TODAY AS IT WAS WHEN WE WERE THERE MANY YEARS AGO.

All photographers, writers, and editors deal with these questions from time to time, especially when it comes to creating and publishing destination features.

After Dan's article was published, he, predictably, received a rash of letters, including one death threat, from irate surfers.

One thing I've discovered is that most of the time, those initial fears ultimately reveal themselves to be completely silly. One article has never ruined an area, and in fact, often the opposite is true. Many times, introducing people to an area, and inviting them to experience it for themselves, engages them and energizes them to protect it and care for it, even once they return home.

Surfing on the Lost Coast is just as wild today as it was when we were there many years ago. No wonder. Any place that requires a 10-mile hike across sand will never be overrun, simply because most people prefer the easier roadside experience.

Still, it invites the question: What's the point of even documenting it in the first place?

That's tough to truly answer, but I believe that no one "owns" knowledge, that all information, especially knowledge that serves to enrich our lives, ought to be shared.

Also, any inspiring feature serves only as a starting point. You can read it, talk about it, and even make plans. But then you still need to go out and discover it in person—and that could mean surfing at the Lost Coast or going out and finding your own secret spot. A place where you can sit around a campfire with good friends and feel like you and your buddies are the only people in the world . . . and forget, for a moment, that you're not.

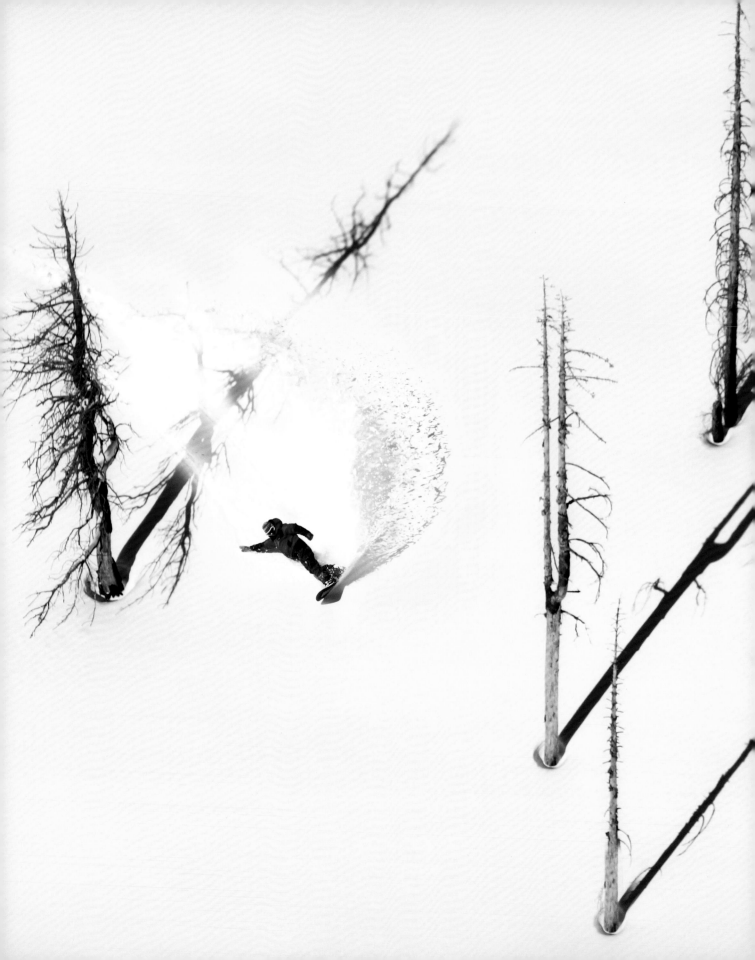

28

LINES IN THE SAND (AND SNOW)

EVER SINCE ADOBE PHOTOSHOP 1.0 came to market in 1990—and to a lesser extent, before then as well—photographers have struggled to find their footing on the slippery slope that is editing, processing, and altering their pictures. We make these changes not only to improve image quality but sometimes also to compensate for shortcomings experienced in the field.

Now that most people shoot and edit their photos with their smartphones, manipulating pictures has never been easier or more prevalent. Subsequently, it seems as though our values as professional photographers are also being pushed and tested alongside the speed with which new photo technology, equipment, and software emerge.

Are photo ethics all just lines in the sand? Where does one draw the line between photojournalism and creative license? These are nuanced, complicated questions. But for me, the discussion comes down to two timeless principles: full disclosure and integrity.

This is a composite photograph of Mikey Wier, a fly-fishing guide from Tahoe, carving a turn at Heavenly Mountain Resort, which I produced for the resort's commercial/advertising purposes. Is the snowboarder depicted here really Mikey Wier? Absolutely. Do these stark, memorable trees really exist at Heavenly? Absolutely. But did Mikey carve this exact turn around this exact tree?

No.

It's important to be honest and open about any manipulations made to photographs that go beyond what are now (although weren't always) considered conventional adjustments, such as tonal work, dodging and burning, dust spot removal, darkening of skies, white balance, color correction, and so on. This photograph goes well beyond those basic adjustments, and here's why:

Every season for over a decade, I was tasked with shooting ski and snowboard action images at Heavenly. As the years went on, I realized I needed to push myself further, farther, higher. I needed to find a way to see and capture the mountain from a new perspective.

I'd always noted this particular stand of trees, scorched by wildfire, and thought they would look really cool from a high-angle perspective. A few years ago, I rented a relatively "affordable" Robinson R44 helicopter to shoot Heavenly from the sky. One of the main challenges you face when hiring a helicopter is time. You're charged by the minute as soon as that engine turns on and those blades start spinning. Therefore, every inefficiency, every idle moment, equals money down the drain.

Typically, when I'm staging a shoot on the ski hill, I'm skiing with a group of three athletes, a mix of male and female skiers and snowboarders. I knew that if I were to shoot from a helicopter, three athletes would be too few. The turnover time—getting the athlete from the bottom back to the top—would be too long. So I hired twenty skiers and snowboarders for the Heavenly helicopter. The day before, I conceived of about eighteen or twenty specific shots and assigned each athlete a specific shot/location. That way, everyone could get in place and have a general idea about what they would be doing, and we'd minimize wasted downtime.

It'd be like shooting fish in a barrel, only the barrel would be the 4,800-acre Heavenly Mountain Resort.

I communicated with my stable of skiers and boarders via radio. However, it's quite difficult to communicate clearly and articulately when you're hanging out the door of a helicopter hundreds of feet in the air, with wind and rotor noise blasting into your mic. The world looks very different from up there, too—though that, of course, was the reason I'd taken to the sky.

When it came time to shoot this stand of burned trees on the north side of Heavenly Mountain, I spent some time building the exact right composition, snapping test frames and picturing exactly where I wanted my athlete—in this case, Mikey Wier—to carve a turn. The composition was better than I'd imagined. I always knew these burned trees would be visually graphic, but I was still surprised by how everything looked so linear, clean, simple, and aesthetic.

However, I had a tough time articulating to Mikey exactly which tree I wanted him turn around, though I did the best I could. "Forty feet above the burned tree to the left of the really short burned tree and downslope approximately six hundred feet from your stance, if you look skier's left," I said into my headset. *It will be a miracle if Mikey knows what the hell any of this shit means,* I thought.

I could feel dollar bills being burned. I just wanted to get Mikey going, get some shots, and move on.

"Dropping! Dropping!" Mikey's partner announced over the radio. "Mikey's dropping in."

Staring through my viewfinder, I was ready to hit the shutter at the decisive moment. I prayed that Mikey had understood my directions and actually carved his snowboard across my painstakingly composed frame.

Ten seconds later, still no Mikey. Damn. Sure enough, Mikey was way left of where I wanted him to be.

It didn't work. I didn't make the picture.

We repositioned the helicopter over Mikey, and I got some great images of him making fast turns in a gorgeous field of white.

Overall, the day was a success. I made a lot of really great pictures . . . but I have to admit to being a little frustrated that I didn't get the shot of Mikey riding through the stand of burned trees.

Fast-forward to months later. It's the end of the season. Time for me to deliver my files to my client. The issue of cleaning up and manipulating photos had been a subject that I'd broached with Heavenly over the years, and like many reputable companies, they think long and hard about their commitment to truth in advertising. I've always been impressed by their strong stance on using only imagery that happened or could've happened at the resort.

BEFORE DRONES, WE HAD HELICOPTERS.

Sure, they're open to cleaning up tracks in the snow and even building composite images, but they draw the line at using images of situations that didn't exist, don't exist, or couldn't exist. For example, I couldn't shoot a skier on one of Heavenly's ridges and then Photoshop Lake Tahoe into the background, even though both that ridge and Lake Tahoe "exist" in some proximity. Nor would they ever use a tight shot of, say, someone skiing deep powder in Utah, even though you can't discern the exact location, and skiing deep powder is an experience you can also get at Heavenly. This is their line in the sand.

Often, when shooting on those perfect, if rare, bluebird powder days, I'll employ a technique called "farming turns." This is similar to staging a shot in climbing (see Chapter 43). What that means, essentially, is that the athletes and I find a field of fresh, untouched snow. One athlete makes a few turns. I shoot a burst of photos. We move 10 feet to the left so our tracks aren't in the frame. Another person makes a few turns. I shoot

a burst of photos. Again, we move 10 feet to the left. Repeat. Inevitably, in the aftermath, I might need to use Photoshop to clean up the tracked snow that appears in the foreground or background. That's one of the most basic, and common, forms of image manipulation in the skiing world.

Or sometimes, I end up working with a snowboarder who (despite my vehement warnings not to) shows up with an AC/DC sticker or a glaring sponsor logo plastered across his helmet. That has to be cleaned up, too, for legal and marketing purposes.

Anyway, I decided it might be worth combining the shot of Mikey making turns in the lower snowfield with the test frame I took of the stand of burned trees. In other words, I decided to create the photograph that I had missed in the field.

In the world of commercial and advertising photography, most art directors would laugh at you if you ever voiced a pang of concern over the ethics of photo manipulation. There's extreme (and usually undisclosed)

manipulation to the faces and bodies that appear on the covers of many women's magazines and men's muscle rags. So another question to pose might be: Where does this snowboarding picture fall on that spectrum? I would say the two aren't even in the same ballpark.

Another point worth making is that I don't believe I would've made this composite if I were shooting for an editorial publication—though I must say, it seems as though the standards of many mainstream magazines have loosened on the subject. More and more composite photographs are appearing in editorial publications without any disclosure.

That brings me to another funny story about this picture. Unbeknownst to me, this shot was submitted to and won a minor photo contest award. Subsequently, it was printed in a magazine with no mention about it being a composite.

It's easy for me to sit here and preach about "full disclosure," but the reality is that pictures must often stand alone, with or without captions. Does full disclosure even matter anymore? There are dangers in believing all photography is real, but what are the dangers in viewing all photography cynically—from an assumption that all shots have been "Photoshopped to death," as they say?

Is the full embrace of image manipulation where we are headed? And if so, what are the implications?

My background is in photojournalism, in which you do not manipulate photographs. I worked for newspapers, I shot with Fuji Velvia film for years, and most of the photographs in my portfolio, on my website, and in the Aurora Photos stock archive are "straight out of the camera," with varying degrees of basic toning and color work done to the digital scans of my slides or the raw digital negative files.

But I also see a changing world, one in which protests against photo manipulation are beginning to feel like a thing of the past. Today, our photos are "filtered to death" on Instagram, but they're also getting hundreds of thousands of likes. For a photographer to darken skies, as opposed to using graduated neutral-density filters, or to build an HDR (high-dynamic-range) composite, as opposed to shooting in better light, is the new normal.

> THE COMPOSITION WAS BETTER THAN I'D IMAGINED. I ALWAYS KNEW THESE BURNED TREES WOULD BE VISUALLY GRAPHIC, BUT I WAS STILL SURPRISED BY HOW EVERYTHING LOOKED SO LINEAR, CLEAN, SIMPLE, AND AESTHETIC.

I wonder if these changes portend the death of photojournalism. Or will they lead to a world in which we praise photographers for taking the latest technology and using it creatively to build stronger images that arguably convey greater truths than anything the old world of photojournalism ever produced?

My sense is that the future will fall somewhere between those two extremes. Besides, what is a photograph but a re-creation of reality itself? No picture can or will ever tell the full truth. Photos will always be just one impression of it.

It's important for us professional filmmakers and photographers to experiment, push our skill sets, and ultimately be comfortable working with the latest technologies at the highest level possible. But only from deep reflection and real-world experience will we know what feels right or wrong, and where we choose to draw that line.

This shot of Mikey at Heavenly *could* have happened; it just didn't. And for that reason, I have no problem with this composite, so long as I'm always forthright about how I created it.

At the end of the day, though, I don't want to lose sight of what's important: Photography is about more than making images. It's also a passion of pursuit—a hunt for that pure, incredible experience of pressing the shutter button, looking down at the display screen, and seeing an unbelievably great shot. On that simple level, this picture fails for me.

However, a good hunter knows that he's not going to catch a ten-point buck every time he walks through the woods. And he also knows that that's no excuse for not putting food on the table.

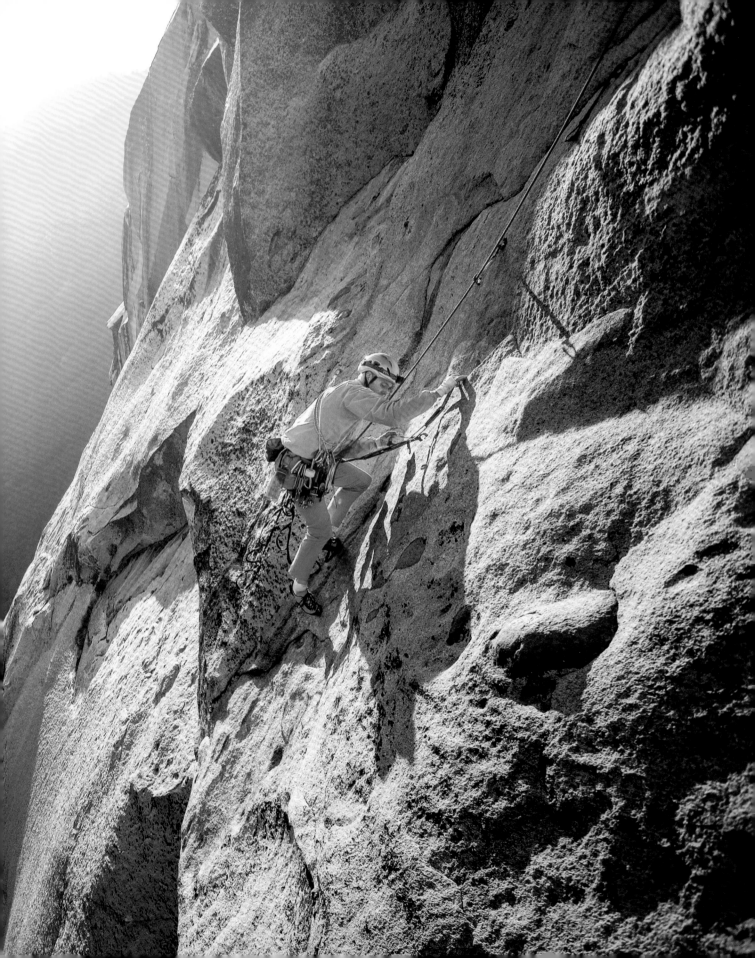

29

NIAD SMACDOWN

IN THE SPRING OF 2008, Jim Collins, the best-selling business author and long-time rock climber, stood at the base of El Capitan around midnight. He would attempt to climb all 3,000 feet of the *Nose* over the next twenty-four hours, a tough challenge known to climbers simply as "the *Nose* in a Day," or NIAD. For Jim, climbing NIAD was something he had always wanted to do, and he had chosen a personal milestone, his fiftieth birthday, to finally go for it.

As you might imagine, only the most experienced and competent climbers are able to manage NIAD. Jim, however, was feeling pretty confident, because he had a secret weapon in tow. His partner was none other than professional climber Tommy Caldwell.

Jim clicked his stopwatch, and said, "OK, go!"

Tommy began climbing at a steady pace.

Everything started off well. Then, a few hundred feet up the route, Tommy screamed, "Aaaaaah! Falling!"

Tommy pitched into the air, taking a surprising 30-foot fall. The rope caught him right as he landed on the very ledge from which Jim was belaying.

"Whoa! Are you OK?" Jim exclaimed.

"Yeah, I'm OK," Tommy said.

"What happened?" Jim asked.

Tommy had actually blown out his shoe. In fact, his big toe was sticking right out of the rubber!

Tommy, though, decided not say anything about his shoes. After all, good climbers know to never blame their faulty equipment for a fall—even in an extreme

situation like this. Tommy also knew Jim well enough to know that if he were to tell Jim that he had blown out his climbing shoe, Jim might insist they both go down.

"I dunno. I guess I just slipped," he muttered. "I'll be more careful from now on. Thanks for the great belay!"

And just like that, completely unfazed, Tommy headed right back up on lead and continued climbing at his usual world-class pace.

According to Tommy, Jim is the most "SMaC" person in the world: specific, methodical, and consistent. And he puts the SMaCdown on any goal, whether that's authoring a new business book or climbing El Capitan in a day.

A bit of background: Jim had been training for NIAD with Tommy over the course of the previous year. With each and every session, back home at an indoor climbing gym in Boulder, Colorado, Jim gradually trained himself to be capable of climbing 3,000 vertical feet with Tommy. They started off doing 500 feet of climbing, then 1,000 feet, then 1,500. Considering a gym is only about 40 feet tall, that's a lot of routes!

Despite Tommy's freak fall from his climbing-shoe malfunction, all that training was paying off on the *Nose* as Jim and Tommy chugged their way up. By the time Jim finally noticed that Tommy's big toe was sticking out, they had already made such great progress that it was easier to go up than down, and so they continued with style.

I was genuinely excited to have gotten an opportunity to photograph them as they climbed El Cap on this day back in 2008.

I had never met Jim Collins before this occasion, but his books on business remain some of the most influential texts I've ever read. Jim is the author of the *New York Times* bestseller *Good to Great*, among several other classics that deconstruct what makes companies successful. He is also a great researcher, an entertaining lecturer, and one of the most sought-after management thinkers in the business world.

I had no idea that he was also a longtime member of my rock-climbing tribe. In fact, I only learned this detail rather casually while talking with Tommy, who is one of my closest friends, on the phone.

Tommy mentioned that he was on his way to a climbing gym in Boulder, to meet up with "Jim Collins—one of my buddies who writes books."

TO ME, THE MOST MEMORABLE DAYS AREN'T NECESSARILY THE ONES WHEN YOU EARN A BIG PAYCHECK.

I did a double take.

"Wait, hold on. Back up. Do you mean Jim Collins, as in the *Good to Great* author?"

"Yeah, that's him," Tommy said. Then he proposed an idea to me: "You know what? It'd be cool if you join us on the actual ascent. You could rap down El Cap and shoot some photos while we're climbing. I think Jim would really like that."

"Really? That would be supercool!" I said. "If he's OK with it, then count me in."

To me, the most memorable days aren't necessarily the ones when you earn a big paycheck. They're the ones when you go out to an incredible location with your friends or other people you respect and enjoy the simple, creative act of making photographs.

So that's basically how I found myself in the company of a great author and a great climber, 2,000 feet up El Capitan.

That morning, I hiked up to the summit with Beth Rodden, Tommy's then-wife and also one of my best friends.

In addition to being a world-class climber, Beth is a trouper who is always down for a big, long day of adventure. She offered to help me carry loads up El Cap, which is no easy feat, and keep me company. Upon reaching the summit around late afternoon, Beth and I rapped down the monolith to get into position and await the NIAD aspirants.

The light was brilliant and spirits were high as Jim completed his goal of climbing the *Nose* in a single day (nineteen hours, to be exact). I was really happy to be there to celebrate with Jim and to capture the moment—the result of a lot of dedication, work, and effort on his part. And, of course, a healthy bit of SMaC execution.

On the hike down, Beth and Tommy paired up and walked slightly ahead of us. That left Jim and me to talk.

"Congrats!" I said. "The *Nose* in a day is an achievement to be superproud of."

"You know what?" Jim said. "The real treat for me was actually just getting to spend so much time around Tommy. That guy is a true hero. He's so good and such a talented climber . . . but what makes him great is that he gets as much pleasure out of helping others achieve their goals as he does in achieving his own success."

RAW TALENT AND BEING GOOD ARE OVERRATED. IT'S WHAT YOU DO WITH THESE GIFTS THAT COUNTS.

Before I could let that profound observation sink in, Jim—who is obviously inquisitive and curious (clearly, the traits of any great writer)—started quizzing me about my photography business.

"What makes your business unique relative to all the other adventure firms in the marketplace?" he said. "And how do you see the photography industry changing in the next decade?" His questions were profound and precise, and challenged me to think about my business in a new way.

"Jim, I'm embarrassed to say this, but I guess I haven't given a ton of thought to the way I run my business," I said. "I guess I just go out and make pictures and shoot films of the things I care most about. I pour my heart into it, and I work as hard as I possibly can. I sacrifice

lots of other things to make images, but I do that by choice. That's my business model."

It has often been said that you should judge a man by his questions, not by his answers. In retrospect, I think that's a really appropriate description of this situation. As our conversation progressed, I realized that Jim wasn't grilling me about my business. He was giving me advice; his questions were simply forcing me to think about things in a new way.

I originally admired Jim because of his work as an author. But after spending forty-five minutes speaking to him as we hiked down the East Ledges trail, my admiration deepened, because I realized that Jim, like most core climbers, is just a down-to-earth guy. He is genuinely passionate about helping other people to run their businesses well. That selfless desire to help others certainly makes Jim great.

Raw talent and being good are overrated. It's what you do with these gifts that counts. Guys like Jim and Tommy are living proof that when you use your talents to give back and empower those around you, it's then that you achieve true greatness.

As for me, I came away from the day with a handful of pretty good images, one of which currently hangs on the wall of Jim Collins's office, alongside a picture of him and President Barack Obama. My favorite image from that day is this one. Is it great? Perhaps not. But it is definitely the best toprope photo I've ever shot of the most epic toprope pitch in the world.

30

INCHES FROM DEATH

IN OUR CYNICAL MODERN AGE, you might be hard-pressed to find a professional athlete who deserves to be called a hero or a role model. Guys like Tiger, A-Rod, and Lance have made us all rather pessimistic that top athletes can be great competitors and also be great people, too.

But if there is one pro athlete I know who actually deserves to be called a hero, it's Tommy Caldwell. Tommy isn't just one of the nicest guys around, he's arguably the best all-around rock climber of all time. No one else has excelled in every climbing discipline to the degree that Tommy has—from 5.15 sport climbs to V13 boulder problems to such visionary big-wall free climbs as the Dawn Wall.

Yet Tommy does all this without blood doping or multimillion-dollar contracts. He leads a humble existence and does it for the pure love of the mountains and adventure.

Tommy is also an amputee. He lost his left pointer finger to a table saw a few years back. That he can still climb at the level he does is unbelievable.

Tommy always gives back to the community. I served on the board of the Access Fund, a nonprofit climbing advocacy group, and I can't tell you how many times Tommy would come to our rescue with a slideshow event to raise money, never complaining or asking for anything in return.

I've pitched profiles of Tommy to various magazines over the years, and many were not interested—because Tommy isn't a Tiger, an A-Rod, or a Lance. In other words, they're not interested because there isn't a sordid underbelly to Tommy's story. I think that if the heroes we choose are a reflection of our society, then

145

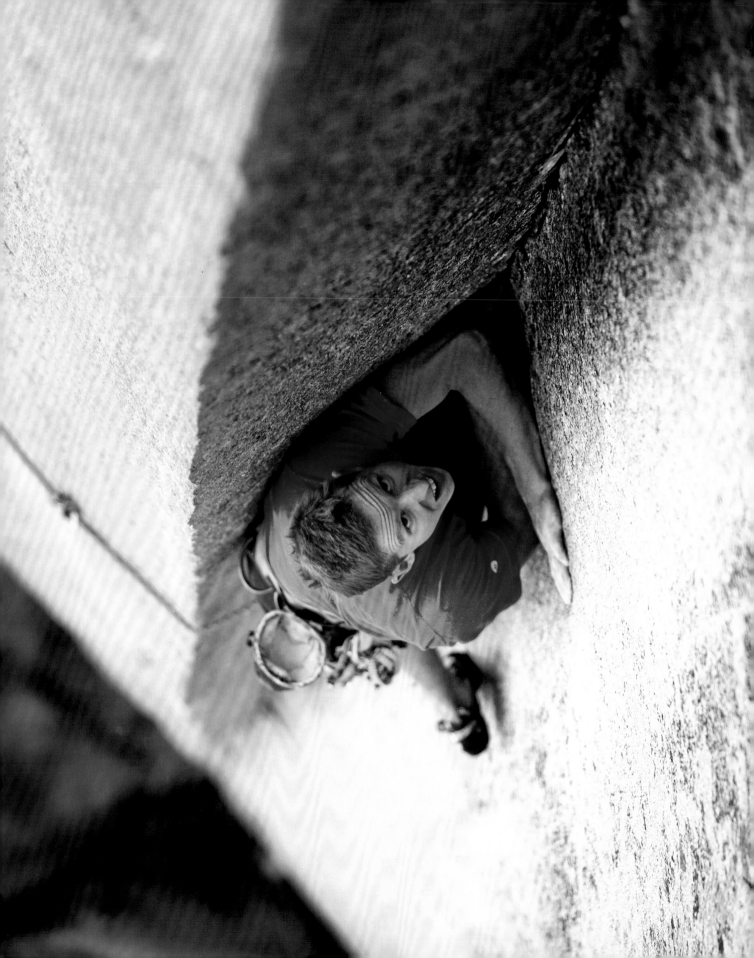

the fact that Tommy Caldwell might not be considered "profile-worthy" simply because he's an upstanding guy says a lot about us and our values.

There are no skeletons in Tommy's closet. He doesn't cheat. He doesn't lie. He doesn't talk shit about others. He's basically just a regular dude who happens to be the best all-around rock climber in the world.

But one of the real reasons I call Tommy a hero is that he saved my life.

BUT IF THERE IS ONE PRO ATHLETE I KNOW WHO ACTUALLY DESERVES TO BE CALLED A HERO, IT'S TOMMY CALDWELL.

In 2005, Tommy and Beth Rodden were working toward a free ascent of the *Nose* on El Capitan. First free-climbed in 1993, by Lynn Hill, the route is perhaps the most famous big-wall climb in the world: 3,000 vertical feet, thirty-one pitches, and difficulties up to 5.14a.

This photo shows Tommy in 2005 on the Changing Corners pitch—perhaps the single hardest pitch of the whole route. Changing Corners comes high on the wall. It's steep, tricky, and exposed.

On this day, we were shooting early in the morning, when the temperatures were prime (i.e., cool) for Tommy. The conditions were also prime for me: open shade, with ambient morning light.

A couple hours earlier, we'd rappelled down El Cap from the summit, where we were camping. Using 1,000 feet of rope strung down to the Changing Corners pitch, Tommy and Beth were able to easily rappel to this crux section, practice climbing it for a few hours, and then jug back up the ropes to gain the summit midday when it became too hot to climb.

For me, the fixed ropes made it easy to always be hanging above Tommy and Beth, creating dramatic pictures by shooting down on them.

When Tommy tied in for his first crack at Changing Corners, I got into position on the fixed rope. Hanging from the 10-millimeter line, I spun around in the air—the wall in this section is that steep. I wanted to shoot with a wide-angle lens so that you could see the entire expanse of El Cap below and really get a sense of the palm-sweating exposure. I snapped a few shots but realized that my rope was in the frame, a frequent issue for climbing photographers, especially with a wide-angle lens.

A hundred feet below me, the end of my rope was tied off to the anchor where Beth was clipped in, belaying Tommy.

"Hey, Beth! Would you please untie the rope? It's in my frame!" I hollered down.

"Sure thing!" she yelled back. She quickly did so and returned to her main task and focus, which was belaying Tommy.

This morning, Tommy was struggling to do all the moves on this sharply cleaved, beautiful dihedral. He was really working for it, giving 100 percent. And for me, that's a great situation. I didn't need to ask him to strike certain poses or do anything else. I just got to be there and capture the action.

I switched to a telephoto lens and continued to focus on making authentic images that documented his real effort. After all the fuss with the rope and the wide-angle lens, ironically, my favorite shot was this one, which I took using a Nikkor 70–200mm f/2.8.

Tommy had climbed most of the way up the Changing Corners dihedral when his foot slipped and he took a 15-foot fall.

When one of your best friends is genuinely frustrated and bummed out, you really know it. But you also know how to try to make that friend feel better. I turned to humor, and started ribbing him.

"Hey, Tommy," I said, "you need me to put on my climbing shoes and show you how it's done?"

And of course he retorted with, "Sure thing. Then I can take your camera and make some pictures that are actually in focus for once!"

We all laughed. Tommy lowered back down to the belay with Beth. And I decided to rappel down to join them at the anchor.

As I was lowering myself, I continued joking around. Then, seemingly out nowhere, Tommy said, "Stop, *stop!* What are you doing?"

The way he said it, with such alarm, caused me to freeze. "What are you talking about?" I asked.

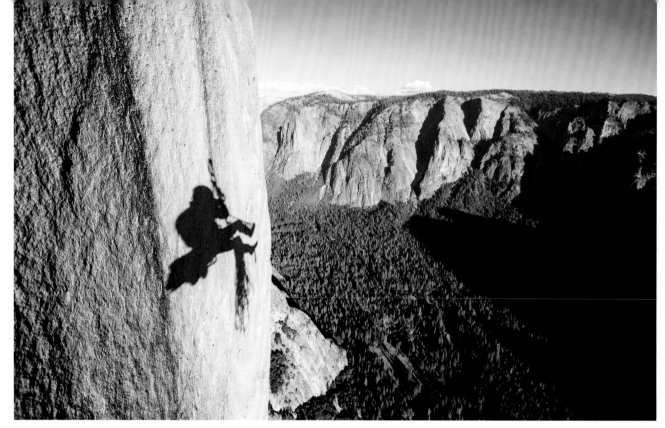

SO MUCH OF WHAT I DO UP ON EL CAP INVOLVES SHOOTING IN A WAY THAT DOES NOT REVEAL MY POSITION. BUT EVERY NOW AND THEN, I CAN'T RESIST SHOOTING MYSELF SO I CAN REMEMBER WHAT IT'S LIKE TO BE UP THERE.

Before Tommy could even answer, I looked down and realized that I was about 12 inches from rappelling off the end of the rope. After asking Beth to untie the rope and get it out of the frame, I had forgotten to pull it up and tie a stopper knot in the end to safeguard myself.

Had Tommy not noticed, I would have fallen more than 2,000 feet to my death.

I went into a fight-or-flight response. I quickly clipped my ascender to the rope as a backup and tied a knot in the rope's end.

My heart was beating so hard that it actually felt like it was coming out of my chest. With each thump, the reality of just how close I'd come to dying—right in front of my friends, no less—sank in.

I got lucky. Lucky that the rope was as long as it was. Lucky that Tommy said what he said, in the way that he said it. But mostly lucky that Tommy was there at all. Despite being distracted by our joking around, he still had the awareness and wherewithal to check his partner's safety—a crucial part of being a great climber.

I walked away from that experience shaken. The next couple of days, I found myself going beyond the usual double- and triple-checking of my systems to checking everything six or seven times. I was hesitant and slow, and everything felt unusually scary.

But by the end of the trip, I was able to get over it. After all, El Cap is my office, my second home. Being on ropes in big, vertical environments isn't just what I do. It's what I love.

Still, you don't come 12 inches from your own death without learning a few lessons. For me, the first one was, boy, life sure is fragile. We cannot take anything for granted. No photograph is worth getting hurt for, or worth risking your life over. I really believe that. What's most valuable to me is consistency. I want to be able to do this kind of fun, exciting stuff day after day over the course of a long and happy life.

The best way to do that is to never get too complacent, never get too comfortable, always look out for your friends and partners, and make every day count.

31

JUST A SNAPSHOT

TODD OFFENBACHER HAD WARNED US that, somewhere here in these parts, the Dog Man was probably lurking in the night. The Dog Man, as legend has it, is a tortured half-man, half-dog creature who loves the taste of children's flesh.

 "Every time you hear a howl in the moonlight, that means the Dog Man has caught another naughty child and is feasting away at their bones," Todd told the transfixed young children huddled around our crackling campfire.

Just then, right on cue, Chris LaScola came stumbling out of the shadows while wearing a full-body dog costume that Todd had borrowed from a local television studio.

Of course, this scared the living shit out of the kids. It was a riot.

If you had asked me in my twenties if I'd ever have children, my answer would've been, "Not a chance in hell!" Like many young dudes, I was unmarried and—sorry, but I don't know how else to say it—selfish about the things I liked to do. I was the typical single guy who envisioned myself living the perpetual bachelor life.

Then, a few years ago, I started spending a lot of time with kids. Scott Wilson, the director of photography and video at The North Face, assigned me to shoot many of the company's youth campaigns. I've never been quite sure why Scott kept giving me these assignments. Perhaps he thought I was just a big kid. Anyway, on this occasion, Scott needed me to put together a shoot to showcase the latest boys' and girls' clothing.

The family I had worked with in the past for these campaigns were my friends Jim and Bonnie Zellers and their two boys, Ryan and Dylan. Now that I also needed to

shoot girls' clothes, I turned to another family I admired: Matt and Danielle Underhill, and their two daughters, Marin and Mattison.

FOR ME, PHOTOGRAPHY HAS COME TO MEAN SO MANY THINGS: IT'S A BUSINESS. IT'S A PASSION. IT'S A LIFESTYLE. IT'S A JOY.

I called both families, and I put together a climbing and camping trip to Bear River Reservoir, one of my favorite climbing areas in the Tahoe area. Along with my friends Todd and Chris, who had developed a lot of the climbing here, we all spent a few nights camping at the reservoir and telling ghost stories about Dog Man around the campfire.

It's hard to call moments like this "work"—even though that's technically what it was.

For me, photography has come to mean so many things: It's a business. It's a passion. It's a lifestyle. It's a joy. And it's a chance to see so many different ways of living. Photography is an excuse to have many different experiences and be exposed to different truths—all valid and thought-provoking.

I could talk for hours about apertures, white balances, off-camera strobes, shutter speeds, focal lengths, and the rule of thirds. But isn't photography, at its most basic core, really all about freezing a special moment in time in order to preserve that memory? And how quickly we pros forget that you don't need a $5,000 camera body to do that!

Over the years, more assignments to shoot campaigns for kids' gear came in. I shot the lead image in this chapter in Red Rocks, Nevada, for another assignment. It may have been the picture that made the next North Face catalog, but it's not the one that has the most meaning to me.

The one that I prefer is the snapshot of all of us sitting around a campfire. It isn't one of the best photographs I've taken; it's not even in the top one thousand photos of my career. Yet, to me, it captures one of my favorite memories. This is the night I first remember

A QUIET MOMENT AROUND THE CAMPFIRE WITH MARIN UNDERHILL, MATT UNDERHILL, AND RYAN AND DYLAN ZELLERS, JUST BEFORE THE ARRIVAL OF THE FEARSOME DOG MAN

thinking that one day I could actually be open to having kids myself.

This whole trip, I got to see how moms and dads interacted with Dylan and Ryan, and Marin and Mattison. And I got to see how cool kids can be.

> **THIS IS THE NIGHT I FIRST REMEMBER THINKING THAT ONE DAY I COULD ACTUALLY BE OPEN TO HAVING KIDS MYSELF.**

As a photographer, I'm always struggling to see scenes and see the world in a new way. Kids don't have that struggle. Seeing things in a new way comes naturally and effortlessly to them. And that's inspiring to be around. At some point on that trip—maybe while sitting here at this campfire—a switch got flipped. I started thinking about this woman I had just started dating. I started thinking about what life might be like with her. And I thought about what it might be like for the two of us to one day become parents.

I sat there, hypnotized by the fire under the pale moon. And somewhere off in the distance, I swear I heard a howl.

32

THE QUEEN OF PAIN

ALONE AND IN THE MIDDLE of a dark desert, Rebecca Rusch pushed herself harder, pedaling faster. Suddenly she flipped over her mountain bike's handlebars and ate dirt.

She gasped and moaned. She had badly dislocated her finger. Blood pooled and poured from her glove. She wondered if she had just compromised her goal of trying to break the speed record for female riders on the Kokopelli Trail—a 142-mile stretch of rugged desert wilderness located between Moab, Utah, and Fruita, Colorado. Lesser athletes would've thrown in the towel and come back to try another day.

But Rebecca got back on her bike and pressed on, pushing herself through the pain, pedaling faster.

Her perseverance was rewarded. On April 27, 2013, she shattered the record. Most people, male or female, take five or six days to complete the ride. Rebecca did it in less than fourteen hours.

Rebecca is a longtime friend and one of the more incredible individuals I know. I mean, you don't get a nickname like "the Queen of Pain" for nothing.

I first met her on the island of Borneo, in 2000. Quokka Sports had hired me to photograph a multisport challenge that involved teams of athletes competing against each other across extreme terrain. Biking, running, kayaking, and climbing were all part of the game.

REBECCA RUSCH, FRONT, PADDLING AT AN ECO-CHALLENGE IN BORNEO, MALAYSIA, WHERE WE FIRST MET

In fact, the event was for the adventure-racing TV show *Eco-Challenge*, producer Mark Burnett's precursor to his much more successful and well-known series *Survivor*.

Eco-Challenge ran from 1995 to 2002, and, in that time, spanned the globe with its wild locations. When I landed in Borneo in 2000, I'd never shot an adventure race before and I wasn't sure what to expect.

After a long set of flights that hopped me from continent to island, I ended up in a room filled with the TV show's producers, support staff, and athletes.

More ambitious and boisterous personalities might use an opportunity like this to network the hell out of the situation, passing out business cards and BSing. Me, I don't really give a fuck about all that. I prefer to have real conversations with real people. And for some reason, the person who got my full attention that evening was Rebecca Rusch.

We became fast friends once we realized we both have a background in rock climbing and a low tolerance for bullshit.

I've been a friend and fan ever since.

During the adventure race, Rebecca destroyed the women's field, not to mention most of the guys.

YOU DON'T GET A NICKNAME LIKE "THE QUEEN OF PAIN" FOR NOTHING.

Years later, I got to experience what it's like to get walloped by her. She had just arrived in Lake Tahoe to train for a different adventure race, with her teammates—three dudes. Being the local, I took them

on a tour of one of my favorite mountain-bike trails, which is right behind my house.

I knew the dudes would leave me in the dust, but my male ego had me believing that I'd at least be able to keep up with Rebecca. After all, this was *my* trail. I'd probably ridden it two hundred times and knew every little turn and stone.

We set off, pedaling at a furious pace. My heart rate was probably 180, but I was determined to keep up with these stud athletes. I was out in front, too, leading the pack. In between gasps for air, I turned back to see Rebecca and her teammates chatting casually with each other, looking like they were out for a leisure ride.

We reached my usual turnaround point in forty-five minutes. For me, this was a *huge* record! I stepped off my bike, relieved to have more or less kept up with this team of professional bikers, and happy to have achieved a new PR.

Rebecca, in a very genuine and surprised way, looked at me and said, "That's it?"

I was completely spent. Rebecca, however, was just warming up.

"Well, I guess that's it for me!" I said, laughing. "You guys keep going, and I'll head home and fire up the grill and put some beers on ice."

"Sounds good!" she chuckled. The team continued riding more than twice the distance we'd already covered, all the way to the top of the Tahoe Rim. I'd tucked my tail and turned around.

There's a real difference between watching adventure racers on television and getting to see and experience their sheer athleticism firsthand. I had no delusions of grandeur about myself. I knew I wasn't a world-class mountain biker by any means, but it wasn't until the point when Rebecca said, "That's it?" that I really appreciated just how good these people are at what they do.

Over the years, Rebecca and I crossed paths at other adventure races, and we always talked about biking and climbing, but I think the topic of most interest to both of us was discussing how we were each trying to turn our individual passions into careers. For me, that was photography, of course, while for Rebecca, it was biking and racing. We compared notes, complained

about similar things, and got ideas and inspiration for new ways forward.

DURING THE ADVENTURE RACE, REBECCA DESTROYED THE WOMEN'S FIELD, NOT TO MENTION MOST OF THE GUYS.

Our careers have progressed and evolved in parallel. What has always made Rebecca stand out in the adventure-racing/endurance world, beyond her fitness and abilities as an athlete, is her entrepreneurial spirit. It takes a certain type of driven personality, fearlessness, and self-confidence to go out into the commercial world and obtain the bikes, clothing, sunglasses, computers, and airline tickets you need to compete in a relatively unknown sport like adventure racing. It's not enough just to be a great athlete. Success also demands that you be a great businessperson and an overall great person whom others like and admire.

One big change in Rebecca's world occurred when adventure racing as a sport fizzled around 2004. The purses, sponsors, and TV coverage weren't what they once were, whether because adventure racing was too abstract for television or too boring to a mainstream audience, or simply because Mark Burnett's attention had shifted to *Survivor*, I'm not sure. But Rebecca had to find new outlets and create new challenges to express her creativity and athleticism.

It was a learning process. A struggle. It was something we talked about whenever we got together.

Ultimately, she went on to make a name for herself in the endurance mountain-biking world, winning women's races while simultaneously beating most of the men's field.

In 2013, Rebecca called and said, "Hey, Corey, I want to go out and try to break the female record on the Kokopelli Trail."

I'd never even heard of the Kokopelli, but as she described it to me, I knew it would be an incredible story worth telling.

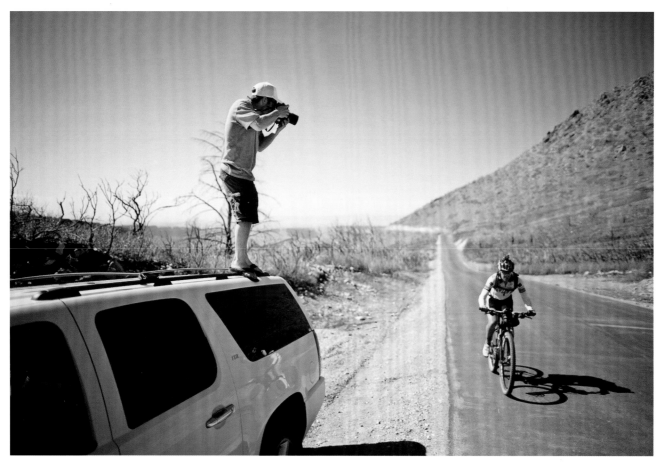

SHOOTING REBECCA RUSCH DURING HER RECORD-SETTING RIDE OF THE 142-MILE KOKOPELLI TRAIL (PHOTO BY JOSH GLAZEBROOK)

Like Rebecca's, my own career had evolved and progressed in new directions. Since 2009, I'd been trying to make the transition from still shooter to director and filmmaker. I had been developing a model of small-footprint productions in which small, light, nimble teams use light-and-fast equipment to capture cinematic content from the wildest places.

Shooting a 142-mile trail in the middle of nowhere was going to be a great challenge at this stage of my directing career—and another chance to put this small-footprint production model to the test.

I assembled my team: Dane Henry as DP, Sean Haverstock as drone operator, and myself as director and still shooter. Since we didn't have a seven-figure budget and since there were so many logistical hurdles involved in capturing this adventure, we decided to shoot what we could from the sidelines during Rebecca's actual ride, and then return in the aftermath to shoot B-roll.

In other words, we'd re-create moments of the record-breaking ride in order to capture the imagery and motion footage we needed.

"Holy shit, look at her go!" Dane said as Rebecca whizzed past us.

"That's just insane!" Sean said.

Working in nothing but moonlight, we shot video and photos using the Nikon D4, for its low-light performance.

We met Rebecca at the finish line, where she collapsed. We captured joy and relief, which poured from her face like the sweat on her brow, and the pain of having endured her harrowing thirteen-and-a-half-hour effort. Rebecca went straight to the emergency room to have a specialist look at her mangled finger and put her on an IV.

> **THERE'S A REAL DIFFERENCE BETWEEN WATCHING ADVENTURE RACERS ON TELEVISION AND GETTING TO SEE AND EXPERIENCE THEIR SHEER ATHLETICISM FIRSTHAND.**

After just one night of rest, Rebecca rallied and we launched phase two of our shoot. We returned to the course to re-create various moments of her ride.

We logged another two intense days of shooting, then faced an incredibly tight turnaround in post. While Rebecca went home to get some well-deserved rest and tend to her finger, we flew back to California and got right to work. This was a week of virtually no sleep, especially for Dane, who edited the piece. We received one round of critiques from Red Bull, basically asking that we cut the piece down from five minutes to three minutes. That in itself is extremely time-consuming, as any editor knows. But we persevered and created something that had everyone psyched. Less than five days after wrapping, our piece was up online.

You know, one thing that's never discussed openly about our lives as professional photographers/directors or as professional athletes is how lonely and desolate these entrepreneurial ventures can feel. They say that freelancers work one hundred hours per week in order to avoid working forty. There's some truth to that, as Dane, Sean, Rebecca, and I all know.

There's no book you can read or degree you can get that teaches you how to be a professional athlete or a creative freelancer. Making a career out of what you love to do can feel like a long, dark, and lonely road, indeed.

The key is to be like Rebecca: just put your head down and keep pedaling forward in pursuit of excellence.

33

LIGHT AND FIT

ONE WINTER, I DECIDED TO carve out some time for a personal project. I wanted to put together a shoot that wasn't for a client, but just for fun. As a freelance photographer, this is one of the most important ways you can spend your time.

A personal project is an opportunity to experiment and take some risks. To learn new skills and techniques. To stretch and flex new mental muscles, broaden your skill set, and diversify your catalog of work. If all goes well, maybe that personal project will lead to a new client, or at the very least, it might help existing clients view you in a new light.

Over 80 percent of the photography I do involves working with available light, usually in beautiful wide-open outdoor environments. One of the best ways to improve in any endeavor is to work on your weaknesses. I wanted an excuse to elevate my lighting skills and push the scope of my abilities as a photographer, all while still shooting athletic subjects in an authentic space.

I called up my buddy Del Lafountain, the owner of a CrossFit gym in South Lake Tahoe, and asked if I could use his facility and borrow some of his athletes over a weekend. He was more than happy to open his gym to me.

As the date approached, I became quite excited about the prospect of playing with a bunch of expensive lighting equipment, which I normally don't use. I rented four Profoto Pro-7b 1200 flash units; seven ProHeads; a ProRing; two Chimera Pro II medium strip lightbanks; Litepanels LEDs, for more nuanced control over the ambient lighting; and a Softlite Reflector (a.k.a. a "beauty dish").

161

I even brought my fog/smoke machine, which I'd purchased about ten years earlier at a Halloween store.

Last but not least, I flew in my friend Bryan Liscinsky, a talented lighting tech from Southern California, to help.

My vision was to make a set of unique commercial-quality images with a high-key look.

We assembled a team on a shoestring budget. I asked six friends who actively do CrossFit in their free time to be our models. My intern, Christian Fernandez, would serve as a photo assistant, while Marina, my wife, would be in charge of makeup and hair.

In exchange for their time and the use of the CrossFit facility, the models and South Tahoe CrossFit would be allowed to use the photos for their own purposes.

The shoot was amazing. I learned a lot, honed some new skills, and reinforced old ones. The team worked together well, and the models definitely enjoyed their "CoreyFit" workout. ("Can you lift that fifty-pound kettlebell over your head just one more time, please?")

The process for this personal project was very similar to one I'd use if I were working for a client. I scouted the gym the day before, walking around and taking notes on how to make the most of the environment. I noted striking backdrops and crucial foreground objects. I identified different things the models could be doing—kettlebell swings, squats, rowing, rings, etc. My challenge and goal (as always) was to create the most visually diverse set of images possible—only this time, in a small indoor space.

Having assembled tens of thousands of dollars' worth of lighting equipment and flown in a lighting tech from So Cal, you'd think that I'd want to shoot only with the strobes. In fact, I'd arrived on location dead set on that very idea. It was the whole purpose of the shoot, after all.

Ironically, my favorite image from the whole day involved no strobes at all.

This is a picture of Del Lafountain, catching his breath between kettlebell swings and standing in front of the American flag, shrouded in dramatic shafts of light.

When I saw that prominent flag, I knew there would be no need for strobes. Here was a photographic opportunity practically handed to me on a silver platter.

I DIDN'T GAIN ANY NEW HUGE CLIENTS DIRECTLY FROM THIS SHOOT. BUT THE RETURN ON INVESTMENT FROM THIS PERSONAL PROJECT WAS MASSIVE.

The lights were off in the gym. The window up and right was casting great natural light onto the gym floor. To really highlight the shafts of light, we turned on the fog machine and I had my assistant fan the smoke with a piece of cardboard, so that it would waft in and exaggerate the beams.

At first, we tried using a reflector to bounce the light back onto Del and fill in the shadows. However, we couldn't angle the reflector in a way that was useful, so we abandoned the reflector idea and turned on our Litepanels 1×1 Bi-Color LEDs to fill in the shadows. The variable-temperature function on these lights gave us the ability to warm the shadows ever so slightly, turning an otherwise cold shadow into a warmer tungsten tint.

I didn't gain any new huge clients directly from this shoot. But the return on investment from this personal project was massive. I made some portfolio pictures that I love, and I learned a lot about the creative process. Most of all, I had fun.

And while I learned many nifty lighting tricks involving strobes, I think the more lasting, universal lesson I learned is to never be so attached to one idea that it blinds you from seeing another, even better idea and executing it as best you can.

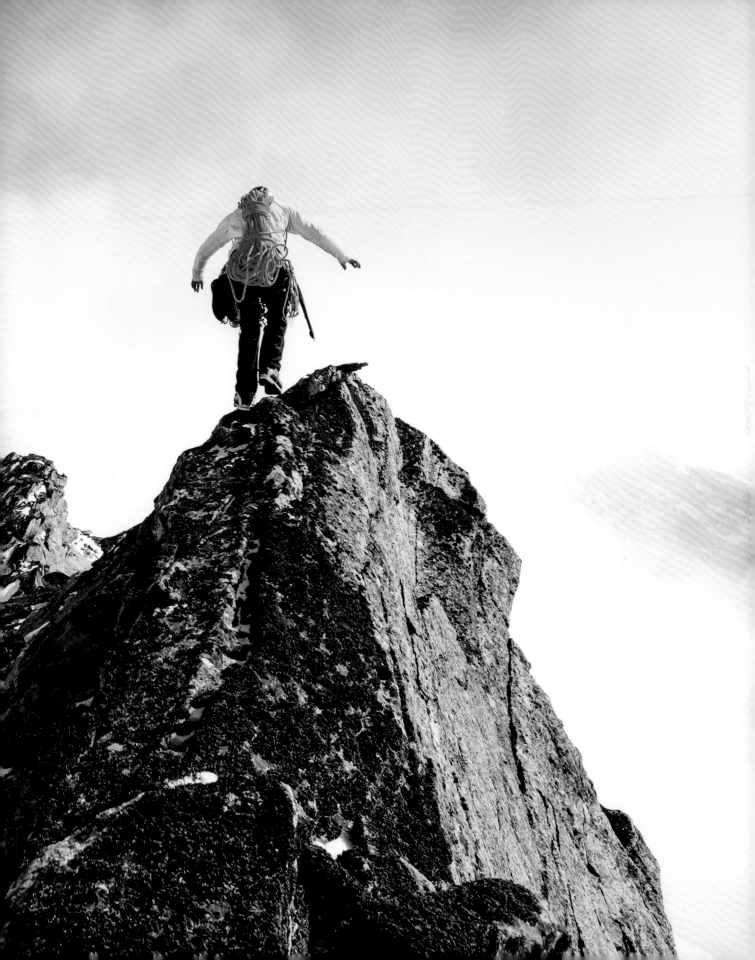

34

WILD ALASKA

IT ALL BEGAN WITH A satellite call from my old friend Tommy Baynard. He phoned from the Arctic, where he was working on his hit TV show *Flying Wild Alaska*. The call was patchy, but his follow-up email included a video clip that depicted breathtaking granite walls and spires.

 "I want to feature you and two professional climbers climbing in this remote area of Alaska for the show," he said. "I have virtually no budget . . . but it would be the adventure of a lifetime!"

Being a freelancer often means being opportunistic and creative when it comes to deciding not only which projects to take on, but how to get them paid for. The reality is, it's rarely easy to do what you love with people you love in a place that's inspiring—all while getting your baseline expenses covered.

But climbing mountains in Alaska sounded like a dream. And it could end up being a conduit for other opportunities. All I needed to do was figure out how to leverage this opportunity to get my expenses paid.

I reached out to Nikon and Polartec, both of whom I already had a great and close relationship with. I pitched a variety of ideas for content creation and gave a budget, and they signed on without too much negotiation. In addition to filming a climbing segment for Tommy's show on the Discovery Channel, we would do a behind-the-scenes video for Nikon and a thirty-second spot for Polartec.

Now, all I needed was the right team. To climb in such a difficult, remote environment and document it for three different projects meant that I would need my friends' help.

I called Tommy Caldwell, who said yes without a second thought. He suggested inviting Hayden Kennedy, then twenty-one and an up-and-coming rock-climbing star.

I also invited Tommy Thompson, Todd Offenbacher, and Dane Henry—expedition pros, production/filmmaking masters, and damn good company. I reasoned that between the six of us, we could break up into two climbing teams of three, allowing us to film an ascent from multiple vantages.

Now, we needed to figure out where we were going, and what kind of madness we were getting into.

A flurry of research revealed the identity of the mountains that Tommy Baynard had described in his initial email. We would be going to the Arrigetch Peaks in the central Brooks Range of northern Alaska. Apart from a few reports in old journals, a couple of entries in an Alaskan climbing guidebook, and a blog post or two, I couldn't find much beta for these mountains.

This lack of information didn't seem to reflect their potential. If they were close to a city, the granite features of the Arrigetch—perhaps best described by the original Inupiat meaning of the word, "fingers of the hand outstretched"—would be world-famous. But they are a long way from being close to anything.

Geologists began exploring the Arrigetch as early as 1911, but the first climbers didn't arrive until the 1960s. Even then, it took years just to get the airdrops right.

In 1971, Ed Ward and David Roberts made the first ascent of one of the more striking formations in the Arrigetch: Shot Tower. Roberts recorded the ascent in the *American Alpine Journal* and included a photo that looked like it could have been taken in Canada's Cirque of the Unclimbables.

A few years later, seven of Roberts's students at Hampshire College, inspired by their professor, embarked on their first expedition in the Arrigetch. One of the trip members was now-famous author and mountaineer Jon Krakauer.

During the trip, Krakauer and Bill Bullard made the first ascent of the south arête of Xanadu, at about 7,100 feet the highest peak in the range. The expedition took four weeks. According to our guidebook, modern climbers should plan on a similar time frame.

HAYDEN KENNEDY, TOMMY CALDWELL, TOMMY THOMPSON, AND TODD OFFENBACHER SKIING IN

We didn't have four weeks. More like ten days. And unlike the vast majority of the climbers before us, we wouldn't be going in August, when one might reasonably expect decent climbing temperatures. We would go in late winter.

Several weeks after that initial phone call, I found myself in the copilot seat of Jim Tweto's Cessna on a scouting mission into the Brooks Range. Jim was the owner of Era Alaska (now Ravn Alaska), the state's largest regional airline service, and the flight was critical in determining our objective: a striking wall on Xanadu, as beautiful as the northwest face of Yosemite's Half Dome, which jumped out at us from miles away. But the recon also revealed a complication: the nearest Jim could land was on a frozen river more than 20 miles from the formation.

The Discovery Channel crew tagged along on the plane ride out to this waypoint. But once they dropped us off, we were on our own. Our warm-up was a 20-mile ski with sleds in tow.

"This is so great!" Hayden hollered, leading the charge and breaking trail up the frozen river.

"Wahoo!" Todd Offenbacher screamed into the cold wilderness. "Love this shit!"

Despite having only ten days total, we burned three days just getting into high camp and scouting a potential line to climb. Fortunately, we found a potential climb quickly, spying a crack system trending up a broad granite face. After a rest, that would be our objective.

Still, this made me a little nervous. Essentially, we would have only one possible day to complete a climb.

The next morning, Tommy Caldwell, Hayden, and I left early on skis and ascended 2,000 feet of mixed terrain to the start of the rock climb. Tommy took the first block, expecting moderate climbing, but his lead started less than auspiciously ... with a big fall that had him downclimbing to the snow to find another start.

This was going to be harder than we'd anticipated.

Taking a different beginning, Tommy pioneered a series of run-out 5.11 face pitches to a large corner. From here, the climbing eased to 5.10 on perfect buffed granite. Hours after beginning the day, we'd reached pitch 11. Now it was Hayden's lead.

Hayden reached the end of his rope and spent ten minutes building an anchor. Tommy and I were suspicious about the solidity of the anchor, given that his body position—sprawled against the rock like a body at a crime scene—didn't inspire confidence. Still, he called down and said the rope was secure, and for us to join him.

As I launched off on my jumars, still speculating about the viability of Hayden's anchor, I had to wonder if this trip was such a good idea after all. Jugging a rope is not usually a faith-based activity—you should be secure in knowing that your rope is well anchored. One of the things I love about climbing is the fact that

risk can be controlled. While the leader might choose to test his skill by sparsely placing protection such as nuts and cams in the cracks of the rock, anchors are the touchstones that mitigate risk and offer a respite. Looking up at Hayden and his awkward body position again, I knew that something was not right. And I was scared stiff.

At first, I tried to place as little weight on the rope as possible, smearing against edges in the rock with my winter boots. After three or four slips where my full weight came onto the rope and the fear rose into my throat like bile, the ridiculousness of these efforts became obvious. I committed myself to jugging as delicately as possible.

When I reached the anchor, I could hardly believe what I saw. Hayden had slotted two small pieces of gear behind an expanding flake of rock. Unable to find a better anchor, his third anchor piece was . . . himself. His right hand was on an edge, and his torqued body provided just enough tension to hold him, and me, to the wall.

I had been jugging from his body.

Tommy is one of the most laid-back people I've ever met. When he arrived at the anchor, he offered his advice in a clear, flat voice that underscored the seriousness of the situation. "Hayden, the one thing that will keep us safe up here is a good anchor," he said. His words gave more insight into his emotions than his voice, or his poker face. "If you can't find one, you need to downclimb and set one up."

Hayden was chagrined. He knew he'd screwed up. His matted hair protruded from his helmet as he avoided our eyes.

"Yeah, I know," he said. "You're right. As soon as Corey started jugging, I realized it. Don't worry—it won't happen again."

Hayden led one more pitch of 5.10 to a large snowy ledge just below the summit ridge. One easy pitch later, fifteen pitches after starting out, we were on top of the wall—and staring at a ridge like nothing we'd ever seen.

It extended like the serrated blade of a knife, sawing north toward the summit of Xanadu, in the distance. In places, it was an inch wide and, at times, razor-sharp. Lichen-covered, jagged, rimed in ice and snow, it

zigzagged toward Krakauer and Bullard's arête, which shot into the sky like a stegosaurus's spine.

"That looks awesome," said Hayden.

As I focused my camera on the back of his head and the arête soaring in the distance, I had to agree. The arête ran up the side of Xanadu like the steep, gabled crest of a pitched roofline.

We quickly began balancing our way toward Xanadu. Hayden accelerated as if he were running along a thin strip of sidewalk a few inches off the ground. He seemed oblivious to the void on either side.

I was relieved to see Tommy proceed with greater care. While sections of the ridge were wide enough to accommodate our boots, it narrowed in others, becoming so thin the only protection would have been Vise-Grips.

"Hey, Tommy," I called out at one particularly thin section. "What do you think about a rope?"

"I was just thinking the same thing," he said.

"Hayden!" I yelled. "Do you want to rope up?"

"No, I'm good," Hayden called back. "It's supercasual here."

Tommy pulled the rope out of his pack while I snapped a shot of Hayden moving along the ridgeline.

Then Hayden fell.

Through my viewfinder, I watched as Hayden's foot slipped and he plummeted down. Miraculously, he caught himself by his armpits and heaved himself back over the edge.

"Whoa!" exclaimed Tommy. He'd seen it, too.

"Hayden, you all right?" I yelled, the concern ruffling my voice.

"Yeah, no problem," he yelled back.

Ah, to be young! Hayden had an air of invincibility that was bolstered by how talented and comfortable he was in the mountains. He'd been climbing since he was a kid. His father, Michael Kennedy, was one of the foremost alpinists of the 1970s and '80s, with unrepeated ascents across the Himalaya. Though Hayden, called "the superyouth" by his climbing partners, was a decade younger than Tommy, he seemed well on his way to following in his footsteps as an all-around climbing stud.

Tommy and I continued along the ridgeline while Hayden navigated ahead of us. The scenery entered my

HAYDEN KENNEDY

peripheral vision as if by osmosis. Steep, pointed peaks rose up on either side of the ridge. In the valleys below, the endless talus that had tormented previous explorers was blanketed beneath vast stretches of white. Spring would come to this northernmost range eventually. But not for us. Not on this trip.

On the west side of the ridge lay 1,500 feet of air, the snow slopes we'd climbed, and—20 miles away, hidden by the rolling undulations of the Arrigetch—the landing strip where Jim was scheduled to pick us up in two days' time. To the east lay 2,000 feet of abyss.

This far north of the Arctic Circle, the light takes on a quality you never see in the lower latitudes. It seemed to magnify the details of the surrounding landscape like a gilded carnival lens.

It did not, however, provide much heat. The sunlit side of my head felt almost comfortable, but the dark side felt the cold bite of a land clad for 80 percent of the year in ice.

Hours later, with much of the day now gone, we reached a notch. We could once again see Jon Krakauer and Bill Bullard's arête. Below us lay the ramp system we thought might get us off the wall.

I looked at Tommy. He was looking down. I looked at Hayden. He was looking up.

It was getting late. The cold pierced my layers as if I were wearing a T-shirt. In the translucent light, Hayden's

bright green jacket shimmered, a vestige of the neon world we had left far behind. Continuing, we all knew, would necessitate an open bivy on top of the highest point in the range, and we were already wearing all our layers.

HAYDEN HAD AN AIR OF INVINCIBILITY THAT WAS BOLSTERED BY HOW TALENTED AND COMFORTABLE HE WAS IN THE MOUNTAINS.

We sipped from a shared brew of tea and discussed our options. I could tell Hayden wanted to climb the arête. His stoke burned so fiercely it seemed to warm him from within. I could tell that despite some mistakes, he was evolving, learning, and growing as a climber.

Still, Tommy and I decided it was time to head down. After the tea, the three of us began carefully downclimbing and rapping the snowy ramp off Xanadu's west face.

The moment we were out of the wind, the temperatures soared. We peeled down to base layers. In an instant, the events of the past twenty hours felt as if they'd happened to someone else.

As the Arctic sun cast its long rays, I took one more photo of Hayden downclimbing ahead of us, toward the base of the mountain and the future of climbing.

That we succeeded in completing a first ascent with such a small window of time felt somewhat miraculous. The experience was one in which we barely broke even

financially, but I came away with one of the most memorable adventures of my life. Just as it had been pitched in that initial phone call.

Postscript:

AFTER THIS TRIP, HAYDEN KENNEDY would go on to establish some of the most difficult alpine climbs of his generation. He avoided the spotlight and turned down many sponsorship opportunities in order to keep his climbing motivations pure.

Around 2016, he met Inge Perkins, a climber and skier from Bozeman, Montana. Like Hayden, she was young and extraordinarily talented.

After years of pushing the limits in the mountains, Hayden and Inge signed their first lease on an apartment in Bozeman so that Inge could finish school. Hayden, meanwhile, was working as a baker in a restaurant and considering going to school to become a nurse. On October 7, 2017, tragedy struck. The couple had gone on an early season ski tour in the Montana backcountry when an avalanche cut loose and buried both of them. Hayden survived the avalanche but couldn't find Inge. Burdened by guilt, he drove home and made the decision to take his own life.

What is there to say about such an awful tragedy? I don't know if I have the words—I don't know how anyone could. I'm left with the extraordinary sadness of having lost a good friend. And I'm thankful for the memories that I get to keep from my trips with him, such as this one. This isn't the first or last time I've lost a friend and climbing partner. But for me, it certainly remains one of the saddest.

35

THREE DEGREES
OF SHARMA

AROUND 2007, I STARTED WORKING with the team in charge of Aperture, Apple's professional photography software at the time. Jim Heiser, who was my contact at Aperture, asked me one day if I had any ideas for an outdoor-adventure project that we could do to create "rich media," as Apple was calling content that combined still and motion back then.

I didn't have an idea just then, but that didn't stop me from saying, "Of course. Absolutely."

I called up climbing/filmmaking brothers Josh and Brett Lowell, and we brainstormed about the project. We really could've done anything. But we quickly realized the right question wasn't *what* but *who*.

Who did we know who was reliable, proven, consistent, and really good?

We approached Chris Sharma. He was the best rock climber in the world, one of our close friends, and most importantly, he was always professional in situations like this. Reliable, proven, consistent, and really good.

We told Chris we wanted to shoot him climbing a new route at Céüse, in the French Alps, for Apple. At first, he didn't seem interested. He had other projects he was training for. And he had a new girlfriend.

"It sounds cool," he said, "but I'm busy with other things."

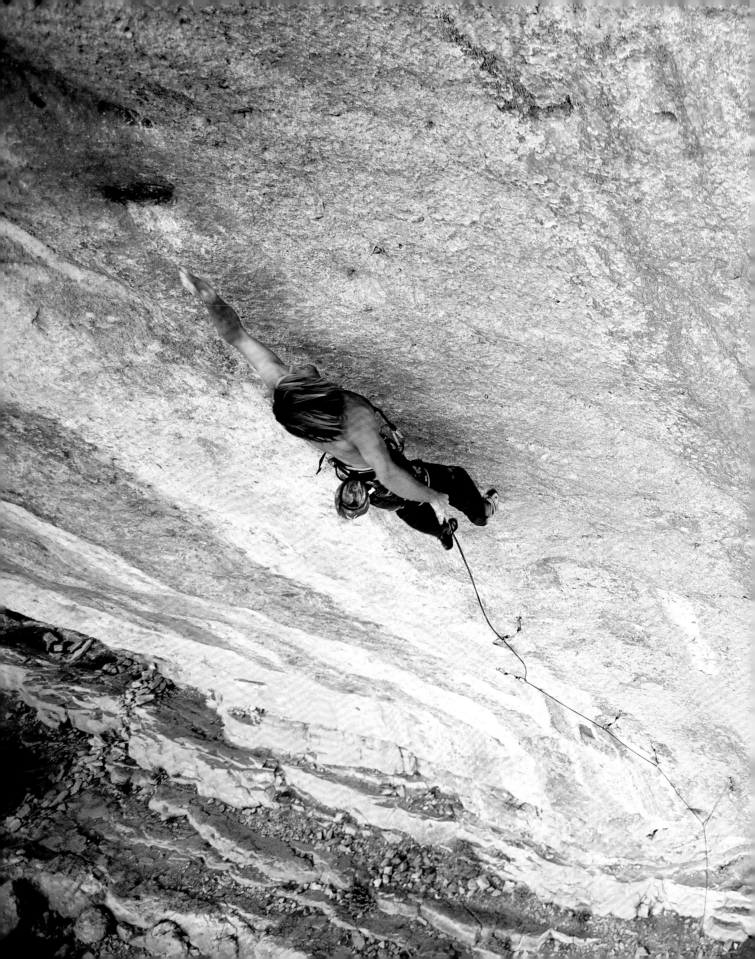

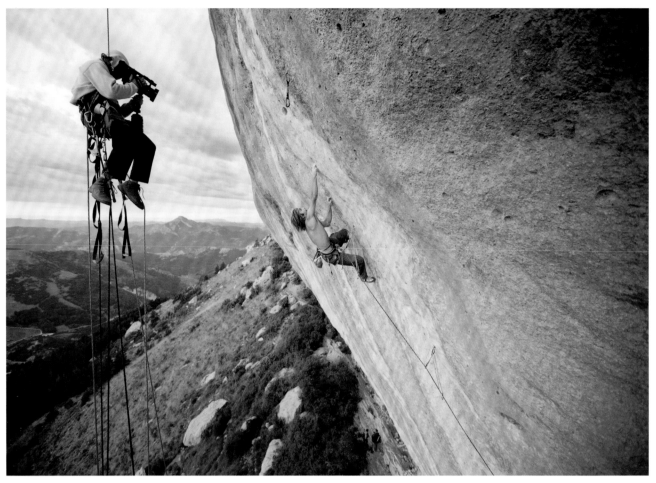

BRETT LOWELL FILMING CHRIS SHARMA ON *3 DEGREES OF SEPARATION* (5.14D), CÉÜSE, FRANCE

Chris actively says no to many projects so that he can put all his energy into one or two things that are the most important to him. Perhaps this is why he's such a great rock climber.

But it was a bummer for us.

We tweaked our pitch. We explained that the route didn't need to be anything hard or iconic—just something that a mainstream audience would find cool.

"I'd do it for a new laptop," Chris said.

"Oh, did we forget to mention that there's a new laptop for you if you help us out?" we said. "Of course you'll get a new laptop!"

We made that last part up. The arrangement with Apple was a bit unclear: nothing more than a loose handshake with Jim. But we were all invested, because the potential was there. When expectations are low, you can overdeliver and really impress an important client, and sometimes it's this kind of work that will lead to some of the biggest projects of your life.

I don't think Chris even owned a cell phone at the time, so the thought of a shiny new MacBook was surely enticing.

Josh, Brett, and I arrived in France and rendezvoused with Chris at the Céüse campground. Over a beer that night, Chris explained that he had found a line to bolt, but he had some concerns.

"I started bolting something today," he said. "But it's probably not that hard. Maybe only 5.13 or something."

Again, we told him we didn't care if it was superhard. It just had to look cool.

"Right on," Chris said.

The next day, we marched up the hill to Céüse, probably the best sport-climbing crag in the world. With its bulging swells, blue and gray sweeps of limestone, smooth

pockets and small edges, and situation high on a mountain-top plateau in the South of France, it's climber heaven.

Josh would film long shots from the ground, while Brett and I planned to jug up fixed ropes and shoot Chris from above. I would be shooting stills, while Brett would shoot video.

IT WAS INCREDIBLE TO BE HANGING ON A ROPE NEXT TO CHRIS WHILE HE WORKED OUT THE MOVES, PRACTICING THE DYNOS.

The real story behind this image, however, is the climb that Chris created. This route, this seemingly non-descript line that Chris may have never bothered bolting had we not approached him with this project, ended up becoming one of his great masterpieces. The route was not just an easy "5.13 or something," as Chris had thought. In fact, it ended up being a unique and difficult 5.14d, which is distinguished by three massive consecutive dynos (huge jumps between holds).

In between forgetting his shoes, food, and water regularly, because he was distracted by his new girlfriend, Chris spent that week working on the line. He completed it after a few days of effort. He called the route *Three Degrees of Separation*, in reference to the three dynos.

It was incredible to be hanging on a rope next to Chris while he worked out the moves, practicing the dynos. As I shot Chris doing his thing, I began to memorize the moves myself. Eventually, I knew what his body would be doing right before he executed. And that memorization contributed to capturing this shot, this decisive moment, which is probably my favorite picture of the whole trip. Chris is completely detached from the wall. You get a sense of how far he's traveling through the air. And you see how steep and big this wall really is. It tells a story and shows what this route is all about. It shows Chris, at peak form, in his element.

In the end, this is why we had called Chris in the first place. Because he's reliable, he's proven, he's consistent, he's really good, and he overdelivers, time and time again. And in the world of photography and filmmaking, the parallels are the same.

The footage ended up featuring prominently in Big Up Productions' *King Lines*, which went on to become the best-selling climbing DVD of all time.

And as for our work with Apple, though I didn't realize it at the time, this small project—like a gift from Jim Heiser—ended up opening a door to one of the most important clients of my career.

And as for that laptop we promised Chris? Well, I ended up just buying one for him for his hard work. I wouldn't be surprised if, all these years later, he's still using it, too.

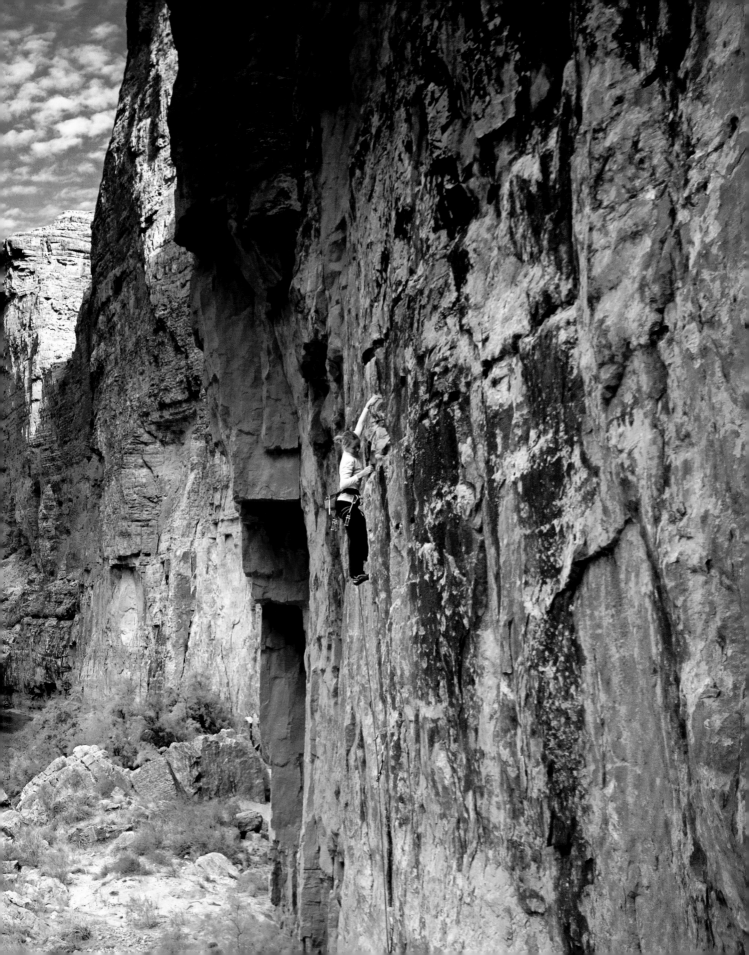

36

PULLING PERMITS
AND RIP CORDS

THE PHONE RANG. IT WAS Chris McNamara. Before I could even say hello, he blurted out, "You're about to get a call from a federal prosecutor. Don't tell him anything, OK?"

Geez! And here I was thinking Chris was going to ask me if I was available to go climbing that afternoon.

Chris immediately hung up, and before I could even process what all the fuss was about, my phone rang again. I tentatively answered.

"Hello, is this Corey? Hi, Corey. I work for the United States of America. I just watched your episode about climbing in the Grand Canyon on NBC Sports. It looked like a great trip. I'd love to ask you a few questions about your trip, if that's OK."

My head spun. What was going on here? I decided to take Chris's advice and got to use an all-time classic line. I said, "I think you're going to have to speak to my lawyer."

I swear I could hear this gentleman's frustration seeping through the phone.

"I'll be in touch with your lawyer," he grumbled, and hung up.

Let's rewind. Nearly two years earlier, I'd joined an exploratory climbing expedition down the Colorado River through the Grand Canyon. The trip was hatched upon the idea that the Grand Canyon, one of the country's premier geological anomalies, held potential as the next great mecca of rock climbing. With untold

WE BROUGHT WAY TOO MUCH BEER ON OUR GRAND CANYON TRIP, WHICH, YES, IS ACTUALLY POSSIBLE. PETER MORTIMER TAKES A SWIG, JOSH LOWELL CONTINUES TO WORK, AND MY BEER IS ABOUT TO BE CONSUMED.

miles of rock, including bands of granite, limestone, and sandstone, surely there would be something worth discovering there.

I conceived of putting together a twenty-day raft trip that would feature two star rock climbers, Tommy Caldwell and Beth Rodden, to tell the story of exploring the Grand Canyon by river through climbers' eyes. I would be joining a production team that included Pete Mortimer and Josh Lowell. We were going to create a story for Josh and Pete's Reel Rock Tour, as well as a spot for NBC Sports. We also brought on Dan Duane, who would write a story for *Men's Journal.*

Chris McNamara came because we all love Chris, and he was an aid-climbing master who could get a rope up on anything.

And my role was to shoot stills for the various editorial publications that would run stories about our trip, as well as advertising material for Marmot, a company that then sponsored Tommy and Beth, and was also supporting this trip.

Our trip ended up being incredible, in that I got to spend nearly a month in one of the most stunning locations on Earth with some of my best friends. The climbing, however, left something to be desired. Turned out the Grand Canyon would not be the next big climbing mecca. Still, we found some climbs and caves for bouldering.

Six days and 35 river miles into our trip down the Colorado River, I shot this photo of Beth Rodden scoring a first ascent of a nice 5.12d trad climb—probably the best route we found on our trip.

Since the Grand Canyon is a national park, there is all kinds of red tape surrounding what is and isn't allowed commercially, especially concerning production crews.

When it comes to pulling permits, my motto is "Always try to do it by the book," with the key word being *try*. There have been times throughout my career—particularly when I was operating as a one-man band or a small-footprint production doing a low-impact, low-visibility job on a tight schedule—when pulling a permit was overly burdensome or even unrealistic, and so I decided to roll the dice, take the risk, and just go for it sans permit.

RED TEAM: JOSH LOWELL, ME, TOMMY CALDWELL, PETER MORTIMER, CHRIS MCNAMARA

This wasn't one of those times, however. This was a big production for TV and a high-profile commercial shoot. So I went by the book, and my name appeared on all of the permits that we'd pulled in order to legally operate as a production crew in the Grand Canyon.

During this period, Chris McNamara was still in the wingsuit-BASE-jumping phase of his adventure-sports career. An early adopter, he became addicted to the adrenaline.

After a couple of years and several very close calls, Chris had witnessed the deaths of too many experienced jumpers, and he realized that if he continued to BASE jump, he was absolutely going to die. He articulated his reasons for giving up the sport in a brilliant essay called "A Short and Too Eventful Jumping Career," which I strongly recommend that you read. His essay is really a letter to other BASE jumpers, imploring them to consider their reasons for jumping, and to perhaps recognize that every time they jump, they're putting their life on the line. This hard decision to give up the immediate gratification of thirty seconds of flight by thinking long-term is one of the reasons I respect and admire Chris so much.

Anyway, prior to that decision, Chris still was that proverbial moth hovering around the flame, and BASE jumping was still very much a part of his life.

During our trip through the Grand Canyon, he wasn't just interested in discovering new climbs. He was also secretly there to check out the BASE-jumping potential.

BASE jumping is illegal in national parks, despite the fact that there's jumping in national parks all the time and jumpers simply try not to get caught.

Chris spied one good spot to jump from during the course of our Grand Canyon trip, and when he decided to do the jump, Josh, Pete, and I filmed it from the ground, because we figured, why not? We weren't sure if we were still in a national park at that point, as we were right on the border with Navajo territory. We had no idea if it would make the cut in our NBC spot.

Well, fast-forward nearly two years, and the BASE-jumping segment *did* make the cut, thanks to a last-minute decision by Pete—which was why I found myself lawyering up in advance of going to federal court. Due to my name being on the permit, I was in trouble, alongside Chris.

The irony of the fact that I was getting in trouble simply because this time I had actually pulled a permit and tried to do everything by the book was not lost on me.

We reached out to Dick Duane, an attorney from Berkeley who, along with legendary climber Tom Frost, helped get Camp 4 in Yosemite National Park recognized as a historic site. He agreed to help us because he loves climbing and especially climbing rebels.

The day we arrived in court, we watched the judge dish out seemingly harsh sentences to two Native Americans who were ahead of us in line. One of them had to go to prison for six months because he threw a can of beer at park ranger. I suddenly started sweating bullets.

"This courtroom is church, and he's the god," said Dick of the judge. "Remember, it's best to just smile and nod and say as little as possible."

During our hearing, the court clerk asked me to state my name and highest level of education.

"My name is Corey Rich. And, let's see, I'm about nine credits shy of a college degree, so I guess that makes me a high school graduate."

CHRIS MCNAMARA IN HIS ELEMENT, ENVISIONING NEW WINGSUIT EXITS

During the opening remarks, the judge leaped onto this fact to reprimand me. "You know, Corey," he said, "you're an idiot. There's no reason not to finish college. You need to go back and get that degree if you're ever going to make anything of yourself. But I'll come back to that later."

I wanted to tell this guy that I was doing just fine, thank you very much.

I was about to open my mouth and stick up for myself, but I remembered whose church I was in. Dick elbowed me in the ribs to make sure I kept my mouth shut and kept smiling.

Dick had reached a plea bargain in advance of our hearing, so in some ways this was all a matter of personal humiliation and legal formalities. Chris and I each had to pay a fine of several thousand dollars, and we were barred from entering national parks for six months.

To Chris, the judge delivered this memorable line: "If I see you in this courtroom again, you better bring your toothbrush," meaning that Chris would be thrown in the slammer.

Part of the plea bargain also involved this incident being erased from my permanent record, which means that, if I ever end up having to apply for a job working for, say, Walmart, I don't have to check the box that says I'm a convicted felon. As a guy with just a high school degree, I appreciate this.

Until then, I think I'll continue telling stories with my camera.

37

SINK OR SWIM

I DON'T KNOW IF THE spirit for adventure and the desire to swap stories over a cold beverage are genetic or if they're something learned, but either way my father played a big role in instilling these traits in me.

My dad, Dave, often spent his weekends either building things out of wood or scuba diving with his friends in the Pacific Ocean. He and his buddies would hop in the car on Friday night, drive out to the California coast, and enjoy a weekend of underwater adventure.

As a six- or seven-year-old kid, I remember my dad coming home with fantastic tales from the sea. Spearguns firing off the deck. Men overboard. Boats sinking. And, of course, tales of catching giant fish and oversized lobster. To my young ears, these were legendary yarns that both stoked my imagination and created a longing to one day have my own adventures.

When I turned thirteen, my dad deemed me old enough to join the men for a weekend of diving. I was enrolled in a scuba certification course that was held in a suburban pool out in the Mojave desert, where we lived. A few weekends later, having passed the course, I was out on the boat with the big boys. It was exciting to see this new underwater world and experience the different plants, marine life, and topography. I most enjoyed spending time with my dad and his friends. They'd drink beer, and I'd sip a Coca-Cola. This was big-time.

The scuba diving itself was, to be honest, less engaging than being around a group of adults who knew how to tell hilarious stories, which may or may not have

WHEN I WAS A KID MY FATHER, DAVE RICH, WENT SCUBA DIVING ALMOST EVERY WEEKEND OFF OF THE CHANNEL ISLANDS, CALIFORNIA. (PHOTO, CIRCA 1980, FROM RICH FAMILY ARCHIVE)

been totally true. My dad also pulled me aside to make sure that I was thinking about the risk.

"All joking aside, Corey," he'd often say, "this stuff is serious business. Make sure that you are methodical. Take it slow. Take all the necessary steps. Do it right. And whatever you do, don't fuck up."

That's how he said it, too. *Take it slow. Do it right. And don't fuck up.*

I was smitten with rock climbing, not scuba diving, but I still found myself with a mask on and dive tank strapped to my back once every five years. I kept a log of my dives, recording my progression.

I never thought that scuba diving would factor into my life as an adult, but one day I got a call from Dan Duane. He had pitched a story to *Men's Journal* about a group of extreme cave divers who were pushing the limits of risk and exploration in the underwater caves of Tulum, Mexico, off the Yucatán Peninsula. Dan described cave diving as being one of the most dangerous things you could possibly do. And these guys were taking it to the next level. *Men's Journal* had green-lighted the story, and they needed a photographer.

Underwater cave diving is so dangerous that it isn't even in most scuba logs. So few people in the world are capable of doing it, let alone willing to take on the risk, that divers who do seem to me like underwater astronauts. These caves aren't mapped, and there is zero natural light, yet they will swim for thousands of meters, if not miles, into caves that could collapse at any time. Anything less than world-class diving skills means you're dead meat. Just as important is having the mind control of a Jedi in order to keep calm and not freak the fuck out.

"So, Corey, how are your scuba skills?" Dan asked.

"Yeah, I can dive," I said. "Absolutely."

While that wasn't a lie, by any means, it wasn't like I was an expert diver, either. (Ideally, they would've called Brian Skerry, my fellow Nikon Ambassador, who actually knows what he's doing in this realm.) Still, as I've said before, my philosophy is to always say yes first and figure it out later. Especially if it's a project that will challenge me in new ways and potentially push me to the breaking point. I may have only taken a handful of underwater pictures, yet I was excited about broadening my portfolio.

CANOEING IN THE SIERRAS. MY DAD IS HOLDING ME, AND MY BROTHER AND MY GRANDMA ANNE ARE IN THE BACKGROUND. (PHOTO FROM RICH FAMILY ARCHIVE)

We arrived in Tulum and, the first night, sat down with four of the divers—Robbie Schmittner, Bil Phillips, Steve Bogaerts, and Kim Davidson—for some tacos and tequila. Robbie, who was the rock-star diver of the group, regaled us with tale after tale of all their horrifying near-death experiences in these caves. It was clear he was a pioneer, hooked on true adventure where the outcome is uncertain.

Cenotes are natural sinkholes that form when the underlying architecture of the limestone bedrock collapses and eventually fills with water—a mix of groundwater and saline ocean water. They're basically big pools in the jungle that open into a dark labyrinth of underwater tunnels and caverns that go for miles and miles, leading to the ocean, other cenotes, or to dead ends. Mexico's Yucatán Peninsula is pockmarked with some six thousand cenotes, representing an amazing frontier of exploration. Archaeologists say these cenotes were once used by the Mayans for ritual human sacrifice, and

that the Mayans believed them to be portals into the underworld. Today's underwater cave explorers have found ten-thousand-year-old human skeletons there.

Often, divers will have to squeeze through unknown tunnels no bigger than their bodies to reach the next chamber. It's like off-width climbing, only underwater, and with the very serious potential of running out of oxygen.

Because cave divers are never sure how far they can go or how long it'll take to get back out, they build stations with caches of spare dive tanks and lights. Surviving is largely a matter of building proper redundancies into everything.

What's most frightening is the fragile bedrock, which routinely collapses. Many of the cave walls, ceilings, and bottoms are also covered in silt, so you have to be cautious not to accidentally brush against a silt bomb—or lose buoyancy and crash into a wall—because it'll unleash a slurry of sediment that makes seeing

impossible and causes disorientation. Due to the fact that you only have so much oxygen, it's not like you can sit and wait for the sediment to settle.

MENTALLY AND PHYSICALLY, I WAS BEING PUSHED TO THE BRINK.

Robbie was busy describing one horror story after another, and I found myself gulping tequila a little more urgently. But at this point, there was no going back. I turned to Robbie and said, "Hey, I just want to be crystal clear. I'll do everything in my power to keep up with you guys and get myself into unique situations. But…please don't let me die!"

Robbie, an expat from England, laughed, tossed back another shot of tequila, and slapped me on the back. "You'll be fine, mate!" he said.

They were all so excited about having us in Mexico, and about this article, that I think they were willing to play the part of watchful guides and bring us through the fray. Or—who knows—maybe they were saying what I wanted to hear, and they actually couldn't care less if I sank like a sack of rocks.

The next few days tested all of my skill sets. I quickly realized that my diving was pathetic at best. I could get around, but not quickly or very easily or efficiently. I never really mastered maintaining neutral buoyancy, and most of the time found myself helplessly pinned to the top of the cenote—which, of course, I tried to pass off as my preferred position for shooting photos.

There were all these little fish that swarmed around me, nibbling on my hair and exposed skin at the entrance to each of the cenotes. The fish, along with the claustrophobic feeling of being very far underwater, engulfed in total mind-altering darkness, had me verging on panic, but I managed to stay collected, fortunately. I probably have my dad to thank for that skill.

When underwater, you obviously can't talk to or direct your subjects the way you would on land. I had to find ways to communicate with the divers using hand signals, gestures, and dive lights (underwater flashlights). As the divers could move around so much more quickly than me, I often relied on them to move my underwater strobes into position to help me light the shots—which involved a rather complicated bit of sign language.

This ended up being one of the most challenging shoots I'd ever taken on. Mentally and physically, I was being pushed to the brink.

By the last day of the trip, I was feeling more comfortable. I had learned how to focus, despite being gnawed on by human-eating fish. I was better at nailing the placements of the underwater strobes, and getting my subjects in focus and correctly exposed.

One of my best photos came on the last day of the trip, thanks to the chance to work with a medium I'm more comfortable with: ambient natural light. We had just entered a cenote that was filled with algae. And from underwater, the sunlit algae exploded into this incredible orange color. I dove deeper to shoot back up into this underwater kaleidoscope. And I made this picture of Bil.

It's a simple shot, but it's a hero shot. And it tells a story about where we are, where we came from, and where we're going—hopefully, as my dad would say, taking it slow.

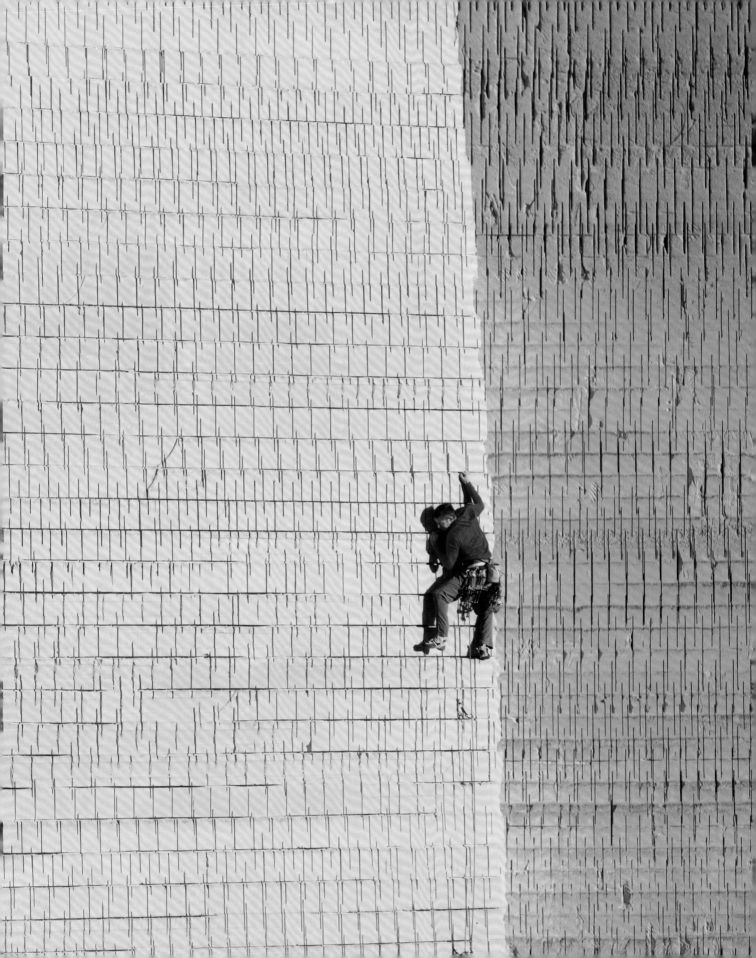

38

SAFE SHOTS

I HAD JUST FINISHED MY freshman year of college when I landed a coveted summer internship at the *Modesto Bee* newspaper. I was young and enthusiastic, and immediately found myself spending enormous amounts of time in the photo lab. Some nights, I even slept there. The group of writers, reporters, and photojournalists at the *Modesto Bee* seemed to find this endearing, because they took me in like a son.

Al Golub was the newspaper's photo editor. Standing an imposing six foot five and weighing 250 pounds, he had stature of a giant, but he had the heart of a teddy bear. He quickly became one of the most important mentors of my career.

Assignments were handed out each morning, and were due that afternoon. There was no time to screw around, go back, and reshoot something. Simply put, the newspaper depended on you coming away with at least one solid image from every assignment.

"Get the safe shot first, Corey," Al always said. "Then, and only then, start taking risks."

These were important words for a young, ambitious photographer to hear. At the end of the day, you have a job to do—and you'd better make sure you do that job before experimenting on the company's dime.

I loved walking into the newsroom each morning and finding out what the day's assignments would be. It was always something new, and always interesting.

"Corey, get in here!" Al commanded one morning. "What do you know about wieners?"

Huh? I thought.

Turns out, Oscar Mayer, purveyor of fine franks, had awarded a small local painting company a contract to paint something like fifty Oscar Mayer Wienermobiles. Today's assignment: a writer and I would head up to the paint shop and cover the Wienermobile story.

"Is it OK if I take the new Nikon body and the new twenty-millimeter lens?" I asked Al. The newspaper had just invested in a small fleet of new Nikon F4 film cameras and lenses. Of course I was eager to use one.

Al studied me for a beat. I was actually dressed nicely that day, as opposed to my usual flip-flops. I had on a jacket, slacks, new shoes, and even a button-up shirt and tie.

"Sure thing, kid," Al said, waving his hand and shooing me away. "Go for it."

I grabbed the camera, which was one of the last film cameras Nikon made, and a brand-new 20mm f/2.8 lens.

The writer and I drove up to the paint shop. We knew we were in the right place when we saw a fleet of 27-foot hot dogs on wheels.

"Mmm, I'm hungry already," said the writer. He was trying to be sarcastic, but being that he was a well-fed slob of a guy, I got the sense that he was serious.

The painter greeted us and told me that I was free to go wherever I wanted, but to be careful about getting too close to the paint gun because there could be overspray.

I stood back a bit, and with Al's advice about getting the safe shot first in mind, I steadily clocked a bunch of establishing shots, with the wide-angle lens, of the painter basting a glorious Wienermobile in tan-colored paint. Then I switched to a long lens and worked that angle. By this point, I had shot a few rolls of film and knew that I had at least one or two solid images to tell the story.

I moved in closer to the painter to get some more-creative pictures. Soon, I found a very unique angle: framing the paint gun in the foreground with the Oscar Mayer Wienermobile stretching out in the background. As I got bolder and bolder in pushing my creativity, I got closer and closer to the wiener painter. Soon, I was standing no more than a foot(long) away.

For some reason, the camera had stopped focusing. *Strange,* I thought.

WORKING FOR THE *ANTELOPE VALLEY PRESS* AS A HIGH SCHOOLER, MY RADIO HANDLE WAS "PHOTO 6" AND, AS YOU CAN TELL BY MY EXPRESSION, I TOOK CARRYING THE COMPANY RADIO VERY SERIOUSLY. (PHOTO BY EVELYN KRISTO)

Eventually, I realized the problem. The newspaper's brand-new lens and camera were coated in wiener-colored paint. And not only was the camera speckled, but so was I: my shoes, slacks, tie, and glasses, all of it painted the garish pink of processed meat.

The writer drove me back to office. He didn't even let me go home and change, forcing me instead to do the walk of shame into the newsroom.

"What in the...?" Al said when he saw me. He probably smelled me first, as the stench of paint hung in the newsroom air. Then his face twisted into a display of stern dismay when he looked down and saw the painted camera. He was about to scold me, but I cut him off.

"Listen, Al," I said. "You'll be happy to know... I got the safe shot first!"

He fumed, turned around, and shut the photo-lab door.

As I progressed in my career, I learned that the safe shot goes by many names. I like calling it the "CYA shot," for the shot that's going to cover your ass.

Coming away with nothing is never an option in this profession. Someone is paying you to get something that works. It doesn't have to be great. It just has to work.

But of course, we professional photographers have "aspirations of greatness," which sounds better than "delusions of grandeur." We think a career chasing

strictly CYA shots is not a career worth having. We want to take risks, because sometimes those risks are what really pay off, if not financially then at the very least in terms of something that is personally meaningful.

Of course, there's a balance. Safe shots can be great. You can cover your ass and capture a picture that you're proud of five, ten, or fifteen years later.

Years later, during a trip to the island of Malta with my friends Sonnie Trotter, Tommy Caldwell, and Tommy's then-girlfriend (now wife), Rebecca Pietsch, for a Black Diamond shoot, all of these lessons came back into play. With just a few days on the island, I made sure to get the safe climbing shots first, and then experiment in the time remaining.

Horrible weather and high winds kept us off the dramatic seaside cliffs for most of the trip. We barely got to climb in the location we'd originally envisioned. However, it ended up being somewhat fortunate, because we ventured inland to find other places to climb and shoot. Against all odds, we found an incredible ancient quarry that lent itself to some unique photography and climbing.

This image of Tommy trad-climbing the side of that ancient quarry isn't the greatest image I've ever taken, but it found its way into numerous catalogs, magazines, and ad campaigns.

And at the end of the day, it was this first shot I took—the "safe" shot—of Tommy scaling this unique stone wall that ended up being my favorite. The bottom line is, you can't come home with nothing.

Al Golub's advice is one of those enduring pieces of wisdom that I carry with me on every shoot: Get the safe shot first. Because so many times, it actually ends up being the best.

As for that paint-speckled camera? I think it's still sitting on the photo desk, an Oscar Mayer wiener–colored paperweight. And where the camera used to have a Nikon logo, someone used a Sharpie to write in my last name: *Rich*.

39
THE DAWN OF DSLR VIDEO

IN 2008, I BOARDED ARGUABLY the most life-altering plane ride of my career. Funny enough, I can't remember where I was going—whether I was flying out to my next photo assignment or returning home from the last one. All I remember from that flight was the edition of *Time* magazine I had picked up at a kiosk prior to boarding.

Plane rides are some of the quietest moments of my day. They are a welcome respite from the frenzy of shooting and directing. It's a block of time when I can sit down and get through all of my emails, process my life, and think about my career from a bird's-eye vantage of 30,000 feet.

Sometimes, though, I ignore the glut of emails and just sit back and catch up on reading or a movie.

I opened this issue of *Time* to a tech column that laid out the details of a new Nikon camera called the D90. Though the columnist wasn't a photographer or filmmaker, he made one very clear and compelling prediction: the future of filmmaking was about to change, all because the D90, with its small digital single-lens reflex and its wide array of high-quality fast, sharp lenses, would enable everyone to create cinematic-quality footage. And, at around $1,000, it was relatively affordable, too.

I fidgeted in my seat, curious about this new tech and daydreaming about the possibilities a camera like that might bring. Although I have to admit, I was skeptical.

At that point in time, I'd been a professional photographer for a good chunk of my life. I wouldn't say that I was feeling creatively stagnant or anything like that—but I was looking for the next challenge, the next opportunity, and the next new way to push myself and keep the creativity fresh.

I had always been interested in filmmaking and visual storytelling, and on occasion I'd experimented with recording both video and sound. Over the years, I'd picked up a half dozen conventional camcorders to play with, but I was always disappointed by the results. I had a high standard for image quality, but because I was nothing more than a curious filmmaking enthusiast, I couldn't justify dropping the coin to get a proper video camera with interchangeable lenses, which those days ran well north of $80,000. To get a true film camera would be even more, not to mention the cost of the film.

The bottom line: for me, filmmaking had always been too cost-prohibitive.

This article, however, intrigued me enough to decide to give filmmaking another shot. And if it wasn't my cup of tea, well—at least I could still make still photos with the camera.

As soon as we landed, I used my iPhone to call B&H and place an order.

The moment the FedEx guy dropped off the package on my doorstep, the D90 was all I could think about. Now I just needed a project to see what the camera could really do.

The camera arrived, coincidentally, the same week I got a call from my friend Josh Lowell. He explained that he was working on a new documentary—*Progression*—about the best climbers in the world. The film aimed to show how these climbers were pushing themselves and the sport forward, each in a unique, inspiring way. Tommy Caldwell would be featured prominently in the new film, as he worked to complete his audacious vision of free-climbing the Dawn Wall of El Capitan.

"Would you be willing to go up on El Cap with Tommy and shoot pictures and video?" Josh asked.

"Of course!" I said, without missing a beat.

"Great. I want to send one of my video cameras out to you to use as well. If you can shoot twenty-five

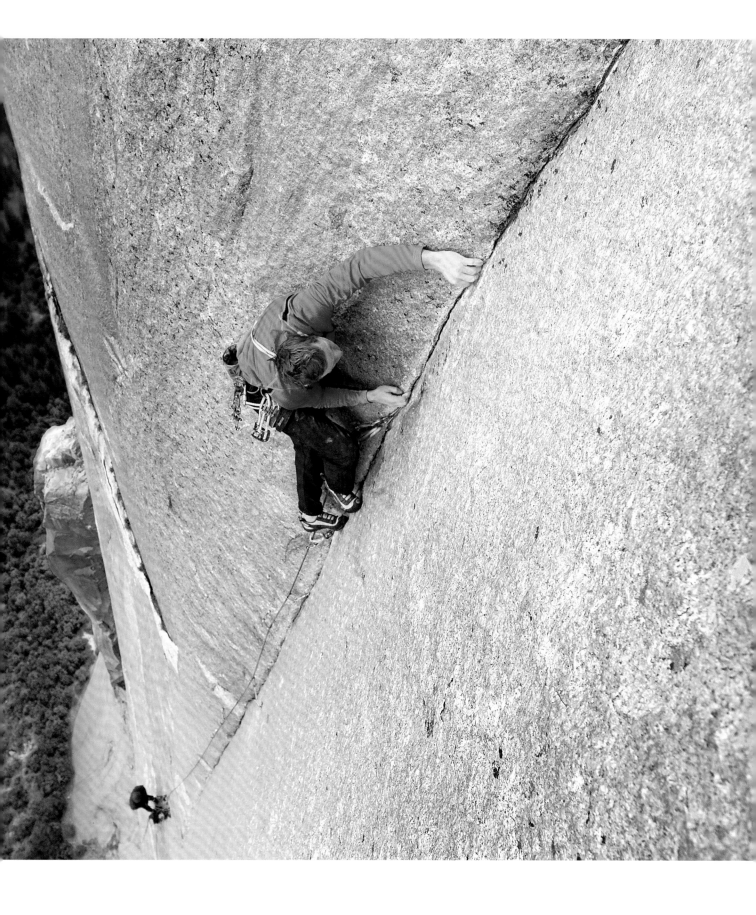

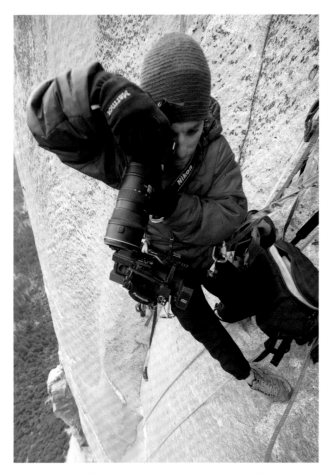

AN EARLY MISSION ON THE DAWN WALL (PHOTO BY COOPER ROBERTS)

"I don't know, Corey," he finally said. "I just don't think a DSLR can get video that is going to look good enough . . . I'll tell you what. I'll send my video camera out to you, you use that to shoot video, and you can use your new D90 to shoot stills. Deal?"

Josh has extremely high standards for his work, which is not surprising. Josh's father, Ross Lowell, was an Academy Award–winning cinematographer who instilled in his sons a perfectionist approach toward filmmaking. (Ross passed away in January 2019 at the age of ninety-two.) Josh and his brother, Brett, have also won dozens of awards, including an Emmy. Filmmaking excellence is in their blood.

I agreed to lug Josh's big, heavy camera up with me on the wall later that month when I met Tommy in Yosemite. However, deep down, I think I secretly knew that Josh's camera wouldn't see the light of day.

Shortly thereafter, I was up on the side of El Capitan. The California sun was beating on the wall, the swallows were making their routine dive-bombing missions down the sheer face of the monolith, and I was feeling happy and energized to be working in "my office." Few climbing areas get me as stoked as El Cap.

Once again, I was blown away by Tommy's climbing project. The Dawn Wall took one of the steepest, hardest, longest lines up the center of El Cap. The idea that anyone would ever be able to free-climb this route seemed almost too ridiculous to entertain.

Then again, it's never a smart idea to bet against Tommy Caldwell achieving something he puts his mind to. I've known him since he was a teen, and he's as

percent stills and seventy-five percent video, we'll have more than enough assets to make this thing work."

It seemed more than a little serendipitous that here I was being given an assignment to shoot both still and moving pictures, and I had also just received the world's first video-enabled DSLR. In fact, as I spoke to Josh on the phone, I was cradling my new D90 in my hands.

I pitched Josh on the idea of me shooting the whole thing with the Nikon D90. I figured that, of course, Josh would obviously leap at this opportunity to be at the forefront of filmmaking—as that *Time* magazine writer was predicting. It was a no-brainer! It would be perfect! Surely Josh would be just as excited for me to use the D90 as I was.

"Eeeeeeeeeeaaaahhhhh," Josh breathed into the phone, making that hemming-and-hawing throaty noise you make when you really want to say, "Absolutely no way!" but you don't want to be a dick.

> THE FUTURE OF FILMMAKING WAS ABOUT TO CHANGE, ALL BECAUSE THE D90, WITH ITS SMALL DIGITAL SINGLE-LENS REFLEX AND ITS WIDE ARRAY OF HIGH-QUALITY FAST, SHARP LENSES, WOULD ENABLE EVERYONE TO CREATE CINEMATIC-QUALITY FOOTAGE.

tenacious as he is talented. Impossible challenges are what this guy eats for breakfast.

There I was, spinning on a 10-millimeter free-hanging rope, dangling in space 2,000 feet above the ground, with my new D90 in tow. Quite an exciting location for my first assignment to capture both still and motion!

Cooper Roberts was also there filming for Josh. And Chris McNamara was there as well, belaying Tommy and giving support.

Though I knew jack shit about shooting video, the transition from still to motion felt surprisingly natural. I was using a Nikon camera body with which I was quite familiar, both in terms of the technical operation, the form factor, and the framing of the scene in a familiar rectangle. I was able to rely on the instincts I'd developed over a long photography career, only now instead of depressing a shutter button and putting my eye to the viewfinder, I simply had to hit "Record" and squint at an LCD.

Not to say that I nailed it. In fact, I made all of the classic rookie mistakes. I had no neutral-density filter, no tripod, no fluid head, no loupe on the back of the camera so I could actually see what I was filming in the midday sun. I didn't understand the correlation between shutter speed and frame rate (e.g., $\frac{1}{50}$ of a second = 25 frames per second).

I only knew I needed to keep the camera steady or move it smoothly, so I relied on a technique I'd honed from shooting climbing stills. I clipped my camera strap to the carabiner of my jumar (which was clipped above me to the rope I was hanging from), then tensioned the camera strap against the jumar, essentially creating two points of a tripod. Then I braced the camera with both hands to make it even more stable.

CHRIS MCNAMARA AND TOMMY CALDWELL AT HOME IN A PORTALEDGE ON THE SIDE OF EL CAP

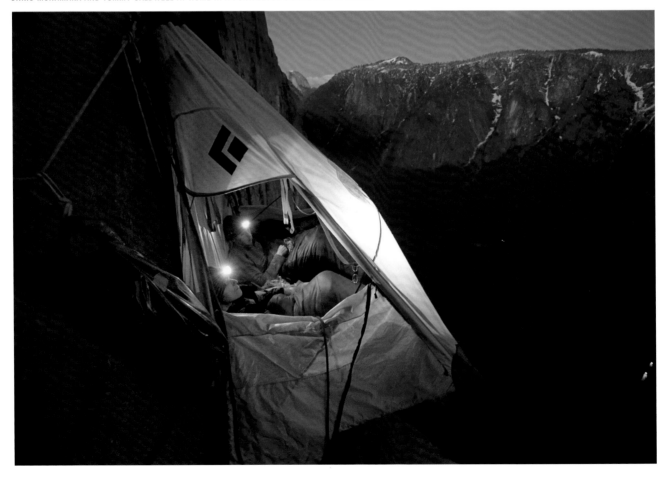

SCREEN GRABS FROM VIDEO: CALDWELL AND MCNAMARA COOKING WALL GRUEL ON THE PORTALEDGE; CALDWELL HAND-DRILLING A NEW BOLT; CALDWELL IN THE MIDST OF A SNOWSTORM

I tried it all. I was panning, tilting, making the camera move. I even found myself racking focus. I was so excited to shoot video that I almost forgot to capture stills. The footage looked sexy and cinematic. I'd never seen anything like it before.

I never recorded long enough. And I invariably missed a lot of action, because as soon as I stopped recording, I would pull my jacket over the camera and hit "Playback." And because I'd been busy trying to rack focus, I too often missed capturing the peak action in focus.

My excitement was now tempered with a bit of anxiety, as I worried about screwing it all up and returning home with no usable content for Josh. Why I didn't have the foresight to test the camera and learn how to use it first—on the ground—let alone send Josh test clips in advance, is beyond me. To this day, it shocks me that I came away with even a couple of good clips.

(A bit of side camera history: Around this time, Canon launched the 5D Mark II, which was like the Nikon D90, only it had full manual control and full HD-recording capabilities. As I was on El Cap, Vincent

JOSH HAS EXTREMELY HIGH STANDARDS FOR HIS WORK, WHICH IS NOT SURPRISING. JOSH'S FATHER, ROSS LOWELL, WAS AN ACADEMY AWARD-WINNING CINEMATOGRAPHER WHO INSTILLED IN HIS SONS A PERFECTIONIST APPROACH TOWARD FILMMAKING.

Laforet, a damn good shooter, was filming his famous "cologne commercial" in New York City using the 5D. The video short rocked the filmmaking world, because he was able to shoot in low light, in full HD, and on a full-frame sensor.)

When I got back to my desk in Lake Tahoe and downloaded the files, I realized that, first of all, I hadn't captured nearly enough stills. But I figured Josh would forgive me, because the video footage looked *amazing*. The shallow depth of field gave this footage a cinematic look that was really extraordinary—especially for 2008, when you couldn't get that look unless you were a Hollywood director using a hundred grand in camera equipment, or making delicate modifications to pro video cameras, which wouldn't have worked up on El Cap.

The real affirmation came when I shared the clips with Josh. When he saw the video, he was blown away by the quality. We all were. We couldn't believe it.

Josh used a ton of my shots in his film, which went on to be a huge success and helped him launch the Reel Rock Tour. We also used the footage I'd captured of Tommy with the D90 to create a piece for Nikon, which was my first real professional foray into filmmaking and the beginning of a long relationship with Nikon. However, when I look at the Nikon piece now, I don't think, "Wow, that's an amazing piece of filmmaking," because I know it's not.

Rather, to me, that piece represents the beginning of a new phase of my life, a gateway into a new career as a photographer *and* a director. It was a moment of technological innovation that paralleled my own progression. I took all that I had learned as a photographer and applied it, knowing now that I finally had the tools I needed to make storytelling—whether it was still or motion—an integral part of my future.

40

PUSHING PATAGONIA

IN THE AUSTRAL SUMMER OF 2009–2010, David Lama made the long journey to Patagonia, with partner Daniel Steuerer, his sights set on doing the first free ascent of the southeast ridge of Cerro Torre, one of the toughest mountains in the world.

The son of a Nepalese father and an Austrian mother, David started climbing at an early age and exhibited a preternatural gift for the sport, which earned him fanfare and big-time sponsorships, including that of the sports-beverage company Red Bull.

His objective had been tried by some of the sport's best alpine climbers without success. It was an audacious goal. Were he to succeed, it would be major news and a great story worth telling.

Adding to the climb's interest, the southeast ridge of Cerro Torre has an infamous role in the annals of mountaineering. To make a very complex story short, in 1970, an Italian climber named Cesare Maestri placed hundreds of bolts on the mountain using a gas-powered air compressor, a wholesale construction project that incited purist climbers such as Reinhold Messner to denounce the ascent as the "murder of the impossible." Decades later, the climbing community continues to debate the demerits of Maestri's actions.

David Lama's sponsors recognized that this would be an incredible story to capture, and Red Bull put together a seven-figure budget to make a movie about its star climber's efforts on Cerro Torre.

Still rather young and inexperienced, David inadvertently ended up becoming the face for yet another Cerro Torre imbroglio, which, at least temporarily, nearly

squelched his promising career, when one of the riggers on the film project added at least thirty bolts to the mountain. Apparently, it had been done for the safety of the camera crew, but to the climbing community, this act was as sacrilegious as spraying graffiti on the walls of Mecca. Overnight, he became the most hated climber in the world: a symbol of brash young egotism that lacked vision, talent, boldness, and respect for the traditions of mountaineering.

Any lesser human would've been crushed by this degree of community ire, not to mention the public-relations nightmare created for his sponsors.

But not David. To his credit, he stepped up to the plate and apologized profusely on behalf of his entire team, accepting full responsibility, despite the fact that he hadn't actually placed any of the problematic bolts himself.

David returned to Patagonia two more times. And in 2011, I joined him and his partner Peter Ortner to document his ongoing battle to free-climb Cerro Torre.

As a classically trained photojournalist, I've always learned that I should make myself as inconspicuous as possible—that is, simply document the story without judging, influencing, or participating in the outcome of the events.

But the reality of producing adventure storytelling media involves a drastic departure from the traditional fly-on-the-wall style of documentary work. Capturing today's cutting-edge climbs is nothing like, say, photographing a golfer sinking a putt at the Masters. There are no press boxes up on Mount Everest, offering photojournalists a removed, sheltered vantage from which they can safely record the action.

When you tie in to a rope with two other climbers, you aren't *just* the photographer; you're a member of the team. There are shared risks and responsibilities, and you necessarily become part of the decision-making process that goes into executing an ascent. You're there participating, but also striving to create the illusion that you aren't there. This can create complex, sometimes logistically conflicted situations, in which you are focused on making pictures, but you also don't want to slow the climbers down.

> PHOTOGRAPHY IS THE ART OF
> ANTICIPATION. THIS IS A REAL-
> LIFE GAME OF CHESS, AND
> THE BEST PHOTOGRAPHERS
> ARE THE ONES WHO CAN
> THINK TWENTY MOVES AHEAD.

I'm always thinking through a multitude of logistical challenges. Which lens do I have on my camera? Am I trying to stop action? If so, at what shutter speed? Do I want shallow depth of field? What's my aperture? Is the sun going to move behind that cloud? How many batteries do I have remaining? Should I switch CF cards? Is this a still situation or a video situation? And the list goes on.

Most importantly, I am thinking about where I want to be relative to my subjects. On an alpine climb, this can be distilled to three basic questions: When should I get ahead? When should I fall behind? And when should I jump off to one side?

Photography is the art of anticipation. This is a real-life game of chess, and the best photographers are the ones who can think twenty moves ahead. What will happen ten seconds out, one minute out, five minutes out, three hours out, and even the next day? A good photographer knows all those answers.

For this picture of David and Daniel approaching the slender turret of granite and ice that is Cerro Torre, lit by the rising sun, I made the decision to fall behind and move to the left. I captured a number of frames as the overstoked climbers marched ahead toward their shining objective.

I was happy to have made this image, but I quickly realized that I had fallen so far behind that I would need to double-time it to catch up with my partners.

This is the balance: You don't want to be the person who is constantly calling ahead, asking your partners to wait for you to catch up. Nor do you want to be the person who is constantly asking your team to pose, to walk/climb in front of the camera multiple times to make sure you get the shot.

In my experience, you can ask those kinds of favors only a few times before you cross the line and become a drag. You want to have minimal impact, but you also need to do your job. Finding that balance is the key to success not just on one climb, but on all the ones that follow.

This trip with David to Patagonia led to many others together around the world, to the Alps, Pakistan, and the Middle East. David continues to invite me on his adventures, and I think that's because he sees me not just as a photographer/filmmaker, but as a climbing partner. Someone he can trust.

In 2012, Lama finally achieved his goal of free-climbing Cerro Torre. He did it in perfect style, without the help or aid of most of Cesare Maestri's bolts. He had achieved his goal, and in the process he both greatly matured as a climber and regained the respect and admiration of the entire climbing world.

Pretty incredible, if you think about it.

As grim and dark as life got for young David during his three-year saga with Cerro Torre, he never gave in, and he always held fast to the attitude that better days lay ahead.

This photograph of these two climbers walking through a dark valley toward a brightening, sun-kissed Cerro Torre has become an apt visual metaphor for David's optimistic attitude, and I often look back on this picture to remind myself how important it is to maintain a positive outlook, whether that's in the mountains or in the business of photography. No matter how dark the valley gets, it's good to remember that *you* are responsible for shaping your future, and that better, brighter times lie ahead.

The trick, sometimes, is just doing your job and keeping up.

41

THE FOURTH ELEMENT

AFTER FILMING TOMMY ON THE Dawn Wall with my Nikon D90 (see Chapter 39), I was hooked, and I began to slowly spend more time shooting video than taking pictures. Photography was still my bread and butter, yet I couldn't stop raving about the future of DSLR filmmaking.

I was invited to SanDisk to give a presentation on the subject of combining stills and motion. After the presentation, one of the company's employees approached me with a very direct question, one that caught me off guard.

"How do I make great pictures?" she asked.

It was a flattering thing to be asked, and at first, I wasn't sure how to give a decent answer. After all, my head was on a different bandwidth, thinking more about filmmaking than photography.

I recited the fundamentals. "I guess they say that there are three things that make a good photograph," I said. "Composition. Light. And moment."

Composition means considering how you want to frame your subject in order to create the most striking image. The often-cited guideline is the "rule of thirds," in which you imagine your image as a grid of nine equal parts divided by two equally spaced horizontal lines and two equally spaced vertical lines. You then place your subject either along these lines or at those intersections—as opposed to dead center. This can create photographs with more tension, energy, and drama.

Light means considering where the light source originates, and what its quality is. After evaluating the source and quality of the light, you go through a thought process that might involve simply tweaking your ISO, aperture, and shutter speed,

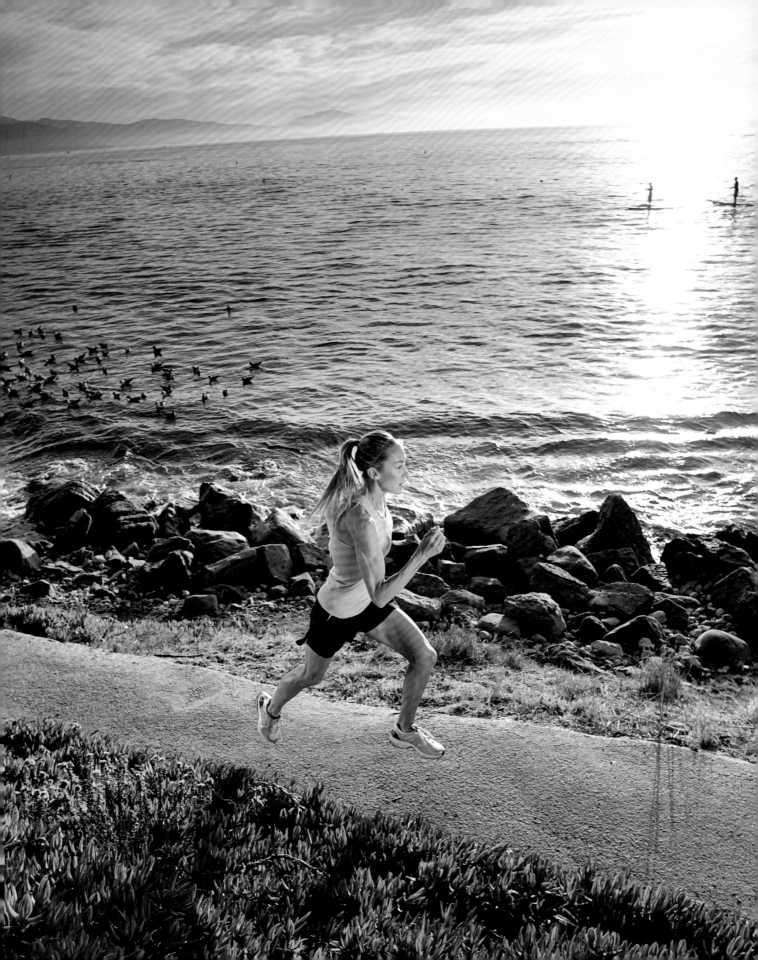

or using reflectors or flashes to create the lighting effect that will best bring out the elements and details most important to your photograph, or altering your camera position to make the angle of light more interesting.

Moment means considering when to press that shutter. A second too early or too late might mean that you miss that perfect expression in your portrait or that crazy moment of action. Timing is everything.

As I recited Photography 101 to this young engineer, it occurred to me that there's also a fourth element that many great photos seem to share. That is, the element of serendipity.

One photo came to mind as being illustrative of having all four of these elements, and it was this running photograph I took a few years ago during a catalog shoot for Road Runner Sports. The composition embodies the classic rule of thirds, with the horizon of the ocean in the upper third, and my running subject placed along the lower third. The light from the sun over the Pacific adds a nice dramatic element, but its position behind the runner meant we needed to use reflectors to fill in the shadows and illuminate our subject so that she really pops. Then, there's the moment, timed to freeze her stride right when her pose is most active and energized, with both of her feet off the ground.

But what makes this shot better than average are the two standup paddleboarders who just so happened to drift into the shot and frame themselves perfectly around the sunlight reflecting off the ocean. This little detail, this serendipitous occurrence, was a gift that I couldn't have scripted. But this kind of stuff happens all the time, and what I've learned is that to get that rare fourth element in your photos, you have to keep shooting. Don't put the camera down.

What I later realized was how these fundamentals are equally as important to filmmaking, especially DSLR filmmaking. That idea of "don't put the camera down"

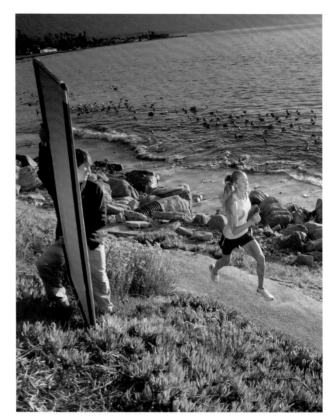

TREVOR CLARK BOUNCING LIGHT ONTO THE SUBJECT WITH A 3X6 FOOT REFLECTOR

translates in the video world to "don't stop recording too early." Let the action unfold, because so often there are these serendipitous moments that happen that will make your shot better than anything you could've scripted.

The other thing I realized was that I was approaching filmmaking the way this young SanDisk employee was approaching photography: as a beginner, with an open mind and willingness to ask even the most basic questions.

I was starting to see a new direction for myself, one in which I would become a filmmaker. But I still wasn't sure what the future held. And I left that presentation wondering what serendipity might come my way.

BRAD JACKSON - LAKE TAHOE, CALIFORNIA
85MM LENS / F/11 / 1/200 SECOND / ISO 100

42

THE HUNTER AND
THE HUNTED

SOMETIMES, IT TAKES A LOADED weapon pointed directly at your head to make you realize that you might have a problem.

But not for me. I already know my problem.

"Hi, my name is Corey. I am addicted to photography, and I will do almost anything it takes to get the shot. I will even beg the guy with the drawn bow and the razor-tipped arrow to *please* let me stand directly in his crosshairs!"

Meet Brad Jackson. He is a former fire captain and the ultimate dude. Now retired, he's focused on the good stuff: climbing, biking, fishing, skiing, hunting, or just tying flies.

Brad and I met when I first moved to South Lake Tahoe, and we instantly became friends. At one point in time, we were both bachelors, and we were each other's wingman. We climbed and skied together, and our days often ended with the clink of two beer bottles in a bar or on the tailgate of a truck.

One night, Brad regaled me with hunting tales. I confessed that I knew nothing about hunting, and even less about the hunting around Lake Tahoe. Brad vowed to change that, and soon we made plans for a day of shooting—both hunting and photography. I made some pictures of Brad hunting and learned a bit about the oldest sport in the world.

Nearly a decade later, my career as a hunter had yet to get off the ground, but my photography skills had improved. I was in a period of experimentation, actually,

BRAD JACKSON IN HIS ELEMENT IN GARDNERVILLE, NEVADA

trying to broaden my skills even further, and I'd organized a shoot using high-contrast studio strobes in a CrossFit gym (see Chapter 33).

On Sunday morning, the second day of the shoot, Brad walked out of the gym after pounding out a hundred air squats during his workout.

Suddenly, I had a vision—an idea for a photograph! Brad in full camo clothing and camo face paint, with a bow. We already had all of these lights set up for the CrossFit shoot. Why not leverage this situation and get the most bang for my buck?

Opportunity was knocking, and my photo-junkie brain responded.

"Brad, do you have time to come back this afternoon for a portrait? It'll only be fifteen minutes, I promise!" I said.

Brad, who knows me so well, found this a familiar request. He understands the searing obsession I have for making photographs. He knows that, for me, chasing a good image is as alluring as hunting down a ten-point buck is for him. He knew there was no way he was getting out of this one. He smiled and agreed to return that afternoon in full hunting costume.

When he arrived, I moved one of the CrossFitters I was photographing out of the way. Using almost the same lighting setup, I dropped Brad into the scene. There was almost no prep time. And I stayed true to my word and got this photograph within fifteen minutes.

However, it's not exactly the shot I wanted. The photograph I most wanted was the razor-tipped arrow pointed directly at the camera, bow fully drawn. But this is where Brad, being much smarter and wiser, drew the line.

"Safety is no accident, Corey," Brad reminded me.

I sighed. He was right. If something went wrong, the arrow would have pierced my Nikkor 70–200mm lens and skewered my skull, making for one gruesome-looking kabob. I settled on this side angle . . . though you've gotta admit: the head-on photograph would've been cooler.

Safety is no accident indeed, but neither is great photography. Getting a diverse body of work is all about being proactive and recognizing an opportunity when you see it. Hunt these moments down, and when they're finally in your crosshairs, make sure you don't miss.

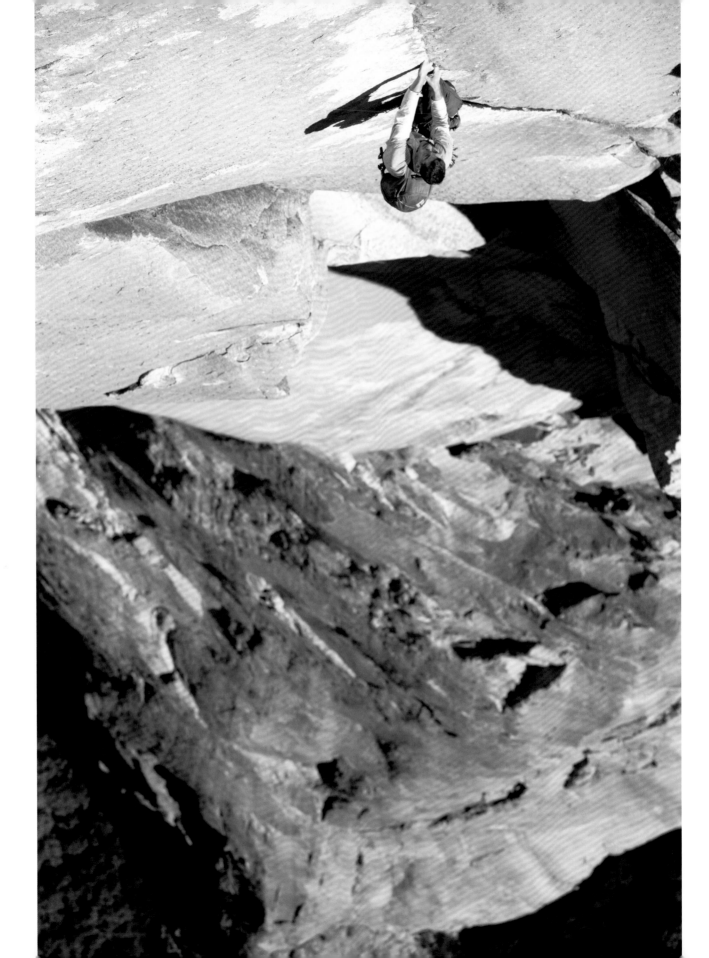

43

FREE-SOLOING EL CAP

WHAT DO YOU THINK WHEN you see this photograph, other than, *What the fuck is that guy doing up there without a rope?*

Does anything about your reaction to this picture change in knowing that this photo—of the famous free soloist Alex Honnold, climbing without a rope 2,500 feet up the *Nose* of El Capitan in Yosemite—was staged for a photo shoot?

Which details matter?

In my life as a professional photographer and filmmaker, one of the questions I most consistently wrestle with is whether to call my work art or journalism—or something in between. As an adventure photographer and filmmaker, I often find myself in situations where I am working with legit athletes facing dire consequences, but sometimes the reasons for creating the shoot aren't documentarian in the strictest sense.

In 2010, Alex Honnold, climbing alone, mostly free-solo, climbed Half Dome and El Cap in under eleven hours—an incredibly fast time. The enchainment was big climbing news back then, even if in Alex's mind it was "no big deal."

Like most climbing achievements, Alex's ascent took place without a stadium-sized audience or even a single camera in tow. One of the most incredible athletic feats of all time happened, and, for all intents and purposes, no one saw it.

So a few days after Alex's linkup, I teamed up with Renan Ozturk, a renowned climber and filmmaker. Together, we collaborated with Alex to re-create his record-setting achievement.

211

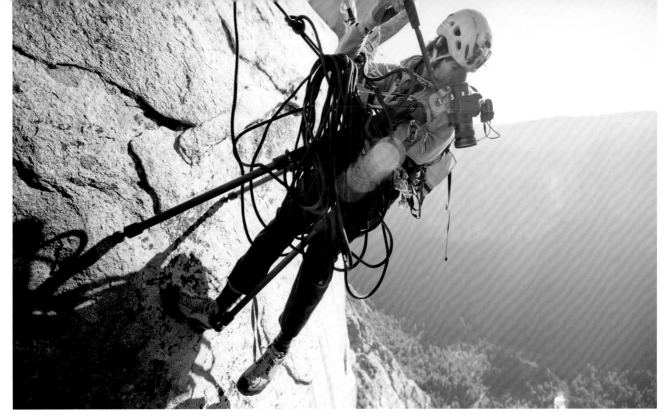

RENAN OZTURK SHOOTING VIDEO OF ALEX HONNOLD ON THE *NOSE*. RENAN WAS THE FIRST FILMMAKER I EVER SAW USING A TRIPOD ON EL CAP.

Alex, Renan, and I hiked up the back of El Cap, jugged up the East Ledges, rapped down the *Nose*, and got into position. Then as Alex resoloed certain sections of the iconic granite big wall, Renan shot video and I shot stills. Together, we all joined forces, carefully and thoughtfully capturing the essence of what Alex had accomplished.

Renan's and my role in this situation was simple. We were there to help Alex share his immense achievement with the world. If we were successful, we would be showing people something they'd never before seen. If we were lucky, people would find it inspiring.

I'm not sure if many people realize the degree to which most outdoor-adventure media is re-created in the aftermath of the actual event by a production team working with the athlete.

Or that if the event is not itself re-created, the shoot will often involve a degree of coaching and direction:

Look that way. Stand here. Ski close to that tree. Move your surfboard to the right. Take your pack off. Walk toward me. Don't look at the camera.

And the all-time favorite: *Could you do that one more time?*

I admit that this is a difficult pill for us core outdoorsy people to swallow. Imagine if you found out that the World Series was actually played in advance, on a private field without an audience, and then once the game had ended, parts of it were reenacted for cameras on a Hollywood set—with that footage then edited down in order to provide viewers with the "essence" of what had taken place.

(Come to think of it, this might not be such a bad thing if it meant we didn't have to sit through all nine innings of a baseball game . . . but I digress.)

Again, it's not a stretch to say that this is how most outdoor-adventure media is created: It's re-created. Or scripted. Or at least directed. Why? Simple: the logistics of capturing these dangerous, inspiring, incredible adventures are formidable, especially when compared to, say, shooting a baseball game, where the environment is contained and controlled, and the event is scheduled to happen at a precise time of day.

Recording, in real time, a climber performing on *his* playing field as he solos up a 3,000-foot vertical face is as overwhelmingly complex as it sounds. It would probably involve preinstalling multiple camera crews

all the way up Yosemite's greatest monolith and having helicopters standing ready for the day and time when the climber arrives at that rare, inspired moment and decides to go for it.

Not even Hollywood, let alone the outdoor industry, has the budget for this kind of production. Nor does it even necessarily make sense to approach making media like this—and it would put a huge amount of pressure on the athlete. Also, it's unlikely that you'd get all the necessary content in one go; pickups would still be needed.

All artists, writers, journalists, and, yes, even filmmakers and photographers, are ultimately seeking truth. We struggle and strive to achieve something resembling that lofty ideal through our various crafts, and this is where our sensibilities as artists come into play. What ultimately matters when it comes to rendering a work? In the end, anything we create—as "successful" or powerful as it may be—will still be but one interpretation of truth.

Take this photo. In one sense, it's as real as it gets. There are no smoke and mirrors. No downright deceptions. We did not Photoshop Alex onto the wall. Were Alex to have slipped the moment after I depressed the shutter, he would've fallen 2,500 feet to the ground below. This is a real climber, on a real route, taking a real risk.

However, during the original ascent, Alex wasn't on this part of the route during this time of day. He was probably wearing a different shirt. He might've looked more tired. (Though, knowing Alex, I doubt it.)

Do these details matter? Is the authenticity of the achievement sacrificed in the re-creation, or honored?

I think these questions are important for any photographer or filmmaker to wrestle with. There are no right answers, though I will say that I believe it's important to make no attempt to hide these details by pretending that this photo was taken during the actual climb. I'm completely open about the fact that this shot is a re-creation of another event, taken in the aftermath, exclusively for the purpose of making the visuals to showcase how inspiring the story is.

This photo is real. Yet... you could also argue that it's somehow not real. And the journalistic side of me continues to struggle with that. But the artistic side takes solace in seeing the bigger picture: that this image tells a greater, better, and truer story than the one I could have documented during the actual event.

These are the details, I believe, that matter.

Postscript:

IT'S WORTH MENTIONING A COUPLE of major events that have happened since this essay was first written. First, on June 3, 2017, Alex Honnold succeeded in his dream to become the first person to free-solo El Capitan via the 5.13a *Freerider* route. This mind-blowing achievement surely ranks as one of the greatest moments in rock climbing, and it's been incredible for me to see how this ascent has launched Alex into a new realm of success and celebrity. "I'm kind of a big deal now," he sheepishly admitted to me as he picked my brain for recommendations of contractors to help him renovate his family's cabin, which he had just purchased, in Lake Tahoe. (Once I told him how much contractors actually cost, he reversed course. "Hmm, maybe I'm not that big of a deal after all!" he joked.)

The second thing I wanted to mention is that my friend and fellow filmmaker Jimmy Chin spent years hard at work codirecting a film with his wife, Elizabeth Chai Vasarhelyi, about Alex's life, with the climax being the free solo of El Capitan. Jimmy and Chai's documentary *Meru*, which won a prestigious audience award at Sundance in 2015, was one of the first climbing films that proved that core climbing stories do have a place in the mainstream. And it was fresh off that film's success that he took on a new film, using many of the tactics I described in this essay, re-creating moments of Alex's solo but also putting in many days on the wall and using multiple crews in order to capture the authentic moments from the actual event. The film, called *Free Solo*, came out in September 2018 to rave reviews and box-office success. And in February of 2019, it won the Academy Award for Best Documentary. Seeing my friends onstage at the Oscars, in tuxedos and evening gowns, was one of the most surreal moments I've watched on television. Their success was well deserved—and more proof that climbing, in the hands of the right storytellers, has the power to transcend our niche world and inspire the rest of society.

44

DIRECTING *WHY*

SITTING AT MY DESK IN the middle of a late-night editing session in California, I heard my iPhone buzz with an incoming call. I picked it up and saw a curious number from Tokyo. I had no idea who could be calling me from Tokyo but answered anyway. My life seems to contain this recurring motif in which the coolest opportunities almost always begin with a random, out-of-the-blue phone call. It's rare . . . but it has also happened often enough for me to know that I should always answer my phone.

I was floored to discover that I was speaking with a team at the K&L ad agency, which represents Nikon globally. They said they had a project for me, but first I had to fill out some nondisclosure agreements. I hung up, filled out a bunch of documents, and emailed them back as PDFs. Thirty minutes later, I was back on the phone with K&L and the creative director, Gen Umei.

Nikon, Gen said, was launching a new camera, but they couldn't tell me what it was called. They referred to it by a code of numbers, which would ostensibly prevent leaks. They asked if I was interested in shooting still photographs and creating a film that would help launch the new camera. They described in great detail all of its new technical attributes. It sounded light-years ahead of its time.

But the part I'll never forget was when Gen said, "Corey, we want to empower you to do something special. We want to give you a big, blank white canvas and let you create whatever you would like."

This was one of those moments that all creative people dream of. I would get complete freedom to tell any story I wanted so long as it illustrated the new still and motion feature sets of the top-secret camera.

After hanging up with Gen, I sat back in the chair at my desk and took in the enormity of what had just happened. I had been plugging away at shooting motion projects for a few years but still really didn't know what it meant to be a director of photography, director, or, dare I say, filmmaker. Of course, having this kind of freedom was a blessing, but it was also partially anxiety-inducing, because I now had to come up with a damn good idea. This pressure was something I was familiar with from my work as a photographer, however. The client, no matter who it is, doesn't want to hear excuses. They just want you to deliver. Period.

I spent a few days brainstorming what I wanted to do—hiking, mountain biking, sleeping, etc.— and eventually arrived at a concept that could be described by a single word: *why*.

What that word meant was exploring the reasons we do the things we do. I was interested in finding three prolific adventure athletes and getting inside their heads to understand what drives them to push the limits every day.

I wanted to profile athletes who were the best at what they do. They also had to be amazing people, role models, and heroes. I made a list of ten or so people, roughly in the order of my preference for who I would want to work with first. I was delighted to only have to make three phone calls to my top three choices, all of whom said yes.

This A-list of athletes included Alex Honnold, one of the boldest, most gifted free-solo climbers ever (see Chapter 43); Dane Jackson, an extraordinary whitewater kayaker and part of the Jackson dynasty of kayaking (see Chapter 24); and Rebecca Rusch, "the Queen of Pain" and one of the most driven mountain bikers, male or female, in the world (see Chapter 32).

I never went to business school, but suddenly I was in the position of being the CFO, so to speak, of this production. I was given a flat amount of money to make

everything happen, and had to consider the cost-benefit of every single decision. From the get-go, I decided that because this was such a unique opportunity, I didn't need to make a lot of money. I was going to spend as much as was necessary to create something powerful and special, something that I could be really proud of. To me, that's all that mattered.

In the process of conceptualizing the film, I started conversations with each athlete about where, when, and what we would shoot. I wanted to capture the authenticity of their spirit and passion, so I asked each of them which location would best represent who they are as an athlete. We also had to consider logistical challenges, such as the time of year, as well as locations with the right aesthetic for the film.

Through those conversations, we decided to shoot Dane in Veracruz, Mexico, with its high-flowing rivers, waterfalls, and jungle setting. We'd shoot Rebecca in Moab, Utah, for its beautiful red slickrock. And we'd shoot Alex in Joshua Tree National Park in Southern California, where he was interested in free-soloing a specific rock climb called *Equinox* (5.12c).

> I WAS GOING TO SPEND AS MUCH AS WAS NECESSARY TO CREATE SOMETHING POWERFUL AND SPECIAL, SOMETHING THAT I COULD BE REALLY PROUD OF. TO ME, THAT'S ALL THAT MATTERED.

I knew Veracruz would be the most logistically challenging location, due to the fact that it's a wet jungle in narco/guerilla country. If I'd had it my way, I would've preferred to shoot Veracruz last, in order to allow myself time to become familiar with these prototype cameras in the less committing locations of Moab and J Tree. Unfortunately, I didn't get my way on this one point. Due to schedule conflicts, it would be *vamos a Veracruz* first, a development that made me nervous.

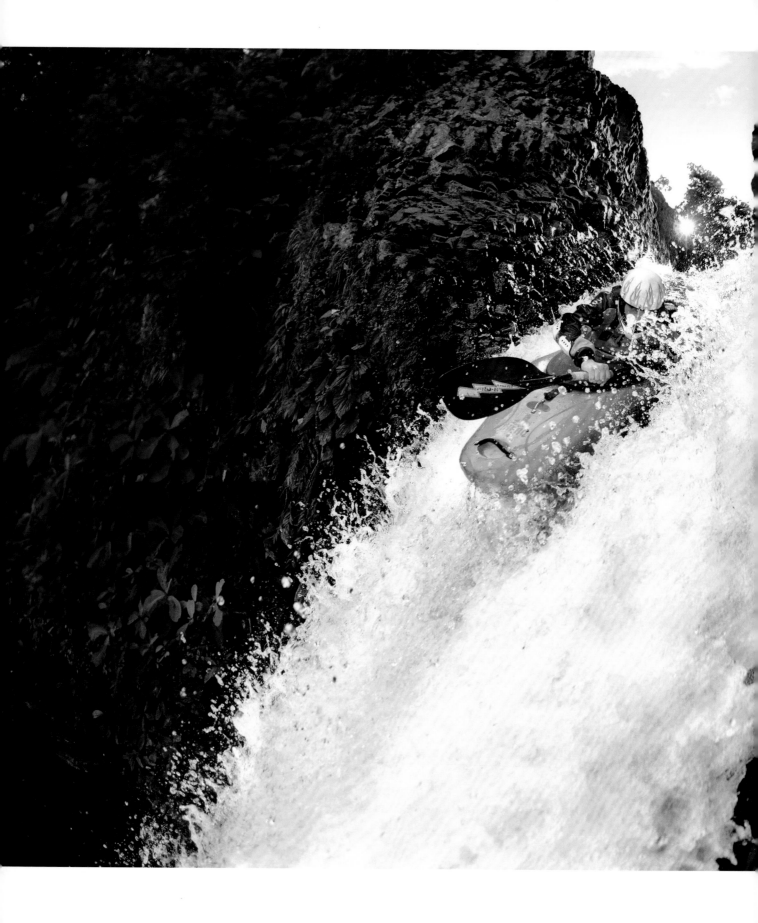

I'd been shooting still photography for major campaigns for over two decades. And since the launch of the Nikon D90, I'd been creating motion projects, too, but it was not my wheelhouse.

And the scope of this production required a whole new level of commitment. I took a moment to pause and realized that this would be a litmus test for me: Did I have the right stuff to be a director? Ever since taking my D90 up on El Capitan to shoot Tommy on the Dawn Wall (see Chapter 39), I had been dreaming of becoming a director. This was my first big chance, and I didn't want to blow it.

It wasn't until I landed in Veracruz and met our client from Nikon that I was informed that we were going to be helping to launch the D4, Nikon's flagship camera. That's when my anxiety went through the roof.

———————

If you had asked me what it means to be a director before I got that fateful phone call from Tokyo, I probably would have joked about sitting in one of those black namesake folding chairs, wearing a scarf, smoking cigars, and grazing on craft services.

Through trial and error, I was learning what being a director actually means. At the highest level, it means you are responsible for every aspect of the production, including creating a solid concept, arcing a story, selecting talent, managing logistics, choosing shots, deciding how many cameras to use, and hiring a production team. The director chooses a team of tough-as-nails professionals and then plays the role of quarterback, calling the shots.

For this film, I hired two very talented DPs, Dane Henry and Rex Lint, two close friends of mine who'd sharpened their skills as cinematographers while working for Vail Resorts. Shawn Corrigan joined the team as an amazing first assistant and camera operator. Chris McNamara and Tommy Thompson, two of my climbing buddies, joined to help with rigging ropes. And my wife, Marina, filled the role of hair and makeup as well as catering, while Blaine Deutsch, who used to be my studio manager (see Chapter 56), produced the whole thing.

The budget is always a big consideration: How will I spend each dollar? What is the wisest way to do so? One

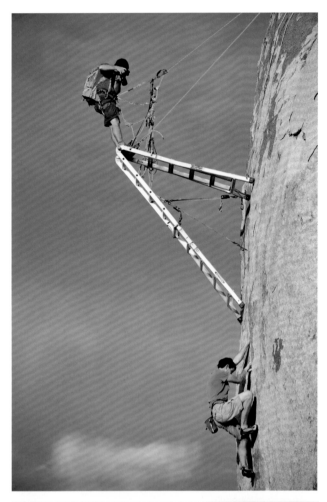

FINDING THE PERFECT ANGLE OF ALEX HONNOLD SOLOING IN JOSHUA TREE TOOK A VISIT TO HOME DEPOT AND SOME CREATIVE RIGGING. THE RESULTING NIKON PRINT AD FOR THE D4 (TOP PHOTO BY SHAWN CORRIGAN)

Instead, I decided to put my money into purchasing equipment that would help us move the camera and create really dramatic never-before-seen shots that would ultimately showcase the D4's feature set best. I splurged and bought a 15-foot ultralightweight jib arm, a longer slider, and some time-lapse motors, all of which would allow us to create more compelling visuals.

I also made the decision to bring along a remote-control helicopter pilot, Mike Hagadorn. Today, using drones is standard-issue, but in 2010, it was quite rare.

I sat down with Blaine, our producer, and we discussed a schedule: How were we going to shoot these three locations in two weeks? Again, this was all trial and error, but we finally came up with a schedule that, at least on paper, seemed like it might work.

Our formula was very simple: we would travel one day, scout and prep the next, and shoot for two days after that. We created shot lists and planned our days down to the hour. Somewhere in those two-day stints of actively shooting, we knew we'd need to carve off half a day to interview the athlete, because the interview, though requiring the least commitment in terms of time, would actually be the most important element. Those interviews would ultimately drive the whole film.

How many cases/bags would we need to carry the gear? How would we pack it? What unique challenges would we encounter in each of the three locations? In many ways, this was all new to me. In other ways, it was extremely familiar.

At this moment, I felt like I was taking everything that I had learned in my life as a photographer/creative individual/business person/athlete and pushing it to new extremes. I was pushing myself and what I knew in a way I'd never before experienced—all before even setting foot on location.

———

of the decisions I made, which I knew we would live or die by, was choosing not to hire a sound recordist to be in the field with us. That was a tough call. Audio is essential, and without great audio, you don't have a motion piece no matter how good your story or the visuals are.

I rappelled down a rope tied to a bridge, positioning myself mere feet from a raging waterfall, just below its lip. Any moment, Dane Jackson would come exploding through the frothing turbulence, and I would go on to capture this still image with a prototype Nikon D4 and a fisheye lens.

After shooting this still photograph, I switched gears and set the D4 in video mode while Dane set himself up for another drop down the free-falling rapids. I was able to capture a sequence of Dane that ended up in the final version of the release video, titled *WHY*.

"COREY-SAN, DO YOU REALLY THINK IT'S A GOOD IDEA TO PUT THE CAMERA ON AN RC HELICOPTER AND FLY IT OVER THE WATER?"

I was learning to juggle the roles of director and DP, photographer, and camera operator, all at once. These worlds of still and motion were crashing together for me in a way that felt as wild as the river raging before my lens. This was also true for Rex, Dane, and Shawn. We were all at critical junctures in our careers, and hungry for opportunity!

I jugged back up the ropes and switched into the role of director. Thirty minutes later, we were rigging a Freefly heavy-lift helicopter with a D4, to capture an aerial video sequence. (This was before folks referred to these tools as drones.)

A representative from Tokyo was there with us, watching what we were doing. When he saw Nikon's new prototype flagship camera—of which there were only nine in the world—get mounted onto the helicopter, he started to squirm uncomfortably. It was hot as hell and everyone was being eaten by mosquitoes, but he seemed particularly agitated.

"Corey, can I ask you something?" he said, pulling me aside. I'll never forget the way he said this next line: "Corey-san, do you really think it's a good idea to put the camera on an RC helicopter and fly it over the water?"

Once again, this was another learning experience of becoming a director, but my go-to instinct was to put on a poker face and say, "Oh, yeah, absolutely. This is no problem. Don't worry—we do this all the time, and it will not land in the water!"

MERE FEET FROM THE WATERFALL, I CAPTURED THIS WIDE-ANGLE SHOT OF DANE JACKSON TAKING THE DIVE. THE RESULTING NIKON PRINT AD FOR THE D4 (TOP PHOTO BY REX LINT)

In my head and heart, I knew that this was complete bullshit, but managing clients is a skill I'd learned on commercial photo shoots, and it was no different in this situation. You tell the clients what they want to hear, coddle them, and make them feel safe and warm, while in reality you sweat bullets as you take massive risks, because that is what is actually needed to create anything worthy.

Mike, our RC pilot, made two great passes over Dane on the river, but on the third pass, Mike pushed the helicopter a bit too hard with an overly aggressive move and lost control.

Mayday! Mayday!

As the helicopter dive-bombed toward the frothing waterfall, I heard the representative from Tokyo shriek. He grabbed at his chest like he was literally having a heart attack. I saw my whole directing career flashing right before my eyes.

Oh, shit!

Mike used to be a ski patroller in Colorado. He has nerves of steel and knows how to operate under pressure. Fortunately, he regained partial control, and with some deft maneuvering was able to crash-land in the jungle as opposed to the water.

Whew.

His evasive maneuvers and quick reflexes had saved the day! The D4, thankfully, was completely fine, and the helicopter, despite some minor scratches, was back up and flying a few days later.

The client gave me a look, and all I could come up with was, "I told you it wouldn't land in the water!"

Over those two weeks, I found my confidence increasing, through our successes and even our near misses. I was gaining my footing as a director, finding that delicate balance between being completely responsible for each and every sequence but also having utter faith in my team and trusting them to execute and make decisions at the highest levels possible. Not being overbearing, but also taking responsibility and owning the whole thing. Not getting sidetracked by shots that didn't reinforce the story we were trying to tell. Not wasting resources on things that didn't build that main story line. Finding my voice and footing and being able to articulate to my team what my vision was, and how to execute that content from an aesthetic, visual standpoint.

I created *WHY* to profile three of the best athletes in the world, and find out why they do what they do. But what ended up happening is that I learned more about who I was, what I would become, and why this is what I love to do.

45

LIGHT AND FAST
IN PAKISTAN

THE STYLE IN WHICH MOUNTAINS are climbed has evolved over the years, from large-scale one-hundred-plus-person nationalistic expeditions, funded by governments, to small two-person teams of climbers bringing a minimum of gear and a maximum of skill to reach the summit. A big part of the rise of this light-and-fast alpine-style climbing has to do with advances in gear and equipment.

But as it all gets pushed harder, faster, and lighter, climbers have wondered: When does light get *too* light?

Photography and filmmaking have also benefited from advances in equipment and techniques, taking a near-parallel trajectory to alpine-style climbing. Better, lighter, and more reliable equipment—particularly DSLR (and now mirrorless) cameras that shoot cinematic footage—has removed the need for Hollywood-scale budgets and one-hundred-plus-person crews to shoot high-production-value stories.

Consequently, it's only natural that light-and-fast alpine climbing and light-and-fast filmmaking would come together.

In fact, it makes a lot of sense. Big mountain ranges are some of the most dangerous places in the world. Due to the rugged, forbidding nature of these locations, it would be nearly impossible to access them with a large team, so small-footprint productions are the future of this brand of storytelling. Today, a single person who's capable of keeping up with the climbers can go in and capture great video and still footage with nothing more than a single camera and a couple of lenses. What

221

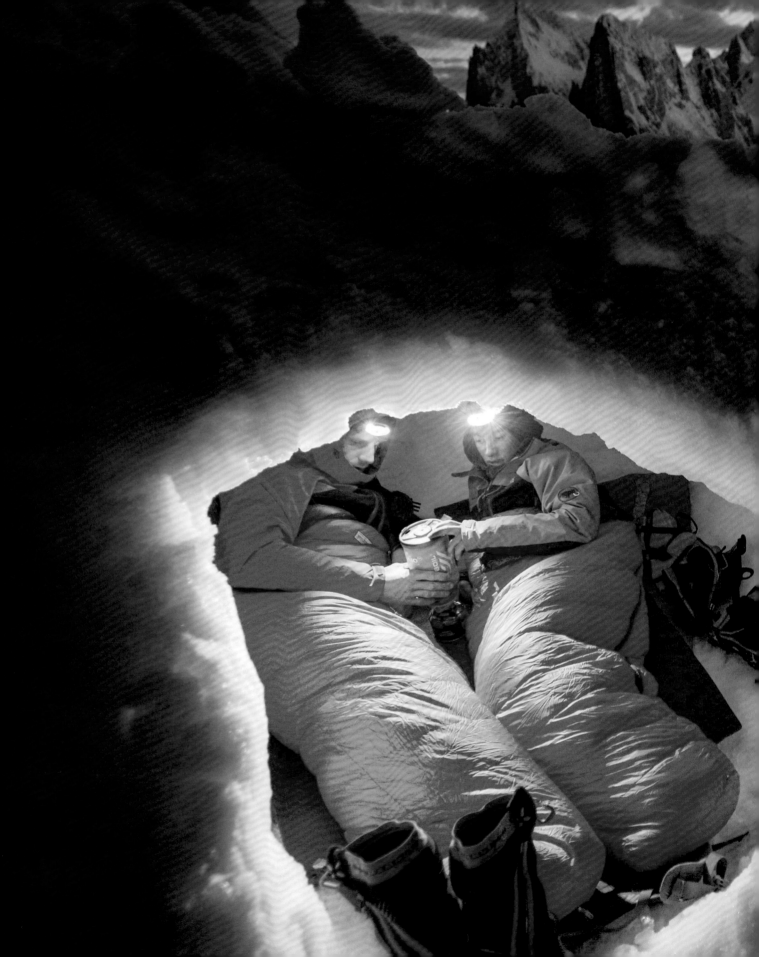

THE GLAMOROUS LIFE OF THE SMALL-FOOTPRINT PRODUCTION TEAM: RUNNING TWO CAMERAS FOR AN INTERVIEW WITH DAVID LAMA IN A HIGH-ALTITUDE BASE CAMP IN PAKISTAN (PHOTO BY ANDREW PEACOCK)

this means is that the opportunity to truly visually capture the essence of mountaineering never really existed until the advent of HDSLR cameras that can capture still and motion.

David Lama and Peter Ortner are two of the greatest young alpine climbers in the world today. We had all met a few years earlier in Patagonia (see Chapter 40). There, we'd hatched the idea of putting together a climbing and media trip to Trango Tower (a.k.a. Nameless Tower), a 20,469-foot granite spire in the Karakoram Range of Pakistan. The Karakoram, home of K2 and other iconic peaks, is a place I'd always wanted to visit. I knew it was an opportunity I couldn't pass up.

Mammut funded our expedition as part of its 150-year anniversary "Biggest Peak Project in History." Just accessing this remote region was extremely expensive, and most of the funding went toward expedition expenses, not our three-person production team, which

included me; Remo Masina, a twenty-one-year-old RC helicopter pilot; and Andrew Peacock, an ER doc from Australia who's built like a 250-pound brick shithouse and can carry more weight than anyone I know. Andrew would be my assistant and second cameraman.

We had a lot on our plates. We had to shoot a television show for German TV, a short film for a European film-festival tour, and stills for global advertising campaigns and magazines. And, of course, we had to actually climb Trango Tower.

I joined David and Peter for the ascent. Andrew aided in shuttling loads of gear, managing base camp, and shooting with a long lens. Remo flew drones around us while we climbed, capturing some truly stunning aerial footage that the world had never seen. It was seriously way ahead of its time.

To be light and fast, I brought one Nikon D600 and two lightweight lenses: the sharp, wide-angle Nikkor

17-35mm f/2.8D, and a prototype Nikkor 70-200mm f/4G.

During the climb, I did a decent job of capturing both still and video content. I recorded video footage first before switching to still, since we needed content to fill twenty-four minutes of television. That's quite a lot. When I felt I had shot enough of one particular scene, I'd switch my D600 to still-photography mode and bang off a few frames.

That's what happened in this photo. We were at around 17,000 feet and had just buffed out a snow-cave bivouac. Believe me, there's nothing I would've loved more than to be in my sleeping bag, inside the snow cave, brewing up some tea with David and Peter. But after two decades of documenting the adventure world, I know that the times that are the most uncomfortable are often the times when you get the best images.

I stood there for what felt like hours, shooting still and moving pictures of David and Peter enjoying warm beverages in a cozy snow cave way up the side of Trango Tower. I thought back to the days of my younger self, shooting a very similar photo in Chamonix (see Chapter 8), and how that experience had prepared me for this one.

(Years later, these parallel experiences ended up being the basis for a TEDx talk I gave called "Embracing Discomfort." Had you asked me at the time if I was truly "embracing discomfort," I might have given you a much different answer, as it's certainly easier to talk about in the aftermath than in the moment.)

We ultimately reached the summit. We even got incredible footage of David, Peter, and me standing there, shot by a drone flying at 20,000 feet and controlled by Remo, down in base camp.

And by the way, this was well before the advent of the DJI Phantom 4. Remo was using a homemade rig with monitors mounted to ski goggles.

We descended without too much drama, and, ironically, it was back in base camp that we realized that going too light and too fast can have catastrophic consequences.

We were doing the most important interview of the whole trip—with David Lama. Andrew was holding a

reflector. Meanwhile, I was juggling two cameras, recording the audio, and also trying to conduct an engaging interview.

I'll admit: I was cocky. Having now directed a few different projects, I was becoming so confident in my camera skills that I actually focused more energy on my interview questions. Classic mistake.

BUT AFTER TWO DECADES OF DOCUMENTING THE ADVENTURE WORLD, I KNOW THAT THE TIMES THAT ARE THE MOST UNCOMFORTABLE ARE OFTEN THE TIMES WHEN YOU GET THE BEST IMAGES.

I didn't know it at the time, but camera two—the tight angle on David's face (i.e., the really important angle)—was out of focus. Despite three recording cycles, there wasn't a single in-focus tight shot.

After returning home from the mountains, I delivered the footage to two different production houses, one in Switzerland and one in Great Britain. The Swiss producers were working on the film-festival cut. When they showed me the rough edit, I asked, "Why didn't you use any shots from camera two?" They didn't have the heart to tell me the truth.

It wasn't until I saw the British cut, for the TV show, that I realized how badly I'd blundered the focus. But the Brits didn't bother to tell me that I'd screwed up. They used my blurry shots—probably to stick it to me a little bit. Every time I see that footage, it feels like daggers in my heart.

Walking that fine line between success and failure is what makes going light and fast so fun. And that's true whether you're climbing, or simultaneously juggling the roles of filmmaker, photographer, director, and interviewer.

So to answer the original question—when does light get *too* light?—I guess my answer would be: it's only too light if you screw things up.

46

ANOTHER DAY AT THE OFFICE

OVER THE YEARS, I'VE SPENT an enormous amount of time hanging from the sides of cliffs, diving in tropical oceans, skiing steep powder, and floating remote rivers, my camera always in tow. But there's another part of my professional life that is nothing like this. I'm still working to creatively tell stories with my camera, only I'm—*gasp*—indoors in a sea of cubicles!

My work in the corporate world is linked to a guy named Jose Azel and a vision we had, which led to the creation of Novus Select.

When I first met Jose, around 2002, it was instantly clear to me that his brilliance as a photographer was matched only by his savvy as a businessman. We quickly became good friends, but we also had a good rapport in a professional sense. I became his business partner at Aurora Photos, a stock photography agency. When I came on board, I helped Jose grow Aurora into one of the leading outdoor and adventure photo agencies in the world.

Despite our focus on stock photography, we found ourselves fielding calls from clients who were happy to license stock but also wanted assignment photographers for their projects.

It was an incredible moment in time. Technology was booming, and the need for high-quality multimedia and visual content had never been greater. There was this huge industry-wide itch—and it sure seemed like the universe was calling out to us to figure out how to scratch it by servicing all of these assignment needs.

Ultimately, Novus Select was born, and we opened an office in New York City, one of the hubs of creativity. We began to charge forward with a new approach to working with clients, and leveraged our connections to photographers, filmmakers, and creatives around the world—people we liked, trusted, and who were, of course, supertalented and hardworking.

Under the umbrella of Novus Select as a production company, I began working with a number of large Fortune 500 companies to help tell their stories through both still and motion photography. And part of the storytelling process frequently involves shooting for some of these enormous companies on their corporate campuses or other company facilities.

Early on, as I tried to get a foot in the door within this world of advertising and commercial photography, I would often hear clients raise a legitimate concern. It went something like this: "Listen, buddy, I can appreciate that you like to hang off ropes and shoot in wild places. But that doesn't mean you can come into these corporate settings and make that work."

I responded by saying, "If I can shoot images in the most dangerous places on the planet, you better believe that I can stand on my own two feet, on concrete, in a temperature- and light-controlled environment, with abundant power available and access to all the equipment I could ever possibly imagine, and take a good photo. And believe me, I know how to work with people."

It's true. Obviously, there are far fewer variables to contend with indoors or in a corporate environment than on the side of El Cap, with two exhausted athletes and a storm moving in. First and foremost, in climbing photography, and adventure photography in general, I have to consider my own safety—double-checking my knots and that everything is rigged properly. After going through those checks, only then do I begin to think about making pictures, which involves an entirely different set of logistical hurdles.

But there are challenges to shooting, say, a sea of cubicles, too. Compared to an open Yosemite vista, a corporate office offers tight constraints in which to work. Making a good if not great photograph in such a small space is surprisingly difficult. I've stood on filing

cabinets, crawled under desks, reorganized furniture, covered windows, completely transformed the light, and shot through plants in order to spice up the foreground. Overall, I've had to push myself hard to find the most compelling, creative ways to capture these interior situations and create authentic moments on demand.

What I think is so cool is how these two very different worlds intersect and even complement each other. I believe that shooting in the adventure world helped me become a better commercial/advertising photographer and director, and vice versa.

Take this image of Tommy Caldwell sitting on a portaledge 2,000 feet up the Dawn Wall. Midday on El Cap is a pretty bleak time of day for free climbers, photographers, and filmmakers alike. The sun on the south-facing wall is relentless. The light is horrible. The climbing conditions are miserable. We'll resign ourselves to sitting on the portaledge, hydrating, checking social media (since there's cell-phone coverage up on El Cap), and swapping stories as we wait around for the blinding heat to pass.

Well, the climbers do. I never put my camera down! Even when it's hot and there's no action happening, I am still working to make pictures.

In order to capture Tommy and Kevin "sky lounging" in a new way, I treated the portaledge as if it were a cubicle. Using the type of creativity I might employ in a corporate or commercial environment, I decided to get down underneath the portaledge and shoot from an unexpected vantage. I spent about fifteen minutes arranging ropes and fussing with my gear in order to have everything I'd need once I got into position.

Under the portaledge, I was pleased to discover that this vantage offered me a way to really appreciate just how airy yet intimate it can feel to be sitting on a tiny canvas rectangle way up the side of El Cap. I used a

50mm f/1.4 lens and intentionally shot wide open at f/2.8 with a $1/4000$ shutter speed and 200 ISO, making the background slightly out of focus and therefore adding depth and dimension.

Instead of getting the same cliché shot or idling around while we waited for it to cool down, I was happy to find a new way to capture an old scenario.

It's interesting how often we tend to define ourselves in narrow, specific ways. Some may call themselves portrait photographers or landscape photographers or bird photographers. I prefer to think of myself as an adventure photographer and filmmaker.

But what I've learned is that these self-imposed descriptors might also be scaring us away from new, completely unfamiliar opportunities—whether that's becoming a partner who helps build a stock-photo and assignment agency into a successful business, shooting in a corporate environment, or telling stories from the side of El Capitan. Why limit yourself when you can try to do it all? What I've learned is to not be afraid to step outside the box—even if it means stepping into a corporate one. In fact, you might be surprised to discover how similar the two worlds are, and even how much the new one has to teach you.

47
CLIMBING'S NORTH STAR

AS A TEENAGER, I NOTICED that most kids my age had posters of Michael Jordan and Nirvana hanging on their walls. I had a poster of Lynn Hill free-climbing the Great Roof on the *Nose*.

That photo of Lynn Hill was shot by the Austrian photographer Heinz Zak, a guy who I not only admired and looked up to, but regarded as a pioneer of big-wall photography in Yosemite. Zak's photo of Lynn pulling past the lip of the Great Roof pitch—one of the most identifiable features on El Capitan, something you can easily see from the valley floor below—was indelible, iconic, and formative to me as a young climber and aspiring climbing photographer.

What I found most inspiring wasn't the photograph but the person who was in the photo, because she was pulling off one of the most groundbreaking climbing achievements of all time.

Lynn Hill, of course, was the best female climber in the world throughout the 1980s. She cut her teeth in Yosemite and Joshua Tree in the late 1970s, climbing and free-soloing alongside a group of rock climbers called the Stonemasters.

In the 1980s, she turned to sport climbing and participated in early international competitions. She dominated those scenes as well.

In 1990, she became the first woman to climb a route rated 5.14a, with her ascent of *Masse Critique*, in Cimai, France. Of this particular route, a famous French climber had once stated his opinion that no woman would ever be able to do it.

231

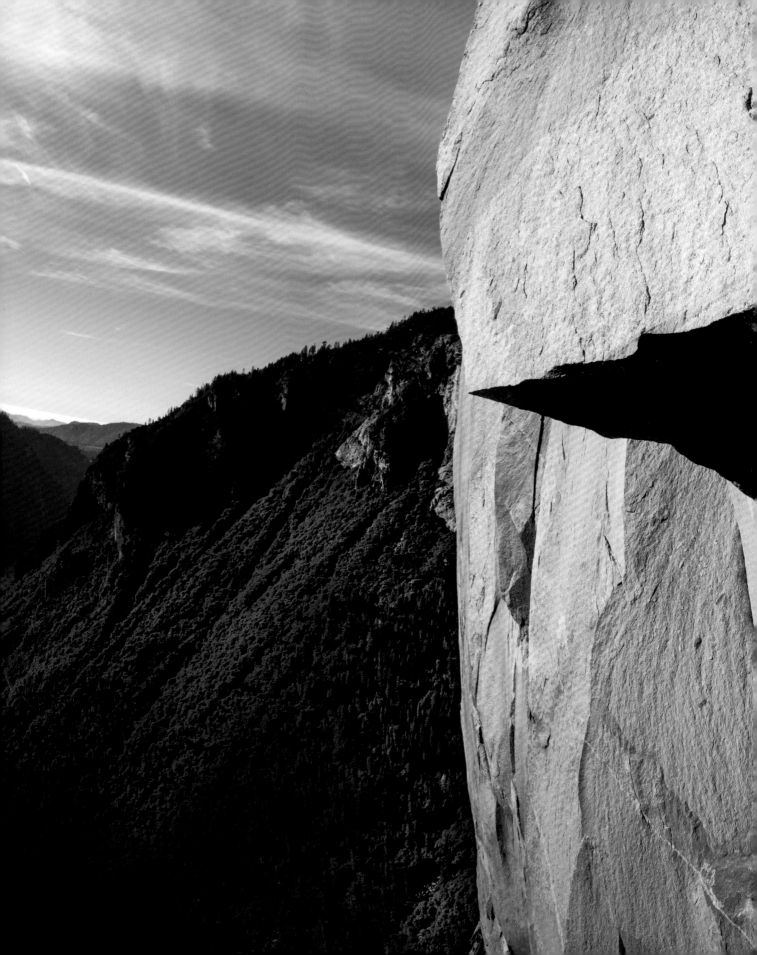

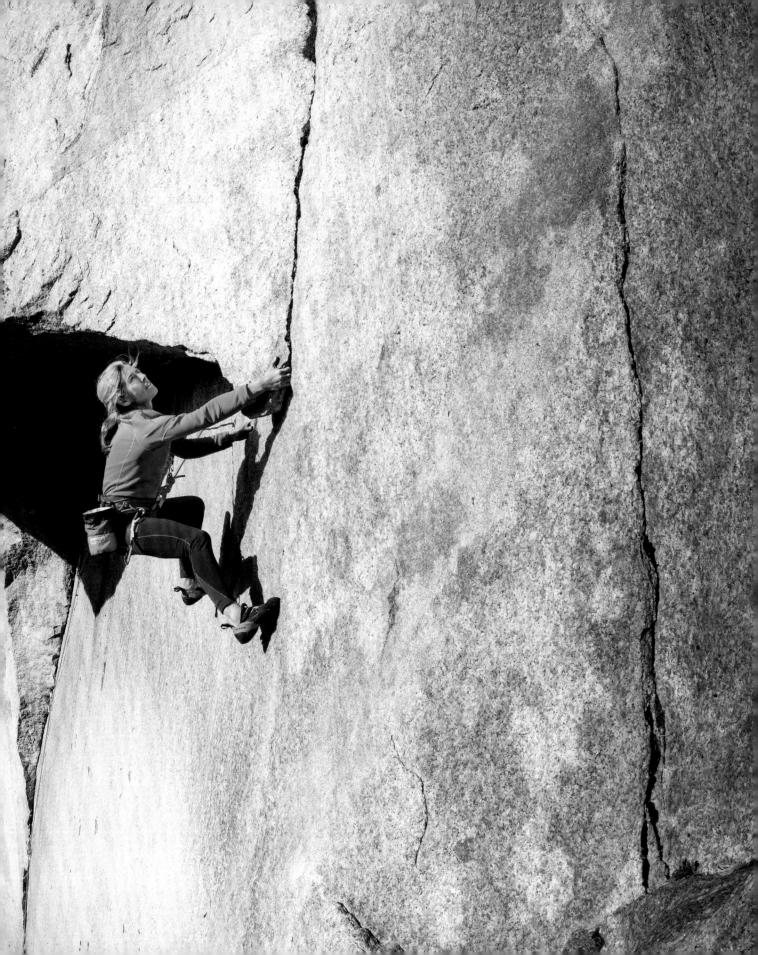

RIGGING THE NODAL HEAD TO SHOOT A PHOTO-SPHERE OF LYNN HILL ON THE GREAT ROOF (PHOTO BY BRETT LOWELL)

Lynn proved him wrong and broke through yet another boundary.

After a decade of sport climbing, Lynn had grown bored with competitions and training. She wanted to return to outdoor climbing and adventure—the aspects of the sport that she'd originally fallen in love with.

John Long, the great climbing author, legendary Stonemaster, and friend and former partner of Lynn's, casually suggested, "Why don't you go try to free-climb the *Nose*?"

Free climbing El Capitan was still very much in its infancy. Only one route had been free-climbed there: the Salathé Wall. The best climbers in the world were looking for the next big route to free-climb, and the *Nose* was the obvious choice.

In fact, getting the first free ascent of the *Nose*, the world's most famous rock climb, was perhaps one of the most sought-after prizes in climbing.

Many of the best male climbers of the era had arrived in Yosemite to take their turns to try to be the one to pull Excalibur from the ground, but they all failed. In particular, they were getting totally shut down by the Great Roof, one of the most recognizable features on the *Nose*.

In 1993, Lynn Hill succeeded where many men had tried and failed. She got the first free ascent of the *Nose*.

"It goes, boys," she said. Three words that said it all, and so much more.

In 1994, Lynn returned to the *Nose* and once again did something that no one else had done: she free-climbed

the route in a single day. If there were any doubts about it before, there were none after: Lynn Hill wasn't just the best *female* rock climber in the world. She was the best rock climber.

More than a decade passed before anyone else managed to repeat her feat. It took no less than the efforts of Beth Rodden and Tommy Caldwell, perhaps the two best El Cap climbers of our generation, to do the second ascent as a team. Then Tommy returned a few weeks later and free-climbed the *Nose* in a single day.

Lynn Hill has always been a role model for female climbers, but she's also been the North Star for all climbers. She showed us that climbing is a sport where all of us—no matter our gender—can reach the highest levels.

Climbing is also a world in which all of us have a high probability of getting to meet our sport's celebrities. For example, I don't think any of my high school friends ever got to hang out with Michael Jordan or go backstage with Nirvana. Not only have I gotten to meet all of my climbing heroes but most of them have ended up becoming my closest friends.

With Lynn, that opportunity to meet arrived when I was invited to give a slideshow at an event in Poland organized by a local climbing club. At the time, it was a big opportunity for me, as I was still young in my career. And then I got a message from the event organizers to all of the presenters, and I happened to look at who was on the email chain. There was Hans Florine, who had been setting speed ascents on the *Nose*; Andrew Skurka, an endurance athlete from Colorado; Michael Brown, an adventure filmmaker; me; and . . . Lynn Hill!

> ## LYNN HILL WASN'T JUST THE BEST *FEMALE* ROCK CLIMBER IN THE WORLD. SHE WAS THE BEST ROCK CLIMBER.

My first thought was, *I clearly don't belong in this list of names.* But that was soon replaced with excitement as I realized I'd be getting an opportunity to hang out with one of my heroes, a person whose poster hung on

my wall, a poster I had kept even as I moved from one house to another.

Before boarding the flight to Poland, I got to spend some time with Hans, Andrew, Michael, and Lynn in a Chicago airport bar. We all had a drink, and I had the time of my life. There was a part of me that was worried that Lynn wouldn't live up to those unrealistic expectations you set for your role models and heroes, but she turned out to be a completely down-to-earth, intelligent, passionate, articulate, fun, relatable person.

I don't remember much about the event in Poland, but I will never forget the experience of sitting next to Lynn on the plane. It was an overnight flight, and soon after boarding, we were all dozing off.

Lynn, however, pulled a move that I had never seen before and have never seen since—which is saying something given that I log a couple hundred thousand miles of airline travel each year.

TECHNOLOGICALLY, THIS WAS A REALLY INTRIGUING PROJECT— AND A PREFACE TO SOME OF THE 360 AND VIRTUAL-REALITY WORK I WOULD END UP DOING YEARS LATER

This petite woman got down on her knees and slept with her head on her seat cushion. This struck me as somewhat odd at the time, though I chalked it up to the fact that Lynn is a visionary, and so I figured that of course she was going to do things a little differently than most people. Part of me was amazed that she wasn't self-conscious about choosing to sleep this way, but most of me was superjealous that I didn't have the confidence to try that position myself!

Years later, that poster of Lynn on the Great Roof came full circle for me when I got a unique opportunity to help create the Google Street View imagery from the Nose of El Capitan.

The team at Google Maps had reached out to my friends Josh Lowell and Pete Mortimer, for help in taking Street View to the vertical world. If you've ever used

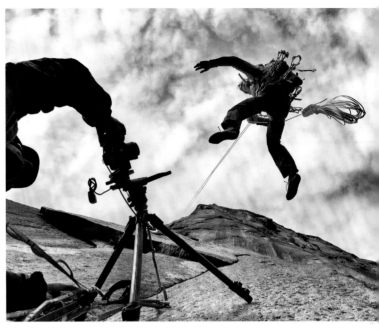

ALEX HONNOLD SWUNG OVER OUR CAMERA RIG ON A ROPE SO THIN IT MADE BOTH BRETT LOWELL AND ME SUPER NERVOUS. (PHOTO BY BRETT LOWELL)

Google Maps, you are likely familiar with Street View mode, in which you can pan around a 360-degree photo sphere that shows the exterior of any address. It's as if you're standing right there.

The idea behind bringing this kind of 360 photography to the Nose was to shoot several iconic locations on the 3,000-foot rock climb, such as the Stove Leg crack, the King Swing pitch, Texas Flake, Boot Flake, and, of course, the Great Roof.

We thought, who better to shoot in these iconic locations than the person whose name is synonymous with the Nose: Lynn Hill!

We were also tasked with shooting some Street View scenes on the Dawn Wall with Tommy Caldwell and Alex Honnold.

Brett Lowell and I—having just spent a bunch of time on the Dawn Wall shooting Tommy Caldwell and Kevin Jorgeson's iconic ascent (see Chapter 55)—were in big-wall shape, meaning we could jumar the shit out of some free-hanging lines with a lot of camera equipment hanging off our harnesses. (Tommy, Alex, and Lynn were all looking fairly fit as well.)

The plan was for Brett and me to capture the Street Views, while Josh and Pete would manage the project from the valley floor.

Technologically, this was a really intriguing project—and a preface to some of the 360 and virtual-reality work I would end up doing years later for Nikon and NBC's Olympic Channel, as well as more for Google. But this was perhaps my first experience with 360 storytelling.

Of all the scenarios that Brett and I captured that week, the one that stood out was re-creating that Heinz Zak photo of Lynn Hill pulling past the lip of the Great Roof. I couldn't believe that I was shooting the very scene that was once a poster in my room.

"Dude," Brett said, with a big childlike grin on his face. "Can you believe we're here?"

It was surreal. And Lynn was able to climb as comfortably and gracefully on this pitch as she had over twenty years earlier. She's still got it.

The photo in this chapter is one of six frames captured using a nodal head to create the 360 sphere. Admittedly, this isn't the greatest single photograph, and had I been given the option, I wouldn't have shot this with a fisheye lens, but I was trying to achieve the photo sphere for Google.

But it gave me the opportunity to once again pause and take a moment to appreciate my position. I felt so lucky to call this place my office, and to call these people, who have been sources of so much inspiration, friends. Especially Lynn.

Postscript:

IN THE PROCESS OF WRITING this chapter and recalling the memory of Lynn Hill's airplane-sleeping technique, I figured that I owed it to myself to actually give it a go. So on a recent flight, I found myself in an empty row and thought it'd be the perfect opportunity to see if Lynn was on to something. Right as I got into position, a flight attendant came by, gave me the craziest look, and said, "Sir, you need to put your seat belt on."

48
AUTHENTICITY IN ARGENTINA

ALLON COHNE WALKED INTO MY office with a skeptical look on his face. He had just begun working as the new marketing director for Kirkwood Mountain Resort in South Lake Tahoe.

My production company/assignment agency Novus Select held a fairly substantial contract for shooting the still photos for Kirkwood. When Allon started at Kirkwood, he set up a meeting with me so I could explain the rationale behind our contract and the associated budget. In other words, he wanted to know: *Where are all these dollars going, exactly?*

"So, Corey . . . why don't you bring me up to speed?" he said, folding his arms across his chest. "My understanding is that your girlfriend's sister created this contract? How interesting!"

It was true. Our deal had been signed when I was dating the sister of the previous marketing director. Fair enough.

Typically, a ski resort will hire one photographer to shoot everything it needs. Novus Select, on the other hand, employs the talents of hand-selected specialists, all pros in their genres. If we need an epic landscape shot, we bring in an amazing landscape photographer. If we need sound recording for a video project shot in a snowy mountain environment, we'll bring in a field sound recordist who knows how to climb and ski. And so on.

As Allon continued to survey me skeptically, I explained the justification for Novus's unusual, niche approach. I pitched him on why our model was so valuable and how it would produce such great results.

By the end of the conversation, it was clear to Allon that I was a sincere, professional guy looking out for Kirkwood's best interests, that I loved photography, and that I loved helping out other photographers. That season, Novus Select produced arguably the best stills that Kirkwood had ever seen.

Over the years, Allon and I have continued to be great friends. He was at Kirkwood for less than two years before he moved on to lead the marketing department for the technical synthetic fabric company Polartec, based just outside Boston. Even after he left Tahoe, we frequently got together when our paths crossed in airport lounges, at trade shows, for backyard barbecues, and we shut down bars on more than one occasion. We have also snatched every opportunity to make turns together around the globe. When you get to work in cool locations around the world with an incredibly funny, smart friend, that's as good as it gets.

Years later, I got another random, out-of-the-blue phone call—this time from Doner, a major ad agency. The Detroit-based agency often worked with auto companies, but it was now also representing Polartec. The folks at Doner explained that the fabric manufacturer was launching a new breathable puffy insulation called Alpha. Unlike down or other types of puffy synthetic insulation, Alpha would keep you warm, but it would vent moisture and allow airflow at the same time.

Over the conversation, it became clear to me that the folks at Doner were used to operating at a very high level. I don't want to say "money was no object," because that's never true for any company, but they were accustomed to working with big crews, celebrities like Arnold Schwarzenegger, and Hollywood-sized production companies that use only medium-format cameras and expensive camera systems like the Arri Alexa.

To launch Alpha, the agency wanted a video spot as well as three "authentic" hero stills—a rock-climbing shot, a glacial-approach shot, and a ski shot—all from one of the wildest, most extreme locations on the planet: Patagonia.

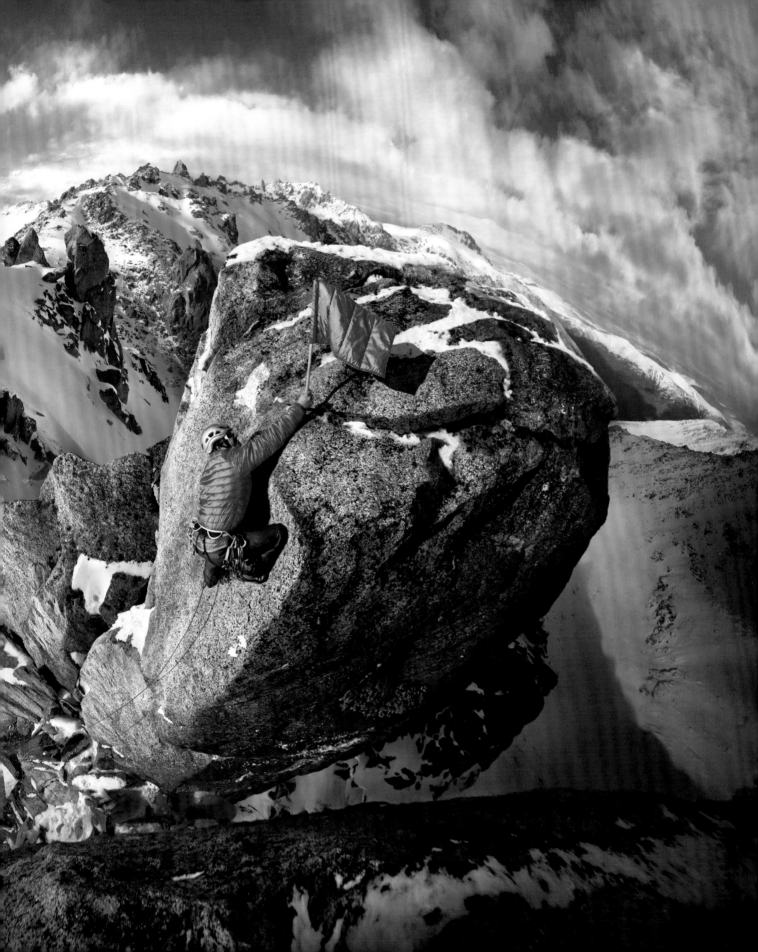

THE PRECONCEIVED IDEA FOR THE AD. OUR JOB WAS TO BRING IT TO LIFE.

Authenticity is one of those words that gets tossed around in advertising, marketing, and PR circles. But you can't just say the word three times and make it come true. Authenticity is something you have to earn. It comes from experience, humility, and respect.

I found myself in the position of once again having to really earn this opportunity—because friendship alone does not get jobs, even if you're friends with the marketing director at the company fronting all the money.

But during my conversation with Doner, I got the sense that these ad reps weren't just skeptical; they were downright dubious. Everything was a debate, from the location to the type of camera equipment I wanted to use. We went back and forth and back and forth—which makes a lot more sense when you remember that advertising agencies bill their clients by the hour! The more they talk, the more money they make.

If only it worked that way for us photographers, too...

"We want authenticity. It needs to look extreme," one of the Doner creatives said. "So we want the mountain to be Cerro Torre. Corey, can you give us Cerro Torre in two weeks?"

First up, I had to explain that there was no way that we could climb Cerro Torre, one of the toughest mountains in the world, in the winter—two weeks after hanging up the phone. It would demand weeks of planning, and at least a month in Argentina in order to prepare for all of the uncontrollable variables.

They were fixated on Cerro Torre, however, after having seen one of my photos from the mountain (see Chapter 40), which had appeared on the cover of the *American Alpine Journal* earlier that year. They kept pushing for it, even offering to hire helicopters to land us smack-dab on the side of this huge, dangerous spire. Again, I had to explain all the (obvious) reasons why this wouldn't work.

I whittled them down and eventually convinced them that we could get exactly what they wanted in Bariloche, Argentina, a milder, more accessible, and more logistically predictable location. In all the important ways, however, Bariloche was just as dramatic.

Then there were all the technical details, which we debated for hours and hours. Doner was accustomed to cameras that cost more than most folks make in a year.

I explained that medium-format photographs are great and provide high resolution, but the cameras are clunky, heavy, have a short battery life, and shoot maybe one or two frames per second. The files are massive and a pain to work with in the field. They're great for studio or lifestyle shoots, where you can be tethered to a computer, and the craft-services truck is around the corner. (And, yes, I know medium-format cameras have come a long way in recent years.) But they don't lend themselves to the light-and-fast approach you need to access remote, wild places and shoot quickly.

NOT HAVING TO SWAP CAMERAS AROUND IN THE FIELD SAVES TIME AND BUDGET. WE COULD BE NIMBLER, MOVE MORE FLUIDLY, AND FOCUS MORE ON CREATIVITY.

Similarly, at the time, the Arri Alexa was heavy and fraught with battery issues, and it required a lot of manpower just to operate.

By using Nikon HDSLR cameras, I said, we could lighten the load on all fronts, from lighter-weight jibs to sliders and tripods. More important, we could use the same camera for both stills and motion. Not having to swap cameras around in the field saves time and budget. We could be nimbler, move more fluidly, and focus more on creativity.

I pitched Doner on the Nikon D800, a 36.3-megapixel camera that had recently launched. I'd already shot the D4 release video, *WHY*, and one of my fellow Nikon Ambassadors, Sandro Miller, had helped launch the D800. In fact, I'd just finished directing two television spots for the state of New Mexico, shot with the D800, and was convinced it was the very best camera for the Bariloche shoot. Using the D800, we could bring more cameras, rely on fewer people, go lighter, be faster, and get stronger footage in a tough, remote situation.

To me, the D800 was a no-brainer.

"There's no way we can shoot this whole campaign on a camera you can buy at Costco!" one of the Doner creatives exclaimed, sounding exasperated.

I think that part of their hesitation to go with the D800 can be explained by the fact that it's never in an ad agency's interest to use cheaper tools, because it diminishes the perceived value they provide to their clients. If you can capture the same quality of content using a "prosumer" camera, then the agency will have a hard time explaining to their clients why they're billing them big dollars for those (increasingly obsolete) Hollywood-style productions.

This was a moment in which the old model of doing business was colliding headfirst with the new wave of technology.

I finally had to send them test files, so that they could see for themselves the video footage and still photographs the D800 could produce. I showed them our New Mexico TV spots, and it was only then that they agreed, if skeptically.

We enlisted the talents of Willie and Damian Benegas, two badass alpine climbers from Argentina who run Benegas Brothers Expeditions, a global

DANE HENRY AND WILLIE BENEGAS GET THE FIRST JIB-ARM ASCENT OF THIS RARE TOWER IN BARILOCHE, ARGENTINA.

expedition-guiding company. Willie and Damian have tons of Everest summits under their belts. They're two of the most decorated alpine and technical rock climbers to hail from South America. I've known them for years from back when they lived in California and spent their days running up the walls of El Cap. I knew that they would bring that authenticity and diligent work ethic to the production—not to mention be fun to be around. They could help on both the production front and act as models.

Finally, we enlisted a young, ripping female skier, Pip Hunt, for that hero ski shot.

I wasn't worried about getting the ski or glacial-approach stills. Those wouldn't be hard, and I was confident that Pip would kill it and be a total pro to work with.

THE FINAL AD

The climbing shot, however, had me concerned. To find a location that no one has ever seen before, or to capture a familiar location in a new and surprising way, is always a challenge—and that's true no matter what kind of camera you're using.

We'd chosen Bariloche because of its relatively easy access to major mountains, but the scouting photos I'd seen of the potential climbing spots were vague. The Benegas brothers had sent a few photos of a ridgeline with dozens of towers on it, but due to our tight production schedule, we'd only have one day to tech-scout and find the right one.

In the weeks leading up to the trip and even when we got there, I'll confess to being nervous about being able to get the promised hero climbing image after all that talk convincing Doner that Bariloche was the place to go. I mean, they'd wanted Cerro Torre, for Chrissake! That was the standard against which I would be measured.

And I kept in mind the flip side to being a good salesman: once you convince someone to go along with your idea, you have to deliver.

When we arrived in the mountains of Bariloche, I was taken aback by the beauty of the alpine environment. Ridges of spiny rock and ice formations ran for hundreds of miles in all directions. The clouds swirled dramatically. Condors filled the sky. It was stunning.

We traversed a ridge located off the side of a ski resort. From the ground, the towers had looked uninspiring, and I found myself having a mild panic attack. But once we got up on the ridge, we found two towers as locations for the climbing picture. From a distance, the leftmost tower appeared more impressive. The second tower, just to its right, looked underwhelming.

Yet when we actually climbed up on the towers and scouted from above, it immediately became obvious to me that the right tower would shoot much better. The background was spectacular, with the valley dropping away and providing that sense of airy mountain exposure.

On location with us were Murray White and Virgil Adams, two creatives from Doner. Brilliant guys and very talented. But their sketch for the hero climbing shot didn't look like the tower on the right. It looked like the tower on the left, and they had already sold Polartec on that sketch.

Again, there was a discussion to convince them that I had a better idea. Still, Murray wanted me to shoot his sketch.

"I can shoot your sketch," I explained, "but it's not going to be as interesting as shooting the tower on the right."

We debated some more. They still wanted the left one. They wanted their sketch. Finally, I said, "Listen, you hired me because you want authenticity. The tower on the right is going to lend itself to a more authentic photograph than the one on the left. You're going to have to trust me that this is going to create a better, more authentic image than your sketch."

Murray and Virgil finally relented after Allon and I tag-teamed them. Just like Allon had all those years ago at Kirkwood, they realized that I had the client's best interests in mind.

I lost the battle over the flag, however. Quite frankly, I wasn't crazy about the concept. I thought it was a bit cheesy. But this was the core concept of the whole ad campaign: placing a flag made of Polartec Alpha atop a climb. It was supposed to represent staking claim to new territory. The flag was where Doner drew the line. It was the one thing that wasn't up for debate.

I realized the only way to do the whole Alpha flag concept without climbers scoffing at the picture was to show a location that was so surprising and beautiful

that they almost didn't notice the flag. I hope this image strikes that balance.

To give a sense of just how far the ad agency team went to try to mesh reality with their own preconceived ideas, they ended up flipping the image, because placing the flag and climber on the other side of the frame more closely resembled the original sketch.

Talk about "authenticity."

Looking back on this shoot, however, I'm proud of how it all turned out. It was one of those rare jobs that we all felt like we'd knocked out of the park in terms of both stills and video. Using the Nikon D800 ended up being absolutely critical, because we shot from multiple angles, and I could easily toggle between video and stills. Mike Hagadorn (now at Freefly) flew a D800 mounted on a drone. Dane Henry joined us as our DP, and Josh Marianelli produced the job and acted as camera assistant in the field. Last but not least, my wife, Marina, did hair, makeup, and wardrobe, and managed to keep the team well-fed.

Since we only had to make three hero still images, the rest of our energy went into shooting video B-roll.

I'm really proud of the stills, but even more psyched about the video footage that came out of this trip.

I'd like to think that this shoot represented a real paradigm shift, not just for us as a small-footprint production, but also for our clients at Doner and Polartec. On the second-to-last night of the trip, Dane stayed up and cut together a highlight reel with the best footage, and put it to some awesome music. On our last night, over beers and fine South American cuisine, we presented what we'd created over the last ten days to our clients and local crews.

Everyone was blown away, including me. We were a five-person crew, and we had delivered a quality of content once reserved to multimillion-dollar Hollywood productions.

The icing on the cake was when we heard that the Alpha campaign ended up winning several awards for Polartec and Doner. I don't know if my friends at Doner ever admitted that the Nikon D800 was the right way to go all along, but they didn't need to. They'd seen what was possible with a light-and-fast team, a lot of creativity, and a healthy dose of debate at each step along the way.

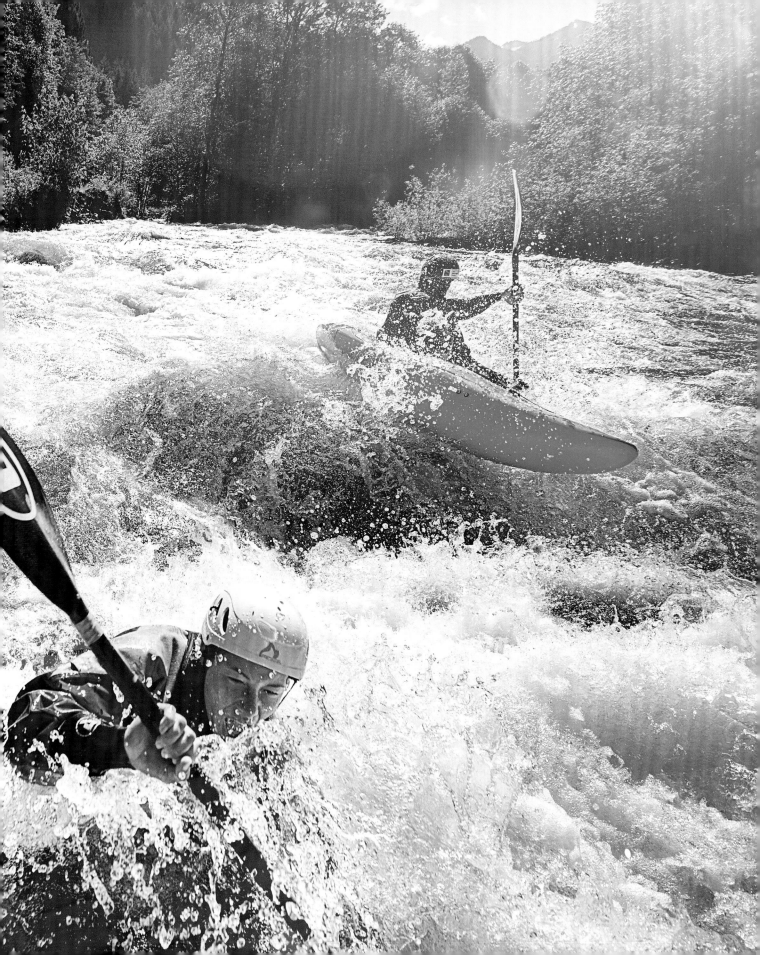

JESSICA GROENEVELD AND JOHN HASTINGS -
CHILLIWACK RIVER, BRITISH COLUMBIA, CANADA
14–24MM LENS / F/5.6 / 1/1250 SECOND / ISO 250

49

FINDING INDEPENDENCE

THE FOURTH OF JULY WAS right around the corner. The days were long, the sun was hot, and the mountains were calling my name. Marina and I were enjoying some precious downtime together at home in Lake Tahoe, looking forward to spending the holiday weekend with our friends. Grilling, eating, biking, climbing, hiking, swimming, and drinking beer were all certainly on the agenda.

It was a Wednesday morning at 10 a.m., which meant it was time for my weekly conference call with Novus Select, the company I'd cofounded. During these weekly telephone meetings, we discussed upcoming projects and made plans for executing various productions.

Chris Dinon, one of the artist representatives at Novus Select, described a last-minute request for proposal from a London-based ad agency representing Mazda.

The concept for the project was supercool. The timeline and the budget, however, were not.

First, the good part: The concept was to shoot three world-class kayakers from the Canadian whitewater kayaking team at a location about an hour outside Vancouver. Two kayakers would be in boats poised at the head of a whitewater rapid, while the third kayaker would be sitting in a Mazda on a dirt road beside the river. After a proper "On your mark, get set, go!" the kayakers on the river would race the Mazda

> BUT THE MOST IMPORTANT INGREDIENT FOR WINNING THE WAR IS ENLISTING A GROUP OF THE MOST HARD-CORE, BADASS MOFOS YOU KNOW.

on the adjacent road. It would be fast-paced, fun, and a great way tie a product to some authentic talent in the adventure realm.

Now for the bad part: For some reason, there was "a really tight budget," a line that always makes me scratch my head when I hear it coming from a company that I know is worth billions of dollars. (This happens more than you'd think.)

Yet this is the reality of media today. Budgets, in many cases, have remained the same, but the number of areas to which those budgets must necessarily be allocated has only multiplied. There's television, print, PR, outdoor, point-of-purchase, trade publications, online, and mobile. There are an increasing number of media needs, and all that content creation has resulted in, you guessed it, "a really tight budget."

But that wasn't even the worst part. The shoot, for various reasons, needed to take place on the Fourth of July.

There goes someone's holiday, I thought to myself. *Poor sucker.*

We went down the short list of photographers/filmmakers who could direct this last-minute gig and do a good job capturing the necessary assets—which were enough video for a two- to three-minute spot and a handful of diverse action stills for Mazda's custom trade magazine.

Unfortunately, it turned out that everyone who could pull this job off said they were either busy or traveling. However, I suspect that most, like me, were more interested in spending the Fourth of July chilling with friends and family.

"Corey, what about you?" Chris asked. "Could you shoot this? I mean . . . someone needs to shoot this!"

I stuttered, trying to come up with a compelling reason as to why I couldn't possibly shoot this, only to draw a big fat blank.

This is the flip side of owning your own business. When no one else is there to get a job done, then guess what? You've got to do it yourself.

"All right, all right!" I said. "I'll do it . . . I will shoot it."

Goodbye, beer. Goodbye, barbecues. Goodbye, fireworks.

Quickly, though, I forgot all about the Fourth of July and became genuinely excited about working with some badass kayakers and shooting for a major car company. It dawned on me that I would be heading onto the symbolic battlefield of my profession: the set of a small-footprint production. And that fired me up most of all.

A small-footprint production is like a battalion on the frontlines. And as the director of a small-footprint production, I get to play the role of a general leading the charge. In any type of warfare, shrewd planning, stealth maneuvers (to avoid permits when possible), going fast and light, and remaining extremely adaptable to changing circumstances as those unexpected bombs start dropping are all keys to survival. But the most important ingredient for winning the war is enlisting a group of the most hard-core, badass mofos you know.

I reached out to my friend and fellow Novus photographer/filmmaker Celin Serbo, who lives in Colorado. Celin had a strong background in the climbing and mountain-guiding world, and in recent years had made strong strides in the world of photography and motion, too. As a climber myself, perhaps I'm biased when I hire a guy like Celin. But I do so knowing what kind of "character" I'm getting.

Celin is a guy who has spent a lot of time in the mountains. He knows how to push himself. He knows what risk, reward, and attention to detail mean, because in climbing, all of those attributes are often the difference between life and death, success and failure. Given the choice between hiring some polished art-school graduate or a former mountain guide and dedicated climber with a bit of raw talent behind the lens, I'd take that climber any day of the week, and twice on Sunday.

Celin was available that weekend, so he came aboard as the DP. We also hired a local on-the-ground field producer who, being a kayaker himself, knew the locations and could help coordinate logistics.

Finally, we were joined by a writer from London, who would write the accompanying piece in Mazda's custom publication. And Marina was our assistant.

We had just two days, and I employed my standard methodology for building a solid and realistic small-footprint schedule, which states that days begin before sunrise and end after sunset. By the time we arrived, we were ready for two grueling days of all-out battle.

On July 2, we stepped on location in the great Canadian wilderness. "I love the sound of a Nikon D4 firing ten frames per second first thing in the morning," I said through clenched teeth, doing my best impression of Lieutenant Colonel Kilgore in *Apocalypse Now*.

In terms of gear, we brought a 16-foot jib arm, a slider, two Nikon D800 cameras for video, and a high-speed Nikon D4 for shooting action stills. With only two days, we were forced to shoot throughout the harsh midday light. Brutal conditions, soldier! And as we were located in a deep canyon, we faced the huge photographic challenge of shooting in the shadows but working beneath a very bright sky. We relied on multiple graduated neutral-density filters—often stacked on top of each other—to create an acceptable exposure.

On this particular shoot, we encountered a unique situation, which is the subject of this chapter's lead image, in which both still and motion photography were complementary.

As Celin focused on shooting video, I focused on both shooting still photos and directing. This was the result of Celin and I brainstorming about how we could make a more unusual video clip of the kayakers passing by from a new angle.

How could we get both the car and the kayakers in the same frame, and do so in a new way?

We came up with the idea of using our 16-foot jib arm to extend the camera out over the river. We timed it so that as the Mazda drove in the background, the kayakers would pass by in the foreground. It took a few takes, but it was well worth the effort. It created an awesome video clip.

As Celin and I are both still photographers at heart, we quickly realized that we needed to switch modes and start shooting this same scenario with stills. So we swapped out our Nikon D800 for a Nikon D4, and captured this shot.

This image is one of my favorite still pictures from the shoot. I would have never gotten this picture had I been on a still shoot, because I never would've had a 16-foot jib arm in tow. I was fascinated that combining still and motion had elevated both pursuits, by providing opportunities that might not have been present otherwise.

The shoot wrapped on July 4 at 11 p.m. That night, Celin, Marina, and I found ourselves back in our dingy Best Western hotel room, toasting with some kind of halfway decent Canadian beer to a job well-done.

"Happy Fourth of July!" Celin said, clinking my beer bottle.

"To a life of being happily self-unemployed," I said, realizing then and there that home is wherever you are if you're with friends and family, and that true independence is the freedom to work as hard as you can, even on a national holiday, seizing every opportunity that comes your way.

50

THE ETHEREAL
GRACE OF ASHIMA

ASHIMA SHIRAISHI, A FIFTEEN-YEAR-OLD rock-climbing phenom from New York City, had come with us to Thailand for film production for Nikon. Over the course of a week, we would be creating a short film about Ashima using Nikon's newest camera, the KeyMission 360, an action camera that shoots both high-resolution stills and HD video in 360 degrees.

We spent most of the week filming her deep-water soloing on rocks jutting out of the Andaman Sea. Ashima had no trouble going up and down rocky tufa 70 feet above the water, as many times as we asked her to do it—which was incredible.

One morning, we ventured to Tonsai Beach, the most popular climbing area in southern Thailand, to film Ashima sport climbing.

We'd gotten there around 6 or 7 a.m. to avoid the crowds, but as soon as Ashima tied in, suddenly a group of fans appeared. They sat cross-legged in the sand, most of them staring up at the quiet teenager, who was steadily working her way through the moves on one of the hardest rock climbs in the country.

Ashima slotted just her right middle finger into a shallow hole in the rock and jumped. Her left hand latched a fingertip-sized protrusion, and her body swung out horizontally. Then she flowed up the rock, as if weightless and with an almost ethereal grace.

When she climbs, Ashima really is captivating to watch. She appears to have been born to do this sport. The only other person I've ever seen move over vertical

rock like her is Chris Sharma (see Chapters 14, 26, and 35). They both have that same preternatural ability to make climbing look easy.

The other similarity between Ashima and Chris that I noticed right away was that she was also just as good at handling fans. Despite being just fifteen years old, she handled herself like an adult. After she lowered off this climb, she graciously stood around to take pictures with dozens of fans who had been waiting for a photo with her. She signed autographs and asked people what their names were and where they were from.

Ashima is a climbing celebrity—the kind of celebrity that people from my generation of rock climbers could've never imagined. She was a globally recognized rock-climbing phenomenon by the time she was ten years old.

There have been myriad profiles, videos, films, and features on her, dating back to when she was a precocious eight-year-old who was turning heads at a scruffy bouldering area in Central Park. The idea that a kid from New York City could become a famous once-in-a-generation rock climber was captivating. Even the *New Yorker* did a profile on her, calling her "possibly the best female rock climber ever—a Gretzky of the granite."

Early on, her parents held a vague yet strong belief that Ashima was destined for artistic greatness, but they didn't foresee her climbing. They had never even heard of the sport, in fact.

Hisatoshi Shiraishi, Ashima's father, spent more than two decades pursuing butoh, a modernist style of dance that emerged in Japan in the wake of World War II. Hisatoshi still goes by his stage name, Poppo. He met Ashima's mother, Tsuya Otake, in an art and fashion school in Tokyo in the 1970s. They moved to New York in 1978.

It was only when Poppo stopped dancing that they thought about having a child. Tsuya became pregnant at fifty years old. She gave birth to Ashima on April 3, 2001.

Ashima discovered rock climbing on her own when she was six years old. She was playing with friends on a playground in Central Park after school, and noticed some men bouldering on a slab of black schist known to climbers as Rat Rock.

Intrigued, the six-year-old approached one of the men, a climber named Yuki Ikumori, who encouraged her to have a try.

These days, Ashima is considered one of the best female boulderers and sport climbers of all time.

"Women have the power to dominate the sport," she said during our interview in Thailand. "It might take a long time . . . Well, maybe not that long." She smiled.

I first met Ashima when she was maybe nine or ten years old during a studio shoot for Adidas Outdoor. I was capturing portraits of some of the brand's athletes, including Ashima. The shoot was great, and I was immediately struck by what a kind, mature, thoughtful kid she was.

After the shoot, her parents insisted that we all go out to dinner, for pizza. We were a pretty small crew that included myself, an assistant, a producer, and my wife, Marina, who was doing hair and makeup for the shoot.

Ashima's parents don't really speak English, so Ashima played the role of gracious, patient translator so that we could all have a conversation and get to know each other. Ashima's father produced an old issue of *Life* magazine that contained a profile about him and his butoh dancing. I couldn't believe it, but my friend and fellow Nikon Ambassador Joe McNally had shot those photos of Poppo years ago. And now here I was, capturing portraits of Poppo's daughter.

It also struck me how important it is to be a good role model for your daughter. At the time of the Adidas shoot, my daughter, Leila hadn't been born, but I've since thought about the nature of Poppo's influence on Ashima as I consider my own relationship with my daughter. Climbing is a world away from butoh dancing, and yet in some senses, they're cut from the same cloth. The core thread linking the two pursuits is that they are fringe lifestyles that offer avenues to finding self-expression and cultivating passion. What better lesson could you as a parent hope to pass on to your child?

I knew I wanted to work with Ashima for the Nikon KeyMission shoot. It was a pretty cool opportunity for her as well. She got to miss a week of school, hang out on the beaches of Thailand with her dad, and go deep-water soloing on these unique sea cliffs that you can only access via longtail boat. And she probably paid for an entire year of her private-school tuition with that one shoot.

WHO WORE IT BETTER: ASHIMA OR ME? (PHOTO TAKEN BY MIKE CORRADO)

A lot of guys in the climbing world my age and older like to bemoan how the sport is changing into something unrecognizable. Climbing is now an Olympic sport—and Ashima will almost certainly be one of the climbers representing the United States in the Olympics. Most people are learning to climb in gyms. And there are unbelievable professional opportunities out there for people who are great climbers, but, more important, for people who are great role models. It's hard to know what to make of it.

But what stands out to me is how great it is to see someone bring a new vision to the sport. Ashima is deeply interested in fashion, art, and hip-hop music culture. She brings these elements to climbing, and climbers are better for it. To me, this is just as valuable as the fact that, two months after our Thailand trip, she became the first female to climb a V15 boulder problem.

To me the lesson is to not be afraid to follow your own path, whatever it may be.

Perhaps Ashima says it best. "I don't really know what I will do throughout my climbing career. My dream is to keep on pushing myself, and, maybe I will push the sport itself. I feel like if people are expecting me to do this, eventually, I will."

51

LEBANON DOUBLE DOWN

IN THE MOUNTAINS OF NORTHERN Lebanon is a limestone wonder that is simply beyond words.

It's called the Baatara Gorge. It features a pencil-thin waterfall trickling into a misty sinkhole, hundreds of feet below. There are also three natural freestanding arches, which add to the Escher-like, mind-boggling character of this natural site. It's a spectacular place, but it took a special person to identify it as a potential venue for rock climbing.

Enter David Lama, the former Austrian sport-climbing phenom who has since become one of the world's best alpinists. In 2014, he first sent me a photo of the Baatara Gorge. The subject of his message read simply *Check this out*. No other words were needed. The potential was clear and stunning.

Over the next year, David and I had numerous conversations with Florian Klingler, David's manager at Red Bull. Florian, as a visionary marketer in the adventure-sports world, recognized that this would be a special project, and fought to make it happen. Thanks to a team effort, we secured the funding we needed to explore this Middle Eastern hot spot.

Everyone went into this project with their own set of goals. For David, he allotted himself one week to find a really hard new free climb, bolt it, clean it, and send it. There are probably only a few people in the world who are capable of pulling off a brand-new 5.14+ in a single week, but David is one of them.

For me and my team, we were tasked with creating a film around David's efforts, as well as capturing all the supporting still imagery. Was the difficulty in achieving all of these goals, in such a short period, a 5.14 effort for our small-footprint production? In hindsight, perhaps it was . . . and that's almost what got me into trouble.

The small team for this production was excellent: Dane Henry, Sean Haverstock, and Bligh Gillies were instantly on board. I've worked and traveled with this surly crew a lot over the years, and no matter what the job entails, when we get together it's always a great time. With at least twenty-five bags between the four of us, we brought everything but the kitchen sink: one 30-foot jib arm, a Freefly Movi M10 gimbal, a CineStar heavy-lift drone with a Movi attached, a Kessler Second Shooter motion-control system, a set of Litepanels Astra LED lights, a few Nikon D4s and D810s, and the high-def RED Dragon camera. (On the way home, we set a personal record for excess baggage fees, paying $4,000 to Middle East Airlines—after a lot of negotiating to bring the rate down from $7,000!)

Upon arriving at the Baatara Gorge, I couldn't believe my eyes. The pictures I'd seen online didn't do this place justice. You might think this would have made our job easier, but in fact, it really added a lot of pressure, because the expectations were suddenly so high.

"Corey, I think the route I'm going to bolt will go here," David said, drawing a line across the cave with his outstretched arm.

"David, that looks incredible!" I said. "Do you think you'll be able to send it?"

"Of course!" David said. "It'll be no problem."

Famous last words. In fact, the route ended up being much harder than David had imagined.

"Shit!" he said after his second day of effort on the climb. "I think this thing is really tough! . . . This is great!"

David was in his element—enthusiastic and optimistic about a world-class challenge.

By the end of the week, David had achieved his goal. I couldn't believe it! He got the first ascent of this 5.14d, making it the hardest rock climb in the Middle East. He named it *Avaatara*, conjoining the word *avatar* with the Baatara Gorge.

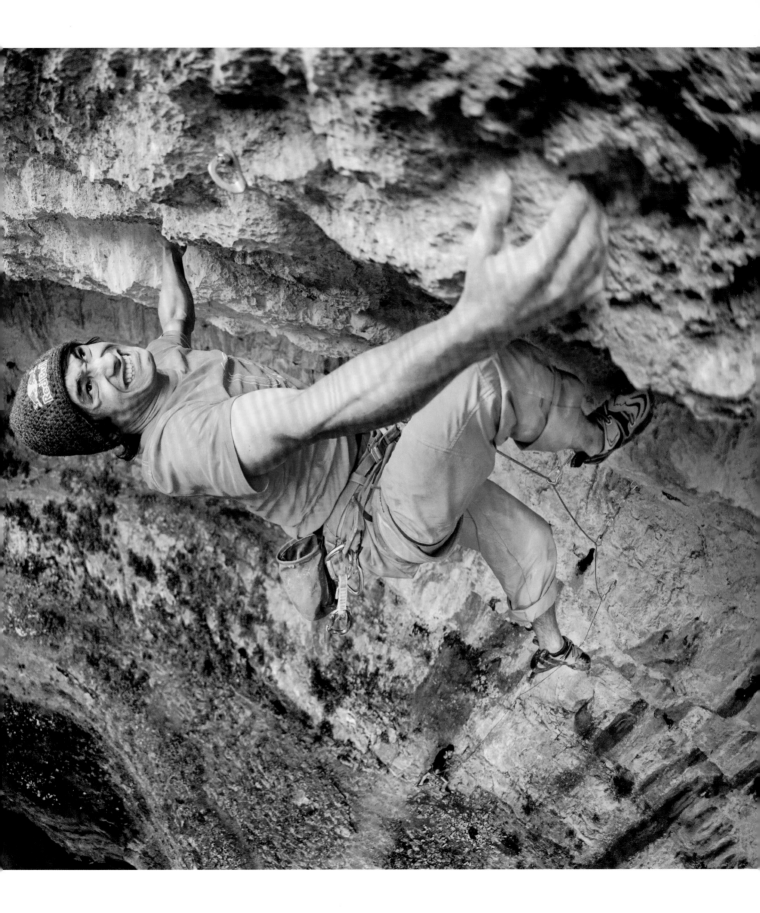

SEAN HAVERSTOCK RUNNING A 33-FOOT HEAVILY MODIFIED JIB ARM IN LEBANON

Meanwhile, our four-person production crew had been working in overdrive to capture the film, which was the top priority for our client, Red Bull. It was also the part of the project we were all most passionate about. As a result, the still photography played second fiddle.

I'll admit it: in the back of my mind I was thinking that we'd be able to simply pull stills from the RED footage. Then, second-guessing myself, I grabbed a D810 and found some time to snap a few photos—you know, the "safe shots" I was supposed to have already taken. In between directing the film, I shot stills of about four situations that I knew I could nail quickly and easily.

Thank God I did!

WE WERE CAPTURING VIDEO AT 120 FRAMES PER SECOND. IT WAS WAY OVERCRANKED FOR THAT SWEET SLOW-MO, WHICH IS WHERE THE RED SHINES.

It wasn't until I got home and began looking through our files that I realized that the stills we were pulling from the RED footage were nowhere near high-quality enough to be taken seriously.

Now, before I disclose too much and get myself into trouble, I should qualify several things. First, we've pulled stills from RED footage in the past (although it hasn't typically been in action-sports scenarios). Also, we were capturing video at 120 frames per second. It was way overcranked for that sweet slo-mo, which is where the RED shines. However, it also meant higher compression. Pixel for pixel, it was no contest. When we weren't shooting overcranked slo-mo, we were filming at a much lower shutter speed than what I would typically use for still action photography—and our camera was constantly moving. And, of course, we were using manual focus on our cinema lenses, which is inevitably prone to more human error compared to the precision autofocus of a DSLR. All said, the stills pulled from our RED footage didn't hold a candle to the stills I had shot on the 36-megapixel Nikon D810 with supersharp Nikkor glass.

These days, virtually every professional camera, and many prosumer and amateur cameras, shoots both stills and video. But the reality is, there is no single camera that can handle every single task, at least not at the highest level—not yet, anyway. Still, that's sort of the dream, right? To be able to have one tool that does it all. To pull photos from video files that can rival, pixel for pixel, anything the best still cameras on Earth can shoot.

When you work as a small-footprint production, every resource is precious. Every decision is a compromise. That's the whole game. To me, technology gets better when it gets out of the way—meaning it allows you to spend more time on creativity and less time doubling down on technical details, which often just slows everything.

I'm reminded of my first newspaper internship, when I was a kid aspiring to become a photojournalist. There'd always be a bunch of crusty old photographers and editors gathered around the office water cooler, railing against the fast-changing world of photography. These were the days of color negative film and print deadlines, but you could feel the high tide of digital cameras and the internet cresting on the horizon. I heard a lot of grandiose predictions around that water cooler: *Digital will never replace film! Print will always be king! The internet is just another fad!*

Of course, none of those statements were true. The lesson I took from my time hanging around that office water cooler was to be a forward-thinking guy. I believe it's better to embrace new technology than to rail against it.

Yeah, in Lebanon, I was probably operating a few years ahead of our time—believing that stills pulled from the RED would work. I may have been wrong then, but I do believe that my instinct was on the right track.

DANE HENRY DROPS INTO THE BAATARA GORGE TO CAPTURE DAVID LAMA'S SUCCESSFUL ASCENT OF THE HARDEST ROCK CLIMB IN THE MIDDLE EAST.

SCREEN GRABS FROM VIDEO: DAVID LAMA WORKING THE LOWER SECTION OF HIS ROUTE; LAMA PULLING THE LIP OF THE SINKHOLE, WITH THE NATURAL BRIDGES IN THE BACKGROUND; ALL SMILES

One day, the time will come when your mirrorless camera will shoot in 10K raw—you will be able to control your video and still exposures independently but shoot both simultaneously. It's going to happen. It's inevitable. But we're not quite there yet. Right now, when it comes to capturing brilliant still images, there's no substitute

WHEN YOU WORK AS A SMALL-FOOTPRINT PRODUCTION, EVERY RESOURCE IS PRECIOUS. EVERY DECISION IS A COMPROMISE. THAT'S THE WHOLE GAME.

for picking up a DSLR camera and doing it the "old-fashioned" way.

Interestingly enough, over a year later I found myself in Austria, with David and Florian, once again making a film of one of David's latest climbs for Red Bull. The priority for Red Bull was gathering high-res video in super-slow motion. And, oh yeah, they also needed stills.

You can be damn sure that I'd learned my lesson! As I hung from a rope a few hundred feet above the ground, with a gorgeous vista of the Austrian Alps sweeping around me in all directions, I had a RED Weapon slung from one shoulder and my trusty Nikon D5 slung from the other.

In the back of my mind was the memory of our time in Lebanon, quickly turning toward thoughts of all the future adventures and opportunities yet to come.

52
RAISING EXPERIENCE

THE BEST MOMENTS OF MY career have always involved the times when business, sport, and lifestyle come together—always in some unique way that makes going to work fun. Getting to "do what you love" is another way of describing this unique intersection. But there's a fourth ingredient involved in creating a successful career. And that is found in the value and depth of the personal connections you make while in pursuit of your passion.

In the summer of 2013, the phone rang. I was holding my six-week-old daughter, Leila, while Marina got some much-needed sleep. "Hello, this is Corey," I said, speaking softly into the phone, so as not to wake my baby.

It was Nikon's ad agency in New York City. They asked if I was interested in being involved in an online brand-building project that would inspire people to go out and take pictures. The "Nikon Experience" would be an immersive website featuring still photographs and audio recordings from myself and two fellow Nikon shooters, Troy House and Taylor Glenn.

Of course I said yes.

I was given a blank slate in terms of subject matter, so I decided to shoot rock climbing in the Luther Spires, a stunning, craggy location near my home in Lake Tahoe. As with every great opportunity, I needed to deliver.

When the stakes get this high, I prefer not to work with some random model vetted by an agency. I want—and really, need—someone whom I trust and know will be professional, work hard, and deliver. And if that person just so happens to be one of my best friends in the world, all the better.

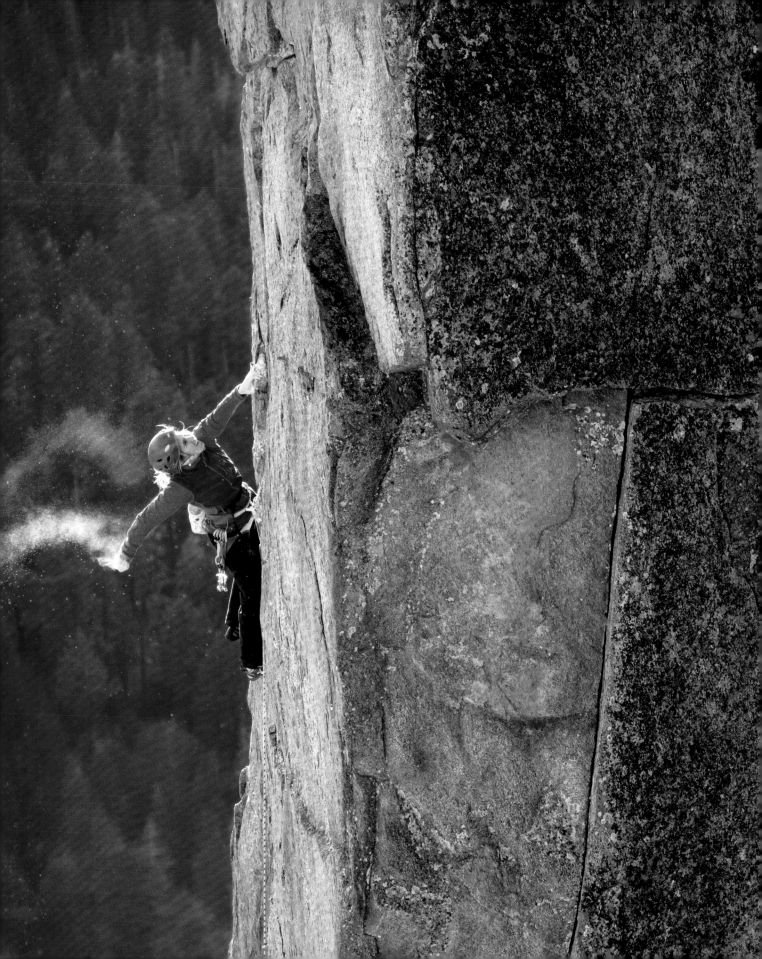

I called up Beth Rodden. At age eighteen, Beth became the youngest female to climb a 5.14a with her ascent of *To Bolt or Not to Be* at Smith Rock, Oregon. Back then, she was winning all the national climbing competitions year after year while also working on free-climbing El Cap with her then-partner Tommy Caldwell. Ultimately, she'd go on to establish the first ascent of one of the hardest single-pitch trad climbs in the world: *Meltdown* (5.14c) in Yosemite.

BUT SOON SHE BECAME EXCITED WHEN SHE REALIZED THAT THIS NIKON EXPERIENCE PROJECT WOULD BE HER FIRST PROFESSIONAL GIG AS A PREGNANT WOMAN.

"This Nikon Experience project is a big deal," I explained to Beth. "I want to eliminate the unknowns."

Beth, Tommy, and I became close friends in Yosemite, up on the walls of El Cap. I would hang off a single rope shooting pictures while Beth and Tommy climbed—2,000 feet of air beneath our feet. Over the years, we three spent many nights sleeping on portaledges and many days traveling the world in pursuit of new adventures. Until I met my wife, Beth was maybe the only woman I could call a close friend. I always appreciated the unique perspective she provided in my life, especially when I was contemplating my own relationships.

It turns out that there are a lot of parallels between the life of a professional climber and that of a professional adventure photographer. There is no course you can take at school that teaches you how to do either. There is no manual for turning passion into a career. To pioneer a way of living is a rather audacious thing, rife with loneliness, uncertainty, and sacrifice. Yet Tommy, Beth, and I, in one another, found friendship and support as we all worked to make our passions into careers.

"I'd love to work on this project, Corey," Beth said. "But there's something I have to tell you . . . I don't think it's going to be a problem, but, um . . . Randy and I are pregnant!"

"Holy shit! That's awesome! Wow! Congrats!" I said. Leila, who was still nestled in the crook of my arm, woke up, fidgeted, and looked up at me. "Looks like Leila is going to have a new little friend soon!" The idea that we'd all be able to raise our families together suddenly seemed very exciting.

"But please don't tell anyone yet," Beth said. "I still haven't told my sponsors."

She admitted she was worried about how becoming a mom would affect her career as a professional athlete. I assured her that it was all going to be fine. She still worried. But soon she became excited when she realized that this Nikon Experience project would be her first professional gig as a pregnant woman.

When the shoot day arrived, we were a large group. Among the many friends and associates from Nikon's New York headquarters and ad agency was Mike Corrado, a top dog in product marketing and leader of the

Nikon Ambassador team (we call him "Lead Ambass-hole"). He is one of my favorite people in the world. In addition to being an excellent photographer with decades of experience, Mike is also a brash, loud-mouth New Yorker who never lets an opportunity go by to make fun of me. But behind it all, he's got a heart of gold.

It was total chaos, with some fun moments as the group of city folks got a taste for real mountains and the effects of altitude as they hiked up the steep climbers' trail to the Luther Spires.

On that day, Beth wasn't showing yet, but she was suffering from bouts of morning sickness.

Beth whispered to me: "Corey, just so you know, I might have to occasionally lower off the route, walk around the corner, and puke."

I chuckled. Despite being pregnant and battling waves of nausea, Beth complained the least, hiked at an athletic pace, and by far climbed harder than everyone else there.

There was a lot of pressure to produce. But we kept Beth's pregnancy a secret from everyone quite well.

We shot all day. I took a moment to smile in acknowledgement of where I was. I was right at that intersection of business, sport, and lifestyle—clearly, I was doing what I loved. I pinched myself and went back to work.

Moments before the "golden hour" of light began, the Nikon crew hiked back down the trail in order to reach the car before dark. But Beth and I stayed out to continue shooting—just like old times. I never even had to tell Beth that we'd be shooting till well past dark. From nearly fifteen years of working together, she already knew.

With the group's departure, it was suddenly quite peaceful. There were only a few of us: me, Beth, her belayer (Kat Elliot), my assistant (Bryan Liscinsky), and Mike Corrado, who'd never miss the opportunity to keep the energy high. We were out in the mountains in a stunning location, breathing crisp air and bathing in golden light.

I WAS RIGHT AT THAT INTERSECTION OF BUSINESS, SPORT, AND LIFESTYLE— CLEARLY, I WAS DOING WHAT I LOVED.

While some people measure success in terms of dollars earned, photographs captured, videos produced, awards won, or recognition gained, I realized that the true measure of success is the quality of friendships made. Doing what I love was incredible, but it could be topped—by getting to share that experience with one of my best friends. This was what it was all about—and what it has always been about.

Today, when Beth and I get together, we sit back and watch our kids play. We sit there reliving all the fun times we've spent together up on walls, and wonder if our kids are going to grow up and become climbing partners and friends. I don't know the answer to that yet, but I do hope they find the friends and network to create a lifestyle of their own choosing, whatever that may be. I like to think that Beth and I have been decent role models in that regard.

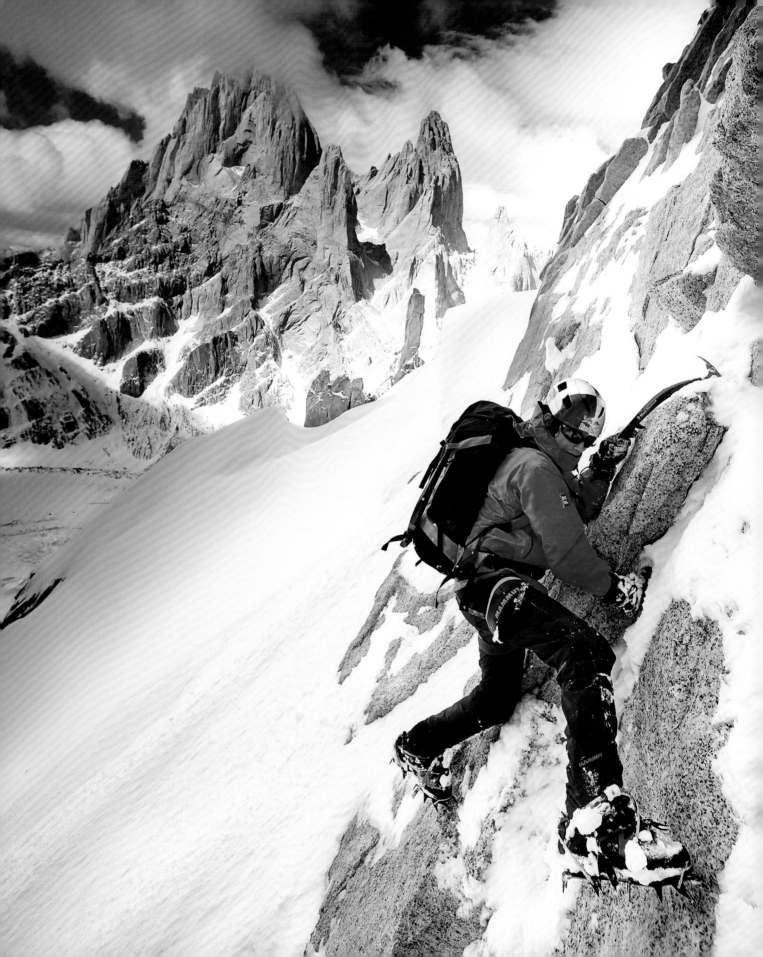

DAVID LAMA - CERRO TORRE, PATAGONIA, ARGENTINA
17–35MM LENS / F/5.6 / 1/640 SECOND / ISO 200

53

THE BEST TIME IS RIGHT NOW

THIS IS AN IMAGE OF David Lama climbing on the slopes of Cerro Torre, a mountain that beat him down for three years in a row. It was only through his undying optimism that he eventually succeeded in free-climbing this iconic peak.

But that's not what I want to write about.

What I want to write about is the Summit Adventure Photography Workshop, an annual workshop in Jackson Hole that I cofounded with one of my mentors, Rich Clarkson.

Rich is getting on in age, but his mind and attitude are as sharp and optimistic as those of any college kid. He is one of the living legends in the photography world, a storyteller who has virtually seen and done it all. As a teenager, Rich fell in love with journalism, interviewing people like Orville Wright and running in the same circles as guys like Ansel Adams.

Rich went on to become one of the most decorated sports photographers of all time, shooting for *Sports Illustrated* as a contract photographer, not to mention other major publications like *Time* and *Life*. Mind you, this was back in the heyday of magazines, when those publications held as much sway as the hand of God when it came to determining whose photography career flourished and whose died.

Rich then went on to serve as the director of photography at *National Geographic* and the assistant managing editor of the *Denver Post*. His perspective on this industry has been invaluable. But perhaps his greatest gift to the profession

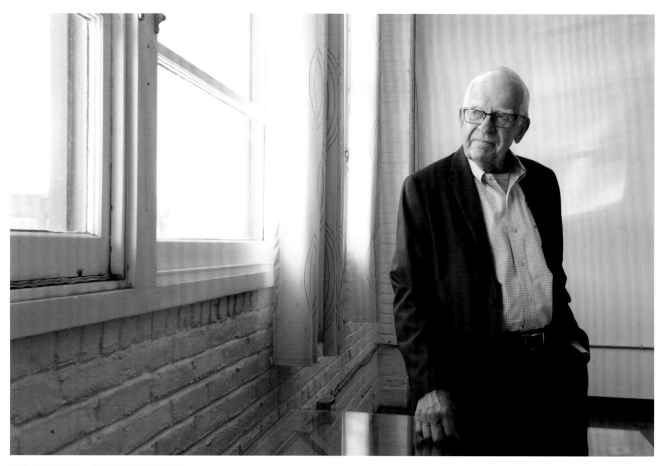

RICH CLARKSON IS A LEGEND IN THE PHOTOGRAPHY WORLD. I AM HAPPY TO CALL HIM A MENTOR AND FRIEND. (CLARKSON CREATIVE PHOTO)

is his amazing ability to select the most talented young photographers in the world and bring them up. He has probably identified and mentored more great photographers working today than anyone else.

Essentially, what I'm trying to say is that when Rich Clarkson speaks, you best shut your trap and listen up to what the man has to say.

During the last day of our 2016 workshop, something happened that really blew me away. About sixty of us were seated at a roundtable discussion in an outdoor amphitheater. Among forty-three students and five faculty members, I was sitting alongside my fellow instructors: Tim Kemple, Keith Ladzinski, Sadie Quarrier, Scott Wilson, Ryan Taylor, Andy Bardon, Bob Smith, Ron Taniwaki, and Lucas Gilman. We fielded questions and talked about the photography business. Then one of the students, a young guy just out of college, asked me a rather cynical question that started something like:

"You know, Corey, when you were growing up in this industry . . ." Which made me feel like an old fart! But I digress.

He continued: "When you were growing up, it was real simple. You interned at a newspaper, you went on to work for magazines, and then you started doing commercial jobs. What do guys like me do today? All that shit is gone! Do any of us honestly expect to have a future in this industry?"

And before I could even figure out how to answer, Rich Clarkson stepped up and launched into one of the most eloquent badass monologues that I've ever heard in my life. Basically, imagine the scene from *A Few Good Men* when Jack Nicholson shuts up the young Tom Cruise in the courtroom, only Rich was far friendlier, more optimistic, more correct, and way more badass. (I'm going to paraphrase here, but know that the actual monologue was at least twice as good.)

"Let me just make something real clear, guys," Rich said. "Right now, listen up! You know, I'm tired of hearing people talk about how the future is not bright. The future for photography and filmmaking and journalism has never been brighter!

"Has journalism changed? Yes. Certainly, journalism has changed. You're not going to go shoot black-and-white for newspapers. And you know what? Frankly, you should be thankful that you're not going to shoot black-and-white for newspapers because that's a thing of the past.

"The future is this thing called the internet. The future is this thing called technology. Today, we photographers, journalists, and filmmakers get to write our own tickets. When we have stories that we're passionate about telling, we have more freedom and more resources available to us than ever before. Equipment is affordable, and our potential outreach is unlimited. Wherever that funding comes from, whether it's philanthropic sources, a corporate underwriter, or by working in a nine-to-five job, you can get it.

"We not only have all the sophisticated tools and channels we need to tell our stories online, but we can deliver those stories to a targeted audience instantly. And if your story is really well told, then guess what? It does this thing called 'going viral,' and millions of people see it.

"Not only that, but if you're doing it really well, you can actually sell the advertising on your site. All the old publishing paradigms have changed, and the power is now in your hands. Don't lament today's new media environment. There are more opportunities for creative individuals like yourself, like everyone here, than ever before.

"We are no longer just photographers. We are all-encompassing storytellers. We are self-publishers.

We do our own promotion and marketing. We build websites and fill them with incredible original content. Today you are only limited by the scope of your own imaginations, and the originality of your own creativity.

"Don't you dare say the future isn't bright. Don't you dare say there are no opportunities left, or that it was better ten or twenty years ago. For photographers, filmmakers, journalists, freelancers, and production companies—for everyone here. You get to leave this workshop and go out there and write your destiny. The future is yours to create.

"Now go out and create."

Everyone in the workshop was left reeling, mouths gaping, after this monologue. I sat there silently for a moment feeling these waves of optimism washing over us—empowering us. The message was as clear as day: don't ever complain about the state of publishing and media today, because of the eighty-some years that Rich Clarkson has been on the planet, this guy thinks that right now we are living in the most golden moment ever for entrepreneurs, photographers, filmmakers, storytellers, and journalists.

It was an amazing idea for everyone to hear. It was a good reminder that maintaining an optimistic attitude and continuing to persevere in the face of adversity will get you to the top in good style. Thanks to Rich Clarkson and David Lama for being the reminders of and inspiration for this simple truth.

54

CREATIVELIVE

WHAT DO MOUNTAINEERING, CHILDBIRTH, AND teaching a CreativeLive course have in common?

They all involve an enormous amount of suffering that strangely fades from your memory as time passes. Magically, you forget all the bad stuff, and soon only the highlights remain.

CreativeLive is helping to change the way we learn. It's an online platform that broadcasts courses in a variety of creative fields to a live audience for free. Think TED talk meets online university course; it's a great way to share information.

For me, the coolest part is that you can watch a course when you want. You aren't limited to class hours. Episodes can be purchased and downloaded later.

In 2013, my friend Chase Jarvis, the founder and CEO of CreativeLive, invited me to teach my own three-day course about a subject that I love to talk about: paralleling still and motion on an HDSLR camera. I was enormously excited to receive this opportunity, because teaching has always been a passion of mine. But what was most appealing was the opportunity to teach in a small, intimate setting while simultaneously reaching thousands of students tuning in around the globe—the best of both worlds.

The schedule, however, was grueling—at least for me. Three days of teaching four ninety-minute segments freakin' crushed me. My brain had never felt so fried! I left with a huge respect for all the professors out there who actually do this, day after day, for a living. It also made me thankful to return to my day job, where the

typical fourteen-hour days are somehow more manageable, because at least you're *behind* the camera.

After all was said and done, I swore I'd never do another CreativeLive course—no way!

Fast-forward three years. I opened up my inbox and saw an email from my old buddy Chase.

Hey, Corey, I've got an incredible proposition for you, the email seductively began.

Chase Jarvis needs no introduction. He is an acclaimed commercial photographer, filmmaker, and a social-media powerhouse. He's a quintessential entrepreneur at the front of the curve, seizing the latest trends and turning them into successful ventures. For instance, CreativeLive is now a one-hundred-plus-person company, with offices in Seattle and San Francisco. That kind of success doesn't just happen by chance.

THE KEY TO TEACHING AT CREATIVELIVE IS THAT YOU HAVE TO KEEP TALKING, NO MATTER WHAT, EVEN AS YOU'RE SHOOTING AND TRYING TO FOCUS ON CREATIVITY.

Chase is also a good guy. Whenever we get together, our conversations are funny and engaging. I really enjoy spending time with him.

But he's also a sneaky bastard, who knows how to write an email pitch that could sell sand to a Bedouin living in the Sahara.

He wanted me to teach another CreativeLive course. *No way,* I immediately thought. But I kept reading.

He explained that it would be an action and adventure-sports course—my specialty, he reminded me. And it would be backed by Red Bull Photography, which would sweeten the pot as compared to last time.

I was hemming and hawing. *Still not sold,* I thought.

It'll take place right in your own backyard, he wrote. *Tahoe. You'll be able to sleep in your own bed at night.*

OK, this was sounding better. Finally, the clincher:

Best of all, we will team-teach it together, so we can share the burden of teaching. And we'll get to knock back brews every night, hang out, and shoot the shit. What do you think?

Memories of the pain of shouldering a three-day CreativeLive course three years ago had faded by the time I reached the end of Chase's email. Suddenly, I was super-freaking-psyched about teaching another course, drinking beers, and hanging out with Chase, who can talk for hours and hours about photography. This was gonna be straight-up easy.

Of course, a few short weeks before the actual course was slated to take place, I got another email from Chase. This one left me feeling a little less optimistic.

Dude, my intentions were good, he wrote, *but I hate to say it. I can only be there for part of the first day. After that, you'll be on your own.*

"Jarvis!" I shook my fist in the air. I couldn't be too mad, though. The real reason Chase had to bail was that he was flying to the White House to talk about creativity. That's a hard one to argue with.

Fortunately, the team at CreativeLive is a well-oiled machine, and they were able to take a lot of pressure off me by helping with lesson plans and content distribution.

Finally, after much preparation, the week came when it was time to step out from behind the camera and start performing as a teacher. The first day was for classroom instruction, and it took place in a cabin. It was a lot of talking, but I was able to share the duties of carrying the conversation with photographers Brett Wilhelm, Jeff Johnson, and Bligh Gillies, and intern Jose Borda. And, of course, Chase, who helped me teach this first day, before leaving for the White House.

We headed out into the field on days two and three, and for me, that's when it got fun. Our locations were around Truckee, at the Northstar resort and at Woodward, a mega action-sports arena with giant foam pits, ramps, trampolines, and skate parks. My favorite day was our last one at Woodward. I never even knew this place existed before the shoot, despite it being just a short drive from my home.

It was there that we shot the talented Corey Martinez, a BMX street rider and Red Bull athlete.

For most of the day, I was tethered to the computer, so that the online audience could see what I was shooting. It was restrictive, because you can only move 10 or 15 feet away. But I wanted to show the audience that it's important to change your angle and find new, surprising ways to capture action—whether that means getting high, getting low, etc. So I untethered from the computer and ran up this three-story tower to shoot from the top floor, looking down into the skate park.

We planned for Corey to air over a mound in the middle of the park. Jeff Johnson set up our two Profoto Pro-B4 strobe packs so that one strobe would create a shadow, and the other would add a kiss of fill light on Corey's face.

The key to teaching at CreativeLive is that you have to keep talking, no matter what, even as you're shooting and trying to focus on creativity. I was talking to the camera, and yelling down to Corey. He hit the jump. *Boom*—the lights fired, and I shot a frame.

I looked down at my camera, and I thought, *Damn, this is as good as it gets. I'm teaching. I'm working with an amazing athlete, and an awesome team. We're making supercool pictures, and getting paid to do it.*

Going out to exotic locations around the world is one of the perks of this profession, but I honestly get just as much enjoyment from shooting in my own backyard. That's especially true when I can go home, spend time with my wife and daughter, and sleep in my own bed. Teaching this course reminded me that with photography, there's always something new to see, or the potential to see something familiar in a new way. That's really what this craft is all about.

As much as I'd been dreading the burden of teaching another CreativeLive course, I realized that it had also brought out the very best in me as a teacher, photographer, and director—all of the things in my professional life that I care about cultivating, improving, and sharing.

The icing on the cake was getting paid to make some cool (in my humble opinion) pictures. The kind of photographs that make you forget about all the suffering and hard work you've put in.

But perhaps the best moment came next, when I had my own opportunity for Chase. I knew exactly how to write the email.

Hey, Chase. I've got an incredible proposition for you...

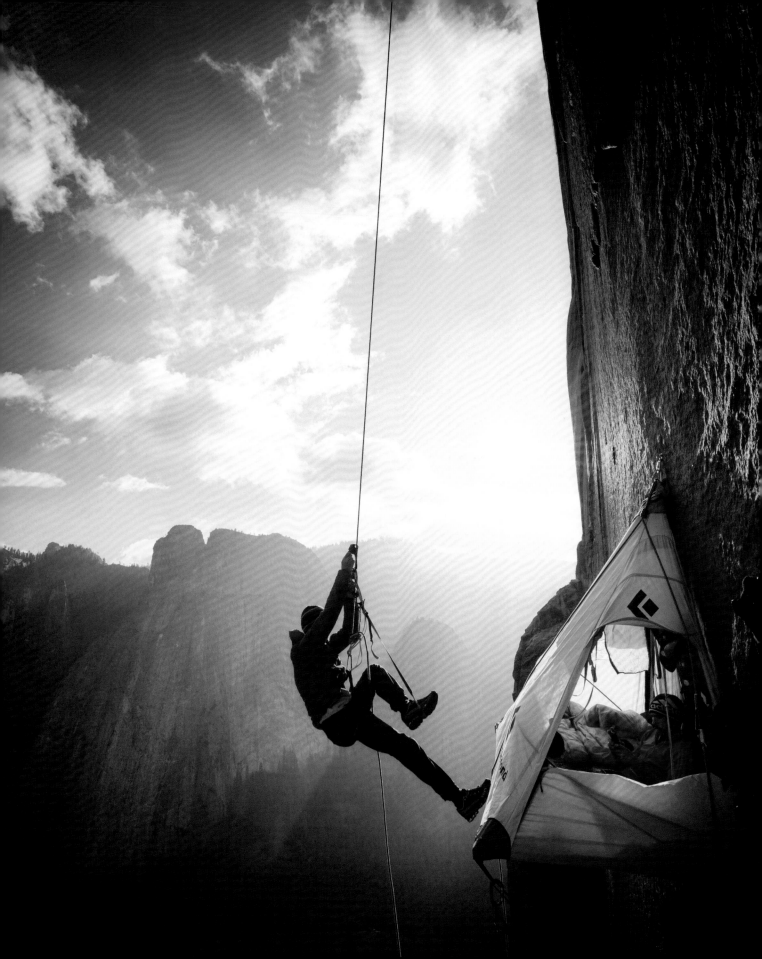

TOMMY CALDWELL AND KEVIN JORGESON - DAWN WALL,
EL CAPITAN, YOSEMITE, CALIFORNIA
14–24MM LENS / F/8 / 1/1000 SECOND / ISO 200

55

YOSEMITE GIANTS

I TOOK THIS PICTURE OF Tommy Caldwell and Kevin Jorgeson at 3:59 p.m. on January 11, 2015. At this point, I'd been living on the side of El Capitan alongside these two climbers for ten days, documenting their efforts to make history and complete the long-awaited first free ascent of the Dawn Wall, a 3,000-foot route that was subsequently dubbed the hardest rock climb in the world.

I don't know what it was, exactly, but the Dawn Wall story gripped the interest of people around the world in a way that I'd never seen before. Rock climbing in general is an obscure activity/lifestyle that is understood by few. But for a couple of weeks in January of 2015, climbing exploded with mainstream media attention. It was incredible!

As a longtime climber and climbing photographer whose roots are deeply embedded in this small niche world, the Dawn Wall media extravaganza was a spectacular thing to behold. Of course, I was honored and humbled to be part of the team—which included my good friends Brett Lowell, Bligh Gillies, and Kyle Berkompas, among others—that helped tell this story to the public through pictures and video.

I was also interested to see that this photograph, with Tommy ascending the rope and Kevin in the portaledge, preparing to climb, was the one that received perhaps the biggest response of all the photographs I took during the ten days I lived on the wall.

What's so fascinating to me about this photograph is that it's not a core rock-climbing picture. From a climbing perspective, nothing particularly extraordinary is

WHAT AN INCREDIBLE MOMENT! THE GOLDEN AGE OF YOSEMITE, WHEN CLIMBING TECHNIQUES AND ATTITUDES ALL BEGAN. HERE, TOM FROST TAKES IN HIS POSITION HIGH ON AN EARLY ASCENT OF EL CAPITAN. (PHOTO BY ROYAL ROBBINS / TOM FROST COLLECTION)

happening. In fact, this could just as easily be a photo of any two weekend warriors from San Francisco.

Yet it was this picture that went viral on *National Geographic*'s Instagram feed, graced the covers of newspapers, hit the cover of a special issue of *Time* magazine, appeared on television news networks around the world, and even appeared on the cover of *Rock and Ice* magazine's special Dawn Wall issue. Essentially, something about this photo touched both the core climbing community and the world at large.

When I look at this picture, I can't help but recognize that it is deeply inspired by one of my climbing and photography heroes: Tom Frost.

Tom Frost, who passed away at the age of eighty-two in 2018, was a friend, mentor, and total badass in both the climbing and photography worlds. He was also one of the humblest guys around. Photographers may know him as a cofounder of Chimera Lighting, based in

Boulder, Colorado. But Tom was also a climbing pioneer during Yosemite's golden age.

Tom began climbing in Yosemite with the Stanford Alpine Club, and graduated from the prestigious university in 1958. That same year, climber Warren Harding completed the first ascent of El Capitan via the *Nose*. In 1960, Tom became part of the team that made the second ascent of the *Nose*.

Tom went on to complete two more noteworthy ascents of El Capitan. In 1961, he joined up with Royal Robbins and Chuck Pratt and achieved the first ascent of the Salathé Wall, El Cap's second route.

In 1964, this same trio as well as Yvon Chouinard completed the first ascent of the North America Wall over nine continuous days. This was considered El Capitan's most difficult climb to date.

Tom's background as an inventor, engineer, and businessman came together in 1972 when he and Chouinard founded Great Pacific Iron Works and started to manufacture climbing gear. This company would ultimately give birth to both Patagonia and Black Diamond Equipment, the successful apparel and climbing-gear companies that we now know today.

While all of these achievements in and of themselves constitute a most envious curriculum vitae, the reason that Tom Frost stands out to me is because his skills as a climbing photographer are, in my mind, unmatched. In fact, he might have been the most naturally talented, and unsung, adventure photographer in the world.

You'd be excused for not knowing any of this, though, because Tom was one of the most down-to-earth guys you'd ever meet. Humility, it seems, is a characteristic that is common to many people who are truly great El Cap climbers—Tommy Caldwell, I'm lookin' at you!

For example, I only learned about Tom Frost's extraordinary photographic skills in a most unusual and unsuspecting way.

THE DAWN WALL MEDIA EXTRAVAGANZA WAS A SPECTACULAR THING TO BEHOLD.

LEFT TO RIGHT: ME, BRETT LOWELL, KEVIN JORGESON, AND TOMMY CALDWELL

As a former owner of the Aurora Photos stock photography agency, I have spent a lot of time over the years reviewing pictures from the top outdoor-adventure photographers. I live, eat, and breathe adventure photography. So it's rare that I come across a photographer who really blows me away with his or her raw talent or entirely new way of seeing things.

So rare, in fact, that it's happened only once.

Several years ago, I approached Tom with the idea for him to become a contributor to Aurora Photos, archiving his photographs to make them available to future generations in a searchable online database. He was excited about the idea, so I made the five-hour drive through the Sierra foothills to his home in Oakdale, California. Tom and his wife, Joyce, welcomed me, fed me, and wanted to hear all about my travels, adventures, business, and love life (I had just started dating Marina, now my wife).

After catching up, it was time to get to work. With loupe in hand, ready to edit, Tom led me to his desk, where he had a light table ready. His shelves were lined with film-filled binders. The negatives and contact sheets were meticulously organized—numbered and arranged by date—which clearly speaks to Tom's mind as an engineer.

I grabbed binder number one, roll number one, and began looking at the contact sheets, occasionally checking the negative to see if the image was sharp. Some of these images were marked with a grease pencil, and I recognized them as iconic photographs of Yosemite's golden age. But in between those more recognizable shots were other pictures that I found to be just as fantastic, if not better.

It felt amazing to be looking at what is arguably rock climbing's most important moments—its very genesis as a modern adventure sport—while one of the very founders himself sat right beside me, recounting one incredible story after another behind each and every frame.

I couldn't believe what I was looking at. Roll after roll, each negative was unique. There were no motor-driven sequences, fired in the hopes that one frame would be in focus and show a decisive moment. Tom had shot no more than a frame or two per scenario—but he had always nailed one. That shot was invariably perfectly

THE DAWN WALL BECAME A PHENOMENON UNLIKE ANYTHING THE CLIMBING WORLD HAD EVER KNOWN.

exposed and composed, capturing a wonderful decisive moment and telling an incredible visual story about the character and spirit of Yosemite's earliest climbers.

I was impressed with his level of technical proficiency and obvious understanding of photojournalism—of using his camera to tell a wonderful story with each shutter depression.

I had become completely engrossed in poring over this archive—so engrossed, in fact, that I didn't realize that hours had passed.

"Corey, let's take a lunch break," Tom suggested. Reluctantly I put my loupe down, and Tom and I went to a nearby Mexican restaurant for some burritos, another passion we both share.

We talked about business and big-picture ideas, but I was really keen to grill Tom about his photographic background. Where had he learned how to use a camera? What *was* this extraordinary photojournalistic background that drove him to capture the original

founders of our sport with such expertise, skill, and creativity?

"How long had you been shooting before you began documenting Yosemite climbing?" I asked Tom. "I started on roll one today, but obviously that's just your climbing archive. Tell me about your photography experience before that."

Tom's response was one of confusion.

So I clarified myself and asked again, "What had you shot before this?"

With the deadpan tone that any engineer uses to deliver facts, Tom simply stated, "That binder you started with today—number one—that was the beginning. That was my first roll."

"What?"

I would've fallen out of my chair except for the fact that we were both sitting in a booth. Most people spend a lifetime trying to master the art and craft of photography, but Tom's keen eye and raw talent were evident in his very first roll of film.

"It was 1960," Tom explained, "and I was standing in Camp 4 with Chuck Pratt and Royal Robbins. We were racking up for what would be the second ascent of the *Nose*. Then Bill Feuerer comes over and just hands me his Leica camera. And he says to me, 'Hey, Tom. Take this up with you. You'll want it.' So that's how it started."

To become familiar with the camera, Tom shot his first scenario, creating the now-iconic image of Royal and Chuck sorting pitons on a Camp 4 picnic table as Bill looks on.

"I was no photographer or photojournalist," Tom said humbly. "I was just a climber who carried a camera."

This was where it all began. Not only had Tom pioneered Yosemite big-wall climbing, but he'd also pioneered adventure photography. In the photography world, I had never seen such raw virtuosity and talent, before or since.

In light of the Dawn Wall media extravaganza, my main takeaway has been one of feeling grateful to be able to stand on the shoulders of Tom Frost—and many others who have since followed in his footsteps—and document an exciting moment in Yosemite's incredible climbing history.

There's also a parallel with Tommy Caldwell and Kevin Jorgeson, in that their achievement is also the result of the pioneers who paved the way for big-wall free climbing before them: the Huber brothers; Paul Piana and Todd Skinner; Lynn Hill; Max Jones and Mark Hudon—all the way back to Tom Frost, Royal Robbins, and Chuck Pratt.

WE ARE ALL STANDING ON THE SHOULDERS OF THOSE WHOSE HARD WORK AND FRESH CREATIVITY CAME BEFORE US.

In *Ascent* magazine, Tommy once wrote: "Embracing all styles of climbing made me the climber I am today. Style is a body of knowledge and a collective, generational work in progress. Nowhere is this truer than in big-wall free climbing."

The same could be said of photography: that it's a generational work in progress. This image that I took of Tommy and Kevin on the Dawn Wall isn't mine, per se. It belongs to all those photographers who came before me and have inspired me over the years, including Glen Denny, Galen Rowell, Greg Epperson, Jim Thornburg, Beth Wald, Brian Bailey, and Bill Hatcher. And it belongs to all those who've come up since: Keith Ladzinski, Tim Kemple, Jimmy Chin, and Andrew Burr—among dozens of others who have simply been, in Tom's own humble words, nothing more than climbers with a camera in tow.

Today, the Dawn Wall is considered the hardest big-wall free route in the world. But tomorrow, there will be some new, stronger climbers who will climb it more quickly and in better style. (In fact, two years after Tommy and Kevin's ascent, Adam Ondra, a young climber from the Czech Republic, managed the second ascent in rapid style.)

The same phenomenon is true with adventure photography. We are all standing on the shoulders of those whose hard work and fresh creativity came before us. And it's our duty to stand as tall as we can, push the limits as high as we can, and wait to see what incredible climbs and visual storytelling tomorrow's generations will bring.

56

HOME

IT SHOULD BE PRETTY OBVIOUS to you by now that I am not a player and I don't have game. I was never comfortable attempting the old photographer pickup line that goes: "Hey, I'm a professional photographer, and I'd love to work with you on my next shoot."

But even a blind squirrel finds a nut every now and again. Sometimes, it walks right into his office.

This story actually begins with my old studio manager, Blaine Deutsch, who is a great, hardworking guy and one of my dearest friends. One day, he, his wife, and their two daughters were at a coffee shop in South Lake Tahoe when Blaine spied a striking young woman reading a book and drinking coffee in the corner. He walked over to the young lady and used his own version of that cheesy photographer pickup line.

"Hey, I work for a photographer in town, and we always need attractive people for our shoots," he said. "Here's my business card. Call if you're ever interested in becoming a model."

I had no idea that Blaine was rolling around town doing this kind of solicitation. It certainly wasn't part of his contract.

Nevertheless, a few weeks later, Blaine's encounter resulted in a follow-up.

That day, I was between trips and catching up on emails.

My ears perked up when I heard an unfamiliar voice in the main office, just behind my closed door. The voice was female, Latin, and full of energy and laughter.

I checked the calendar to see if we had any visitors scheduled, but no one was listed. My curiosity grew. I had to see to whom this voice belonged.

I grabbed a folder of papers and shuffled out my door, pretending to be very busy. The voice belonged to one of the most beautiful, vivacious women I'd ever seen. She was talking to Blaine. I gave the woman a casual little nod, didn't say anything, and then quickly shuffled back into my office.

From behind my closed door, I texted Blaine: *Who is that?*

He texted back: *Marina. She's from Brazil.*

Please introduce us before she leaves, I replied.

Quickly, I hopped on the computer and literally Googled *Brazil*. The country's Wikipedia page came up, and I started reading and memorizing facts about this proud South American nation.

Just then, Blaine and Marina entered the room, and I pulled up my email and pretended to be in the midst of typing a very important message.

"One moment," I said, typing a few more lines, then hitting "Send" on an email to no one. I spun around in my chair and stood up.

"Hi, I'm Corey," I said, finally introducing myself to Marina.

We made small talk. I asked her where she was from, and she said Brazil.

"Oh, wow, I've always been interested in Brazil," I said. "One of the things that has always fascinated me is that it has a population of two hundred eight million people, and it's a larger landmass than the United States minus Alaska."

Marina smiled in a bewildered way, and the conversation continued. Without being too obvious, I found out her relationship status through a sneaky line of questioning. From what I gathered, she and some girlfriends from Brazil were living here on work visas and earning college credits while honing their English skills. I also gathered that she was single.

"I'm actually between work visas right now, and so I'm spending a lot of time watching movies," she said. "I love the cinema."

If I had any game whatsoever, I would've said something like, "Oh, I love the cinema, too. We should go to a movie together."

Instead, I just stood there and watched as this softball sailed across the plate. I didn't even take a swing. Even worse, I had now completely run out of facts about Brazil, so I stood there with a vacant look on my face.

"Well, it was nice to meet you!" she said.

I watched her slowly walk away.

Say something, you idiot! Say something now!

Nope. She reached the front door, walked through, and left.

What the hell is wrong with you? Why didn't you ask her out?

I beat myself up the rest of the afternoon.

The next day, I was on a plane to China for another shoot. I spent the entire ride looking out the window, painfully reliving that missed opportunity. I wondered if I'd ever see Marina again.

Four months later, I was gearing up for a shoot for Vail Resorts in Lake Tahoe. It was a midwinter nighttime lifestyle shoot, and I showed up to our location to greet about thirty extras. Unbeknownst to me, there, as one of the talent, was Marina.

I had no idea if she was still single. But I told myself that this time I wasn't going to screw this up. I might strike out, but I vowed to at least go out swinging.

I said hello and started chatting with Marina. But the professional part of my brain buzzed, and I quickly realized that this was a real gig. Despite the ambiance, I was at work. The client was there, and it was a fairly large and important project. I reminded myself that I couldn't get totally distracted and flirt with Marina the entire time.

As this was a nightlife shoot, the talent was all dressed up. Marina was wearing a sexy black dress and heels. This didn't help me focus on doing my best work. (In fact, if you look at the resulting deck of photos that I took, Marina ended up being the focus of damn near every one.)

After the shoot was over, we went out to a huge dinner at a Mexican restaurant. I've always insisted on doing a wrap dinner. Partly, it's because we can't always pay everyone enough for their time and hard work. But I also love doing a wrap dinner because it's the time when we can all really get to know each other. It's one of my favorite elements of our productions.

SCREEN GRABS FROM VIDEO: LEILA FULL OF WONDER IN THE PONDEROSA FOREST NEAR OUR HOME; MARINA TEACHING LEILA CULINARY SKILLS; WAKE UP SNUGGLES BEFORE A NEW DAY FULL OF ADVENTURE

I couldn't help but notice that at least three or four extras had also been flirting with Marina during the shoot. As she sat down at the table, I saw all of their eyes light up at the opportunity to be the one sitting next to her. Trying not to be obvious, they all started moving in to take that seat. As I had already vowed not to let another softball cruise by without taking a swing, I jumped in front of them, deftly ducked under the arm of a waitress carrying a tray of margaritas, and dove through a crowd to be the first to reach that empty chair.

"Mind if I sit here?" I asked, slightly out of breath.

"Of course. I would love that!" Marina said.

We talked through the entire dinner. It was a genuine conversation, but I'll be honest—I also tried to impress her with tales of my climbing adventures and give the impression that I was some hard-core mountain dude.

Everyone started trickling out of the restaurant, but it felt like Marina and I were just getting going. Pretty soon, there were only a few people left at the bar. The bartender announced last call.

"Why don't we go to another bar?" Marina suggested.

Of course, I agreed.

We exited onto the street to find that, without exaggeration, it had snowed about 2 feet since we'd arrived. It was absolutely puking snow. We got to our cars. Marina was driving a Jeep Cherokee, and I had a Subaru. She pulled out first and tried to whip a U-turn through the berm of snow that the plows had created in the middle of the road.

I followed directly behind her, also about to make the same U-turn. But for some reason, Marina stopped in the road, and I nearly rear-ended her. If that wasn't bad enough, now my Subaru was stuck.

For about a minute, Marina sat in her Jeep watching me fishtail and spin around trying to get up and over the berm. Finally she got out of her Jeep and walked over, still wearing her high heels.

"Does the mountain man need some help?" she asked.

I laughed. "This is a little embarrassing," I said.

"I'm serious!" she said. "We have to get to the next bar, Corey!"

Before I knew it, Marina was pushing my car through the snow.

When this petite Brazilian in an evening gown and high heels successfully pushed my car through waist-deep snow during a puking snowstorm at midnight, that's when I knew she was a keeper.

At the next bar, as I recounted what seemed like my hundredth story of the night, Marina leaned over and gave me a kiss. Maybe it was because she was tired of waiting for me to make a move. Or maybe it was her way of getting me to shut up. Either way, it set the tone for our relationship. Years later, she was the one who asked me to marry her.

Since that memorable snowy night, our lives have become braided together in such an incredible way. I doubt that Marina, growing up in the south of Brazil, ever imagined that one day she'd be a hard-core mountain gal, skiing and climbing in Lake Tahoe. And I know that I never imagined one day spending Christmases on a beach in southern Brazil, sipping caipirinhas and speaking broken Portuguese to my new family.

But perhaps the biggest surprise for both of us was the joy of becoming parents. Our daughter, Leila, was

born in July 2013, and I learned that becoming a parent is an experience in which everything changes, and yet also nothing changes except for the fact that the best parts of your life get even better.

As a guy who cut his teeth in the climbing world, I have always placed a premium on the number of days I get to spend away from home in pursuit of adventures, using my camera to tell stories about the things that I most love.

That got a lot harder once there was this amazing little girl waiting for me at home, looking up to me to be her father. I think this is a phenomenon that happens to all new parents. There is a period during which your identity shifts and your priorities change and you wrestle with how everything in life is now going to fit and work together.

In late 2017, Nikon USA called to let me know that it was launching the D850, which would become arguably the most impressive DSLR camera on the market. The Nikon team wanted a film in advance of the camera's release. They gave me a small budget and a blank slate. I could shoot whatever I wanted, but they said they wanted something that was important to me.

I looked at the camera's specs, and it seemed like a dream rig. A silver bullet. I pictured what I could do with the D850 in some stunning, exotic location.

That year, however, I'd already traveled more than in any other year of my career. I was excited to help with the launch, but I also found myself weary at the thought of further travel.

That afternoon, I took Leila and our dog, Preta, hiking among the boulders and pine trees behind our house. As I threw sticks for Preta and watched Leila run around the forest, the instruction to shoot something important to me echoed within. It struck me that the most important subject matter was actually right here at home.

I called up my friends at Nikon and pitched them the idea of shooting my living room.

"I always keep a camera out on my kitchen counter," I explained, which was true. "I'll just swap it out for the D850 and see what I can create here at home."

Here I was, a professional photographer and director two decades into his career, pitching Nikon on using its new high-end camera to create a simple home movie.

But . . . they ended up loving the idea. Over a day or two, I shot one of the most important films of my career. I used no fancy camera-movement techniques. There were no jib arms or sliders or Movi stabilizers. It was all handheld and shot on a single 50mm prime lens. The result was a two-and-a-half-minute movie called *Home*, starring Marina, Leila, and Preta, with cameos by some of our closest friends and family.

The film isn't a masterpiece, by any measure. There are shots that I wish were better. But the most important aspect of this film was the experience I had of stripping it all away and going back to the basics, back to being that thirteen-year-old kid who had just picked up his first camera simply because he wanted to shoot rock climbing and tell stories. I was shooting what was most important to me, and that's all that mattered.

If I compare my life today to my life many years ago when I was a single guy Googling *Brazil* in my office between productions, in some ways many things are more complicated. My office is no longer in the basement of my house; I have a brick-and-mortar location on Ski Run Boulevard in South Lake Tahoe. I'm no longer a single entrepreneur, but a business partner at Novus Select, a growing production company with a bunch of employees, Fortune 100 clients, and a network of creatives around the world.

The biggest change, though, is that I now have a family—a wife, and a daughter, whose passport included stamps in over a dozen countries by the time she was two years old.

But what I've realized is that these changes don't add complexity. They add simplicity. It helps that Marina is gifted with an ability to just roll with the flow, but it's so much easier now to know and remember what's really important to me.

I have no idea what comes next, but I have seen how it all can work together in the best way possible. The goal is to keep doing more of that—only bigger, better, simpler, and surrounded by more of the people I love. The most exciting thing is all the stories the future holds.

PHOTO BY BRYAN LISCINSKY

EPILOGUE:
HOW *STORIES BEHIND THE IMAGES* WAS CREATED

I'VE NEVER BEEN A GREAT writer, but I've always known the power of the written word and how well it complements still imagery. I have worked with writers and journalists throughout my career, and have seen how working together as a team provides a lot of opportunities, especially in the magazine/editorial realm, that you can't access alone. For me, oral storytelling has always been something I love and am pretty good at. It's a skill that just comes naturally. Getting it onto a piece of paper, however, was where I came up short.

At some point, I started working with Andrew Bisharat, a writer who has helped me with a variety of projects, including turning stories that I had in my head into written essays. We started out posting our stories on my blog and Facebook, and simply branded the series "Story Behind the Image." SBI began with no aspirations of becoming a book. It was simply a way to share behind-the-scenes stories about my work as a professional photographer and filmmaker. Some of the essays were simply educational: literally, a recipe for how to make this exact photograph. But soon, they become more personal. And, as Andrew pointed out, the more personal a story gets, the more enduring it becomes.

Our process for creating SBI was pretty unique, and it's worth sharing here, in the spirit of pulling back the curtain. My work sees me traveling upward of 250 days each year (in the busiest/biggest years), going from one shoot to the next, so here's what we did: I'd choose a memorable image from my archive, and then Andrew and I would get on the phone and brainstorm potential themes. After thinking over what kind of story I could tell about each picture, I'd use my iPhone and record a voice memo for Andrew, literally telling him the story about how I created that picture, trying to tell these stories as though I was sitting at a campfire with Andrew at some campground. He would transcribe the voice memo, and then use his skill as a writer to spin each tale into a book-worthy yarn.

I found myself recording these SBI voice memos in all types of situations: sitting on planes, sitting at a bar in a hotel while cheesy music played in the background, driving across the country, holding my sleeping baby daughter, or pedaling my mountain bike up a hill behind my home in South Lake Tahoe.

Best of all, through this multiyear process, Andrew and I became close friends.

As time passed, and we saw that some of these posts were receiving as many as one hundred thousand views, we thought we should turn SBI into a book. We realized that while these stories can all be read individually, when put together, they cohere into something that resembles a memoir of my life as a climber, photographer, filmmaker, husband, and father.

ACKNOWLEDGMENTS

THEY SAY YOU'RE THE AVERAGE of the five people you spend the most time with. But over the course of creating this book and reflecting on my career, it became profoundly obvious that I am the sum of dozens and dozens of incredibly talented and smart people, without whom none of this would have been possible. From the bottom of my heart, thank you to all of the people who have helped me build a career and life that I deeply love and am profoundly grateful for.

Thank you to all the people who appeared as the talent, models, and athletes in the images in this book. Without your hard work and willingness to push your own limits, none of these images would've held any power.

Thank you to all of the mentors and teachers that I've had along the way. Your generosity with sharing information and providing opportunities to me left an enormous impression, and that is something for which I continue to feel indebted and try to pay forward to the next generation.

Thanks to all of my colleagues, my fellow photographers and filmmakers, for pushing each other and helping all of us raise the bar.

Thank you to all of my clients, not just for the opportunities to combine passion with work, but for the friendships that we've cultivated along the way, which extend not just to future work projects but to backyard summer barbecues and late nights around campfires and early mornings in the mountains.

Thank you to my tireless and talented staff at Corey Rich Productions, and now Novus Select, for being the infallible machine that makes all of this possible. Especially, thank you to my partners at Novus for standing alongside me and shouldering the weight of running a contemporary storytelling company while also cutting me the slack to pursue passion projects like this book!

Thank you to the team at Mountaineers Books, and all the copy editors, photo editors, and photo re-touchers who played a crucial role in shaping the contents of this book.

Thank you to my friends and community in South Lake Tahoe, for keeping me grounded, providing love and support, and giving me a reason always to look forward to coming home.

Thank you to my parents for providing me with the values that I hold dear, and instilling in me a love and appreciation for telling stories.

Thank you to my beautiful family, especially Marina, for providing all the love and support in the world, and for being an angel.

Thank you to the next generation of climbers, fans, and storytellers—seeing your creativity and work keeps the fire lit, and inspires me every day to push harder.

Finally, thank you again to everyone that I have shot with, worked with, and mentored or been mentored by. I consider all of you to be the dearest and truest of friends. It's honestly these lifelong friendships that are the best part of this job.

Thank you, thank you, thank you!

Some of the people who appeared in these photos and stories are no longer with us; many of them having died in the mountains as they pursued their passions. The reality is that the longer you play these sports, the longer the list of your dead friends becomes. At this point, my list is way longer than I could've ever imagined—and I'm sad to say that I know it'll continue to grow. This is something I've always struggled with, but the other side is that we wouldn't be the same people without these sports, this community, this lifestyle. For that joy in life, at least, I'm thankful. And I extend that gratitude to the families and close friends of those we've lost.

ABOUT THE AUTHOR

COREY RICH has built a life and career around his passions for travel, adventure, and telling stories with his camera. With a background in rock climbing and photojournalism, Rich has created a body of work that spans a range of genres, from iconic still imagery for leading editorial publications, to television spots and films, to high-production-value commercial projects for Fortune 100 companies.

In addition to shooting photographs and directing films, Rich teaches and shares knowledge with the next generation of storytellers through various workshops, lectures, and other online courses.

He lives with his wife, Marina, daughter, Leila, and dog, Preta, in South Lake Tahoe for the world-class climbing, biking, skiing, and incredible community of passionate people who live there. To follow his work and adventures, find him at http://coreyrich.com or on Instagram @coreyrichproductions.

MOUNTAINEERS BOOKS

recreation • lifestyle • conservation

MOUNTAINEERS BOOKS is a leading publisher of mountaineering literature and guides—including our flagship title, *Mountaineering: The Freedom of the Hills*—as well as adventure narratives, natural history, and general outdoor recreation. Through our two imprints, Skipstone and Braided River, we also publish titles on sustainability and conservation. We are committed to supporting the environmental and educational goals of our organization by providing expert information on human-powered adventure, sustainable practices at home and on the trail, and preservation of wilderness.

The Mountaineers, founded in 1906, is a 501(c)(3) nonprofit outdoor recreation and conservation organization whose mission is to enrich lives and communities by helping people "explore, conserve, learn about, and enjoy the lands and waters of the Pacific Northwest and beyond." One of the largest such organizations in the United States, it sponsors classes and year-round outdoor activities throughout the Pacific Northwest, including climbing, hiking, backcountry skiing, snowshoeing, camping, kayaking, sailing, and more. The Mountaineers also supports its mission through its publishing division, Mountaineers Books, and promotes environmental education and citizen engagement. For more information, visit The Mountaineers Program Center, 7700 Sand Point Way NE, Seattle, WA 98115-3996; phone 206-521-6001; www.mountaineers.org; or email info@mountaineers.org.

Our publications are made possible through the generosity of donors and through sales of more than 800 titles on outdoor recreation, sustainable lifestyle, and conservation. To donate, purchase books, or learn more, visit us online:

MOUNTAINEERS BOOKS

1001 SW Klickitat Way, Suite 201 • Seattle, WA 98134
800-553-4453 • mbooks@mountaineersbooks.org • www.mountaineersbooks.org

An independent nonprofit publisher since 1960

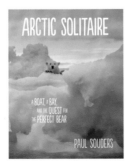 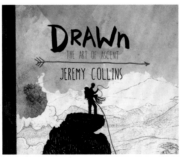 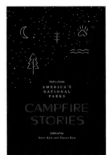